KB077084

타이포잔치 2013: 서울 국제 타이포그래피 비엔날레

2013년 8월 30일–10월 11일
문화역서울 284

주최
문화체육관광부

주관
한국공예·디자인문화진흥원
한국타이포그라피학회

조직위원회
안상수, 위원장
김지현
라르스 뮐러
네빌 브로디
서영길
폴라 셰어
왕쉬
하라 켄야

총감독
최성민

큐레이터
고토 데쓰야
김영나
유지원
장화

'무중력 글쓰기' 공동 기획
이정엽

'한글날 전야제' 기획
홍철기

추진위원회
이병주, 위원장
김경선
김승배
김현미
크리스 로
성재혁
한창호

사무국장
이민아

코디네이터
전영주
김민영
이나란
백송민

홍보
안태정

현장 매니저
이은정

그래픽 디자인
유윤석

그래픽 디자인 도움
김나래

전시 디자인
이웅렬 (곰 디자인)
김영나
최성민

제작, 설치
이웅렬 (곰 디자인)

미디어 설치
박근수 (미지아트)

글
최성민
유지원

번역
최성민
최기원

편집
최성민
인진성

교열
이은실
이미진

홈페이지 디자인
홍은주 / 김형재

개막식 음악
함영준

Typojanchi 2013: Seoul International Typography Biennale

August 30
–October 11, 2013
Culture Station Seoul 284

Hosted by
Ministry of Culture,
 Sports and Tourism

Organized by
Korea Craft & Design
 Foundation
Korean Society of
 Typography

Organizing Committee
Ahn Sang-soo, chair
Neville Brody
Hara Kenya
Kim Jee Hyun
Lars Müller
Paula Scher
Seo Yung-gil
Wang Xu

Curatorial Director
Choi Sung Min

Curators
Goto Tetsuya
Jiang Hua
Na Kim
Yu Jiwon

Co-curator, Writing
 in the Air
Lee Jung Yeop

Curator, Hangul Day
 Eve Festival
Hong Chulki

Surge Committee
Lee Byung-ju, chair
Han Chang-ho
Kim Hyun-mee
Kim Seung-bae
Kymn Kyung-sun
Sung Jae-hyouk
Chris Ro

Administration
Lee Min-ah

Coordinators
Jeon Young Joo
Kim Min Young
Lee Naran
Baik Song Min

Public Relations
Ahn Tae-jeong

Exhibition Management
Lee Eun Jung

Graphic Design
Yoo Yoon Seok

Graphic Design Assistance
Kim Narae

Exhibition Design
Lee Woong-ryeol
 (Gom Design)
Na Kim
Choi Sung Min

Construction
Lee Woong-ryeol
 (Gom Design)

Media Installation
Park Keun Su (Mijiart)

Writing
Choi Sung Min
Yu Jiwon

Translation
Choi Sung Min
Choi Ki Won

Editing
Choi Sung Min
In Jinsung

Copyediting
Lee Eun Sil
Lee Mi Jin

Website Design
Hong Eunjoo and
 Kim Hyungjae

Opening Reception Music
Hahm Youngjune

후원
NAVER

공인
이코그라다

협력
가나아트센터

협찬
안그라픽스
산돌커뮤니케이션
으뜸프로세스
작업실유령
서울스퀘어
괴테-인스티투트
오스트리아 교육문화예술부

Sponsored by
NAVER

Endorsed by
Icograda

Cooperation by
Gana Art Center

Supported by
ahn graphics
Sandoll Communication
Top Process
Workroom Specter
Seoul Square
Goethe-Institut
Austrian Ministry for
 Education, the Arts
 and Culture

문자를 창의적인 미디어로서 조명하고, 타이포그래피를 통해 각국의 글자 문화 및 디자인 교류와 소통을 도모하는 유일한 국제적 비엔날레인 타이포잔치 2013의 개최를 진심으로 축하드립니다.

시각디자인은 물론 디자인 전반에서 그 바탕을 이루는 타이포그래피는 문화의 근간인 문자를 통해 우리의 생각은 물론 언어의 감성까지 담아내며 다양한 예술 분야와 일상생활에 깊이 관여하는 분야로, 박근혜 정부의 국정 기조인 문화 융성의 실현과도 밀접한 연관이 있습니다.

타이포잔치는 지난 두 차례 개최 경험을 통해 국제적인 디자인 및 문화 행사로 발돋움하고 있습니다. 특히, 이번 행사는 유럽과 미국의 문자 문화권까지 포함하여 그 규모를 확대하였으며, 국내외 유망 작가가 함께함으로써 국제 비엔날레로서 내실을 기하였습니다.

아름답고 우수한 한글을 고유 문자로 사용하는 우리가 주최한다는 타이포잔치의 특별한 의미를 살려, 앞으로도 이 행사가 디자인을 통한 문자 문화의 교류와 소통의 대표적인 장으로 자리매김해나가기를 기대합니다.

이번 전시의 성공적인 개최를 위해 애써주신 안상수 조직위원장님, 최성민 총감독님을 비롯한 관계자 여러분, 한국공예·디자인문화진흥원과 한국타이포그라피학회에 감사드립니다. 또한, 좋은 작품으로 참여해주신 국내외 작가 여러분께도 감사의 말씀을 드립니다.

타이포잔치가 디자인계뿐만 아니라 일반 국민이 가장 가까운 일상 속의 문화로서 디자인의 의미를 재발견하고 디자인의 새로운 모습을 경험하고 느끼는 소중한 기회가 되었으면 합니다.

감사합니다.

문화체육관광부 장관
유진룡

I would like to congratulate the hosting of Typojanchi 2013, the only international biennial for typography where cultures and designs from around the world are exchanged and communicated through typography, while shedding light on typography as a creative medium.

As a foundation of visual communication design as well as design at large, typography conveys our thoughts and feelings of language through letters, the foundation of culture, and is deeply involved in diverse creative fields as well as our daily lives. It is also closely associated with the idea of cultural renaissance, one of the initiatives of this administration.

With its third edition, Typojanchi is leaping forward as an international design and cultural event. This event, in particular, has been scaled up to encompass the typographic culture of Europe and and the Americas, substantiating itself as an international biennial with renowned artists at home and abroad.

There is a significance in the typography biennial being held in Korea, where the beautiful Hangul is used as a national script. Reflecting this special meaning, I hope that Typojanchi can establish itself as a model platform of exchange for typographic culture.

I would like to thank Ahn Sang-soo, chair of the organizing committee, Choi Sung Min, curatorial director, and their staffs, Korea Craft & Design Foundation and the Korean Society of Typography, for their hard work for the successful organization of the event. My thanks also go to the artists from all over the world who have contributed their superb works to the exhibition.

I hope that Typojanchi 2013 offers a precious opportunity for not only designers but also the general public to rediscover the significance of design as part of their daily lives, and to experience and feel the new facets of design.

Thank you.

Ryu Jin-ryong
Minister of Culture, Sports and Tourism

높고 푸른 하늘만큼이나 모든 사람의 마음이 풍성해지는 결실의 계절 가을, 타이포잔치 2013의 성공적인 개최를 위해 많은 노력을 기울이신 모든 분께 감사와 치하의 말씀을 드립니다.

한국공예·디자인문화진흥원은 공예와 디자인 문화의 진흥과 가치 확산을 위해 다양한 사업을 진행하고 있으며, 이번 전시는 올해로 3회째를 맞이합니다. 타이포잔치는 세계 유일무이의 문자 예술 비엔날레로서, 문자 예술의 진수를 선보이고 동시에 타이포그래피의 다양한 분야를 국내에 소개하여 널리 알리는 행사로 자리매김하였습니다. 이 전시가 디자인 전시의 새로운 척도가 됨은 물론 국내에 소개되지 않았던 해외 유수의 작가들을 소개하는 귀한 자리가 될 것임을 확신합니다.

이번 전시에 발군의 작품을 출품해주신 작가분들과 안상수 위원장님을 비롯한 조직위원회, 최성민 총감독님, 한국타이포그라피학회, 기타 관계자와 이번 타이포잔치 2013을 위해 뜨거운 헌신의 열정을 아끼지 않으신 많은 분들께 깊은 감사의 인사를 전합니다.

이 비엔날레가 앞으로도 국내외 글자 문화의 교류를 비롯하여 디자인 문화 발전의 주도적 역할을 하는 전시로 지속될 수 있도록 여러분의 많은 관심과 성원 부탁드립니다.

감사합니다.

한국공예·디자인문화진흥원

In this enriching season of autumn with the clear blue sky, we would like to extend our gratitude and high respect to everyone that has poured in every effort for the successful hosting of Typojanchi 2013.

Korea Craft and Design Foundation is engaged in diverse projects and programs to promote the culture of craft and design and spread its values, and this year's Typojanchi marks its third edition. Typojanchi is the world's only biennial solely devoted to typography, and it has established itself as an event to show the essence and variety of typography. This exhibition will, no doubt, serve as a ground to introduce the works of renowned artists at home and abroad who have not been introduced in Korea, while serving as a new yardstick for design exhibitions.

We convey our deep appreciation to all those who have exerted their passion and devotion for Typojanchi 2013—artists whose great works are exhibited, the chair of the organizing committee, Ahn Sang-soo, and its members, the curatorial director Choi Sung Min, the Korean Society of Typography, and everyone else who has been involved in the event.

We wish for your continuous interest and support for this biennial to play a leading role in the development of design culture, and in the exchange of typographic ideas at home and abroad.

Thank you.

Korea Craft & Design Foundation

타이포잔치 2013 '슈퍼텍스트' 개막을 축하합니다.

타이포잔치 2001은 전문적인 타이포그래퍼들이 모여 타이포그래피의 흐름을 조망해볼 수 있는 귀하고도 새로운 시도였고, 10년 만에 부활한 타이포잔치 2011에서는 '동아시아의 불꽃'이라는 주제 아래 한국, 중국, 일본 디자이너들의 작품을 한자 문화권이라는 공통분모 위에서 만날 수 있었다면, 이번 타이포잔치 2013은 참여 작가의 면면에서 알 수 있듯이 명실공히 세계적인 비엔날레로 거듭난 전시라고 생각합니다. 또한 지금까지는 작가 위주의 전시, 다시 말해 유명 타이포그래퍼들의 기존 작품을 볼 수 있는 전시였지만, 이번 전시는 '슈퍼텍스트'라는 주제 아래 철저하게 기획되고, 그 주제와 전시 공간에 맞도록 새로이 제작된 작품들의 전시입니다.

글자는 모든 사람의 공통된 커뮤니케이션 도구이고 약속된 기호이지만, 어떻게 바라보고 해석하느냐에 따라서 다른 의미, 다른 형태가 됩니다. 즐거움 또한 즉각적으로 반응하는 즐거움도 있지만 곱씹어볼수록 잔잔히 우러나오는 즐거움도 있습니다. 이번 타이포잔치 2013은 크게 소리치지 않아도 큰 감동을 주는 작품들을 선보인다고 생각합니다.

타이포그래피의 표현 주체인 글자는 그 나라의 정체성이고 문화이며 얼굴입니다. 한글은 우리나라의 아이덴티티이며 우리의 문화입니다. 따라서 우리나라가 중심이 되어 각국의 정체성과 문화를 견주어볼 수 있다는 행사의 존재만으로도 가슴 벅찬 일이라고 생각합니다. 이번 전시에서는 타이포그래피가 문학과 결합하여 새로운 작품들을 생산해냈지만, 타이포그래피는 여러 다른 분야와 결합하면서 다양한 형태의 문화로 확장될 수 있는 매개체라는 점에서 우리 문화를 성장시킬 유용한 씨앗이라 생각합니다. 작품은 전문가들이 만들어내지만, 작품을 통한 새로운 자극과 학습은 일반 대중의 글자에 대한 태도와 의식을 변화시켜 나가는 데에도 큰 역할을 하리라 확신합니다. 이러한 전시가 우리의 문화 수준을 조금씩 넓히고 높일 수 있는 계기가 되었으면 합니다.

끝으로 물심양면으로 많은 도움을 주신 문화체육관광부와 한국공예·디자인진흥원에 감사를 드리며, 이번 전시를 위해 오랜 시간 동안 힘써주신 최성민 총감독과 큐레이터들께 감사의 마음을 전합니다.

한국타이포그라피학회 회장
김지현

I would like to celebrate the opening of Typojanchi 2013 "Supertext."

Typojanchi 2001 was a rare and new opportunity for professional ty-pographers to gather and witness the trends of typography. Typojan-chi 2011, which was resumed after a ten-year hiatus, presented works of Korean, Chinese and Japanese designers under the theme of "Fire Flower of East Asia," emphasizing a common cultural background to ap-preciate the works. This edition of Typojanchi, as the list of participating artists demonstrates, establishes itself as a world-class biennial. Also, if the past editions were centered on the artists, organized as showcases of renowned typographic designers, Typojanchi 2013 has been tightly curated under the theme of "Supertext," with the works largely created afresh with the theme and for the exhibition space.

Letters as socially established signs are a common tool for communi-cation. Depending on how one sees and interprets them, however, they can take different forms and meanings. Pleasure, too—there is the plea-sure of immediate response, but there also is the kind of pleasure that emerges slowly out of much contemplation. To me, the works presented in Typojanchi 2013 are deeply touching without shouting.

Letters as the expressive agents of typography are part of a nation's identity, culture and image. Hangul is Korea's identity and its culture. The mere existence of a Korean exhibition where we can appreciate dif-ferent identities and cultures is exciting. In this edition of Typojanchi, ty-pography has been approached in its overlap with literature to produce new works. But typography can be explored in relation with many other fields, working as a facilitating medium. In this respect, typography can be a useful seed for the growth of our culture. Works are created by professionals, but the new insights and inspiration the works may pro-vide will play a significant role in heightening the public awareness of typography. I hope this exhibition can be a momentum for promoting and elevating our culture.

Finally, I would like to thank the Ministry of Culture, Sports and Tour-ism and the Korea Craft & Design Foundation for their generous sup-port. And I would like to extend my appreciation to the curatorial director Choi Sung Min and the curators for their passionate efforts.

Kim Jee Hyun
President, Korean Society of Typography

'뚝배기보다.장맛'이라는.속담이.있습니다..

장이.문학이라면..뚝배기는.글자일.것입니다..
언제나.뚝배기보다.장이었지만..이번엔.뚝배기가.장을.초대했습니다..
뜨거운.국물을.충직하게.실어나르던.
글자.뚝배기들이.수상한.잔치를.벌인.것이지요..

타이포잔치는.타이포그라피.분야를.한정짓고.수식하는.것이.아닌.
'글자.와(&).무엇'이라는.본능적.생식을.위해.짝짓기를.시도하는.
뜨거운.감응의.장입니다..

당돌한.한글의.특성대로..이.열린.잔치에서.
뜻밖의.멋스럽고.즐거운.상상이.잉태되길.바랍니다..

언제나.그렇지만..
한글이.그저.고마울.따름입니다..

타이포잔치 2013 조직위원장
안상수

there.is.a.saying.that.goes.
it's.the.taste.of.the.soup..not.the.bowl..

if.the.soup.is.literature..the.bowl.is.letters..
it.has.always.been.the.taste.of.the.soup..not.the.bowl..
but.this.time..the.bowl.invites.the.soup.
the.bowls.of.letters.used.to.contain.the.soup.faithfully..
now.they.are.having.an.unusual.party..

Typojanchi.does.not.confine.or.qualify.typography..
it.is.a.ground.for.passionate.empathy.
to.mate.typography.with.others..

true.to.the.daring.spirit.of.hangul..
in.this.open-hearted.party..
i.hope.that.wonderful.and.joyful.imaginations.are.incubated..

with.gratitude.to.hangul..
as.ever..

Ahn Sang-soo
Chair, Typojanchi 2013 Organizing Committee

가나다순

Contents xv

In Alphabetical Order

Contents xvii

Supe

t

ext

검정 지면에 관하여

루이 뤼티

《자정》 서두에서 수전 하우는 과거에 제본공이 "삽화와 본문이 서로 비비지 않게" 하려고 권두 삽화와 표제면 사이에 끼워 넣곤 하던 얇은 종이를 언급한다. 그녀가 말하기로, "기호는 그것이 표상하는 대상 또는 존재와 동체를 이룬다고 여겨지지만, 말과 그림은 본질 면에서 경쟁 관계에 있다. 도상과 경전의 중간 영역은 흔히 분쟁 지대다." 이 글에서 소개하는 소설 작품 지면들이 바로 그런 분쟁 지대에 해당한다. 하우가 지적한 대로, "장난꾸러기는 표면 갖고 놀기를 좋아한다." 이어지는 지면들은 검정 표면 갖고 놀기를 좋아한다.

트리스트럼 샌디
그림 1과 2는 로렌스 스턴의 《신사 트리스트럼 샌디의 인생과 생각 이야기》(1759–1767)에 등장하는 검정 지면을 보여준다. 엄밀히 말해 그들은 검정 지면이 아니라 마주 보는 본문 영역이 전부 검정 사각형으로 칠해진 지면이다. 트리스트럼은 1권 12장에서 요릭 목사의 몰락과 죽음을 슬피 이야기한 다음, 그를 기리는 뜻에서 검정 사각형을 배치한다.

그는 ××교구에 있는 자신의 교회 경내 한구석에 묻혔고, 그 무덤에는 친구 유게니우스가 유언 집행자 허락을 받아 덮은 평범한 대리석 판이 하나 있는데, 판에는 묘비명과 애도가를 겸해 세 단어가 달랑 새겨져 있다.
아, 불쌍한 요릭!

검정 사각형이 경건한 묵념처럼 등장한 다음, 트리스트럼은 지엽적인 이야기를 다시 이어간다. 판별로 세부 배치를 비교해보면 흥미롭다. 옥스퍼드 클래식스 1983년판은 원본보다 판형이 조금 크고 원래는 없던 면주를 책 전체에 더했지만, 원저의 양식적 특징은 대부분 충실히 보존했다.
반면, 삽화가 곁들여 나온 1949년도 맥도널드 판(그림 3)에서는 오른쪽과 왼쪽에 하나씩 있던 검정 면이 고작 그림 한 장으로 축소되어 (희한하게도 두 모서리가 둥

On Black Pages

Louis Lüthi

In the prologue to *The Midnight*, Susan Howe makes reference to the tissue interleaf that bookbinders used to place between frontispiece and title page, "in order to prevent illustration and text from rubbing together." She writes: "Although a sign is understood to be consubstantial with the thing or being it represents, word and picture are essentially rivals. The transitional space between image and scripture is often a zone of contention." The following pages, taken from novels and short stories, are examples of such zones of contention. As Howe notes, "mischief delights in playing with surfaces." These pages delight in playing with black surfaces.

Tristram Shandy

Figures 1 and 2 are the black pages in Laurence Sterne's *The Life and Opinions of Tristram Shandy, Gentleman* (1759–1767). Strictly speaking, they're not black pages but a recto and a verso with a black rectangle that fills the entire text column of each page. Tristram places them here, in chapter 12 of volume one, in memory of parson Yorick, after having told the sad story of his downfall and death:

> He lies buried in a corner of his church-yard, in the parish of—, under a plain marble slab, which his friend Eugenius, by leave of his executors, laid upon his grave, with no more than these three words of inscription serving both for his epitaph and elegy.
> Alas, poor Yorick!

The black surfaces mark a respectful pause, after which Tristram resumes his digressive tale. It's instructive to compare the layout of these pages in different editions of *Tristram Shandy*. Although the 1983 Oxford Classics edition is slightly larger in format than the original edition and has added running heads throughout the book, it has faithfully retained most of the author's stylistic idiosyncrasies.

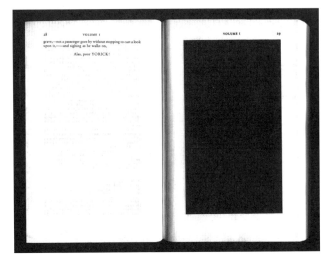

1

2

그림 1, 2. 로렌스 스턴, 《신사 트리스트럼 섄디의 인생과 생각 이야기》(옥스퍼드 대학 출판사).

Figures 1 and 2. Laurence Sterne, *The Life and Opinions of Tristram Shandy, Gentleman* (Oxford University Press edition).

3

그림 3. 로렌스 스턴, 《신사 트리스트럼 섄디의 인생과 생각 이야기》(맥도널드).

Figure 3. Laurence Sterne, *The Life and Opinions of Tristram Shandy, Gentleman* (MacDonald edition).

4

그림 4. 로렌스 스턴, 《신사 트리스트럼 섄디의 인생과 생각 이야기》(모던 라이브러리).

Figure 4. Laurence Sterne, *The Life and Opinions of Tristram Shandy, Gentleman* (Modern Library edition).

글게 처리된 형태로) 대략 지면의 3분의 2를 차지한다. 게다가 위치도 바뀌었다. 해당 장 끝이 아니라 "그는 ××교구에 있는 자신의 교회 경내 한구석에 묻혀 있고…" 문장 앞에 삽입된 모습이다. 검정 바탕에 흰 글자가 손으로 쓰인 그림이 지면 아래에 있는 점으로 보아, 위치를 바꾼 것도 그것이 "대리석 판"의 삽화라고 암시하려는 뜻이었던 모양이다.

1940년대부터 나온 모던 라이브러리 판(그림 4)에서는 검정 사각형이 더욱 축소되어, 13장 시작 전 남은 공간에 비집어 넣어진 모습으로 나타난다. 여기에서 사각형은 지면 배치와 전혀 무관한 형태를 띠고, 그 결과 이야기의 한계에서 소통을 철저히 배제 또는 무력화하려는 의도로 고안된 장치, 그럼으로써 서사 공간을 추상적 평면으로 변형하는 그 영역이 그저 부유하는 기하학적 장식으로 변질하고 만다.

그림 5는 "시각적으로 흥미로운" 문학을 전문으로 하는 부티크 출판사 비주얼 에디션스가 2010년에 펴낸 판의 검정 지면이다. 디자이너는 이 지점 이전에 쓰인 글을 모두 겹침으로써 검고 붉은 형상을 만들어낸 듯하다. 여백을 존중하는 지면이기는 하지만, 글—대부분은 요릭이라는 인물에 관한 글이 아니다—을 이용해 글의 부재를 창출한다는 데에는 어딘지 부조화한 면이 있다. 영리하게 디자인된 책이기는 하지만, 나는 언젠가 리디아 데이비스가 문체를 두고 한 말을 떨칠 수가 없다. "재미 삼아 로렌스 스턴 작품을 현대 영어로 옮겨본 적이 있다. 어느 정도까지는 성공했다. 일부 서사 내용, 일부 해학과 기벽은 보존할 수 있었다. 그럼에도 괴로웠다. 그가 쓴 표현을 '현대적' 표현으로 바꿀 때마다, 작품에서 본질적이고 유쾌한 특이성이 그만큼 사라졌다."

여행하는 사람들

《트리스트럼 섄디》에 바치는 의도적 헌사로서, B. S. 존슨의 《여행하는 사람들》(1963)에서도 검정 지면은 등장인물의 죽음을 나타내지만, 여기에서 검정 표면은 서사를 끊으며 단락 중간에 삽입되고, 여백 없이 지면 가장자리에 걸쳐 찍힌다. (그림 6, 7) 이어지는 두 지면은 아예 잉크로 뒤덮였다. 진실로 검은 지면이다.

14쪽 앞으로 가보면, 무작위 패턴으로 형성된 회색 면이 "심장마비 후 의식불명 상태"를 나타낸다.(그림 8) 단편적인 문장은 심장마비 자체를 나타낸다.

다시.
다시.
내가 이긴다. 돌아. 다시.
끝이 보여. 싸워. 쿵쿵.
봐. 그거.
끝.
나는 … 반드시 … 거기에 … 꼭 …
아!

By contrast, the illustrated MacDonald edition (fig. 3), published in 1949, reduces the recto and verso to a black rectangle (with, for some reason, two rounded corners) that takes up two-thirds of a page. What's more, its position within the text has changed: instead of at the end of the chapter, it's inserted before "He lies buried in the corner of his church-yard"—a placement which, in combination with the hand-drawn lettering at the bottom of the page, seems to suggest that it's an illustration of the marble slab.

The Modern Library edition from the 1940s (fig. 4) shrinks the black rectangle even more, squeezing it into what little space there is left on the page before the start of chapter 13. The shape here has nothing to do with the layout, and what was intended as a total preclusion or annulment of communication within the confines of the story, an area that transforms the narrative space into an abstract plane, has instead become a floating, geometric embellishment.

Figure 5 is the black page in the edition published in 2011 by Visual Editions, a boutique publisher that specializes in "visually interesting" literature. It seems they've layered all of the preceding pages in order to achieve this black-and-red spread. Although these pages respect the margins of the book's layout, there's something odd about using words—most of which are not about the character Yorick—to create an absence of words. The edition is smartly designed, yet I can't help but think of something Lydia Davis once said in an interview: "I tried, once, for fun, translating Laurence Sterne into more contemporary English. It worked to some extent—some of the narrative content was preserved, some of the humor, quirkiness, etc.—but it was painful. Each time I abandoned some phrasing of his in favor of an 'updated' version, an essential, delightful peculiarity of the work was lost."

Travelling People

In deliberate homage to *Tristram Shandy*, a black page in B. S. Johnson's *Travelling People* (1963, figs. 6 and 7) marks the death of a character, though here the black surface interrupts the narrative in mid-paragraph and it bleeds off the page. The following two pages are entirely covered in ink: two truly black pages.

Fourteen pages earlier, the same technique is used with random-pattern gray "to indicate unconsciousness after a heart attack" (fig. 8). The choppy prose is meant to indicate the heart attack itself:

Again.
Again.
I'm beating it. Turn. Again.
I can see the end. Fight. Pounding.

그림 5. 로렌스 스턴, 《신사 트리스트럼 섄디의 인생과 생각 이야기》(비주얼 에디션스).

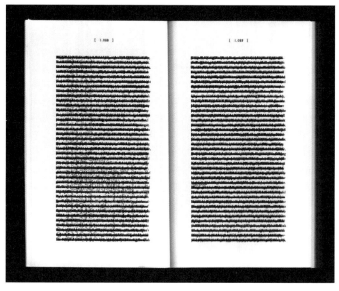

5

Figure 5. Laurence Sterne, *The Life and Opinions of Tristram Shandy, Gentleman* (Visual Editions edition).

6

7

8

9

그림 6–9. B. S. 존슨, 《여행하는 사람들》.

Figures 6–9. B. S. Johnson, *Travelling People*.

회색 무작위 패턴은 다음 지면으로 이어진다. 그곳에서 화자가 문장 몇 조각을 내뱉자, 물결선 무늬가 나타나 "수면 중 또는 회복 중인 의식"을 나타낸다.(그림 9) 존슨이 설명하기로, "그 부분은 심장마비에 걸린 노인의 내적 독백이다. 의식 잃은 사람의 독백을 말로 표현하는 것은 불가능하지만, 스턴의 검정 지면을 변형한 덕분에 문제를 해결했다." 《트리스트럼 섄디》에서와 달리 죽음은 서사 자체를 이루기보다 서사에 단계적으로 끼어든다. 그러므로 검정이 바깥에서 오는 것도 자연스럽다. 그 기원은 지면 너머에 있기 때문이다. 순서대로 보면, 그 효과는 그래픽적이라기보다 영화적이다.

<h2 style="text-align:center">설명</h2>

도널드 바설미의 단편 〈설명〉은 1968년 5월 《뉴요커》에 처음 실렸다.(그림 10, 11) 소설은 Q와 A가 나누는 대화로 이루어진다. Q는 인간의 이성적이고 질서 정연한 측면, A는 감각적, 감성적 측면을 체현한다. 그들은 예술, 정치, 여자, 그리고 "기계"라 불리는 것, 즉 대화에 주기적으로 끼어드는 검정 사각형을 논한다.

> Q: 이 기계가 정부를 바꾸는 데 도움이 될까?
> A: 정부를 바꾼다…
> Q: 사람들 요구에 더 잘 부응하게 하는 거지.
> A: 나는 그게 뭔지 모르겠어. 뭐 하는 기계인데?
> Q: 글쎄, 잘 봐.
> A: 조금… 과묵해 보여.

《뉴요커》에 실린 이야기에는 검정 사각형이 네 번 등장하는데, 언제나 지면상 그 존재를 직접 가리키는 구절에 뒤따르거나 앞서는 자리를 차지한다. "글쎄, 잘 봐", "잘 봐", "어디에 쓰는 물건이지?", "… 내 딸 사진을 보여줄게"가 그런 구절에 해당한다. Q와 A는 대화 순간에 자신들이 몰두한 생각을 아무렇게나 사각형에 대입한다. 사각형에 대한 반응이 크게 다른 것은 말할 나위 없다. "기계"는 순수성의 추상적 표상이 되기도 하고, 기술과 예술의 돌이킬 수 없는 통합을 상징하기도 하며, 놈 촘스키가 제안한 언어 습득 장치의 도해가 되기도 하고, 환상을 투영하는 공간이 되기도 한다. 어떤 경우든, 설명은 없다.

바설미는 단편 선집 《도시 생활》(1970)을 펴낼 때, 〈설명〉 앞에 검정 사각형 하나를 더하라고 요구했다. "지면에 활자가 너무 없다는 문제를 해결해준다"는 이유였다.(그림 12) 게다가 책에 실린 판에서는 세 번째 사각형이 아예 없어지기도 했다.(그림 13-15) 단행본에서는 본문 단 너비가 《뉴요커》보다 넓으므로, 검정 사각형도 활자에 비해서는 크고, 여백에 비해서는 작아 보인다. 하지만 이렇게 차이가 있다고 해서 문제가 되지는 않는다. 사각형의 밑바탕이 되는 출판 관습—임시 도판 상자—이나 기능이 훼손되지 않았기 때문이다.

See. The.
End.
I will … must … reach … will …
Oooooooh!

The random-pattern gray continues on the next page. Then, after the narrator utters a handful of sentence fragments, a pattern of wavy lines indicates "sleep or recuperative consciousness" (fig. 9). "The section concerned," Johnson explained, "is the interior monologue of an old man prone to heart attacks; when he becomes unconscious he obviously cannot indicate this in words representing thought, but a modified form of Sterne's black page solves the problem." Death interrupts the narrative in stages, as it were, instead of forming an integral part of it as in *Tristram Shandy*. Accordingly, the black comes from without—its origin lies beyond the page. Viewed as a sequence, the overall effect is more cinematic than graphic.

The Explanation

Donald Barthelme's short story "The Explanation" was first published in the *New Yorker* in May 1968 (figs. 10 and 11). It's a conversation between two characters referred to as Q and A. Q embodies the rational, ordered aspects of human nature, A the sensual, emotional aspects. They discuss art, politics, women, and the black square that periodically interrupts them, which is referred to as a "machine":

Q: Do you believe that this machine could be helpful in changing the government?
A: Changing the government …
Q: Making it more responsive to the needs of the people?
A: I don't know what it is. What does it do?
Q: Well, look at it.
A: It has a certain … reticence.

There are four black squares in the story published in the *New Yorker*, each immediately following or preceding comments that refer directly to its presence on the page: "Well, look at it," "Look at it," "What's this one used for," and "… show you a picture of my daughter." Q and A read into the square whatever preoccupies them at that moment in the conversation; needless to say, their reactions to it are vastly divergent. The "machine" could be viewed as an abstract representation of purity, as a symbol of the merging of technology and art, or as a space on which to project fantasies. In any case, no explanation is forthcoming.

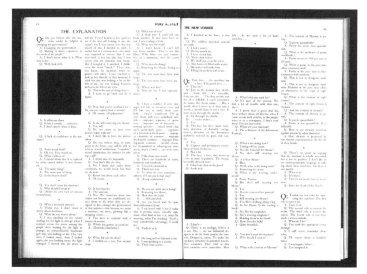

10

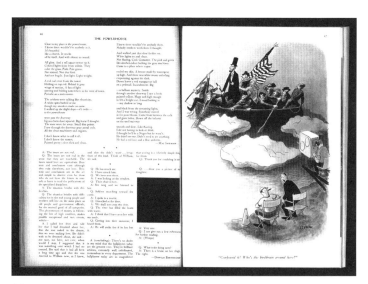

11

그림 10, 11. 도널드 바설미, 〈설명〉(《뉴요커》).

Figures 10 and 11. Donald Barthelme, "The Explanation" (*New Yorker* publication).

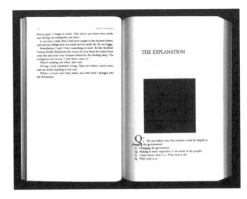

12

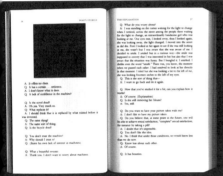

3

14

5

그림 12-15. 도널드 바설미, 〈설명〉(펭귄).

Figures 12–15. Donald Barthelme, "The Explanation" (Penguin edition)

한편, 얼마 전(2005년) 재판된 문집 《이야기 40편》 서문에는, 데이브 에거스가 마이클 실버블랫에게 바설미에 관한 좋은 기억 하나를 75단어로 써달라고 부탁하고, 이에 마이클은 작은 검정 사각형 하나로 답하는 대목이 있다.(그림 16) 기억상실? 비밀? 아니면 단순한 장난일까?

슐레겔에게 부당한 키르케고르

1968년 10월, 바설미의 단편 〈슐레겔에게 부당한 키르케고르〉가 《뉴요커》에 실렸다.(그림 17) 문체도 〈설명〉과 비슷하고—역시 《도시 생활》에 수록되었다—Q와 A의 대화 형식을 띤다는 점도 같으며(이번에는 역설이라는 개념을 주로 다룬다), 한 번일 뿐이지만 검정 사각형도 등장한다. 〈슐레겔에게 부당한 키르케고르〉에서 검정 영역은 직접 언급되지 않는다. 오히려 사각형은 A가 꺼냈다가 역설적으로 거두어버리는 고백 일부를 가리는 듯하다. 이유는 불분명하지만, 이후 《이야기 60편》 전집(1981) 등 단행본에서는 사각형이 삭제되었다.

아케이드 프로젝트

바설미가 자신의 소설에 삽입한 검정 사각형은 발터 벤야민이 《아케이드 프로젝트》에서 상호 참조를 표시하는 데 쓴 작은 검정 사각형을 연상시킨다. 수기 원고(그림 18)에서 그는 "편집자에게 관련 자료를 알려주려고 32개 기호(다양한 잉크와 색으로 그린 사각형, 삼각형, 원, 수직 십자, 수평 십자 등)로 이루어진 체계"를 사용했다. 독일어판에는 검정 사각형이 남아서—그림 19는 첫 절 도입 면을 보여준다—'산보객'이나 '날씨' 같은 주요 주제와 연결 지점을 표시한다. 그 검정 벽돌은 조밀하게 콜라주된 미완성 서사시를 헤쳐가는 데 도움을 준다.

종이 인간

표면적으로 샌디에 더 가까운 검정 지면은 살바도르 플라센시아의 《종이 인간》(2005)에서 찾아볼 수 있다. 이 소설은 여러 화자와 다단 배치로 이루어졌다. 책 전체에서 검정 사각형은 '아기 노스트라다무스'라는 특정 인물이 화자 역할을 할 때마다 등장한다.(그림 20) 독자가 언뜻 상상하는 바와 달리 그는 죽은 것이 아니라, '토성'이라는 전지전능한 추상적 존재에게 자기 생각을 일부러 숨기는 중이다. 아기 노스트라다무스는 '꼬마 머세드'라는 인물에게도 그 은폐술을 가르쳐주고, 그에 따라 검정 사각형은 다른 화자의 단으로도 확산한다.(그림 21, 22)

나는 침대에 앉아 라임 껍질을 벗기고 과실을 먹었다. 아버지와 프로기는 도미노 탁자 앞에 앉아 있다. 나는 눈을 감고 아기 노스트라다무스가 가르쳐준 방법대로, 내 생각을 부정하지 않으면서 정신을 집중했다.

In his short story collection *City Life* (1970), Barthelme added a black square at the very beginning of "The Explanation" (fig. 12). "It solves the problem," he said, "of having so little type on that page." What's more, the book version gets rid of the third square (figs. 13–15). The text column width in the paperback is broader than in the *New Yorker*, making the black squares larger in relation to the type size, yet smaller in relation to the margins. This discrepancy isn't problematic, though, because neither the publishing convention they derive from—the use of image placeholders—nor the function they serve is compromised.

Incidentally, in his introduction to the recent reprint (2005) of the collection *Forty Stories*, Dave Eggers asks Michael Silverblatt to tell, in 75 words, one of his favorite memories of Barthelme. Silverblatt replies with a small black square (fig. 16): amnesia, secretiveness, or a self-conscious prank?

Kierkegaard Unfair to Schlegel

In October 1968 Barthelme published the short story "Kierkegaard Unfair to Schlegel" in the *New Yorker* (fig. 17). Similar in tone to "The Explanation" (and also included in *City Life*), it too takes the form of a conversation between Q and A. This time their dialogue centers on the concept of irony, which is interrupted once by a black square. However, the square is not referred to directly; rather, it seems to obscure part of A's confession, which he then ironically retracts. For reasons unclear, the black square was omitted in subsequent versions of the story printed in book form, as in, for instance, the definitive collection *Sixty Stories* (1981).

The Arcades Project

The black squares that dot Barthelme's stories are reminiscent, among other things, of the small black squares that Walter Benjamin used in order to signal cross-references in *The Arcades Project*. In his manuscript (fig. 18), Benjamin used "a further system of thirty-two assorted symbols (squares, triangles, circles, vertical and horizontal crosses—in various inks and colors) to refer the editor to related papers." The German edition retains the black squares—figure 19 is the opening page of the first section—which indicate links to broader topics such as "flaneur" and "weather." So here the black blocks help the reader navigate through a densely collaged, unfinished epos.

The People of Paper

An ostensibly more straightforward, Shandean use of a black page is found in Salvador Plascencia's *The People of Paper* (2005), a novel with several narrators and a variable, multi-column layout. A black rect-

16

그림 16. 데이브 에거스, 도널드 바설미의 《이야기 40편》 서문.

Figure 16. Dave Eggers, introduction to *Forty Stories* by Donald Barthelme.

17

그림 17. 도널드 바설미, 〈슐레겔에게 부당한 키르케고르〉(《뉴요커》).

Figure 17. Donald Barthelme, "Kierkegaard Unfair to Schlegel" (*New Yorker* publication).

A

[PASSAGEN, MAGASINS DE NOUVEAUTE(S), CALICOTS]

»De ces palais les colonnes magiques
A l'amateur montrent de toutes parts,
Dans les objets qu'étalent leurs portiques,
Que l'industrie est rivale des arts.«
　　　Chanson nouvelle cit Nouveaux tableaux de Paris ou
　　　observations sur les mœurs et usages des Parisiens au
　　　commencement du XIXᵉ siècle Paris 1828 I p 27

»A vendre les Corps, les voix, l'immense opulence inquestio-
nable, ce qu'on ne vendra jamais.«
　　　Rimbaud

»Wir haben«, sagt der illustrierte Pariser Führer, ein vollständiges
Gemälde der Seine-Stadt und ihrer Umgebungen vom Jahre
1852(,) »bei den inneren Boulevards wiederholt der Passagen
gedacht, die dahin ausmünden. Diese Passagen, eine neuere Erfin-
dung des industriellen Luxus, sind glasgedeckte, marmorgetäfelte
Gänge durch ganze Häusermassen, deren Besitzer sich zu solchen
Spekulationen vereinigt haben. Zu beiden Seiten dieser Gänge, die
ihr Licht von oben erhalten, laufen die elegantesten Warenläden
hin, so daß eine solche Passage eine Stadt, eine Welt im Kleinen ist
■ Flaneur ■, in der der Kauflustige alles finden wird, dessen er
benötigt. Sie sind bei plötzlichen Regengüssen der Zufluchtsort
aller Überraschten, denen sie eine gesicherte, wenn auch beengte
Promenade gewähren, bei der die Verkäufer auch ihren Vorteil
finden.« ■ Wetter ■
Diese Stelle ist der locus classicus für die Darstellung der Passagen,
denn auf ihr entspinnen sich nicht allein die divagations über den
Flaneur und das Wetter, sondern auch was über die Bauweise der
Passagen in wirtschaftlicher und architektonischer Hinsicht zu
sagen ist, könnte hier seine Stelle finden.　　　　　　　[A 1, 1]

Namen von Magasins de Nouveautés: La fille d'honneur / La Vestale / Le
page inconstant / Le masque de fer / Le petit chaperon rouge / La petite
Nanette / La chaumière allemande / Au mamelouk / Au coin de la rue –

18　　　　　　　　　　19

그림 18. 발터 벤야민, 《아케이드 프로젝트》 원고.

Figure 18. Walter Benjamin, manuscript of *The Arcades Project*.

그림 19. 발터 벤야민, 《아케이드 프로젝트》 독일어판.

Figure 19. Walter Benjamin, *Das Passagen-Werk*.

결국 잉크는 한 지면을 모두 뒤덮고, 그 결과 지면은 비례와 면주를 제외하면 《트리스트럼 섄디》의 두 검정 지면을 닮게 된다.(그림 23) 《트리스트럼 섄디》에서 검정 지면은 한 인물이 다른 인물(물론 요릭은 스턴 자신에 바탕을 둔 인물이지만)에게 내보이는 제스처지만, 《종이 인간》에서 그것은—허구적이건 아니건—저자와 등장인물 사이의 형이상학적 관계를 다룬다. 플라센시아의 수기 원고(그림 25, 26)에는 그가 검정 면에 관한 생각을 적어놓은 대목이 있다.

> 내가 이해하기로(사실 대부분이 그렇게 이해하지만), 지면에서 흰 공간은 침묵, 부호는 소리에 해당한다. 하지만 《트리스트럼 섄디》의 검정 사각형에서 나는 조용한 슬픔, 즉 죽음을 읽었다. 그 반전은 무척 흥미로웠다. 그럼에도 그것이 직관을 거스르는 것은 사실이었다. 그리고 나는 아기 노스트라다무스가 침묵만을 표시하는 데 만족하지 못했다. 소설을 진행하면서, 나는 그 어둠을 축 처진 무음에서 적극적 저항으로 변형하려 했다.

끝 부분에 이르러 꼬마 머세드의 기술은 둔탁해진다. "아기 노스트라다무스가 가르쳐준 방법을 그대로 따라 할 수 있는 순간은 매우 드물었고, 그런 순간에조차 나는 기껏 작은 파라솔을 잠깐 들 수 있었을 뿐이다. 날카로운 사각형 방패는 이제 펼칠 수 없었다." 마지막 문장을 마치자 검정 동그라미 하나가 나타난다. 종결부, 마침표, 흰 무대 밖으로 걸어나가는 주인공의 모습이다.(그림 24)
　한편 플라센시아는 셰인 존스가 《종이 인간》을 표절했다는 혐의를 내비친 바 있다. 존스의 《라이트 박스》는 확실히 비슷한 줄거리를 따른다. 게다가 초판에는 "부유하는 어둠의 상자"도 있었는데, 플라센시아는 그것이 "아기 노스트라다무스의 사고 은폐술을 암시하는 듯"하다고 지적한다. 펭귄 판에서는 그 상자가 빠졌다.

엄청나게 시끄럽고 믿을 수 없게 가까운

무수한 사진과 그림, 그래픽 요소가 실린 조너선 사프란 포어의 《엄청나게 시끄럽고 믿을 수 없게 가까운》—《종이 인간》과 같은 해(2006)에 출간되었다—말미에는 활자로 이루어진 검정 지면이 나타난다.(그림 27–29) 산문에서 이미지로 점진적 변형이 가능했던 것은, 자간 축소라는 디지털 조판 특유의 기능 덕분이었다. 이 부분에서 화자는 말을 못하는 노인이다. 그는 공책에 글을 써 타인과 소통하는데, 이 장은 그가 자신의 죽은 아들에게 보내는 편지로 이루어졌다.

> 네게 해야 할 말을 다 하기에는 책의 지면이 모자랄 거다. 글씨를 작게 쓸 수도 있고, 종이를 갈라 두 쪽으로 만들 수도 있고, 글 위에 또 글을 쓸 수도 있겠지만, 그러고 나서는 어째야 할까?

angle appears throughout the book whenever a particular character, called Baby Nostradamus, is the narrator (fig. 20). It turns out he's not dead, as the reader is initially led to believe, but deliberately obscuring his thoughts from the character Saturn, an all-powerful abstract being. Baby Nostradamus teaches another character, Little Merced, this method of concealment and the black consequently spreads to another narrator's column (figs. 21 and 22):

> I sat on my bed peeling the skins from limes and then eating the meat. Father and Froggy sat around the dominoes table. I closed my eyes and followed the procedures that the Baby Nostradamus had taught me, focusing but making sure not to deny my own thoughts.

Eventually the ink fills the text columns of one page, which therefore resembles one of the two black pages in *Tristram Shandy* in all but proportion and running heads (fig. 23). Whereas in *Tristram Shandy* the blackness is one character's gesture to another (though parson Yorick is obviously based on Sterne), in *The People of Paper* it concerns the metaphysical relationship between character and author. Figures 25 and 26 are two pages from the manuscript in which Plascencia wrote down ideas concerning the use of black surfaces. Plascencia:

> The way I understand the page (and most people for that matter), white space is silence and any inscription equals sound. Yet when I see the black rectangle in *Tristram Shandy*, I read a quiet sadness—death. I became really interested in this inversion. Still, this seemed counterintuitive, and I wasn't satisfied with the Baby Nostradamus signifying silence. As the novel progressed, I tried to turn the darkness from a limp muteness into an active form of resistance.

Toward the end of the book, Little Merced's skills have dulled: "In those rare moments when I was able to do as the Baby Nostradamus had taught me, I could lift only a small parasol for a short time. The shield was no longer sharp and angular" A black circle appears after the last word of the book: a coda, a period, a character's good-bye (fig. 24).

When Shane Jones's *Light Boxes* was published in 2010, Plascencia more or less accused him of plagiarizing *The People of Paper*. Among other things including a remarkably similar plot, Jones's novel contains "a floating box of darkness, which," Plascencia notes, "seemed to be alluding to the Baby Nostradamus's thought blocking abilities." The second edition of *Light Boxes*, published by Penguin, got rid of this black square.

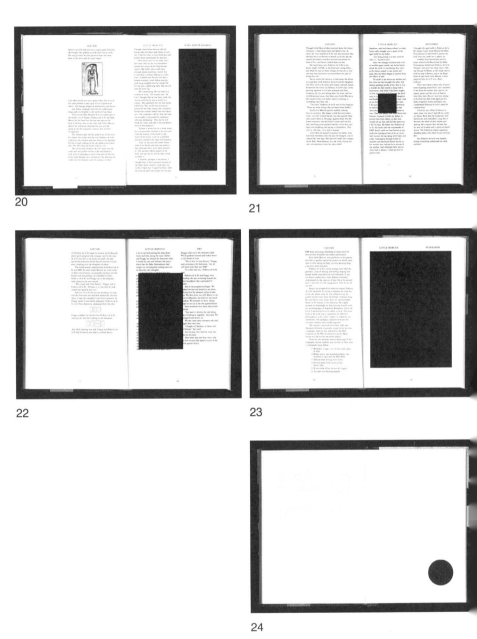

그림 20–24. 살바도르 플라센시아, 《종이 인간》.

Figures 20–24. Salvador Plascencia, *The People of Paper*.

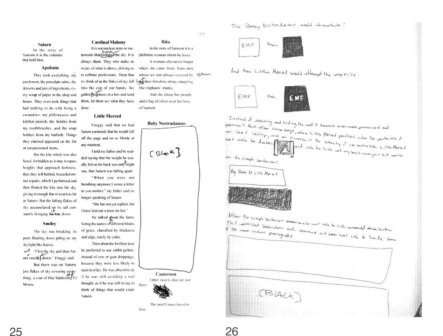

그림 25, 26. 살바도르 플라센시아, 《종이 인간》 원고.

Figures 25 and 26. Salvador Plascencia, manuscript of *The People of Paper*.

말 그대로다. 노인에게는 하고 싶은 말을 다할 시간과 공간이 부족하다. 어조는 감상적이다. 그는 거듭 선언한다. "끝없이 빈 책과 시간이 필요하다." 가장 빽빽한 마지막 지면은 비주얼 에디션스 판《트리스트럼 섄디》의 검정 지면을 닮았다. 아울러 버트런드 러셀이 말한 '트리스트럼 섄디의 모순', 즉 삶에 관한 글은 삶 자체를 절대로 따라잡지 못한다는 생각도 떠올리게 한다. 뒤에는 거의 검은 지면이 하나 더 있다.(그림 30) 한밤중 공동묘지 장면에 삽입된 밤하늘 사진이다.《엄청나게 시끄럽고 믿을 수 없게 가까운》에는《햄릿》, 특히 저 유명한 독백을 암시하는 대목이 수두룩하다.《햄릿》에서 그 독백을 촉발한 것이 바로 요릭의 해골이 발굴된 사건이다. 궁정 광대 요릭, 그는 스턴이 목사에게 붙여준 이름의 원주인이다.

생상어 텍스트

스티븐 홀의《생상어 텍스트》(2007)는 타이포그래피 이미지가 풍성한 작품이다.《엄청나게 시끄럽고 믿을 수 없게 가까운》과 마찬가지로, 이 책에도 플립 북처럼 읽게 꾸며진 지면들이 있다. 그 절정은 (형이상학적) 상어를 만나는 장면이고, 디지털 타자 스크립트가 폭발하는 광경으로 끝난다.(그림 31) 다른 부분과 마찬가지로, 여기에서도 이미지는 산문과 같은 장면을 묘사한다.

> 물보라를 일으키며 내게 달려들었다—추억과 후회와 소망과 슬픔과 행복과 꿈—상어의 대가리, 양편에 검정 장난감 눈깔이 달린 회색 총알 모루 점보제트가 쩍 벌어지며 이빨로 가득 찬 검고 붉은 깔때기가 열렸다.
> '네가 누구인지 안다.'
> 나는 그놈의 뻘건 구멍에 노트북을 던져넣었고, 루도비전이 산산이 부서지는 나무에 비행갑판을 처박을 때 뒤로 나자빠졌는데—

아우스터리츠

《아우스터리츠》나《토성의 고리》같은 W. G. 제발트의 책에서는 삽입된 이미지가 본문과 거의 동등한 서사 수준에서 관심을 끌려고 다투므로, 둘 사이 관계 역시 복잡하다. 하지만 때때로 독자는 전면에 깔린 사진이나 문서에 마주치기도 하는데, 그때 시선은 서사로 되돌아가기 전에 얼마간 이미지 위를 맴돌 수밖에 없다.《아우스터리츠》(2002)에서는 이런 일이 몇 차례 일어나는데, 그중 가장 강렬한 것은 나치스가 유대인 게토로 사용하던 체코 마을 테레진을 주인공이 방문하는 대목이다. 수용소에 끌려간 어머니를 둔 아우스터리츠는, 그곳에서 허름한 건물과 닫힌 문에 마주친다.

> 하지만 내게 가장 불가사의했던 것은 테레진에 있는 건물의 문과 출입구였다. 내 생각에 그들 모두는 아직 아무도 꿰뚫은 바 없는 어둠을 가로막는 듯했다. 내 생각에, 아우스터리츠가 말하기를, 그 어둠 속에서 움직이는 것이라

Extremely Loud and Incredibly Close

A black page made up of words occurs toward the end of Jonathan Safran Foer's *Extremely Loud and Incredibly Close* (2006), a novel that contains numerous photos, drawings, and other graphic elements. A gradual transformation from prose to image is achieved by exploiting a possibility unique to digital typesetting, namely, negative spacing (figs. 27–29). The narrator of this section is an old man who cannot speak; he communicates to others by writing in a notebook, and this chapter is a letter that he writes to his deceased son. The old man has run out of time and space to say everything he wants to:

> There won't be enough pages in this book for me to tell you what I need to tell you, I could write smaller, I could slice the pages down their edges to make two pages, I could write over my own writing, but then what?

This is what literally happens. The tone is sentimental; the old man repeatedly exclaims: "I want an infinitely blank book and the rest of time." The last, densest page resembles the black page in Visual Editions' *Tristram Shandy*. It's also reminiscent of what Bertrand Russell called the "Tristram Shandy paradox," which states that writing about a life will never catch up with life itself. Later, there's another nearly black page: a photo of the night sky, inserted during a scene that takes place in a graveyard at night (fig. 30). *Extremely Loud* is peppered with allusions to the famous soliloquy in *Hamlet*, which is prompted by the digging up of Yorick's skull—Yorick, the court jester that Sterne's parson is named after.

The Raw Shark Texts

Steven Hall's *The Raw Shark Texts* (2007) is abundantly illustrated with typographic imagery. Just as in *Extremely Loud*, a sequence of pages is meant to be read as a flipbook. The climactic scene is an encounter with a (metaphysical) shark, ending with the explosion of a digital typescript (fig. 31). Here, as elsewhere, the imagery illustrates a scene that's also described in prose:

> It came up at me in a burst of spray—memories and regrets and wishes and sadness and happiness and dreams—the shark's head, two black toy eyes either side of a huge grey bullet anvil jumbo jet slashed open all across into a black and red funnel full of teeth.
> *I know what you are*.
> I threw the laptop into its open red hole and tumbled backwards

27

28

29

30

그림 27-30. 조너선 사프란 포어,《엄청나게 시끄럽고 믿을 수 없게 가까운》.

Figures 27-30. Jonathan Safran Foer, *Extremely Loud and Incredibly Close*.

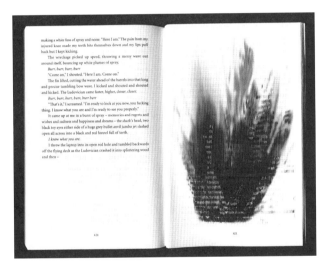

31

그림 31. 스티븐 홀, 《생상어 텍스트》.

Figure 31. Steven Hall, *The Raw Shark Texts*.

곤 벽에서 벗겨져 내리는 백색 칠감과 거미줄을 짓거나 마룻바닥 위를 구부러진 다리로 분주히 기어 다니거나 줄에 매달려 먹잇감을 기다리는 거미들 밖에 없을 듯하다.

이어서 엄숙하게 닫힌 문 사진이 네 장 나오는데, 그중 하나는 절반쯤 검정이다. (그림 32, 33) 아무 말도 없다. 영어판의 마지막 두 지면에서는 쪽 번호마저 빠져 있다. 닫힌 문 너머의 꿰뚫을 수 없는 어둠은 독일의 집단적 기억을 표상하지만, 또한 잊힌 과거를 재구성하려 애쓰는 아우스터리츠 자신의 사적 기억을 암시하기도 하는데, 그 시도를 충실히 듣고 기록하려 하는 화자는 침묵의 장벽에 부딪힌다.

터널

《터널》(1995)을 탈고한 윌리엄 H. 개스는, 출판사에 보내는 원고지에 지면 배치와 디자인 지침을 한 다발 첨부했다. 그는 그 지침이 "[자신의] 의도를 나타낸다"고 생각했기에, 본문에 삽입할 드로잉, 활자체, 쪽 번호 등을 꼼꼼히 지정했다. 개스는 책 커버에 아무것도 찍지 않기를 원했다. 그가 지시하기로, "책은 거친 검정 천으로 양장해야 한다. … 커버는 무거운 검정이어야 한다. … 앞쪽 면지 역시 비슷한 검정이어야 한다." 그러나 그 검정 면지에는 주인공이 지하에 파는 터널 도면을 흰색으로 인쇄해야 한다. 지은이와 출판사 이름을 꼭 넣어야 한다면, 그것들은 제목과 함께 표지와 커버 책등에만 찍어야 한다. "따라서 독자는 포장을 펼치듯 책에 진입하게 된다. 커버를 거쳐 표지를 열고, 익명의 어둠을 통과한다. 유일한 단서는, 그렇게 들어간 책이 일종의 터널이라는 암시뿐이다." 불만투성이에 지극히 불쾌한 주인공 W. F. 콜러는 나치 독일에 집착하는 역사가이고, 칠흑처럼 새까만 표면은 처음부터 독자에게 그의 폐소공포증 세계를 대면하게 하려는 장치이다. 본질적으로 개스는 《터널》이 콜러의 책이 되기를 원했다.

* * *

언뜻 짐작하기에도 그 모든 검정은 소통에 해로울 것만 같다. 개스가 의도한 바와 달리, 《터널》 초판 커버는 완전한 검정이 아니었다. 커버에는 제목과 지은이 이름이 당연하다는 듯 강렬한 흑백 타이포그래피로 찍혀 나왔다. 앞쪽 면지로 의도되었던 도면은 표제면에 쓰였다.(그림 34) 대조적으로, 댈키 아카이브 판《터널》(1998) 표지는 개스의 의도를 나름대로 그려준다.(그림 35) 무거운 암녹색 드로잉은 책이 "일종의 터널"임을 노골적으로 밝힌다. 그처럼 극진한 출판사의 배려를 보니, B. S. 존슨이 쓴웃음을 섞어 들려준 일화가 떠오른다. "어떤 전국 일간지(보수적 논조로 유명한 신문)에서《여행하는 사람들》서평용 책을 반송하면서, 왜 일부 지면이 검정으로 잘못 나온 책을 보냈느냐며 불평한 적이 있다."

off the flying deck as the Ludovician crashed it into splintering wood and then—

Austerlitz

In W. G. Sebald's books, the embedded images have a complex relationship with the text because they usually vie for attention on the same narrative level. However, sometimes the reader is presented with a full-page reproduction of a photograph or document and his gaze is obliged to linger on the image itself before resuming the story. This happens several times in *Austerlitz* (2002), most strikingly when the main character visits a Czech town that was used by the Nazis as a Jewish ghetto. There, Austerlitz, whose mother had been deported to the camp, is confronted with rundown buildings and closed doors:

> What I found most uncanny of all, however, were the gates and doorways of Terezín, all of them, as I thought I sensed, obstructing access to a darkness never yet penetrated, a darkness in which I thought, said Austerlitz, there was no more movement at all apart from the whitewash peeling off the walls and the spiders spinning their threads, scuttling on crooked legs across the floorboards, or hanging expectantly in their webs.

Four somber photographs of shut doors follow, one of which is half black (figs. 32 and 33). Nothing is said; in the English edition, page numbers are even omitted from the last two pages. The impenetrable darkness behind these closed doors is representative of Germany's collective memory and of Austerlitz's own personal memory as he tries to reconstruct a forgotten past, an attempt faithfully listened to and recorded by a narrator who comes up against such barriers of silence.

The Tunnel

When William H. Gass completed *The Tunnel* (1995), he appended a set of layout and design instructions to the typescript that he handed in to his publisher. He regarded these as "indications of [his] intentions," and they included detailed notes on the drawings incorporated into the text, the choice of typefaces, page numbering, and so on. Remarkably, Gass wanted nothing to be printed on the cover or the dust jacket. "The book," he instructed, "should be bound in rough black cloth The dust jacket should be a dull black The front endpapers should be similarly black," but on them should be drawn, in white, a diagram of the tunnel that the main character digs in his basement. The title and, if absolutely necessary, the author and the publisher's name should ap-

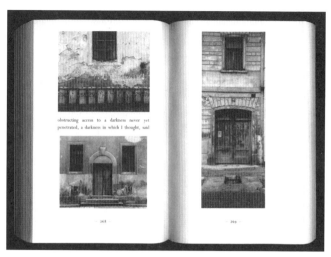

32

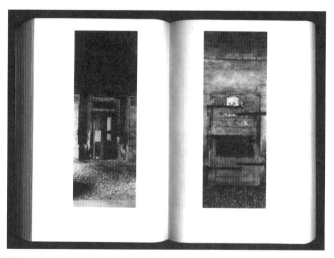

33

그림 32, 33. W. G. 제발트, 《아우스터리츠》.

Figures 32 and 33. W. G. Sebald, *Austerlitz*.

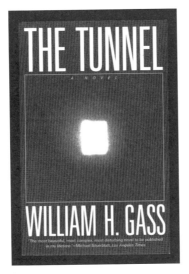

34

그림 34. 윌리엄 H. 개스, 《터널》(노프).

Figure 34. William H. Gass, *The Tunnel* (Knopf edition).

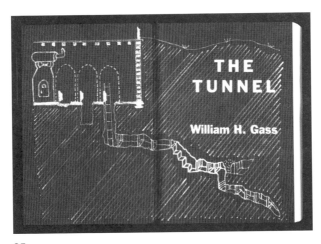

35

그림 35. 윌리엄 H. 개스, 《터널》(댈키 아카이브).

Figure 35. William H. Gass, *The Tunnel* (Dalkey Archive edition).

참고 문헌

Matthew. "An Interview with Salvador Plascencia." *Nashville Review*, spring 2010.

Barthelme, Donald. *Sixty Stories*. 1981. London: Penguin, 2003.

— *Forty Stories*. 1987. London: Penguin, 2005.

Daugherty, Tracy. *Hiding Man: A Biography of Donald Barthelme*. New York: St. Martin's Press, 2009.

Foer, Jonathan Safran. *Extremely Loud and Incredibly Close*. London: Penguin, 2006.

Gass, William H. *The Tunnel*. 1995. Normal, IL: Dalkey Archive, 1998.

— "Designing The Tunnel." *Context*, no. 18, 2006.

Hall, Steven. *The Raw Shark Texts*. Edinburgh: Canongate, 2007.

Howe, Susan. *The Midnight*. New York: New Directions, 2003.

Johnson, B. S. Travelling People. London: Corgi, 1963.

— Introduction. *Aren't You Rather Young to Be Writing Your Memoirs?* London: Hutchinson, 1973.

Jones, Shane. *Light Boxes*. 2009. New York: Penguin, 2010.

Manguso, Sarah. "Interview: Lydia Davis." *The Believer*, January 2008.

Plascencia, Salvador. *The People of Paper*. 2005. London: Bloomsbury, 2006.

Sebald, W. G. *Austerlitz*. 2001. London: Penguin, 2002.

Sterne, Laurence. *The Life and Opinions of Tristram Shandy, Gentleman*. London: MacDonald, 1949.

— *The Life and Opinions of Tristram Shandy, Gentleman*. New York: Modern Library, n.d.

— *The Life and Opinions of Tristram Shandy, Gentleman*. Oxford: Oxford University Press, 1983.

— *The Life and Opinions of Tristram Shandy, Gentleman*. London: Visual Editions, 2010.

[최성민 옮김]

pear on the spine of the cover and of the dust jacket. "Thus one enters the book through a series of unwrappings: the sleeve, the dust jacket, in effect, the lifted cover, passing through an anonymous darkness, whose only assistance is the suggestion that the book, so entered, is a kind of tunnel." The main character, W. F. Kohler, is a thoroughly unpleasant man, a frustrated historian obsessed with Nazi Germany, and these pitch-black surfaces were meant to confront the reader with his claustrophobic world from the outset. In essence, Gass wanted *The Tunnel* to be Kohler's book.

<p style="text-align:center">* * *</p>

All this black is at first glance inimical to communication. The dust jacket and the cover of the first edition of *The Tunnel* were not, as Gass had intended, completely black; the title and his name are on it, of course, in a bold black-and-white typographic composition. The diagram that was intended for the front endpapers was used on the title page (fig. 34). By contrast, the cover of the Dalkey Archive reprint of *The Tunnel* (1998, fig. 35) illustrates Gass's intentions: a somber, dark-green drawing makes it explicitly clear that the book "is a kind of tunnel." Such prudence on the part of the publisher calls to mind B. S. Johnson's wry observation that a "national daily newspaper (admittedly one known for its reactionary opinions) returned a review copy of *Travelling People* with the complaint that it must be a faulty copy for some of the pages were black."

References

Matthew. "An Interview with Salvador Plascencia." *Nashville Review*, spring 2010.

Barthelme, Donald. *Sixty Stories*. 1981. London: Penguin, 2003.

— *Forty Stories*. 1987. London: Penguin, 2005.

Daugherty, Tracy. *Hiding Man: A Biography of Donald Barthelme*. New York: St. Martin's Press, 2009.

Foer, Jonathan Safran. *Extremely Loud and Incredibly Close*. London: Penguin, 2006.

Gass, William H. *The Tunnel*. 1995. Normal, IL: Dalkey Archive, 1998.

— "Designing The Tunnel." *Context*, no. 18, 2006.

Hall, Steven. *The Raw Shark Texts*. Edinburgh: Canongate, 2007.

Howe, Susan. *The Midnight*. New York: New Directions, 2003.

Johnson, B. S. *Travelling People*. London: Corgi, 1963.

— Introduction. *Aren't You Rather Young to Be Writing Your Memoirs?* London: Hutchinson, 1973.

Jones, Shane. *Light Boxes*. 2009. New York: Penguin, 2010.

루이 뤼티는 그래픽 디자이너 겸 저술가다. 저서로 《자기 반영 지면에 관하여》
(로마 퍼블리케이션스, 2010)와 《유아 A》(파라과이 프레스, 2012)가 있고,
《돗 돗 돗》,《봉사하는 도서관 소식지》,《F. R. 데이비드》 등에 글을 발표하기도
했다. 타이포잔치 2013 참여 작가다.

〈검정 지면에 관하여〉는 소설에서 시각 요소의 유형을 연구한 책 《자기 반영
지면에 관하여》(이 책 416–419쪽) 가운데 첫 장을 손질한 글이다.

Manguso, Sarah. "Interview: Lydia Davis." *The Believer*, January 2008.

Plascencia, Salvador. *The People of Paper*. 2005.
 London: Bloomsbury, 2006.

Sebald, W. G. *Austerlitz*. 2001. London: Penguin, 2002.

Sterne, Laurence. *The Life and Opinions of Tristram Shandy,*
 Gentleman. London: MacDonald, 1949.

— *The Life and Opinions of Tristram Shandy, Gentleman*.
 New York: Modern Library, n.d.

— *The Life and Opinions of Tristram Shandy, Gentleman*.
 Oxford: Oxford University Press, 1983.

— *The Life and Opinions of Tristram Shandy, Gentleman*.
 London: Visual Editions, 2010.

Louis Lüthi is a book designer and writer. He has published *On the Self-Reflexive Page* (Roma Publications, 2010) and *Infant A* (Paraguay Press, 2012), as well as texts in *Dot Dot Dot*, *The Serving Library* and *F. R. David*. He is a participating artist of Typojanchi 2013.

"On Black Pages" is an amended version of the first chapter in *On the Self-Reflexive Page*, a typological study of visual elements in works of fiction (see pp. 416–419 of this book).

고유명사

proper noun

폴 엘리먼은 런던에서 활동하는 작가다. 그는 타이포그래피, 목소리, 몸짓, 출판물, 퍼포먼스, 글쓰기에 이르는 광범위한 매체를 통해 기술과 언어의 관계를 탐구하면서, 흔히 그래픽 디자인이나 처리된 언어의 형태와 용도에 비판적 초점을 맞춘다. 최근에는 탈린 쿠무 에스토니아 미술관(2013), 시애틀 워싱턴 대학교 헨리 미술관(2012-2013), 마스트리흐트 마레스 현대 문화센터(2012-2013), 글래스고 트램웨이 LUX/ICA 동영상 비엔날레(2012), 뉴욕 현대미술관(2012) 등에서 전시에 참여했으며, 2013년 뉴욕 월스페이스 갤러리에서 개인전을 열었다. 예일 대학교와 아른험 베르크플라츠 티포흐라피에 논문 지도 교수로 출강 중이다.

〈사랑의 진실을 알려주오〉는 엘리먼이 2002년부터 꾸준히 작성한 공업용 재료 목록이다. 시인 W. H. 오든의 노랫말('사랑'의 특징으로 추측되는 사물, 장소, 사건을 나열하는 가사)에서 제목을 따온 이 작품은 우리 물질 세계를 구성하면서도 나무, 금속, 종이, 플라스틱 등 총칭으로 말고는 불리는 일이 드문 요소들을 하나씩 불러낸다. 특별한 순서를 따르지 않고 하나의 긴 미완성 문장처럼 제시되는 목록은 재료 생산과 언어 생산을 융합하며 두 활동 모두의 불완전한 성격을 반영한다.

Paul Elliman is a London-based artist. Across a range of media, including typography, the human voice, bodily gestures, publication, performance and writing, he explores the relationship between technology and language, often with a critical focus on aspects of graphic design or forms and uses of processed language. His work has been shown internationally at museums and galleries, recent examples including Kumu Art Museum of Estonia, Tallinn (2013); Henry Art Gallery, University of Washington, Seattle (2012-2013); Marres Centre for Contemporary Culture, Maastricht (2012-2013); Lux/ICA Biennial of Moving Images, Tramway, Glasgow (2012); and Museum of Modern Art, New York (2012). He had his solo exhibition at Wallspace Gallery, New York, in 2013. Elliman

is visiting critic at Yale University, New Haven, and graduate thesis supervisor at the Werkplaats Typografie, Arnhem.

O Tell Me the Truth About Love is an ongoing list of industrial materials that Elliman began compiling in 2002. Taking its title from a song lyric by the poet W. H. Auden (which lists out things, places and events that are supposed to characterize "love"), the list offers a roll call of all those things that constitute our material lives yet are rarely called by names other than a few generic terms such as wood, metal, paper or plastic. Lacking any apparent order, the list is presented as a long, unending single sentence that merges the production of materials with the production of language, reflecting the inconclusive nature of both.

폴 엘리먼
1961년생, 영국.

Paul Elliman
Born in 1961, UK.

사랑의 진실을 알려주오
2002–현재.

O Tell Me the Truth about Love
2002–ongoing.

O Tell Me The Truth About Love
Paul Elliman

Die-cast metal, black annealed wire, hot-dipped bright-spangled galv, zinc section, copper, tungsten, chromium, friction-welded bright bar, sheared-edge zintec, lead, cast iron, nickel foil, brass, cold-rolled mild steel, white antistatic non-toxic PVC, ceramic metal, matt black thermoplastic, bonded natural rubber, spring steel, ivory faced insulation board, rebar, lycra, bitumastic, stainless steel foil, profiled medium density fibreboard, unalloyed nickel, TiCoat™, structural steel, lamellar graphite, high strength bronze, cermet (metal-ceramics), nebar, aluminium, molybdenum steel, veneered board, brazed carbide, high cobalt steel, polyurethane tube, fine steel wool, blow-moulded plastic, polypropylene, butyl, PVA, PVC, perspex, Ripstop Nylon™, flow-soldered circuit board, plasma-cut steel plate, plastex, polychoc, polyurethane, venise, chipboard, masonite, sterling board, kiln-dried unplaned ash, softwood ply, fluted cardboard, glass, celophane, Vectran, vulcanized rubber, NBR (Nitrile Binder Rubber), stainless steel wire rope, aramid fibres, asbestos, klingersil, rubber bonded cork, exterior veneered plywood, Supagraf™ Laminate, klinger graphite, glass fibre, silicone rubber, Jute yarn, tin plate, NRS Hydroskin™, cellulose, Centurion™Jointing, plasticised gelatine, single-ply polyester, carbon loaded silicone, Kevlar™, Supaplas™, Viton™, Twaron™, spiral wound stainless steel, thermoplastic rubber, stove enameled steel plate, galvanised wire, copolymer polypropylene, nylon, linen, black elastic rubber, Teflon, phenolic resin, polymide, pressure treated pine, die-cast alluminium alloy, bonded elastic rubber, extruded aluminium, oxide cloth, emery cloth, coated newsprint, ultralite veneered MDF, viscose, titanium, nitride coated steel, Watershed™, Bakelite, ebonite, Vulcanite, magnesium alloy, forged steel, copper alloy, cellulose acetate, neoprene sponge rubber, magnetic soft steel, formica, tungsten carbide tipped masonry, brick, stone, concrete, blown polypropylene, marble, quarry tile, glazed ceramic, Breeze, laminated glass, silicon carbide, Zirconium, white bear-tex™, Norgrip®, induction hardened steel, cemented carbide, stellite, calico, sisal, insulation board, acrylic tube, neoprene rubber sheet, Macor®, cast nylon, ceramic board, ceramic blanket, ceramic paper, Duratec, Microtherm™, sintimid™ polyimide, peek glass fibre, pressed galvanised steel, polyphenylenesulphide, torlon, glass filled nylon, PVDF, ensituf polyurethane, polyester, PETG copolyester, acetal copolymer, Delrin®, polyethylene, polycarbonate sheet, case carburizing steel, PVC laminated aluminium, phospher bronze, leaded gunmetal, nickel aluminium bronze, bright dawn key steel, MicroPlush™, flannel, bright mild steel, carbon case hardening steel, glavanised perforated sheet, polypropalene sheet, Waterbloc™, stainless steel sheet, rotary sheered brass shim, Percale, heat bonded aluminium honeycomb core, Nomex™, beryllium copper crinkle, alumina ceramic, moulded nylon, Plastite®, moulded acetal polymer, steel tube, dipped vynil plastic, zinc-plated clear passivated steel, Damask, thin sheet stainless steel, fibreboard, synthetic rubber, high grade opal white rigid PVC, Sentinel™Jointing, medium density fibreboard, hardened chipboard, plasterboard, zinc-plated boron steel, cold passivated zinc plated stainless steel, zinc-plated low carbon mild steel, polyethylene gloss coated spring steel, cadmium plated galvanised steel, , bulk fibre, Gore-Tex™, zinc-plated malleable cast iron, partition board, unichrome plated steel, 316-S31 marine-grade stainless steel, pre-galvanised channel section steel strip, cold-rolled formed pre-galvanised steel section, bright zinc plated galvanised steel, tar paper. Brass blade, Scotch-Brite™, black phosphate oil finished spring steel, glass clear reinforced polyester, clear unreinforced PVC, mild steel boiler plate, cadmium free ultra flexible PVC, clear amorvin HNA non-toxic PVC, blue oil resistant superelastic PVC compound, superflex KZ PVC ducting, PVC coated polyamid fibre fabric, superflex calor high temperature ducting, autoclavable Tygon® tubing, nitrile tubing, acetal resin, Zamac, matt aluminium plate, non-corrodible glass-filled nylon, nickel chrome finished rustless steel, phosphate yellow polyester coated steel, lithium, mild steel flat bar, fluorocarbon rubber, mild steel prallel flange channel, polyethylene foam rubber, mild steel durbar, velveteen, mild steel reversing mill plate, normalised pressure vessel plate, roller quenched and tempered plate, high-frequency induction

(HFI), welded linepipe, casing pipe, piling, glass-fibre reinforced technopolymer, freecutting steel, tyre wire, open mesh HB walkway, weldmesh, high tensile reinforcing rod, blooms, billets, slab, high impact plastic cartonboard, polyster resin, dura-steel rail, zincalume, plate, extruded aluminium box section, solid acrylic block, gold anodised aluminium box section, hardened and tempered steel blade, Velcro™, PVC rubber, reinforced polyurethane, hardened ground steel blade, T&G 'V' grooved and beaded MDF, whipcord, high grade tool steel, polished flat stock, foam liner, satin chrome-finish hardened steel beam, Plaztazote liner, vinyl-covered steel, glass fibre reinforced super-polyamide, polyamide nylon, thin finish birch ply, powder-coated steel, stress-free black granite, anti-rust paint-finished cast iron, crystal pink granite, grade 17 close-grained cast-iron webbed and slotted angleplate, hardened 60 HRC ground chrome steel, ultra micro-lapped surface finished high-chromium steel, Gaskoid™, European hardwoood, 800 Hv hardened high alloy steel, elastomeric, carbide-tipped stainless steel, chemically blackened knurled steel, tungsten carbide-tipped machined steel, polycarbonate, beryllium-copper, diecast alluminium, duplex-hardened polymethyl acrylate, Terry cloth, chrome-plated brass, polycarbonate bi-asperic lens, Tufset®, polished acrylic, black gloss wood filled phenolic, knurled torque thermoset phenolic, matt chrome steel, black high impact polymer, PVC-covered wire rope, black oxide steel, black matt finished Duroplast, chrome-plated die-cast zinc, matt-finished reinforced thermoplastic, electropolished ASTM 304 grade stainless steel, low gloss black ABS plastic, matt powder-coated die-cast zinc, epoxy coated aluminium, polyurethane coated aluminium burnished steel, green super-elastic low toxic PVC, bright zinc plated steel, nickel plated steel, glass-reinforced black nylon, ground flat stock tool steel, rayon, polyolefin copolymer-polypropylene plastic, ivory acetal, black Japanned steel, silver anodized aluminium bichromated steel, cable, straight grained French oak, white polyamide sheathing, natural latex, oil resistant rubber, graded cork particle board, smooth rounded tempered steel, alloyed nickel, zinc plated low carbon steel, JiffyBag™, woven compressed stainless steel wire pad, three-layer hardwood core, black soft sponge rubber ceiling strip, cork, nitril, Dychem, electroless nickel plated mild steel, Ultrex™, polyamide reinforced nylon, black low-density polyethylene, flexible extruded barium ferrite, neodymium iron boron, ceramic ferrite, UV stable EPSM rubber, WaveTex™, bright chrome plate, brushed metal, nickel plated solid brass, laminated steel, lacquered steel, triple plated solid steel, xenoy thermoplastic, hardened special steel alloy, hardened boron alloy steel, blue vinyl, high elastic foam, ribbed rubber, pressed sheet steel, outing flannel, fully moulded polypropylene, galvanised sheet steel, injection moulded thermoplastic, Nylatron®, pwder coated metal sheet, chloraprene rubber, medium density polyethylene, red powder-coated square section steel epoxy, zinc-plated tubuar steel, welded angle iron, full hard stainless steel blade, varnished WPC plywood, high tenacity polyester webbing, heat treated alloy steel, galvanised wire rope, polyester fibre strop, polypropylene tape rope, carbon paper, braded polyethylene cord, powder-coated carbon steel, vivak, stove-enamelled blue-finished high-grade grey cast iron, SRBP board, soft copper tube, chromium plated brass, nickel plated hot pressed brass, 4-ton tensile strength engineering resin, white polypropylene, ethylenepolypropylene silicon rubber seal, Siliphos®, silicone red dektite, polyethylene foam, high speed steel, armaflex rubber insulation sheet, blue rigid unplasticised nylon, PVC-U, styrene and acrylonitrile copolymer polybutadiene (ABS), RawHide™, veneered blockboard, cadmium plated metal band, thixotropic solvent cement, plastic tube, tempered steel, rilsan graphite, PTFE spindle seal, solenoid coil, Pertex™, thermoplastic moulded valve, selltape, Hytrel Tubing, silicone elastomer, extruded brass bar, zinc passivated plated steel, plastic shim, nylon coil, teflon FEP 140 tube, coated board, raw edge moulded notch narrow section wedge belt, Powergrip®, polychloroprene, steel tensile polyurethane compound, Harris Tweed, moulded nylon resin, hard anodised extruded aluminium, polyethylene gasket, ultra-high molecular-weight polyethylene, grey polyamide, muslin, translucent moulded polypropylene, Norprene®, industrial grade tubing, high-impact polystyrene, melamine-faced FR chipboard, Sizel, transparent polycarbonate, cubed foam, zinc-plated wire mesh, corrugated fibreboard, punched steel, PowerSpan™, birch plywood, reinforced padded PVC, suede leather, polythene tarpaulin, mild steel circular hollow section, polypropylene strapping, raw cotton string, double-submerged arc welded linepipe, polyethylene stretch film, silicone sponge rubber, liquid crystal polymer, seven-strand catenary wire, Victrex®, 5-ply Brazilian blockboard, powder-coated mild steel tube, lightweight PVC ducting, polyethylene laminated jute fabric, gunny cuttings, technora flock synthetic fibre, injection-molded plastic, vulcanised organic proxide compound, Cordura™, paramide

copolymer, austenitic stainless steel, Tufflex, water-resistant polymer-coated printable paper, seamless mild steel hollow section, optical fiber cable (OFC), terazzo, duralumin, styrofoam, felt, synthetic glycerol, p-phenylene terephtalamide, bitumen-coated roofing board, expanded graphite, oildag, aquadag, metakaolin, fumed silica, Aerosil®, Cab-O-Sil®, Konasil®, cesium formate, toner, extruded polystyrene, ethylene vinyl acetate (EVA), Vestoplast®, Taggant, sodium dodecylbenzenesulfonate, alkylbenzenesulfonates, polyacrylamide gel electrophoresis, Coomassie Brilliant Blue, Brilliant Blue FCF, Tartrazine, Green S, Paraquat, Dippel's Oil, ammonium hydroxide, turpentine, renardine, neatsfoot oil, kerosene, ultra-low sulfur kerosene, gramoxone, peek, crimplene, tencel, ingeo fibre, luminex, lurex, lyocell, olefin fibre, PLA fibre, fluorescein, eosin, porcelain, kaolinite, whitewash, agar, reinforced concrete, glass fiber reinforced concrete, weatherboard, corrugated galvanised iron, sheet metal, Zincalume® steel, Galvsteel™, Colorsteel® Endura™, Colorsteel® Maxx™, Axxis®Steel, Steltech® beams, sandpaper, biaxially-oriented polyethylene terephthalate (BoPET), Mylar®, Melinex®, Hostaphan®, Teijin®, Tetoron®, Teonex®, tinsel, paperboard, kraft board, cellophane, duct tape, gaffer tape, speed tape, masking tape, velostat, papyrus, amate, papier mâché, coated paper, foam peanut, Blu-Tack®, Tipp-Ex, Coroplast™, Kydex®, Lexan™ polycarbonate, Lexan™ Sheet, Noryl™, phenolic plastic, Polygal™, Polycoolite™, Primalite™, Selectogal™, shrinkwrap, zein, bubble wrap, emery paper, fiber cement siding, ferrocement, vermiculite, Fluorinert™, aluminum conductor composite reinforced, putty, bondo, asphalt, drywall, molasses, high-fructose corn syrup, fiberglass reinforced plastic, polyepoxide, gelcoat, Corian®, Glulam (glued laminated timber), Parallam®, avonite, arborite, alpikord, Consoweld, modal, Zylon, cellulose triacetate, magnetic tape, pulp cellulose, velvet, silk, madapolam, fiberglass, vinyl ester, para-aramid, kégresse track, chalcogel, silica gel, penicillin, pyrex, fused quartz, CorningWare® (pyroceramic glass), Zerodur™ (aluminosilicate glass-ceramic), bioglass, AgInSbTe, borophosphosilicate glass, borosilicate glass, ceramic glaze, Vitreous enamel, Shino glaze, swatow ware, bone china, pykrete, cement-bonded wood fiber, cutler's resin, prepolymer, Silicone resin, urea-formaldehyde, corduroy, twill, chino cloth, denim, serge, drill, bone ash, bone char, gunpowder, worsted wool, coal tar, anthracene, cubic zirconia, Pyrodex®, forbon, melamine resin, alkyd, glyptal, phenol formaldehyde resin, Novotext™ (cotton-reinforced bakelite), Tufnol®, phenolic foam (Oasis™), molded urethane, expanded polystyrene, styrophone, wood flour, linoleum, linoxyn, canvas, lincrusta, anaglypta, cardura, naphtha, bronze wool, glass wool, cotton candy, stone wool, tall oil, asbestos insulating board, Greensulate™, gauze, polygon mesh, gazar, modacrylic fibre, rep, rayadillo, elastolefin, spandex, darlexx, vinylon fibre, microfibre, stretch wrap, liquid packaging board, azlon, casein paint, tempera, bamboo fibre textile, basalt fiber, sisal twine, hemp twine, henequen twine, metal-coated plastic, plastic-coated metal, lurex polyester, needle punched polypropylene, heat bonded polyester, geosynthetic clay liner, sea byssus cloth, sea silk, cameline, catgut, metallised film, air-laid paper, freon, Tyvek®, chiengora, guanaco fiber, Manila hemp, tagal straw, Manila paper, copra, onionskin (paper), cotton paper, hemp paper, roofing felt, crêpe paper, wrapping tissue, glassine, kraft paper, wheat paste, methyl cellulose, wax paper, asphalt-saturated felt, foamcore, closed-cell PVC foamboard, thermosoftening plastic, gelatin emulsion, India ink, photographic paper, acrilan fabric, Merrifield resin, parkesine, Vespel™, saran wrap, M5 fiber, copper lamé, zephyr cloth, waxed cotton, nylon organza, carnauba wax, cyanoacrylate, porcelain enamel, Tartan Track™, Tegaderm™, acrylonitrile butadiene styrene, galalith, celluloid, crystalate, Micarta™, qiviut, chiffon velvet, ciselé velvet, cevoré velvet, lyons velvet, carbon black, rhonditic steel, solder, admiralty brass, aich's alloy, Prince Rupert's metal, aluminium brass, Muntz metal, arsenical brass, cartridge brass, gilding metal, naval brass, nickel brass, red brass, white brass, white tombak, rich low brass, tonval brass, mushet steel, wrought iron, pig iron, sponge iron, Damascus steel, silicon electrical steel, marine grade stainless steel, martensitic stainless steel, Celestrium™, high-strength low-alloy steel, fernico, ferroalloy, Molybdochalkos, magnox, Silver-mercury amalgam, Thallium amalgam, Tin amalgam reflective mirror coating, gioactive glass, flint glass, soda-lime glass, cobalt glass, cranberry glass, lead glass, milk glass, phosphosilicate glass, photochromic lens, Ultra low expansion glass™, uranium glass, Wood's glass, ZBLAN glass, glass-coated wire, glass ionomer cement, glass-to-metal seal, nanofoam, photosensitive glass, Mesoporous silica, precipitated silica, colloidal silica, carbonless paper, hydrophobic silica, Vaseline™, simethicone, Isinglass, Japanese tissue, zeolite, microcrystalline wax, rhenium diboride, AstroTurf™, Omniturf, surcingle, mycobond, soilon, Cer-Vit, Hebron glass, Nabulsi

soap, aleppo soap, yellowcake, hydronalium, adamite, maraging steel, polymer concrete, fly ash cement, LDPE, zinc duralumin, aluminium composite panel, nickel-cobalt alloy, styrene butadien rubber (SBR), nicalloy, carbon fiber reinforced plastic (CFRP), sendalloy, stampable sheet, cellulosic fiber insulating board, invar, Nb-Ti alloy, free cementite, corson alloy, sendust, polyimide foam, quenched and tempered high strength steel, Kalrez®, melamine formaldehyde, hot rolled steel sheet, phosphorus deoxidized copper, laminated veneer lumber, HDF, hemacite, white cast iron, luppe, nanogel, ceramic fiber, ballistic foam, prestressed concrete (PS), silicon steel plate, EPDM, copper sulfate, semikillde steel, manganese brass, tempaloy, ferritic stainless steel, PMMA, corrosiron, durana metal, antibubble, molybdenum high speed steel, polysulfide rubber, monel metal, galvanneal steel sheet, polytetrafluoroethylene, polylactic acid, aldrey, ferro-manganese, nylon plastic, epichlorohydrin, high impact polystyrene, bog iron ore, perminvar, bio-ceramics, green gold, michigan steel casting co. (MISCO) alloy, aluminum-lithium alloy, silicon steel, light weight concrete, methylene diphenyl diisocyanate, polyamides, transformation induced plasticity steel (TRIP steel), permathern, synthetic wood, burning resist plastics, constantan, syntactic foam, metallic microlattice, cadmium amalgam, aerographene, XNBR, PC/ABS, ferro-phosphorus, motalloy, glass fiber reinforced plastic, lumen bronze, polyetherimide, nilvar, bromobutyl, albrac, copper-tungsten alloy, manganese-bismuth alloy, electrum, Lurex®, skeleron, PET, chromium-molybdenum steel, chain steel (SBC), spiegel eisen, metal foam, tantiron, manganese steel, aerogel, gun metal, sorel's alloy, nihard, iron sulfide, polychloroprene rubber (CR), metal chalcogenide aerogel, high wear resistant Al-Si alloy, kanthal, mercoloy, vermicular graphite cast iron, german silver, acieral, miscrome, cold rolled steel sheet, Homasote®, glued laminated timber, cupro-nickel, Inconel, super invar, niobium-base alloys, oxygen-free high-conductivity copper (OFHC), durco, alcress, hastelloy, AE concrete, lautal, urea-formaldehyde resin, platinum, methyl rubber, oriented strand board, butadiene rubber (BR), artificial silica sand, tombac, carbon carbon composites, elinvar, 18-8 stainless steel, ferro-silicon, glass fiber reinforced cement (GRC), PVDC, oilless bealing alloy, isoprene rubber (IR), silumin, beryllium oxide, fluoro rubber, acrylonitrile-butadiene rubber (NBR), vinyl acetate resin, ethylene propylene rubber (EPR), isoprene-isobutylene rubber (IIR), uranium alloy, acrylic rubber, ductile cast iron, polylactide biopolymer, Innegra S, delta metal, safe emulsion agar gel, aero-bronze, silver solder, ferro-chrome, sintered carbide, urethane rubber, killed steel, thermowood, PE/ABS, engineered bamboo, high silicon cast iron, high manganese-zinc alloy, heat resisting plastics, parallel strand lumber, prepacked concrete, hiduminium, spheroidal cementite, kaolin, thermit, rimmed steel, duriron, alneon, hafnium-base alloys, permalloy, fiber reinforced ceramics (FRC), niresist, durichlor, fecraloy, NM bronze, aerated concrete, HDPE, everdur, Hypalon®, herculoy, AlSiC, electric galvanized steel sheet, elverite, alkene, ticalium, getter alloy, chilled iron, autoclaved lightweight concrete (ALC), alumel, pozzolan cement, metalic alloy for hydrogen storage, low expansion alloy (Lo-Ex), chromel, megapyr, dymalloy, tobin brass, phospher bronze, almasilium, defoamer, permalloy, liquid metal, austempered ductile iron, dynamo bronze, silentalloy, vacuum processed concrete,

2002 ongoing

공공재산
public property

안테나 총서는 예술에서 특정한 현상 또는 새로운 사상 조류를 밝혀내고 탐구하려는 목적으로 암스테르담의 출판사 팔리즈에서 펴내는 에세이 시리즈다. 그 기획은 완성되고 닫힌 작품이 아니라 향후 토론과 연구를 위한 참조점을 제공하는 데 목표를 둔다. 2009년부터 여덟 권이 간행되었으며, 다루는 주제는 예술가 작업실의 위상, 연구자로서 예술가, 공동체 예술 등 다양하다.

　메타헤이븐은 이 시리즈에 독특한 시각적 정체성을 부여한다. 권별 표지는 대비되는 색을 띠는 모호한 형체들이 흐릿하게 뒤엉킨 모습을 보여준다. 표지는 마치 커다란 패턴의 일부인 것처럼 보이지만, 그 패턴의 정체는 불분명하다. 그러나 그 형상은 무엇인가에 매우 가까이 다가갔다는 느낌을 준다. 표지와 내지에는 작은 검정 막대기가 일관성 있게 등장하며 일종의 '로고' 기능을 한다. 그리고 책등에서 그 막대기는 '도서관 라벨'의 일부가 되는데, 그런 느낌은 무광 종이에 찍힌 유광 바니시 덕분에 더욱 또렷해진다. 이 장치는 문제의 책이—따라서 책에 담긴 생각이—사적으로 보유하며 보호하는 재산이 아니라, 공적으로 순환하며 쓰여야 하는 지식임을 암시하는 듯하다.

다니엘 판 데르 펠던과 핀카 크뤽이 세운 메타헤이븐은 정치와 미학에 초점을 두는 디자인 연구 스튜디오다. 최근 작업으로는 뉴욕 현대미술관 PS1에서 열린 개인전 《구름 속의 섬》, 쇼몽 국제 포스터 그래픽 디자인 페스티벌에 설치한 〈유목민 체스: 지리학〉, 순회전 《그래픽 디자인: 생산 중》에 설치한 〈페이스스테이트〉, 2013년 스트렐카 프레스가 펴낸 전자책 《농담이 정부를 무너뜨릴 수 있을까?》, 위키리크스 브랜딩과 상품 디자인 등이 있다. 2010년에는 그들의 공상적 디자인 제안과 글, 생각을 엮은 책 《비기업 아이덴티티》(라르스 뮐러 퍼블리셔스)를 펴내기도 했다.

Antennae is a series of essays published by Valiz, Amsterdam, with an intention "to pinpoint certain phenomena or new lines of thought in the

arts and to explore them." It is meant to provide a "point of reference for further discussion and research," rather than—by implication—self-contained works. Eight volumes have been published since 2009, and the subjects include the significance of the artist's studio, the artist as researcher and community art.

Amsterdam-based studio Metahaven has given the series a unique visual identity. The cover of each volume features amorphous shapes in contrasting colors blurred together. It looks like a piece of a larger pattern, although its exact identity is unknown. But it does create a sense of being very close to something. A small black bar consistently appears on the cover as well as on the inside pages, functioning as a "logo." On the spine, it becomes a part of a "library label," the impression being reinforced by spot gloss on the uncoated paper. This device seems to suggest that the books—and, by extension, the ideas within—are to be circulated among and used by the public, rather than simply kept private and protected.

Founded by Daniel van der Velden and Vinca Kruk, Metahaven is a studio for design and research focusing on politics and aesthetics. Recent projects include the solo exhibition *Islands in the Cloud* at MoMA PS1, New York; *Nomadic Chess: Geography*, an installation at the Chaumont International Poster and Graphic Design Festival; *Facestate*, an installation for the travelling exhibition *Graphic Design: Now in Production*; the e-book *Can Jokes Bring Down Governments? Memes, Design and Politics*, published by Strelka Press, 2013; and branding and merchandise design for WikiLeaks. *Uncorporate Identity*, an anthology of their speculative design proposals, writings and ideas, was published in 2010 by Lars Müller Publishers.

메타헤이븐
2007년 설립, 암스테르담: 다니엘 판 데르 펠던, 1971년생, 네덜란드 /
핀카 크뤽, 1980년생, 네덜란드.

Metahaven
Founded in 2007, Amsterdam: Daniel van der Velden, b. 1971, the Netherlands, and Vinca Kruk, b. 1980, the Netherlands.

metahaven.net

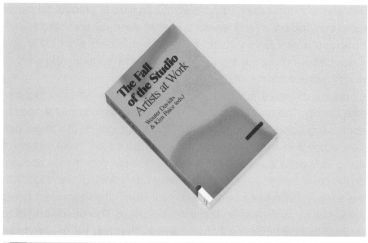

안테나 총서
2009–현재. 오프셋, 사철에 표지. 각각 13.5×21 cm, 두께와 쪽수 다양.
암스테르담: 팔리즈.

Antennae
2009–ongoing. Offset lithography, sewn in sections, covers.
13.5×21 cm each; thickness and extent vary. Amsterdam: Valiz.

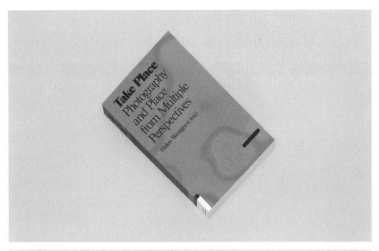

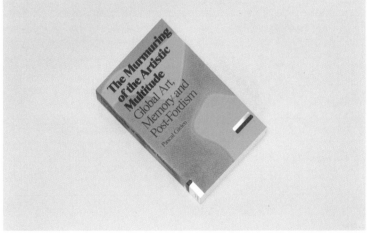

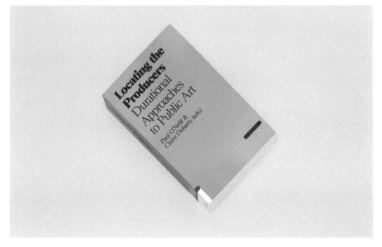

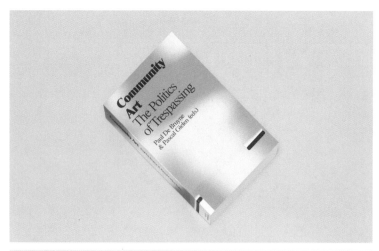

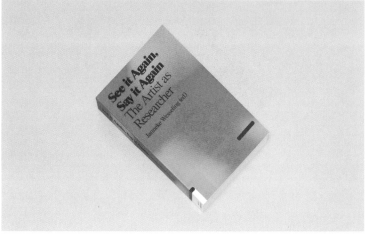

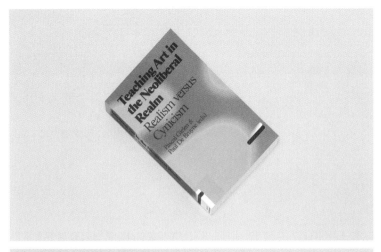

공동체
community

더 북 소사이어티는 구정연과 임경용이 서울에서 운영하는 독립 서점 겸 문화 공간
이자, 소규모 출판 플랫폼이기도 하다. 2010년 설립된 이후 한국 디자인, 독립 출
판, 문화 예술 영역에서 의미 있는 역할을 담당해왔다. 다양한 문화, 출판 사업에 참
여했으며, 2009년과 2013년에는 서울에서 활동하는 여러 문화 공동체를 취재해
《공공도큐멘트》를 펴냈다. 《인생사용법》(문화역서울 284, 서울, 2012),《돌과 땅》
(공간 꿀, 서울, 2012),《아름다운 책 2010》(서교예술실험센터, 서울, 2011),《디자
인 올림픽에는 금메달이 없다》(인사미술공간, 서울, 2010) 등의 전시에 작가 또는
기획자로 참여하기도 했다.

　더 북 소사이어티의 〈서점들〉은 세계 곳곳에서 활동하는 소규모 독립 서점 열 곳을
초대해 타이포잔치 2013 전시 기간에 운영하는 임시 서점이다. 지리적, 문화적 맥
락은 다르지만 자율성과 실험성이라는 정신을 공유하며 각자 위치에서 분투 중인
문화 공동체의 현황을 알아보고, 그들 사이에 소통과 연대를 꾀하는 작업이다. 임시
서점 〈서점들〉에는 참여 서점이 추천한 책들이 전시되고, 각 서점 운영자와 더 북
소사이어티가 나눈 대화가 제시된다. 이렇듯 〈서점들〉은 출판문화와 디자인의 물적
토대를 이루는 유통 체계 일각을 살펴보며 '독립' 문화의 조건과 전망을 시사한다.

참여 서점: 루게믹 북숍(에스토니아 탈린), 더 북 소사이어티(한국 서울), 비북스(독
일 베를린), 산 세리프(네덜란드 암스테르담), 섹션 7 북스(프랑스 파리), 스탠드 업
코미디(미국 포틀랜드), 스플릿/파운틴(뉴질랜드 오클랜드), 오무(그리스 아테네),
유토레히토(일본 도쿄), 페리미터(오스트레일리아 멜버른).

The Book Society is a small bookstore in Seoul, doubling as a cul-
tural space and a platform for publishing. Founded by Helen Ku and
Lim Kyung yong in 2010, it has been playing an important role in the
culture of independent art, design and publishing. It has participated in

many curatorial and editorial projects, and published two volumes of *00 Document* (in 2009 and 2013), which reports on the autonomous activities of various cultural communities operating in Seoul. It has also participated in many exhibitions as an artist and/or curator, including *Life: A User's Manual* (Culture Station Seoul 284, 2012), *Stone And Land* (Ccuull, Seoul, 2012), *Beautiful Books in Korea 2010* (Seoul Art Space Seokyo, 2011) and *The Design in the Age of Creative Seoul* (Insa Art Space, Seoul, 2010).

Bookshops is a temporary bookshop opening during the Typojanchi 2013. In fact, it is a "hub" of ten small-scale, independent bookstores from around the world. The invited bookstores are all different in terms of size and context, but they do share a similar spirit of independence and experimentation. *Bookshops* attempts to identify the conditions under which these struggling agents of culture are operating, and initiate a dialog with them. A selection of books from the invited bookstores are displayed, and the conversations between them and the Book Society on the issues of autonomy are presented. *Bookshops* sheds light on a material base of design and publishing, and provides a perspective on the global situation of independent culture.

Participating shops: b-books (Berlin, Germany), The Book Society (Seoul, Korea), Lugemik Bookshop (Tallinn, Estonia), Ommu (Athens, Greece), Perimeter (Melbourne, Australia), San Serriffe (Amsterdam, the Netherlands), Section 7 Books (Paris, France), split/fountain (Auckland, New Zealand), Stand Up Comedy (Portland, US), and Utrecht (Tokyo, Japan).

더 북 소사이어티
2010년 설립, 서울: 구정연, 1976년생, 한국 / 임경용, 1975년생, 한국.

The Book Society
Founded in 2010, Seoul: Helen Ku, b. 1976, Korea, and
Lim Kyung yong, b. 1975, Korea.

thebooksociety.org

서점들
2013. 복합 매체 설치. 크기 가변.

Bookshops
2013. Mixed-media installation. Dimensions variable.

과민 반응

over-responsiveness

홍은주와 김형재는 2008년과 2006년에 각각 국민대학교 시각디자인학과를 졸업했다. 홍은주는 제로원 디자인센터와 투플러스를 거쳐 현재 프리랜서 디자이너로 활동 중이다. 김형재는 간텍스트와 시민문화네트워크 티팟을 거쳐 이음출판사와 문지문화원 사이에서 디자이너로 일하는 한편, 계원예술대학교에서 그래픽 디자인을 가르치고 있다. 홍은주와 김형재가 함께 디자인한 프로젝트로는 현실문화, 티팟, 백남준 아트센터, 하이트 컬렉션, 서울시립미술관을 위한 그래픽 아이덴티티와 홍보출판물, 웹사이트 등이 있다. 《다음 단계》(티팟, 2009), 《GZFM 90.0 91.3 92.5 94.2》(공간 해밀톤, 2010), 《아름다운 책》(서교 예술실험센터, 2011 / 도쿄 아트북페어, 2012) 등 전시를 기획했고, 2007년 이후 《가짜잡지》, 2012년 이후 《도미노》 잡지 기획과 편집에 참여하며 디자인을 맡기도 했다.

홍은주와 김형재가 디자인한 웹사이트는 매체의 물질성을 드러낸다. 그들이 흔히 개발과 제작도 겸해 만들어내는 웹사이트는 2000년대 초부터 굳어지다시피 한 한국 웹 디자인의 관성을 깨고, 과제의 성격에 따라 매번 원점에서 사고하는 무모한 모습을 보인다. 그들은 '웹 UX'나 프로그래밍 전문가가 아니며, 따라서 모든 프로젝트는 그들에게 새로운 시도와 학습의 기회가 된다. 그러나 그러한 집중 자습이 완벽할 수는 없으므로, 그들이 코드와 요령을 엮어 만든 웹사이트는 매끄러운 작동과 거리가 멀기 일쑤다. 그 사이트에서는 텍스트와 이미지, 코드가 이면에서 결합하는—또는 서로 어긋나는—덜그럭 소리가 들릴 정도다. 그러나 바로 그렇기에, 그들의 웹사이트는 매끈한 표면으로 밀봉된 구조가 아니라 작동 원리와 특성을 노출하는 현대적 속성을 띠게 된다.

'사용자 경험' 면에서 그들이 만들어내는 웹사이트의 표피적 인상은 거칠고 투박하지만, 개념적으로 그들의 디자인은 무척 깔끔하다. 예컨대 홍은주와 김형재가 디자인한 타이포잔치 2013 웹사이트는, 전시 작품 각각의 별명에 '슈퍼'라는 접두사를 달아 매번 다른 순서로 나열하는 화면으로 문을 연다. '슈퍼유령', '슈퍼가공언어', '슈퍼실화', '슈퍼농담', '슈퍼쌍무지개', '슈퍼형용모순' 등 그들이—그들의 코

드가—지어내는 슈퍼별명들은 타이포잔치 2013의 관심 영역을 잘 드러낼 뿐만 아니라, 그 자체로 짓궂은 언어 놀이가 된다.

이어지는 화면들은 '슈퍼텍스트'의 불안정성을 강조하듯 건드리기만 해도 바뀌는 디자인을 보여준다. 그 바탕을 이루는 '반응형 웹 디자인' 기법(화면 크기에 따라 요소의 배열과 크기가 바뀌는 기술)은 본디 최적화라는 기능적 목적을 위해 개발되었지만, 홍은주와 김형재는 그 기술을 오용하고 남용함으로써 과잉 최적화한 디자인의 신경질적 상황을 창출해낸다. 그렇게 만들어진 과민 반응형 웹사이트는 타이포잔치 2013을 중립적으로 소개하는 데 그치지 않고, 오히려 전시를 바라보는 어떤—아마도 불안한—시선을 반영하는 듯하다.

Hong Eunjoo and Kim Hyungjae graduated from the Department of Graphic Design, Kookmin University, Seoul, in 2008 and 2006 respectively. Hong worked at the Zero/One Design Center and Two Plus before starting her own practice. Kim started his career at Gan Text and TPot, and currently works for Eum Books and Moonji Cultural Institute Saii while teaching at Kaywon School of Art & Design. They have worked together on a number of projects, designing graphic identities, publications and websites for clients including Hyunsil Cultural Studies, TPot, the Nam June Paik Art Center, the Hite Collection and the Seoul Museum of Art. They have co-organized the exhibitions *The Next Step* (TPot, Seoul, 2009), *GZFM 90.0 91.3 92.5 94.2* (The Space Hamilton, Seoul, 2010) and *Beautiful Books in Korea* (Seoul Art Space_Seogyo, 2011 / Tokyo Art Book Fair, 2012). They also founded the magazine *Gazzazapzi* (2007–), and have been involved in another magazine, *Domino,* as part of the editorial team and the designer.

The websites designed by Hong Eunjoo and Kim Hyungjae tend to reveal the materiality of the medium. Often also developed and implemented by them, the sites would break from the Korean web design conventions established since the early 2000s, daring to start from scratch each time. They are not experts in the "web UX" or programming, so each project becomes a challenge and opportunity for new experiments and learning. By virtue of the limited self-learning, the websites they constructed with existing codes and ad hoc solutions are often a step away from smooth operation: one can almost hear the rattling sound of texts, images and codes assembling—or disjointing—themselves. Intended or not, their websites would expose their own inner workings and natures rather than sealing them behind slick surfaces.

If the websites are rather rough and crude in terms of "user experience," their conceptual foundations are usually neat and solid. For example, the website of Typojanchi 2013 that Hong Eunjoo and Kim

Hyungjae created opens up with a screen enumerating the terms for the exhibited works in a random order, attaching the prefix "Super-" to each of them. The suggested "super-terms," from "Superghost" to "Super-processed language," "Supertrue story" and "Superoxymoron," illuminate the interests of the exhibition, while playing their own wordplay.

The successive pages, in which the elements are rearranged the moment one touches upon any of them, emphasize the unstable nature of the Supertext. At the base is a "responsive web design" technique (the positions and sizes of elements are automatically adjusted to fit the changing window size), which was originally developed for optimal display of contents. Hong Eunjoo and Kim Hyungjae mis- and overuse the technique to create the nervous state of the over-optimized. The "over-responsive" Typojanchi 2013 site does not simply present the works in a neutral way: rather, it seems to suggest a certain—probably uneasy—perspective on the exhibition.

홍은주 / 김형재
홍은주, 1985년생, 한국 / 김형재, 1979년생, 한국.

Hong Eunjoo and Kim Hyungjae
Hong Eunjoo, b. 1985 Korea, and Kim Hyungjae, b. 1979, Korea.

keruluke.com

슈퍼텍스트
2013. 웹사이트.

Supertext
2013. Website.

과정
process

오은의 시는 한국 시에서 소홀히 취급되는 언어유희의 미학을 극단까지 몰고 간다. 그의 수사학은 유쾌하면서도 정교하고 날렵하다. 다양한 화자가 등장하는 다문화주의적 시 세계를 보여주면서, 독자의 의식을 끊임없이 자극하고 확장한다. 그러나 이러한 시작은 단순한 말놀이에 그치지 않는다. 오히려 단어의 의미와 관계를 심화하고 새로운 언어적 상황을 창조해내면서 언어가 구성하는 사회적 조건과 가치들을 끊임없이 의심하고 질문하게 한다. 오은은 서울대학교 사회학과를 졸업하고 한국과학기술원 문화기술대학원에서 석사 학위를 받았다. 2002년 《현대시》로 등단했으며, 시집 《호텔 타셀의 돼지들》과 《우리는 분위기를 사랑해》, 미술 산문집 《너랑 나랑 노랑》 등을 써냈다.

크리스 로는 미국에서 태어나고 자란 교포 2세로, 한국 생활은 2010년부터 시작했다. 한국 시각 문화에 관한 호기심에서 학생들과 함께 추진하고 발간한 《온돌 프로젝트》는 3호를 맞이했다. 베터 데이스 연구소를 운영하며 디자인 글쓰기, 그래픽 디자인, 타이포그래피에 관한 폭넓은 리서치를 수행하고 있다. 연구 프로젝트와 책 디자인 외에도 브랜딩, 광고, 모션 그래픽 등 전 방위에 걸쳐 활동하는 데 관심이 있다. 크리스 로는 미국 버클리 대학교에서 건축 전공으로 학사 학위를, 로드아일랜드 디자인대학에서 그래픽 디자인으로 석사 학위를 받았다. 현재 홍익대학교 교수로 재직하면서 한국타이포그라피학회의 학술 출판 이사로 활동 중이다.

크리스 로는 오은의 시 〈날〉을 창작 과정에 관한 작품으로 해석한다. 그리고 시 창작과 디자인 창작 과정의 공통 요소로 사람의 손을 영상의 주요 소재이자 주체로 제시한다. 이 영상 시에서 손은 말을 짓고 부수고 바꾸면서, 서로 다른 의미를 완성해낸다.

Oh Eun's work pushes the aesthetics of wordplay—largely neglected in Korean poetry—to its extreme. His rhetorics are cheerful yet poignant and agile. His poems feature various language-speakers and relentlessly provoke and expand the reader's consciousness. But his poems do not end up as mere wordplays: rather, they further complicate the mean-

ings and relations of words and create new verbal situations, asking questions on our social conditions and values shaped by our language. He studied sociology at Seoul National University, and earned a master's degree from the Graduate School of Culture Technology, KAIST. He debuted in 2002, and has published two collections of poems and an anthology of essays on art.

Chris Ro is a second-generation Korean-American designer, living and working in Korea since 2010. He has organized with his students a research project devoted to the Korean visual culture, *Ondol Project*, and has published three issues so far. With his studio Better Days Institute, he has been involved in extensive researches on design writing, graphic design and typography. As a practitioner, he works across various media including book design, branding, advertising and motion graphics. He studied architecture at the University of California in Berkeley, and earned his MFA from the Rhode Island School of Design. Currently he is professor at Hongik University, and a board member of the Korean Society of Typography.

Chris Ro interprets Oh Eun's "긁" as a tribute to creative processes, and discovers hands as a common element in the creation of text as well as imagery. In this motion poetry, the hands compose, break and modify words, playing a crucial role in realizing different meanings.

긁

The fundamental thread that links both text, type and form throughout this project is process. It is an examination and expression of how we, both as creators, go about creating something from nothing. As I began to decipher the text of the artist, Oh Eun, I began to interpret it as a rather playful tribute to his own processes and idiosyncrasies while generating text. So I began to think what might be apropos in such contexts. And after much deliberation, it occurred to me that perhaps I could also reflect on some of my own processes and means for creation. It then occurred to me that perhaps the one thing we did share was the enabling of our hands to put thought to form or thought to content. So process was the overarching theme and our hands became the instigator or catalyst, that which enabled process. Our hands are the vehicles by which we both express ourselves. Chris works with his eyes. Oh Eun works with his ears. We both tell our stories with our hands. Marks to paper.

The other sub-theme that we were experimenting with was the completion of meaning. With some of these instances of 긁 we were curious how the hands could add or subtract meaning through these interactions. So in several cases during the animation, the hands are adjusting, changing or bringing in different completions of 긁.

The project was difficult to say the least. As a semi-Korean or almost-Korean, I have my issues with everyday functioning text. But to take this expressive text and interpret and really catch the nuances was extremely difficult. It was written in a manner that was not too difficult to at least understand the basic underlying meaning but again, it is the nuances that I could not pick up on. At least, not right away. But I think this is the challenge of the graphic designer. It is how we interpret and re-interpret in a visual way that other people can experience. And in so doing, others can also see in some ways, the way I see Oh Eun's text. But again, it was not easy. I think physically this was quite challenging too. Animation is never an easy process. And the sheer amount of time this project took was challenging as well. But it was very rewarding. It was a different way for me to think and challenge how and what I see animation as. I think to date, this is one of the more or most challenging projects I've worked on and it is challenging both from a language and making point of view. But I think it was also just as rewarding as it was another opportunity for me to challenge my relationship with Korean language, text and meaning and also for me to work with a very blessed artist. So for that, I am as always, quite thankful.

The software used for this was all primarily the Adobe creative suite. Adobe After Effects was used for putting everything together and in motion. Adobe illustrator and photoshop were used to create all the pieces to move. I shot a lot of film for the hand sequences. My wonderful wife, Yunim Kim, was kind enough to be a gracious model. So it is her hands you see that are actually interacting with the type. A lot of work. But a lot of fun. [Chris Ro]

오은
1982년생, 한국

크리스 로
1976년생, 한국.

Oh Eun
Born in 1982, Korea.

Chris Ro
Born in 1976, Korea.

날

태초에 할 말이 있었다
살 날, 살아갈 날에 아득바득
갈 날이 있었다
날카롭게 갈 칼날이 있었다
발달할 근육이 있었다 팔팔할 마음이 있었다 빨빨 흘릴 땀이 있었다
바깥에는
쌀쌀맞은 사람들이 있었다
깔깔대며 비웃는 사람들이 있었다
그 틈을 비집고
알딸딸한 상태로 달리는 내가 있었다
나를 키운 건 팔 할이 말들이었다 앞에 있는 것도
뒤에 있는 것도
할 말들이었다
어김없이 날들이었다 그러고도 살날들이었다 입에 찰찰 달라붙는 날것의 말들이었다
살 말도, 팔 말도 아니었다
짤깃한 말발뿐이었다
칼칼하면서도 발랄한 목소리뿐이었다
그 목소리로
말할 날이 있었다
갈팡질팡하며 우왕좌왕하며 살날이 있었다
나에게도
잘살 날이 있었다
찰 달, 차오를 달이 있었다 아직도 더 할 말이 남아 있었다

[오은, 2013년 신작]

날
2013. 단채널 영상. 서울스퀘어 미디어 캔버스 상영용으로 제작.

날
2013. Single-channel video. Created for screening at the Seoul Square
Media Canvas.

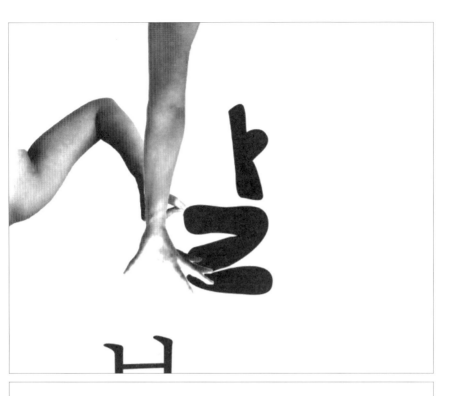

금언
maxim

앤서니 버릴은 그래픽 미술가 겸 판화가, 디자이너다. 리즈 폴리테크닉과 런던 왕립 미술대학에서 그래픽 디자인을 전공했다. 활자체와 인쇄물에서 영상과 3차원 설치까지 광범위한 매체를 포괄하는 그의 작업은 런던 바비컨, 미니애폴리스 워커 아트 센터, 브레다 그래픽 디자인 미술관 등 전 세계 미술관에서 선보였으며, 런던 빅토리아 앨버트 미술관과 뉴욕 쿠퍼휴잇 국립 디자인 미술관에 영구 소장되어 있다.
언어와 말장난은 버릴의 작업에서 큰 비중을 차지한다. 예컨대 목판 인쇄 포스터 연작은 작가가 우연히 발견하거나 엿들은 문장을 목판 활자로 강렬하게 찍어낸 작품이다. 원래 문맥에서 떨어진 문장들의 정확한 의미는 꼬집어 말하기 어렵다. 때로는 모호하게 훈계하거나("일은 열심히 하고 사람들은 상냥하게 대해") 선동하는("우리는 여기에, 때는 지금!") 어조를 띠기도 하고, 다소 권위적인("너만의 아이디어를 떠올려라") 어감을 풍기기도 하지만, 메시지 자체는 대체로 단순하고 평이하다. 그러나 버릴의 타이포그래피는—사실상 폐기된 인쇄 기법이 제공하는 풍부한 색과 강렬한 활자체, 깊은 질감을 통해—그처럼 평범한 내용과 결합하면서, 일상적 언어를 신기하게도 거리감 있으나 널리 공명하는 작품으로 격상시킨다.

Anthony Burrill is a graphic artist, printmaker and designer. He studied graphic design at Leeds Polytechnic and the Royal College of Art, London. His practice encompasses a vast range of applications, from typeface and print to screen-based or three-dimensional media. His work has been shown in numerous exhibitions in galleries and museums around the world including the Barbican in London, the Walker Art Center in Minneapolis and the Graphic Design Museum Breda, and included in the permanent collections of the Victoria and Albert Museum in London and the Cooper-Hewitt National Design Museum, New York.
Language plays an important role in Burrill's work. His Woodblock Poster Series, for example, is based on sentences and phrases he found or overheard, blown up in scale and presence by bold woodblock

poster types. Taken out of the original context, the exact meaning of each phrase is often elusive. The tone varies from vaguely inspirational ("Work Hard & Be Nice to People") to mildly authoritative ("Think of Your Own Ideas") and anthemic ("We Are Here & It Is Now!"), but the messages themselves are mostly plain and simple. It is Burrill's treatment— the rich colors, expressive letterform and deeply tactile quality granted by the now largely obsolete printing technique—combined with the apparently commonplace content that elevates the mundane to something curiously distanced yet resonant.

앤서니 버릴
1966년생, 영국.

Anthony Burrill
Born in 1966, UK.

anthonyburrill.com

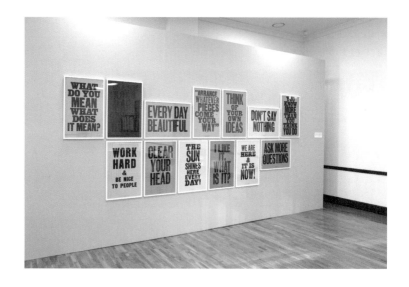

목판 인쇄 포스터 연작
2004–2013. 종이에 목판 인쇄. 각각 51 × 76 cm. 인쇄: 애덤스 오브 라이.

Woodblock Poster Series
2004–2013. Woodblock printing on paper. 51 × 76 cm each. Printed by
Adams of Rye.

WE ARE HERE & IT IS NOW!

Anthony Burrill for Wrap

ASK MORE QUESTIONS

GET MORE ANSWERS
Anthony Burrill

WORK HARD & BE NICE TO PEOPLE

Anthony Burrill

MAKE YOUR MARK ON THE WORLD

Daniel Black

THINK OF YOUR OWN IDEAS

Anthony Burrill

"ARRANGE WHATEVER PIECES COME YOUR WAY"

VIRGINIA WOOLF

Anthony Burrill for Mould's House

YOU KNOW MORE THAN YOU THINK YOU DO

Anthony Burrill for the USA

기준선
baseline

───────

유윤석은 홍익대학교와 미국 예일 대학교에서 그래픽 디자인을 전공했다. 2006년
부터 다국적 스튜디오 베이스의 뉴욕 사무실에 근무하면서 세비야 비엔날레, 광주
비엔날레, 개고시언 갤러리, 스탠드, 그린힐 협동조합, 웰슬리 대학교, 뉴욕 어린이
미술관, 세인트루크 오케스트라를 위한 브랜딩 프로젝트에 참여했다. 2011년 서울
에 돌아와 스튜디오 '프랙티스'를 운영하며 아이덴티티와 전시, 책, 인쇄물을 디자인
하고 있다. 대표적인 클라이언트로 백남준 아트센터, 월간 디자인, 신문박물관, 광주
비엔날레, 홍콩 갤러리 페로탱 등이 있다.
　유윤석이 디자인한 타이포잔치 2013 '슈퍼텍스트' 그래픽 아이덴티티는 관습적
역할에서 자발적으로 분리되고자 하는 존재 개념에 바탕을 둔다. "활자를 디자인하
거나 글자를 배열하는 데 쓰이는 기준선은 전통적 조건과 관습을, 거기에서 벗어난
't'는 글쓰기에 적극적으로 개입하는 현대 타이포그래피와 그 디자이너들의 모습을
대변"한다. 때때로 't'는 겹겹이 쌓인 '텍스트'의 관습을 뚫고 솟구치기도 하고, 때로
는 만화를 연상시키는 연기 구름을 남기고 유유히 날아오르기도 한다. '텍스트'에서
풍기는 권위적 인상을 가볍게 넘어서는 유윤석의 그래픽 아이덴티티는 '슈퍼텍스
트'의 유희적 측면을 포착한다.

───────

Yoo Yoon Seok studied graphic design at Hongik University, Seoul, and
Yale University, New Haven. He has worked at the New York office of
Base Design, and was involved in projects for international clients in-
cluding Sevilla Biennial 2006; Gwangju Biennale 2008; Gagosian Gal-
lery; Stand; Greene Hill Food Co-op; Wellesley College; Children's Mu-
seum of the Arts, New York; and Orchestra of St. Luke's. In 2011, he
founded the studio Practice in Seoul, and has designed graphic identi-
ties, exhibitions, publications and printed promotional materials. Major
clients include the Nam June Paik Art Center, Yongin; *Design* magazine;
Presseum, Seoul; Gwangju Biennale Foundation; and Galerie Perrotin
Hong Kong.

The "Supertext" graphic identity Yoo designed for Typojanchi 2013 is based on the idea of spontaneous departure from conventional roles of typography. "Typographic baseline, used in designing typefaces or arranging characters, represents traditional conditions and conventions, while the escaping 't' signifies contemporary typography and its designers who have been actively participating in writing," according to Yoo. Sometimes the "t" emerges penetrating the layers of "text." At other times, it surges up leaving behind a cartoon-like figure of gas. The identity captures the playful aspects of "Supertext," rising above the often serious and authoritative notions of "text."

유윤석
1974년생, 한국.

Yoo Yoon Seok
Born in 1974, Korea.

we-practice.com

슈퍼텍스트
2013. 그래픽 아이덴티티, 인쇄 홍보물. 매체 다양.

Supertext
2013. Graphic identity and printed promotional materials.
Various media.

놀이
play

히데치카와 쓰카다 데쓰야는 1993년 도쿄에서 실험적 타이포그래피 집단 다이니혼 타이포 조합을 결성한 후 문자를 즐겁게 해체, 재조합, 재구성함으로써 새로운 타이포그래피 문자 개념을 개발해왔다. 런던, 바르셀로나, 도쿄에서 개인전을 열었고, 싱가포르, 홍콩, 한국 등에서 여러 전시에 참여했다. 2003년에는 바르셀로나에서 열린 결성 10주년 기념 전시에 맞추어 작품집 《타입 카드 플레이 북》을 펴내기도 했다.

다이니혼 타이포 조합의 최근 작품 〈자구〉는 문구 제품 시리즈다. 말 그대로 '글자 도구'를 뜻하는 〈자구〉는 알파벳 문자로 형상화되어 있다. 각도기(protractor)와 압정(pin)은 'p', 자(ruler)는 'r', 서류 받침(tray)은 't' 모양을 띤다. 제품 이름이 형태를 결정하며, 그와 함께 독특한 기능을 더해준다. 다이니혼 타이포 조합 특유의 가벼운 해학이 이 작품에도 배어 있다. "〈자구〉는 책상에 재미를 불러옵니다!" 업무가 특히 고된 날, 〈자구〉가 우연히 빚어내는 하이쿠를 감상하며 잠시 여유를 즐겨보면 어떨까.

Hidechika and Tsukada Tetsuya set up an experimental typography group called Dainippon Type Organization in 1993, and have been pursuing new ideas of typographic characters by playfully deconstructing, recombining and restructuring letterform. They have held solo exhibitions in London, Barcelona and Tokyo, and participated in group exhibitions around the world, including in Singapore, Hong Kong and Korea. Their monograph, *Type Card Play Book*, was published in 2003 to accompany a ten-year anniversary exhibition in Barcelona.

Dainippon Type Organization's recent work *Jigu* is a series of office supplies. Literally meaning a *letter-tool*, each *Jigu* product is shaped in an alphabet letter: "p" for protractor, another "p" for pin, "r" for ruler, and "t" for tray. The name of a product motivates the shape, adding an incidentally unique function to the tool. A light-hearted sense of humor permeating the Dainippon Type Organization's body of work is also evident

here: "*Jigu* brings fun on your desk!" On a particularly stressful day in the office, you might be pleasantly surprised to see a haiku is forming itself with your *Jigu*.

다이니혼 타이포 조합(大日本タイポ組合)
1993년 설립, 도쿄: 히데치카(秀親), 1968년생, 일본 / 쓰카다 데쓰야(塚田哲也), 1971년생, 일본.

Dainippon Type Organization
Founded in 1993, Tokyo: Hidechika, b. 1968, Japan, and Tsukada Tetsuya, b. 1971, Japan.

dainippon.type.org

자구(字具)
2012–현재. 복합 매체. 크기 다양.

Jigu
2012–ongoing. Mixed media. Various sizes.

농담
joking

———
김기조는 서울대학교 디자인학부 학생이던 2004년부터 독립 음반사 붕가붕가 레코드에서 수석 디자이너로 일하기 시작했고, 2010년부터는 독자적인 1인 타이포그래피 스튜디오 기조측면을 운영해왔다. 그가 디자인한 작품으로는 장기하와 얼굴들, 브로콜리 너마저, 눈뜨고 코베인, 미미 시스터즈 등의 음반이 손꼽힌다.

이처럼 잘 알려진 음반 작업 외에도, 김기조는 독자적인 한글 레터링 작업을 진행하며 여러 전시에 참여하기도 했다. 그는 신문 표제, 캠페인 구호, 진부한 농담 등에서 문구를 빌려 1960-1970년대 한글 레터링 스타일로 빚어내는 작업을 즐기지만, 그러한 작업이 단순한 복고 취향으로 환원되지는 않는다. 오히려 그는 가까운 과거—삶을 향상시킬 수 있다는 생각이 그럴듯하게 느껴지던 시대—에서 빌린 시각언어를 통해 오늘날 청년 세대의 좌절과 실망을 포착하려 한다. 그렇게 그의 작업은 '좋았던 시절'을 그리워하기보다 미래에 관한 상상, 또는 그 상상이 어려워진 오늘날의 현실을 역설적으로 반영한다.

김기조는 "맥락이 박리된 채 벽에 걸리는 순간부터 농담은 그 지위를 상실한다"고 말한다. 〈농담의 방식〉은 박제화한 결과물로서 농담을 거부하고, 농담이 만들어지는 순간과 현장을 총체적으로 제시하는 작업이다. 작가 자신이 전시 공간에 일정한 자리를 마련하고, 일정한 시간에 그 자리를 차지하며 스스로 정한 규약에 따라 행동하고, 그러면서 농담을 만들어낸다. 그 '농담'은 작가가 현장에서 만들어내는 시각적, 언어적 메시지를 빌리기도 하고, 현장 환경 자체가 되기도 하며, 작가 자신이 되기도 한다. 그러나 무엇보다 우스운—또는 씁쓸한—농담은 작가가 전시장을 일터 삼아 그곳에 출근하고, 농담을 일 삼아 처리하고 만들어내며, 관객은 그 광경을 구경하는 상황 자체가 아닐까?

농담의 본질은 대체로 예상하지 못한 상황에서 예상하지 못한 순간 예상하지 못한 방식으로 던져지는 말, 그리고 그 말을 통해 순간적으로 열리는 어떤 공간에 있다. 그렇다면 농담을 기대할 수밖에 없는 상황과 공간, 거기에서 자발성을 상실한 채 '생산'되는 농담은 이미 단순한 농담이 아니다. "맥락이 박리된 채 벽에 걸린" 농담

이 아니라면, 맥락에 각인된 농담, 또는 그 자체가 농담이 되는 맥락—〈농담의 방식〉
은 그처럼 복잡한 농담의 작동 방식을 탐구한다.

———

While still studying graphic design at Seoul National University in 2004, Kimm Kijo started operating as art director at the independent music label BGBG Record, Seoul, and since 2010, he has been running his own studio, Kijoside. He has created record sleeve designs and art-directed for numerous Korean indie-rock bands, including Jang Kiha and the Faces, Broccoli, You Too?, Nuntteugo Cobain, and Mimi Sisters.

Apart from the work for music industry for which he is mostly known, he has also been creating more autonomous work, often taking banal text bits from headlines, campaign slogans and silly jokes, and rendering them in a style strongly reminiscent of the lettering from the 1960s and 1970s Korean popular culture. Rather than a nostalgic retro, however, his work echoes the anxiety and frustration of today's youth in the visual language borrowed from the recent past—the times when, as it may seem now, the idea of life as something makable and improvable could be held more plausibly. Thus, in its oblique way, his work responds to the future, or the present difficulty of imagining it.

"The moment when a joke is taken out of its context and put on the wall, it ceases to be a joke," says Kimm. Instead, *A Way of Making Jokes* attempts to present the total context, the time and the place for him to make jokes. The artist prepares a certain place in the exhibition space, occupies it at certain times, acting by certain rules, producing jokes. The "joke" in question may be the visual/verbal messages he creates on site, or the site itself, or himself trying to make jokes. Or, perhaps the most poignant joke here is the situation itself with the artist coming to the space as if it was a workplace, making jokes as if it was his job, and the visitors watching him working to make jokes.

The essence of a joke lies in the space suddenly opened up by an unexpected utterance, in an unexpected time and place and situation. Then, a joke "produced" without spontaneity in a situation where the joke is clearly expected, is not exactly a joke anymore. If not a joke "taken out of its context and put on the wall," then one embedded in the context, or the context as a joke, *A Way of Making Jokes* explores the complex mechanisms by which things are said to amuse others.

김기조
1984년생, 한국.

Kimm Kijo
Born in 1984, Korea.

kijet.egloos.com

농담의 방식
2013. 복합 매체 설치, 퍼포먼스. 크기 가변.

A Way of Making Jokes
2013. Mixed-media installation and performance. Dimensions variable.

규칙이 없는
상태를
전달하는 방법

네,
네.

한동안
옷을
필요가
없겠네요

어떻게
하면
저렇게
될까요

이것은
원을
그리는
일이
아니니까요

나는
이게
어떤
의미인지
안다

대체 역사

alternative history

신세카이 타이포 연구회는 시각적, 역사적, 전문적 관점에서 "오늘을 사는" 문자를
체험하고 새로운 가능성을 발굴, 검증, 개발하려는 목적으로 2011년 쓰카다 데쓰
야와 히데치카, 즉 다이니혼 타이포 조합(大日本タイポ組合)과 활자체 디자이너
오카자와 요시히데가 결성한 집단이다. '신세카이', 즉 '새로운 세상'이라는 이름은
이 연구 집단의 야심을 함축한다.

오카자와 요시히데는 1994년 활자체 디자인 스튜디오 지유고보(字游工房)에 입
사해 〈히라기노 패밀리〉, 〈유치쿠 미다시 민초〉, 〈히라기노 UD 패밀리〉 등의 개발에 참
여했다. 2009년 독자적 활자체 스튜디오 요코카쿠(ヨコカク)를 세운 그는 현재까지
〈고도모노지〉(こどものじ, 어린이 서체), 〈도로노지〉(どうろのじ, 도로 서체), 〈도토
노지〉(ドットのじ, 점 서체) 등을 발표했다. 히데치카와 쓰카다 데쓰야는 1993년
도쿄에서 실험적 타이포그래피 집단 다이니혼 타이포 조합을 결성한 후 문자를 즐
겁게 해체, 재조합, 재구성함으로써 새로운 타이포그래피 문자 개념을 개발해왔다.

신세카이 타이포 연구회의 실험작 〈가로쓰기 가나〉는 활자체 디자인의 '대체 역
사'에 해당한다. 또는 일본어 서체의 미래에 관한 SF적 상상이라고도 부를 만하다.

가로쓰기 가나

일본 문자는 본디 세로 방향으로 쓰였다. 그러나 오늘날은 컴퓨터 화면상 표현과 영
어 등 다른 언어와의 호환성 때문에 가로로―왼쪽에서 오른쪽으로―쓰이는 경우가
대부분이다. 가나 문자는 한자를 단순화해 만들어졌는데, 한자 역시 당시에는 세로
로 쓰였다. 그에 따라 문자 획은 세로로 움직이는 동세를 띠게 되었다. 그처럼 필연
적인 획 동세를 지닌 가나 문자가 왼쪽에서 오른쪽으로, 가로로 쓰인다. 가나가 탄생
한 당시에는 상상이나 할 수 있는 일이었을까?

여기에서 우리는 이렇게 묻고 싶다. 만약 가나 문자가 가로쓰기 문자로 진화한다
면 그 모습은 어떠할 것인가? 우리는 현대적 관점에서 가나의 역사를 다시 살펴봄으
로써 가로쓰기 전용 가나 문자의 형태를 발견해보려 한다. [신세카이 타이포 연구회]

Shinsekai Type Study Group was founded in 2011 by Tsukada Tetsuya and Hidechika, together known as the Dainippon Type Organization, and the type designer Okazawa Yoshihide. The goal has been to survey the kind of typography that is "living today," and to discover, examine and develop its unpredictable possibilities from graphic, historical and professional perspectives—hence the name, Shinsekai, meaning "new world."

Okazawa Yoshihide joined the type design studio Jiyu Kobo in 1994, and worked on various projects including *Hiragino Family*, *Yuchiku Midashi Mincho* and *Hiragino UD Family*. Having set up his own type foundry Yokokaku in 2009, he has released *Kodomonoji* (kid's type), *Doronoji* (road type) and *Dottonoji* (dot type). Hidechika and Tsukada Tetsuya set up the experimental typography group Dainippon Type Organization in 1993, and have been pursuing new ideas of typographic characters by playfully deconstructing, recombining and restructuring letterform.

Shinsekai Type Study Group's speculative project, *Horizontal Kana*, amounts to an "alternative history" of type design—or a sci-fi imagination of the future of the Japanese letterform.

Horizontal Kana

Japanese scripts were initially meant to be written vertically. Today, However, they mostly appear horizontally—from left to right—in order to represent on the computer screen as well as to combine with international languages such as English. *Kana* characters of Japanese scripts, in particular, were invented from simplified *kanji* (Chinese characters), which also used to be written vertically. Therefore, the strokes of each character show vertical movement. *Kana* characters containing such inevitable strokes are set horizontally from left to right—who could have imagined that when *kana* characters were born?

Here, we would like to pose a question: if *kana* characters are mutating into a new set of horizontal-written characters, what would they look like? We would like to discover new figures of *kana* especially for horizontal writing, reviewing the origin and history of *kana* from the perspective of its contemporary use. [Shinsekai Type Study Group]

자세한 정보
For further information, see:
http://shinsekai.type.org/horizontal_kana/ShinsekaiTSD2012_
 horizontalKana.pdf
http://youtu.be/coys__ujUko

신세카이 타이포 연구회(新世界タイポ研究会)
2011년 설립, 도쿄: 오카자와 요시히데(岡澤慶秀), 1970년생, 일본 /
히데치카(秀親), 1968년생, 일본 / 쓰카다 데쓰야(塚田哲也), 1971년생, 일본.

Shinsekai Type Study Group
Founded in 2011, Tokyo: Okazawa Yoshihide, b. 1970, Japan;
Hidechika, b. 1968, Japan; and Tsukada Tetsuya, b. 1971, Japan.

shinsekai.type.org

가로쓰기 가나
2012. 서체 개념.

Horizontal Kana
2012. Letterform concept.

A
왼쪽에서 오른쪽으로 가로쓰기가 진행했을 때 가능한 형태.

Letterforms potentially evolved from left-to-right horizontal writing.

B
왼쪽에서 오른쪽으로 가로쓰기가 진행했을 때, 흘림체 양식이 더욱 발달해
글자들이 서로 연결되는 모습.

Letterforms potentially evolved from left-to-right horizontal writing,
showing cursive and joined forms.

C

오른쪽에서 왼쪽으로 가로쓰기가 진행했을 때 가능한 형태.

Letterforms potentially evolved from right-to-left writing.

대화
dialogue

허하오는 베이징 중앙 미술학원(CAFA)에서 석사 학위를 받고, 현재 같은 학교에서 시각디자인 전공 주임교수로 재직 중이다. 2011년부터는 같은 학교 박사 과정에서 디자인 이론과 교육을 연구 중이다. 2000년대 초부터 그는 독립적으로 활동하며 도서 디자인 작업을 해왔다. 디자이너 단체에 가입하거나 특정 조류에 속한 적이 없는 그는 거의 언제나 외로운 장인처럼 홀로 작업하곤 했다. 그러나 이처럼 은둔자 같은 인상을 오해해서는 안 된다. 지난 10여 년 동안 허하오는 100여 권에 이르는 책을 만들어냈고, 그들은 아이웨이웨이, 린톈먀, 잔왕, 양푸둥, 쉬빙, 여진톈 등 중국 현대 미술가의 작업을 국제적으로 알리는 데 크게 이바지했기 때문이다.

허하오가 디자인한 책은 대부분—대형 공사 간행물이 아니라—적은 자원으로 만들어진 독립 출판물이라는 점이 중요하다. 그는 주어진 수단을 극대화하는 일에 지식과 기술을 쏟아붓곤 한다. 그렇기에 작업은 책의 내용과 의미에 집중되고, 디자이너는 편집자 기능을 겸하게 된다. 이러한 접근법은 중국 독립 문화 출판계에서 일정한 접근 방식을 형성하는 데 크게 이바지했다. 디자이너와 작가, 필자가 상호 이해를 바탕으로 동등하게 협력한다. 디자이너는 작업에 독자적인 통찰을 불어넣지만, 그 목적은 '디자인' 자체보다 내용을 살찌우는 데 있다. 그렇게 만들어진 작품은 개방적 대화의 결실을 구현하고, 이는 다시 문화 전반에 이바지한다.

'대화'는 허하오의 작업 전반에서 중요한 부분이지만, 그것이 동료와 나누는 담론만 뜻하지는 않는다. 거기에는 역사와 나누는 대화도 포함된다. 《신서잉 10년》은 1996년부터 1998년까지 베이징에서 사진가 류정(刘铮)과 룽룽(荣荣)이 함께 펴낸 《신서잉》(新摄影, 새로운 사진)을 기념해, 당시 간행된 네 호를 전부 복각해 담은 책이다. 여기에서 허하오의 디자인은 매우 섬세하다. 천 씌운 상자는 절제된 모습으로 원작을 기린다. 복각된 잡지는 생생하고 거친 에너지를 그대로 전한다. 부록의 디자인은 원래 잡지를 모방하지 않고, 오히려 진지한 회고에 어울리는 차분한 타이포그래피를 보여준다. 허하오가 학생이던 시기에 발간된 《신서잉》은 중국 현대 사진예술뿐 아니라 오늘날 허하오 자신이 몸담고 있는 독립 출판에서도 선구자로 꼽히는

잡지다. 그런 점에서 《신서잉 10년》은 허하오가 선배에게 경의를 표하면서 자신의 뿌리를 되새기는 작품으로도 볼 만하다.

He Hao earned his MFA from the China Central Academy of Fine Arts (CAFA), Beijing, where he is teaching currently. Since 2011, he has been studying design research and education in the doctoral program of the the same school. He has been working independently since the early 2000s, focusing on book design. He has never been affiliated with any professional organizations, and has almost always worked on his own, like a lone artisan. The hermit-like outward persona, however, can be misleading: He Hao has produced more than a hundred books during the past ten years, and they have played a significant role in communicating internationally the work of contemporary Chinese artists, including Ai Weiwei, Lin Tianmiao, Zhan Wang, Yang Fudong, Xu Bing and Ye Jintian.

It is important to note that most of the books He Hao designed were published independently—not by large government publishing houses—with limited resources. He would bring his knowledge and skills to make the most out of given means. This has necessitated—and indeed, justified—a focus on the content, the meaning of a work, with the designer functioning also as an editor. This practice has helped form a certain way of working in the increasingly active scene of Chinese independent cultural publishing: a designer and an artist or a writer work symbiotically on a project based on mutual understanding; a designer may bring his or her own insights to the project, not for the sake of "design" itself, but to contribute to the content; the resulting work will bear the virtue of the open dialogue, contributing in turn to the culture at large.

"Dialogue" is a key aspect in He Hao's body of work, but it does not only mean a discussion with his contemporaries: it also means a conversation with history. *New Photo: 10 Years* is a commemorative edition of *New Photo*, a "private collaborative journal" edited and published by the photographers Liu Zheng and Rong Rong in Beijing from 1996 to 1998. The edition presents facsimile reprints of all four issues of the seminal magazine in a carefully constructed box. Here, He Hao's treatment is very subtle. The cloth-covered box is respectful yet restrained. The reprinted issues are left to speak for themselves, with all the rough energy and vividness. The design of the supplement does not attempt to imitate the original journals: instead, it adopts a calm typography for the subject that deserves a serious retrospection. *New Photo* was published while He Hao was still a student. It was a forerunner not only of Chinese contemporary photography, but also of the kind of indepen-

dent publishing that He Hao himself is now part of. In this respect, *New Photo: 10 Years* can be seen as an homage to his precedents, as well as a valuable reminder of his own roots.

허하오(何浩)
1975년생, 중국.

He Hao
Born in 1975, China.

신서잉 10년
2007. 오프셋, 재봉, 표지, 천 씌운 상자. 전 4권에 부록. 전체 32×45×5.8 cm.
베이징: 싼잉탕 사진예술센터(三影堂摄影艺术中心).

New Photo: 10 Years
2007. Offset lithography, stitched, covers, cased in cloth. Four volumes
and a supplement. 32×45×5.8 cm overall. Beijing: Three Shadows
Photography Art Centre.

독해
decoding

───────
유니코드는 전 세계 문자 대부분을 디지털로 표상하고 처리할 수 있는 산업 표준이다. 세계 각국의 주요 컴퓨터 소프트웨어, 하드웨어 기업을 회원으로 하는 비영리 단체 유니코드 컨소시엄이 제정하며, 호환되지 않는 기존 문자 인코딩의 한계를 극복하는 데 목적을 둔다. 요컨대 유니코드의 궁극적 목표는 활어와 사어를 막론하고 전 세계 모든 언어의 모든 문자를 포괄하는 단일 통합 문자 집합을 수립하는 것이다. 1991년에 발표된 첫 유니코드는 24개 문자 체계를 위한 7161개 문자를 포함한다. 최신 버전(6.2)은 2012년에 발표되었으며, 100개 문자 체계를 위한 11만 182개 문자를 포함한다.

　디코드유니코드는 유니코드와 관련된 정보와 지식을 타이포그래피 디자이너와 공학자, 언어학자 사이에서 소통하려는 목적에 따라, 2004년 마인츠 공과대학 커뮤니케이션 디자인과에서 시작한 연구 프로젝트다. 독일 교육부의 지원을 받아 "디지털 활자 문화를 위한 독립적 플랫폼"으로 구상된 디코드유니코드는 마인츠 공과대학의 타이포그래피 교수 요하네스 베르거하우젠이 이끌었고, 디자이너 시리 포아랑안 등이 주요 연구자로 참여했다. 2005년 문을 연 웹사이트는 주요 국제 디자인상을 받았고, 기본 다국어 평면의 유니코드 문자를 한눈에 보여주는 포스터 역시 널리 인정받았다. 2011년에는 페어라크 헤르만 슈미트를 통해 단행본 《디코드유니코드: 세계 문자》를 펴내기도 했다. 2012년에는 유니코드 6.0의 10만 9242개 문자가 전부 '출연'하는 비디오가 인터넷에 공개되었다.

　유니코드는 문자의 역사에서 중요 기점을 표시한다. 마침내 전 세계 모든 언어를 단일 체계로 표상할 수 있게 되었기 때문이다. 문자 체계, 플랫폼, 프로그램을 막론하고, 유니코드 문자에는 각기 고유 번호가 할당된다. 그런 점에서 유니코드는 디지털 논리가 궁극적으로 확장된 또 하나의 사례에 불과할지도 모른다. 그러나 거기에는 문화적 의미도 있다. 유니코드가 서로 다른 문자 사이의 공간적(어떤 문자 체계라도 동등하게 접근하고 처리할 수 있다), 시간적(이집트 상형문자처럼 '사라진' 문자도 표상할 수 있다) 거리를 좁혀줌에 따라, 디자이너나 저술가는 외래 문자를 훨

씬 가까이 느낄 수 있게 되었다. 그 직접적 결과로 다양한 언어와 전문적 조판을 뒷
받침해주는 '글로벌' 폰트가 출현하기도 했지만, 글쓰기와 타이포그래피에 더욱 근
본적 변형 효과를 가할 만한 작업도 머지않아 출현할 것이다. 베르거하우젠 자신은
"디자이너든 서체 전문가든 학생이든 자신이 쓰는 문자 너머를 살펴볼 필요가 있다.
그러면 여러 면에서 디자인 이론에 대해 질문하게 될 것"이라고 제안한다.

요하네스 베르거하우젠은 뒤셀도르프 공과대학에서 커뮤니케이션 디자인을 전공
했다. 1993년에서 2000년까지 프랑스 파리에서 디자이너로 활동했고, 1998년에
는 프랑스 국립 조형예술 센터의 지원을 받아 ASCII 코드에 관한 연구 프로젝트를
수행했다. 2007년부터 설형문자 디지털 폰트를 개발해왔고, 2012년에는 독일연
방공화국 디자인 어워드 금상을 수상했다. 현재 마인츠 공과대학에서 타이포그래
피 교수로 재직 중이다.

Unicode is an industrial standard for digitally representing and handling
text in most of the world's writing systems. Coordinated by the Uni-
code Consortium, a non-profit organization whose members include
most of the major computer software and hardware companies around
the world, the aim of the Unicode has been to surpass the limitations
of character encodings specific to local languages, which were mostly
incompatible with each other. In short, one of the ultimate ambitions
of the Unicode is to develop a unified standard set that encompasses
all the characters of all the languages of the world, living or dead. The
first version of the Unicode was released in 1991, which included 7,161
characters for 24 scripts. The latest version (6.2) published in 2012 can
represent 110,182 characters for 100 scripts.

Decodeunicode was launched in 2004 by the department of commu-
nication design at the Fachhochschule Mainz, as a research project to
communicate the facts and knowledges related to Unicode among ty-
pographic designers as well as engineers and linguists. An "indepen-
dent platform for digital type culture," Decodeunicode has been led by
Johannes Bergerhausen, a professor of typography at the Fachhoch-
schule, in close collaboration with the designer Siri Poarangan, with
initial support from the German Ministry of Education and Research
(BMBF). The public website devoted to the project (www.decodeuni-
code.org) went online in 2005, and has won many international awards.
So has the poster displaying all the Unicode characters of the Basic
Multilingual Plane. The book *Decodeunicode: Die Schriftzeichen der
Welt* was published in 2011 by Verlag Hermann Schmidt, Mainz. The
video "starring" all the 109,242 characters of the Unicode Standard 6.0
was released online in 2012.

The development of Unicode marks a significant point in the history of writing: finally, every language in the world can be represented with a single system. Regardless of the script, the platform or the program, a Unicode character is assigned a unique numeric code. In this sense, Unicode may simply be another ultimate extension of the digital logic of computing. There is, however, a cultural implication in this development, too. Now a designer or a writer can feel much closer to foreign scripts, as Unicode is collapsing the distance both in space (any number of different scripts can be accessed and processed) and time (it can represent "lost" writing systems, such as hieroglyphs). An immediate result has been the emergence of "global" fonts, which provide glyph sets large enough to handle many different languages and specialist settings. More fundamental and truly transformative effects on writing and typography have yet to come. Bergerhausen himself has suggested: "Looking beyond their own Latin alphabet can be useful for designers, typographers and students alike, as it leads to many questions about the theory of design."

Johannes Bergerhausen studied communication design at the Fachhochschule Düsseldorf. From 1993 to 2000, he lived in Paris and worked for Gérard Paris-Clavel and Pierre Bernard, the founders of Grapus. In 1998, he conducted a research project on ASCII, with a grant from the Centre National des Arts Plastiques. Since 2007, he has been working on a digital cuneiform font. In 2012, he was awarded with the Design Award of the Federal Republic of Germany in Gold. Currently he is professor of typography at the Fachhochschule Mainz.

요하네스 베르거하우젠
1965년생, 독일.

Johannes Bergerhausen
Born in 1965, Germany.

decodeunicode.org

디코드유니코드
2012. 단채널 비디오. 2시간 31분. 편집: 요하네스 베르거하우젠.
디자인: 다니엘 베커, 요하네스 베르거하우젠, 시리 포아랑안, 벤첼 슈핑글러,
마티아스 볼린. 소프트웨어 개발: 다니엘 베커. 음향: 롤란트 코르크.

Decodeunicode
2012. Single-channel video. 2 hours 31 minutes. Edited by
Johannes Bergerhausen. Designed by Daniel A. Becker, Johannes
Bergerhausen, Siri Poarangan, Wenzel S. Spingler, and Mathias Wollin.
Software developed by Daniel A. Becker. Sound by Roland Korg.

A

U+0041
BASIC LATIN

ݢ

U+0620
ARABIC

झ

U+0977
DEVANAGARI

鸚

U+9E1A
CJK UNIFIED IDEOGRAPHS

U+B7AB
HANGUL SYLLABLES

U+A37E
YI SYLLABLES

U+12000
CUNEIFORM

U+131D6
EGYPTIAN HIEROGLYPHS

디제잉
DJing

───────
창작자의 말에 따르면 《커버》는 단순한 잡지가 아니다. 오히려 분류하기 어려운 형태로 실현된 그래픽 저작물에 가깝다. 《커버》는 호마다 집단 지성, 사회운동, 시와 이미지 등 다른 주제를 다룬다. 그리고 해당 주제에 따라 완전히 다른 형태로 발행된다. 창간호는 크기가 조금씩 다른 '읽을거리'로 구성되어 "탈중심화한 온라인 글 읽기 풍경"을 탐구한다. 2호를 이루는 '신문' 네 부는 월가 점령 운동과 네빌 브로디의 《반디자인 페스티벌》, 《신문은 죽었다》 전시, 〈중요한 일 먼저〉 선언문 등을 다룬다. 3호는 크기가 다양한 인쇄물이 판지 상자에 담긴 형태로 출간되었고, "시와 이미지의 관계, .txt와 .jpg의 관계는 무엇인가?" 같은 질문을 살핀다. 특집호로 출간된 '커버 리포트'는 제목 그대로 잡지 표지를 집중 취재한다.

　디자이너 루타오가 밝힌 대로, 이 종이 잡지에는 포스트-웹 2.0 감수성이 배어 있다. 조밀하게 쌓인 레이어, 어지러울 정도로 다양한 코드와 포맷을 서로 다른 문화와 시대에서 '샘플링'해 조밀한 암시와 참조의 그물로 엮어내는 모습이 그렇다. 이처럼 겉으로 드러나는 극대주의는 또한 잡지의 야심을 반영하기도 한다. "오늘날의 텍스트와 이미지를 재배열하고 재구성하며, 그래픽 코드를 해독하고 창출한다"는 야심이다.

　《커버》의 접근법에서 현대 디제잉 방법론이 떠오른다면, 미술 평론가 니콜라 부리오가 《포스트프로덕션》(2001)에서 내세운 주장을 돌이켜봐야 한다. "디제이와 프로그래머라는 쌍둥이가 새로이 만들어내는 문화 풍경에서는 독창성(무엇인가의 기원이 됨)이나 심지어 창조(무에서 유를 만들어냄) 같은 개념도 서서히 흐려진다. 디제이와 프로그래머는 모두 문화적 산물을 선택하고 새로운 맥락에 삽입하는 일을 한다." 《커버》는 포스트프로덕션 디제이로 기능하는 오늘날의 그래픽 저자를 예증한다.

《커버》는 루타오가 항저우에 설립한 스튜디오 디자인 유나이티드(DU)가 편집하고 디자인하는 잡지다. DU는 브랜딩과 시각적 마케팅, 독립 출판, 정보 디자인과 편집 디자인 등 다양한 부문에서 활동하고 있다. 《커버》 창간호는 2011년에 나왔다.

According to its creators, *Cover* is not only a magazine: it is a medium for graphic authorship, often realized in a form that defies easy classification. Each issue is devoted to a specific theme: collective intelligence, social and political movements, or poetry and imagery. A radically different format is adopted each time, reflecting the given theme. Three "readers" of slightly differing sizes make up the first issue on "the decentralized landscape of online reading." Four volumes of tabloid-sized "newspaper" cover the topics of the second issue, from the Occupy movement and Neville Brody's *Anti-Design Festival*, to the *Newspaper is Dead* exhibition and the First Things First manifesto. Variously sized printed matters are packed in a cardboard box as the third issue, which asks such questions as "What is the relation between poetry and imagery, between .txt and .jpg?" The Cover Report special issue on, literally, cover designs of various magazines.

As the designer Lu Tao proclaims, there is certainly a post-web 2.0 sensibility to this printed magazine, to its densely layered visual elements, dizzyingly diverse codes and formats "sampled" from different cultures and times, interwoven as a mesh of allusions and references. But the apparent maximalism also speaks of its ambition, which is "reconfiguration and reconstruction of contemporary texts and images, decoding and recreation of graphic codes."

If the approaches of *Cover* sound like a method of contemporary DJs, one might as well consult the art critic Nicolas Bourriaud, who in *Postproduction* (2001) argued: "Notions of originality (being at the origin of) and even of creation (making something from nothing) are slowly blurred in this new cultural landscape marked by the twin figures of the DJ and the programmer, both of whom have the task of selecting cultural objects and inserting them into new contexts." *Cover* is a prime example of contemporary graphic authorship as postproduction DJing.

Cover is edited and designed by Design United (DU), a studio founded by Lu Tao in Hangzhou. DU is involved in various areas from branding and visual marketing to independent publishing, information and editorial design. DU launched *Cover* in 2011.

디자인 유나이티드
2008년 설립, 항저우: 루타오(卢涛) 대표, 1974년생, 중국.

Design United
Founded in 2008, Hangzhou: Lu Tao, principal, b. 1974, China.

커버
2011-현재.

Cover
2011-ongoing.

1호 '집단 지성': 2011. 3책 1권. 오프셋, 중철에 표지. 18×26.5×0.3 cm, 44쪽 / 19×26.5×0.4 cm, 60쪽 / 20×26.5×0.4 cm, 72쪽.

No. 1, "Collective Intelligence": 2011. Three volumes. Offset lithography, saddle-stitched with covers. 18×26.5×0.3 cm, 44 pp; 19×26.5×0.4 cm, 60 pp; 20×26.5×0.4 cm, 72 pp.

2호 '마지막 신문': 2012. 4책 1권, 별책. 오프셋, 접지, 삽지, 띠지.
29×42×0.2 cm, 24쪽 / 29×42×0.2 cm, 32쪽 / 29×42×0.2 cm, 20쪽 /
29×42×0.2 cm, 24쪽 / 별책. 14.5×21×0.1 cm, 24쪽.

No. 2, "The Last Newspaper": 2012. Four volumes and a supplement.
Offset lithography, collated, inserts, outsert. 29×42×0.2 cm, 24 pp;
29×42×0.2 cm, 32 pp; 29×42×0.2 cm, 20 pp; 29×42×0.2 cm, 24 pp;
supplement, 14.5×21×0.1 cm, 24 pp.

3호 '시각×시가': 2012. 다양한 크기의 인쇄물. 오프셋, 실크스크린, 판지 상자.
전체 24×35×2 cm.

No. 3, "Visual×Poetry": 2012. Various multiples. Offset lithography,
silkscreen, cardboard box. 24 x 35 x 2 cm overall.

특집호 '커버 리포트': 2013. 오프셋, 고무줄 철에 표지, 삽지. 16×24×0.5 cm, 88쪽.

Special edition, "Cover Report": 2013. Offset lithography, loosely bound with rubber ring, insert, outsert. 16×24×0.5 cm, 88 pp.

말
Words

런던에서 활동하는 타이포그래퍼 윌 홀더는 구술성과 대화를 도구이자 모델로 삼아 작가들과 함께 책을 만든다. 그 작업에서 의뢰인, 저자, 주인공, 편집자, 디자이너 역할은 즉흥적으로 나뉘거나 공유되곤 한다. 예술에서 읽고 쓰기의 위상을 다루는 저널 《F. R. 데이비드》를 편집하고 디자인해왔으며, 2009년 5월에는 런던 ICA에서 구어와 책임을 주제로 한 전시회 겸 이벤트 프로그램 《토크쇼》를 공동 기획하기도 했다. 미국 작곡가 로버트 애슐리의 전기를 공동 편집하는 한편, 윌리엄 모리스의 《유토피아 소식》(1876)을 2135년 배경으로 개작해 디자인 교육과 실무 지침으로 연재하는 작업을 진행 중이다.

F. R. 데이비드
이 글은 《더 매거진: 사려 깊은 해외 잡지 19》(파주: 지콜론북, 2013)에 실린 윌 홀더의 인터뷰 일부를 저작권자의 허락을 받아 발췌한 것이다. 글쓴이와 엮은이가 조금씩 수정하고 최성민이 한국어로 다시 옮겼다.

[《F. R. 데이비드》의 배경에 관해]
《F. R. 데이비드》 저널은 발행처인 더 아펄 아트 센터의 시각 아이덴티티로 출발했다. 안 데메이스터르 관장이 취임하면서 내가 그곳의 그래픽 디자인을 맡게 되었다. 새 아이덴티티는 간단히 말해 "사과(appel)의 A", 또는 끊임없이 의미와 가치를 생산하는 이미지와 텍스트의 상동곡(常動曲)으로 요약할 수 있다. 그로써 나는 문학과 미술을 밀접히 파악하던 신임 관장을 반영하고, 단일한 천재 저자로서 미술가 개념을 표상함과 동시에, 미술 작품을 둘러싼 글쓰기 (여기에는 보도 자료, 행정 문서, 언론 기사 등도 포함된다) 역시 미술관 '아이덴티티'의 일부로 '디자인'되어야 한다는 인식을 높이려 했다. 그러나 그런 작업이 '그래픽' 디자이너 손으로 이루어지는 일은 드물다. 내가 할 수 있는 일은 읽고 쓰기에서 어떤 감수성을 기르고 퍼뜨리는 프로그램을 수립하는 것뿐이었다. 나는 일정한 모범을 세움으로써 글쓰기의 잠재성을 넓히고자 했다. 더 아펄이 내 뜻을 지지해주긴 했지만, 실제로 읽히고 쓰인 아

이덴티티에 그런 생각이 크게 반영된 것 같지는 않다. 지금도 그렇지만 그때도 나는 이상주의자였던 모양이다.

[디자인과 편집에 관해]

디자인도 중요하긴 하지만, 나는 처음부터 간단한 타이포그래피 규칙을 세우고 따름으로써 편집에 더 많은 시간을 할애하려 했다. 세부적으로는 더 아펄의 과거* 아이덴티티가 확장된 부분이 많다. 표지에 사과의 빨강, 초록, 검정 잉크만 쓰고, 엽서용 종이에서 광택이 없는 면에 겉표지를 찍는 것(보통 이미지는 매끄러운 면에, 텍스트는 거친 면에 찍는 관습을 뒤집은 것이다)이 한 예다. 글 도입부에 다양한 전통적 '머리글자'를 쓰는 기법은 이미지와 텍스트의 경계를 건드리는 전략을 이어간다. 이 기법은 짧은 시처럼 본문 자체가 이미지가 되는 글에서 가장 두드러진다. 비슷한 전략이 표지에도 적용된다. 호마다 책등에는 글자가 하나씩 찍히는데, 순서대로 늘어놓으면 글자들이 연결되어 'F. R. DAVID WORDS DON'T COME EASY'라는 문장을 이루게 된다. (최근 호에는 'WORDS'의 'D'가 찍혀 있다.) 사람들이 책꽂이에서 책등에 적힌 머리글자를 보며 어떤 상상을 해보았으면 하는 바람에서 시작한 일이다. 예컨대 2013년 봄호는 네 가지 다른 표지로 나왔고, 책등에는 'R'자가 찍혔다. '그녀가 아는 것이라곤 장미는 장미이고 장미이고 장미라는 사실뿐이라고 생각하는가?'라는 뜻을 품은 글자다. 그리고 책갈피에 차례를 적은 것은 지금 생각하기에도 기발했다. 특허를 냈어야 하는 건데!

 편집에서 가장 중요한 점은 글 읽는 조건과 그 글이 편집자로서 내 마음속에서 발휘하는 효과를 재현하는 데 있다. 그런 점에서, 즉 글 읽는 조건을 관리하는 측면에서 글의 순서는 중요하다. 그러나 게재 순서를 제외하면 글을 선택하는 기준은 간단히 설명하기가 어렵다. 호별 '주제' 역시 상당히 많은 글을 읽은 다음에야 비로소 떠오르곤 한다. 나는 읽을 책 몇 권을 염두에 두고 도서관에 가곤 한다. 그렇게 몇 권을 읽다 보면 다른 책도 읽게 되고, 그러다 보면 며칠이고 그곳에서 책만 읽으며 시간을 보내게 된다. 그 기쁨을 재현하는 일 말고도 매우 인간적인 생각이 얼마간 있다. 글 읽기와 마찬가지로 그런 생각 역시 보편적으로 이해할 수 있다. 다시 말해—나는 활자 조판과 글쓰기를 거의 구분하지 않는데—그것도 디자인이다. 생각은 '어떻게' 공통된 앎으로 조형되는가? 디자인은 생각을 글로 표현하는 작업이다. 언어는 작가나 디자이너뿐 아니라 모든 사람이 같은 목적에서 같은 수단으로 생산하는 질료다. 누구나 여러 직업의 상호 의존성을 유지하며 읽고 쓰고 말한다. 내 임무는 언어 소통의 '공예'를 발전시킬 만한 읽기, 배우기, 나누기, 펴내기 조건을 정립하고, 함께 타인의 작업을 생산하는 사람들 사이에서 실용적 역할을 해내는 데 있다.

[과정에 관해]

타이포그래피는 '언어를 조직화하는 일'이라는 정의에 따라, 나는 《F. R. 데이비드》

에서 읽고 쓰기를 관리하고 디자인한다. 그러나 학술적이거나 가설적인 작업은 아니다. 생각을 나누는 과정에서 생각 자체가 변하고 진화하는 과정을 보여줄 뿐, 학술 논문처럼 정해진 규칙을 따르지는 않는다. 내가 《F. R. 데이비드》를 굳이 '저널'['학술지' 외에 '일기'라는 뜻도 있다. ─옮긴이]이라고 부르는 데는, 내가 나날이 읽는 과정을 기록함으로써 읽고 쓰기에 관한 나 자신의 인식과 이해를 그때그때 다듬어지는 대로 전파하려는 목적이 있다. (때로는 지난 6년에 걸쳐 천천히 쌓인 과정을 생략하고 이제 처음 《F. R. 데이비드》를 접한 독자가 혼란을 느끼지는 않을지 염려되기도 한다.) '나날이'라는 말은 도서관은 물론 어떤 상황에서든, 언제든 읽기가 이루어진다는 사실, 그리고 어떤 생각이 도서관 책에서 빵 제조법이나 대중가요(《F. R. 데이비드》의 좌우명 '말은 쉽게 나오지 않는다'는 1980년대 팝송 가사[가수 F. R. 데이비드의 〈워즈(Words)〉라는 곡을 말한다. ─옮긴이]에서 따온 것이다)나 가구로 변형되었다가 다시 한 편의 시로 변형되는 과정 모두가 삶을 이룬다는 사실을 시사한다. 《F. R. 데이비드》는 생각의 생기를 기록하는 매체다. [윌 홀더]

*내가 더 아펄의 그래픽 디자인에서 손을 뗀 지 2년이 넘었다는 사실을 강조해야겠다. 지금은 내가 만든 'A' 대신 더 화려하고 이미지에 중심을 둔 아이덴티티가 쓰인다.

The London-based typographer Will Holder makes publications with artists, using orality and conversation as tool and model for publishing conditions—whereby roles of commissioner, author, subject, editor, and designer are improvised and shared. Holder is editor of *F. R. David*, a journal concerned with reading and writing in the arts. In May 2009 he co-curated *TalkShow* at the ICA, London: an exhibition/events programme dealing with speech and accountability. He is co-editing a biography of American composer Robert Ashley, for four or more voices; and rewriting William Morris' *News from Nowhere* (1876) into a serially published guide for design education and practise—set in 2135.

F. R. David

The following text is based on Will Holder's interview for *The Magazine* (Paju: G-Colon Book, 2013). The original text has been slightly amended both by the author and the editors.

[About the background of *F. R. David*]
The journal was seen as part of the visual identity of De Appel Arts Centre, its publisher. When Ann Demeester took over as director, I began to produce the Centre's communication. Besides wishing to represent Ann's affinity between literature and the arts, and the idea of the artist

as singular author-genius, the identity (simply: "A is for apple"—or the "perpetuum mobile" between image/text that produces an ongoing, infinite adjustment of meaning and value) hoped to indicate that the writing produced around artworks (including press releases, administration, journalism etc.) were an equally "designed" part of the "identity" of an institution—yet usually not in the hands of the "graphic" designer. The best one can do is aim to set up a programme that fosters and distributes a sensitivity to reading and writing. My aim was to broaden the potential of that writing, by example. Though De Appel has supported me in this, I don't think it had much real resonance with their own—written and read—identity. This was and is my idealism, I suppose.

[About the designing and editing]

From the point of view of design, though not unimportant, a simple set of typographic rules were set up from the start, and followed in detail until today, enabling more time for involvement with the editorial. Many of the details are an extension of De Appel's old* identity, such as the covers being printed in the apple's red, green and black, on the matte side of a two-sided postcard stock (alluding to images usually being printed on the glossy side, text on matte side). The play between image and text still plays out in the varying use of the traditional "initial" at the beginning of a chapter—most successful when text (short poems) becomes an image. This also plays out on the cover: each issue has a letter on the spine, spelling out F.R.DAVID WORDS DON'T COME EASY (currently at the "D" of "WORDS"). Each letter is represented on the cover, in the hope that if one sees the spine-letter in the bookcase, a mental image of the cover may be produced (e.g., "R" is for "Do we suppose that all she knows is that a rose is a rose is a rose is a rose" of the four covers for the Spring 2013 issue). One thing that still pleases me is the contents on the bookmark (I should patent this!).

Editorially: the most important aspect is a responsibility to reproduce the conditions of reading, and the effect that a certain text produced in me, the editor. The sequence and ordering of writings is an important factor in setting this up (i.e., managing the conditions of reading). Besides that it is difficult to say how I choose certain works, and usually an issue's "theme" doesn't surface until I'm far into reading as much material as I can. Usually, I go to the British Library with a few books waiting for me. These lead to others, and I can sit there for days enjoying reading. Besides reproducing this pleasure, I am conscious of a set of very human ideas, which, like reading may be universally understood. Again—there is a very fine line between typesetting and writing, for me—this is an expression of design: i.e., *how* those ideas are

formed towards a shared understanding. The design lies in their textual expression. Language is a material that not only artists and designers, but those from all walks of life produce for the same means and ends: we all read, write, speak and listen to maintain the interdependency of our various occupations. My work is to set up conditions for reading/learning/exchange/publishing that enable something like a "craft" of a linguistic exchange to develop, and pragmatically play out between those who co-produce the work of others.

[About the process of making]
Following a definition of typography as "the organisation of language," *F. R. David* enables me to practice the management and design of reading and writing—without this becoming an academic or hypothetical pursuit. What this means is that the journal is a demonstration of how ideas adapt and evolve as they are exchanged. These ideas do not follow a fixed protocol—as academic writing might, for example. In this sense, my calling it a "journal" has more in common with it being a record of what I read, from day to day, in an attempt at transferring an increasingly refined understanding of reading and writing (sometimes I worry that people who only come to *F. R. David* now, will be lost without the slow build-up in the past six years). "From day to day" means that this takes place in all kinds of situations, but at all times—not just the library, of course—and the transformation of an idea from a library book to a recipe for bread to a pop song (*F. R. David*'s motto, "Words, Don't come easy," is from the eighties hit) to a piece of furniture back to a poem, is all part of life. *F. R. David* is a record of the liveliness of ideas.
[Will Holder]

*I must stress that I have not been the designer at De Appel for more than two years, and my "A" has been pushed aside for a more spectacular, image-driven form of communication.

윌 홀더
1969년생, 영국.

Will Holder
Born in 1969, UK.

1호 '아직은…': 2007 봄. 12×19×1.4 cm, 200쪽. 공동 편집: 팔케 피사노.

Issue 1, "As Yet…": Spring 2007. 12×19×1.4 cm, 200 pp. Edited with Falke Pisano.

2호 '의도의 책': 2008 여름. 12×19×1.7 cm, 244쪽.
공동 편집: 율리아 악세노바, 제시 버치, 안 데메이스터르, 에드나 판 다윈,
새라 파라, 인티 게레로, 비르기니야 야누스케비추테, 디터르 룰스트라터.

Issue 2, "The Book of Intentions": Summer 2008. 12×19×1.7 cm,
244 pp. Edited with Yulia Aksenova, Jesse Birch, Ann Demeester,
Edna van Duyn, Sarah Farrar, Inti Guerrero, Virginija Januskeviciute
and Dieter Roelstraete.

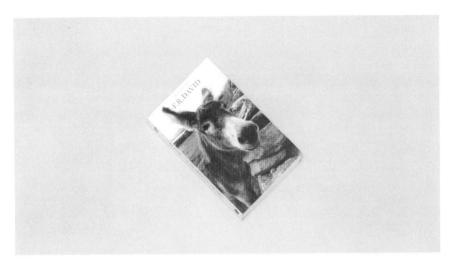

3호 'A는 "orses"(Asses 아님)': 2008 가을. 12×19×1.6 cm, 216쪽.
공동 편집: 안 데메이스터르, 디터르 룰스트라터.

Issue 3, "A is for 'Orses' (Not for Asses)": Autumn 2008.
12×19×1.6 cm, 216 pp. Edited with Ann Demeester and
Dieter Roelstraete.

4호 '것과 헛소리': 2008 겨울. 12×19×1.7 cm, 240쪽.
공동 편집: 안 데메이스터르, 디터르 룰스트라터.

Issue 4, "Stuff and Nonsense": Winter 2008. 12×19×1.7 cm, 240 pp.
Edited with Ann Demeester and Dieter Roelstraete.

5호 '당신만 간직하세요': 2009 봄. 12×19×1.7 cm, 240쪽.
공동 편집: 안 데메이스터르, 디터르 룰스트라터.

Issue 5, "Keep It to Yourself": Spring 2009. 12×19×1.7 cm, 240 pp.
Edited with Ann Demeester and Dieter Roelstraete.

6호 '바보 서문': 2009 겨울. 12×19×0.6 cm, 80쪽.
공동 편집: 안 데메이스터르, 디터르 룰스트라터르, 에드나 판 다윈.

Issue 6, "Iditorial": Winter 2009. 12×19×0.6 cm, 80 pp.
Edited with Ann Demeester, Dieter Roelstraete and Edna van Duyn.

7호 '사랑을 담아': 2010 여름. 12×19×1.3 cm, 176쪽.

Issue 7, "With Love": Summer 2010. 12×19×1.3 cm, 176 pp.

8호 '회전 주기': 2011 여름. 12×19×1.5 cm, 208쪽. 공동 편집: 마이크 스펄링어.

Issue 8, "Spin Cycle": Summer 2011. 12×19×1.5 cm, 208 pp. Edited with Mike Sperlinger.

9호 '물론, 새로운 것은 아니다': 2012 봄. 12×19×1.7 cm, 240쪽.

Issue 9, "This is Not New, of Course": Spring 2012. 12×19×1.7 cm, 240 pp.

10호 '미혼모를 위한⋯': 2013 봄. 12×19×1.5 cm, 208쪽.

Issue 10, "… for Single Mothers": Spring 2013. 12×19×1.5 cm, 208 pp.

명상
meditation

그래픽 디자이너 겸 교육자인 판친은 닝보 성시 직업 기술학원 예술학원 원장, 닝보 국제 디자인 비엔날레(IGDB) 창립 큐레이터, 닝보 그래픽 디자인 협회 회장, 저장성 창의 디자인 협회 부이사장으로 재직 중이다. 지난 20년 동안 그는 서체 디자인과 편집 디자인, 브랜딩 등 다양한 영역에서 왕성하게 활동해왔다. 그의 작품은 20여 국가에서 전시되었으며, 2000년 프랑스에서 열린 《인간을 위한 물》 국제 포스터 디자인 공모전, 질리나 국제 환경 포스터 트리엔날레, 화동 디자인 상, 중국 국제 그래픽 디자인 공모전, 중국 그래픽 디자인 등 여러 공모전에서 수상했다.

판친이 한자에 접근하는 방식은 구조와 역사에 민감하면서도 교리에 얽매이지 않는 특징을 보인다. 2005년부터 그는 한자를 모듈화하는 방식을 연구해왔다. 그가 개발한 '활자' 체계는 수만 개에 달하는 단자(單字)가 아니라 불과 20여 개로 환원된 최소 형태 단위에 기초한다. 그러한 단위가 조합되어 만들어지는 한자는 전통적 서예나 타이포그래피 관점에서는 거칠어 보여도 에너지와 호기심으로 생동하는 모습을 보인다. 더욱이 가독성도 떨어지지 않는다.

지난 몇 년 동안 그는 그러한 체계를 바탕으로 수식 조판용 활자 도장을 제작해 《금강경》 모노프린트를 만들어왔다. 불교 경전 《금강경》에는 6,900자에 이르는 한자가 포함되어 있다. 매일 그는 하루의 명상 일과를 실천하듯 거대한 한지 두루마리에 푸른 잉크로 조금씩 글을 찍어나간다. 그는 이 작업이 디자인이나 예술은커녕 심미성과도 무관하다고 말한다. 오히려 《금강경》은 복잡한 사회 현실이나 끊임없는 욕망에서 벗어나려는 정신적 수행에 가깝다.

때로는 실수도 하고 오자도 찍어내지만, 바로잡지 않는다. 실수도 삶의 일부다. 시간이 흐르면 그의 기교도 늘어날 것이고 판단력도 더욱 섬세해질 것이며, 그에 따라 글자 형태도 조금씩 달라질 것이다. 정말 긴 시간이 흐른 뒤에 보면, 그 체계는 전혀 새로운 중국 문자로 진화해 있을지도 모를 일이다.

Pan Qin is a graphic designer and educator. He is dean of the School of Arts, Ningbo City College of Vocational Technology and founding curator

of the Ningbo International Design Biennial (IGDB). He is also serving as chairman of the Ningbo Graphic Designers Association, and deputy president of the Zhejiang Association of Creative Design. He has been active during the last twenty years in variety of areas, including letterform design, editorial design and branding. His work has been exhibited in more than twenty countries, and recognized by many awards including the grand prix at the international poster design competition *Water for Human Kind* in 2000, France; the 9th International Triennial of Environment Posters in Zilina Slovakia; the Huadong Design Award; the Chinese International Graphic Design Competition; and Graphic Design in China.

Pan Qin's approach to the Chinese writing system is characterized by his sensitive yet unorthodox understanding of its structure and history. Since 2005, he has been studying the modularity of *hanzi*, the Chinese characters. The "type" system he developed is based on a small number of elemental graphic units rather than the tens of thousands of full characters. The resulting, composite characters may be visually crude by the standard of traditional calligraphers or typographers, but they are full of wild energy and curiosity. And they are still legible.

During the past few years, he has applied this system with the printing blocks he made for hand composition to create a monoprint version of *Diamond Sutra*, a Buddhist scripture containing 6,900 Chinese characters. Everyday he adds to the text in blue ink on an enormous scroll of rice paper, taking it as a daily meditative duty. According to Pan Qin, the project has nothing to do with design or art, nor even with any sense of beauty: it is mainly for his own spiritual practice, free from complicated social realities or restless desires.

Every now and then he will make mistakes and compose the wrong characters, but they are left without correction—mistakes are a part of life, too. In time, his skill will improve and his judgment will be further refined, inducing subtle changes in the letterforms. In the very long run—who knows—the system may evolve beyond recognition to an entirely new set of Chinese characters.

판친(潘沁)
1967년생, 중국.

Pan Qin
Born in 1967, China.

금강경
2005–현재. 종이에 모노프린트. 크기 가변.

Diamond Sutra
2005–ongoing. Monoprint on paper. Dimensions variable.

菩提於意

菩薩不住相而施其

提菩薩應如是布施

色布施不住聲香

惟於法應無所住

몽타주
montage

판형은 A4보다 조금 크다. 표지에는 머리에 검정 비닐봉지를 뒤집어쓴 남자의 다소
심란한 사진이 실려 있다. 혹시 죽은 사람일까? 엉뚱한 질문이 아니다. 문제의 책은
메리 셸리의 《프랑켄슈타인》이기 때문이다.
 표지를 펼치면 본문 지면을 포개 접은 모서리가 드러난다. 표지 책등이 지면에 접
착되지 않고, 뒤표지 일부만 마지막 지면에 불안하게 붙어 있기 때문이다. 그런데 지
면이 실로 묶이지 않았다. 중철한 소책자 여러 권이 풀로 한데 붙은 구조다. 스테이
플러로 박은 책—프랑켄슈타인 남작이 자신의 괴물을 창조할 때 그런 스테이플러
를 쓰지 않았을까 상상해본다. 소책자 가운데 한 부는 나머지와 엮이지 않고 앞표지
에 붙어 있다. 따라서 표지를 펼치면 책등을 실제로 '꺾고' 책을 둘로 쪼개는 느낌이
든다. 그러나 이러한 분리에는 더 평범한 이유가 있다. 앞표지에 붙은 부분에는 독일
어 번역이 실렸고, 나머지에는 영어 원문이 고스란히 실렸다. 모두 명쾌한 산세리프
체 활자를 사용했다.
 그리고 사진이 있다. 여러 사진은 의학이나 과학과 연관되어 보인다. 일부는 현대
적이지만, 더러는 은밀한 기록 보관소에서 훔쳐온 듯한 사진도 있다. 때로는 사진이
본문과 병치되거나 중첩되지만, 어떤 지면에서는 본문 없이 이어지기도 한다. 사진
에는 기괴한 느낌이 있고, 그 느낌이 소설의 고딕풍 요소를 강화해준다. 그러나 광택
지에 원색으로 찍힌 우주 사진이나 현미경 사진에서는 삐딱한 익살도 엿보인다. 그
들은 마치 칼 세이건의 《코스모스》에 실린 사진처럼 통속화한 영적 경외감을 자아
내기 때문이다.
 아무튼 책에 실린 사진들은 단순히 본문을 보조하는 데 그치지 않고 스스로 이야
기를 전한다. 그 효과는 뚜렷이 영화적이지만, 케네스 브래너 영화의 미끈한 감각과
는 거리가 있다. 오히려 이 책은 제임스 웨일의 1931년 작품에서부터 〈프랑켄슈타
인, 늑대 인간을 만나다〉 등 여러 프랑켄슈타인 영화와 잠재적 아류작을 짜깁기한
점프컷 몽타주 같다. 다시 말해 여기에서 사진들이 이야기를 전하는 방식 자체가 프
랑켄슈타인 박사가 자신의 피조물을 만들어낸 방식과 닮았다. 출처와 의미가 다른

여러 이미지를 마치 스테이플러로 철하듯 접합 부위를 드러내며 연결해 새로운 이
야기를 만들어낸다는 점에서 그렇다.

크리스토퍼 융과 토비아스 베니히는 베를린에서 활동하는 그래픽 디자이너다. 1999년
라이프치히 그래픽 서적미술 대학교 재학 중에 만난 그들은 이후 다수의 상업적, 독자
적 프로젝트를 함께 진행했다. 크리스토퍼는 2013년 스튜디오 융을 설립했고, 토비
아스 베니히 역시 같은 해에 자신의 이름으로 스튜디오를 세웠다.

The book is slightly larger than A4. The cover shows an unsettling pic-
ture of a man, whose head is covered by a plastic bag. Is he dead? This
is a relevant question, given that the book is an edition of Mary Shelley's
Frankenstein, designed by Christopher Jung and Tobias Wenig.

The cover opens in a way that exposes the inner edges of the book
signatures: the spine is not glued to them, and only the back cover is
partly—and unnervingly—attached to the last page. The signatures are
not thread-sewn, as it turns out. They are, in fact, a set of saddle-stitched
booklets, simply glued together. Saddle-stitched with wire staples—one
imagines that Baron Frankenstein might have used some of them when
he was creating his monster. One of the booklets—or signatures—is at-
tached to the front cover, separating itself from the others. It gives the
effect of physically "breaking" the spine and tearing apart the book
by opening it. But there is a plainer reason for this separation: the first
booklet contains the German translation, while the rest are devoted to
the original, unabridged English text, all set in a clear sans-serif type.

Then there are pictures, many of which are of medical or scientific
nature. Some look contemporary, while others seem like out of certain
esoteric archives. Sometimes the pictures are juxtaposed or overlapped
with text, while on some pages they are left alone. The pictures have
uncanny quality, underpinning the gothic elements of the story. But
one can also sense a certain knowingness, especially in the pictures of
the universe and the micro-universe reproduced in full-color on glossy
paper: they exude—or are meant to evoke—popular-spiritual awe, in a
similar way that the pictures from Carl Sagan's *Cosmos* do.

In any case, the pictures do not simply support the text: they tell the
story on their own terms. The effect is emphatically cinematic, but not
exactly of Kenneth Branagh's. It rather feels like a jump-cut montage of
many *Frankenstein* films, from James Whale's 1931 version to *Franken-
stein Meets the Wolf Man* and other possible derivatives. In other words,
the way the pictures tell the story itself resembles Dr. Frankenstein's
method of creation: images from diverse sources and of different asso-

ciations are stitched together as if by wire staples, creating a new narrative yet leaving their seams visible.

Christopher Jung and Tobias Wenig are graphic designers based in Berlin. They met while studying at the Hochschule für Grafik und Buchkunst Leipzig in 1999, and have worked together on various commissioned and self-initiated projects. Christopher founded his Studio Jung in 2013, and Tobias Wenig his eponymous studio in the same year.

크리스토퍼 융
1975년생, 독일.

토비아스 베니히
1976년생, 독일.

Christopher Jung
Born in 1975, Germany.

Tobias Wenig
Born in 1976, Germany.

studio-jung.com
tobiaswenig.com

프랑켄슈타인
2010. 오프셋, 중철 소책자 접착 제본, 표지. 21×28.5×2 cm, 216쪽 /
부록 80쪽. 메리 셸리 원작(1818). 라이프치히: 루보크.

Frankenstein: Or the Modern Prometheus
2010. Offset lithography, saddle-stitched in sections and glued, cover.
21×28.5×2 cm, 216 pp; supplement, 80 pp. Original text (1818) by
Mary Shelley. Leipzig: Lubok Verlag.

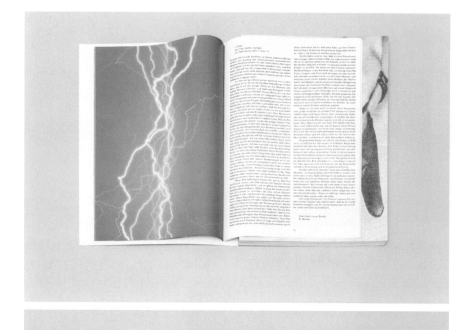

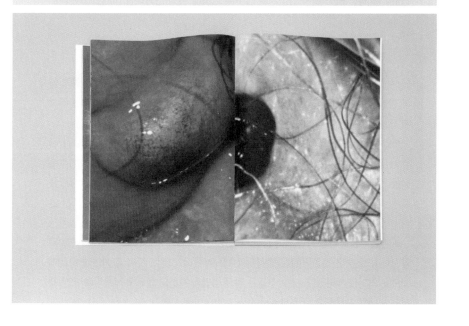

묘사

description

장샤우핀은 베이징에서 활동하는 그래픽 디자이너이자 디자인 연구자, 교육자다. 도시와 건축, 공공 문화에 관심이 많은 그는 그래픽 디자인이 아직 알려지지 않은 곳을 향한 관문이자 서로 다른 지식과 생각을 끊임없이 연결하는 방법이라고 이해한다. 2×4/OMA 베이징 사무실에서 근무했고, 2011년 독자적인 스튜디오 맥스 오피스를 설립했다. 맥스 오피스는 다양한 분야에 걸쳐 디자인과 리서치 프로젝트를 진행 중이다.

묘사

《묘사》는 '묘사'라는 말의 여러 측면을 논함으로써 그래픽 디자인과 연관 분야의 일부 현상을 암시하고 드러내며, 그럼으로써 알려지지 않은 곳에 빛을 비추려는 리서치 프로젝트다. 같은 제목으로 출간된 책은 그간의 성과를 엮어 제시한다.

책을 편집하는 과정에서 다양한 분야(건축, 언어학, 사회심리학, 통계학, 출판 경영 등)의 전문가를 초빙해 가상 포럼을 열고 '묘사'라는 말의 기본 측면을 해석하게 했다. 토론은 언어, 방법, 욕망, 내용, 각본, 관점, 블랙박스, 유형, 채널, 추한 것, 숭배 등 다양한 주제를 다루었다. 패턴 언어와 건물 시공법(건축), 지식 경영(도서 관리), 서로 다른 언어의 충돌(언어학) 등에 관해 통찰력 있는 해석이 나왔다.

초대 손님들은 전통적 주제에 관한 사안과 사물을 자신의 관점에서 재해석하고 재발견하며, 익숙한 것은 새로운 방식으로 재묘사했다. 그럼으로써 그 사안과 사물에 새로운 의미를 부여했다. 또한 그들은 같은 방법을 자신의 실무에 적용하며 개별 체계와 세계를 구축하고, 독특한 사회적 유토피아를 조형했다.

그래픽 디자인의 핵심은 가시적 표면에 있지 않을지도 모른다. 우리는 보이지 않는 수준에도 개별 체계를 세워야 한다. 그 수준에서 모든 의제를 재묘사하는 한편, 결과물을 통해 개별 유토피아를 드러내 보여야 한다. 그럼으로써 그래픽 디자인은 효과적인 사유 방법, 질문 방법, 이상적 세계를 묘사하는 방법이 된다. 즉 문학에 가까워진다. 《묘사》에서 타이포그래피를 포함한 가시적 요인은 우리를 보이지 않는 세계로 이끌어주는 글쓰기 방법으로 기능할 뿐이다. [장샤우핀]

Zhang Shoupin is a graphic designer, design researcher and teacher based in Beijing. Focusing on urban, architectural and public cultural fields, Zhang sees graphic design as an access to unknown domains, a way to constantly connect different knowledges and ideas. After working for 2×4/OMA's Beijing office, he founded his own design studio Max Office in 2011. Max Office works with various institutions on design solutions and research projects.

Description

Description is a research project, which, by discussing various facets of this multi-disciplinary word, tries to insinuate and reveal certain phenomena in graphic design and related activities, hence to illuminate the unknown from afar. The eponymous publication is an aggregation of current results from this ongoing project.

A virtual forum was organized during the editing process, inviting guest speakers from different fields (architecture, linguistics, social psychology, statistics, book management, etc.) to interpret the basic aspects of the word "description." The discussions covered different topics, including languages, methods, desires, content, scenario, standing point, black box, typology, channel, and the worship of ugliness. The interpretations are quite inspiring, from those of pattern language and building methods (architectural design), knowledge management (library science), and the conflicts between different languages (linguistics).

The invited guests have re-read and re-discovered things and matters related to the orthodox subjects from their own perspectives, re-describing the familiar in new ways. By doing so, they have endowed those things and matters with new meanings and definitions. They have also used the same method in their practices, indefatigably trying to establish their individual systems and worlds, to shape their own unique social ideals.

The core of graphic design may not be lying in the visible. We need to build individual systems at a different yet invisible level. We need to re-describe all agendas at this level, meanwhile, to demonstrate an individual utopia through output. Here, graphic design acts more like literature, more as an effective way for us to think, to question, to describe an ideal world. In *Description*, visible factors including typography act only as the medium for writing, in order to direct us to the invisible. [Zhang Shoupin]

장샤우핀(章寿品)
1980년생, 중국.

Zhang Shoupin
Born in 1980, China.

maxoffice.org

묘사(描述)
2008. 오프셋, 사철에 표지. 14.8×20×2.8 cm, 400쪽. 작가 발행.

Description
2008. Offset lithography, sewn in sections, cover. 14.8×20×2.8 cm,
400 pp. Self-published.

무언
unwriting

————

도쿄에서 미술, 패션, 음악계를 중심으로 활동하는 그래픽 디자이너 하마다 다케시의 작업은 브랜딩, 포장, 편집, 타이포그래피를 아우른다. 최근 프로젝트로는 패션 브랜드 플럼피너츠, 파리고, 유니폼 익스페리먼트의 아트 디렉션, 준지 이시쿠로 사진 작품집, 리퀴드룸 클럽 공연 포스터 시리즈 등이 있다. 2000년부터 그는 온라인 잡지 《타이거》(www.tigermagazine.org)를 운영해왔다.

문학의 주름

문학은 단순히 저자가 독자에게 내용과 가치를 일방적으로 '주는' 이야기가 아니다. 오히려 그것은 저자와 독자의 소통이다. 사르트르가 말한 대로 독자는 이야기를 읽으면서 또 다른 이야기를 창조할 수 있다.

저자가 글로 쓰지 못하는 것, 또는 글로써 표현할 수 없다고 느끼는 것, 하지만 독자는 행간을 통해 읽어낼 수 있는 것이 있다. 문학은 쓰인 글과 쓰이지 않은 글로 이루어지며, 문학 작품의 진정한 가치는 쓰이지 않은 의미를 독자가 어떻게 읽어내느냐에 달려 있다.

"아름다운 책에서 일어나는 오독은 모두 아름답다"는 마르셀 프루스트의 말은 소통과 디자인에 관해 여전히 유효한 의미를 던져준다.

쓰여야 했던 말—과연 그것은 쓰일 수 있었을까? 일본 최고 소설가인 다자이 오사무는 소설 《인간 실격》에 이런 글을 적었다.

지금 나에게는 행복도 불행도 없습니다.
모든 것은 지나가기 마련입니다.
내가 지금까지 아비규환으로 살아온 이른바 '인간'의 세계에서 단 하나의 진리라고 생각되는 건 그것뿐입니다.
모든 것은 지나가기 마련입니다.
나는 올해 스물일곱이 됩니다. 흰머리가 부쩍 늘어서 사람들은 대개 내가 마흔이 넘은 줄 압니다.

마지막 문단은 주인공의 현 상태를 묘사하는 문장이 아니다. 그 지점까지 소설을 읽어온 독자에게 그 문장은 주인공의 인생 자체, 그가 이 마지막 문단에 이르기까지 겪어온 고통을 표상한다.

어떤 것은 글로 옮기는 순간 사라지고 만다. 그것을 어떻게 쓸 것인가? 어떻게 쓰지 않을 것인가? 이에 관한 저자의 판단과 기교가 문학 작품의 질을 좌우한다. 하지만 독자는 쓰인 글 속에서 어떻게 쓰이지 않은 글을 읽어내는가? 어떤 것은 소통해야 하기에, 바로 그 이유에서 글로 쓰이지 않는다. 그것이 바로 저자와 독자가 공유하는 것이다.

TV나 영화에는 글쓰기에 전념한 작가가 원고지를 구겨 던지며 종이 뭉치가 쌓이는 장면이 종종 나온다. 소통의 어려움, 글쓰기의 어려움을 은유하는 모티프로 나는 '구겨진 종이'를 택한다. 그리고 그 위에 영상을 비추어 콜라주를 만든다. [하마다 다케시]

Tokyo-based graphic designer Hamada Takeshi's work encompasses branding, packaging, editorial and typographic design for art, fashion and music industries. Recent projects include art direction for the fashion brands Plumpynuts, Parigot and Uniform Experiment; photobook for Junji Ishiguro; and posters for the club Liquidroom. Since 2000, he has been running the online magazine *Tiger* (www.tigermagazine.org).

Crease of Literature

Literature is not simply about a story whose value and meanings are unilaterally "given" by the author to the reader: it is a form of communication between them. And, as Sartre said, a reader also creates a story while reading one.

There are things authors cannot write, or deem impossible to express in writing, but readers can still read them between the lines. Literature consists of written texts and unwritten texts, and it is the way a reader discovers the unwritten meanings where the true value of a literary work is to be found.

Here, I would like to remind of an aphorism by Marcel Proust that misreading occurring in a beautiful book is all beautiful, which is still relevant to communication and design.

Things that should have been written—could they have been written at all? Osamu Dazai, one of the most famous novelists in Japan, wrote the following passage in his *No Longer Human*:

Now I have neither happiness nor unhappiness.
Everything passes.
That is the one and only thing I have thought resembled a truth in the society of human beings where I have dwelled up to now as in a burning hell.
Everything passes.
This year I am twenty-seven. My hair has become much greyer. Most people would take me for over forty.

The last paragraph is not intended as a mere description of his state at the moment. To those who have read the novel so far, it represents his entire life: the pains that the man had to go through all the way up to this paragraph.

Some things are lost when they are put into words. How to write them? How not to write them? An author's judgment and skills regarding these questions critically affect the quality of the work. But also, how may readers read the unwritten on top of the written text? Some things remain unwritten precisely because they must be communicated—these are the things that authors and readers share.

We often see a typical scene on TV or in films where a concentrated writer keeps crumpling pages on which he/she was writing and throwing them away on a pile of paper balls. As a metaphor for the difficulty of communication, the difficulty of writing, I use "crumpled paper," on which moving images are projected to form a collage. [Hamada Takeshi]

하마다 다케시
1970년생, 일본.

Hamada Takeshi
Born in 1970, Japan.

hamada-takeshi.com

문학의 주름
2013. 복합 매체 설치: 종이, 2채널 비디오. 크기 가변.

Crease of Literature
2013. Mixed-media installation: two-channel video, paper.
Dimensions variable.

무한성
infinity

봉사 도서관은 2011년 데이비드 라인퍼트, 스튜어트 베일리, 앤지 키퍼가 "출판을 통해 스스로 형성되는 협동 아카이브"로 공동 설립한 프로젝트다. 사업은 크게 세 부문으로 구성된다. 첫째는 자료가 생성되는 대로 수집해 PDF 문서로 게시, 누구나 자유롭게 내려받을 수 있게 하는 웹사이트다. 둘째는 다양한 물건과 책으로 이루어 진 물리적 도서관으로서, 현재는 주로 예술 기관에서 장소를 빌려가며 세계 곳곳을 떠도는 중이다. 셋째는 웹사이트에 출간된 PDF를 정기적으로 갈무리해 인쇄된 책 형태로 출판하는 《봉사 도서관 소식지》다. 이 소식지는 스튜어트 베일리가 2000 년에 창간해 2010년 마지막 호까지 편집하고 디자인한 잡지 《돗 돗 돗》의 연장선 에서 미디어, 시간, 교육, 언어, 타이포그래피, 흑백 사이키델리아 등 다양한 주제 를 느슨히 다룬다.

설립인들에 따르면 봉사 도서관은 도서관의 역사적 진화 과정상 끝자락에 있는 개 념이다. 초기 도서관은 귀중한 문서를 보관, 보존하며 일반인의 접근을 제약하는 아 카이브 모델에 기초했다. 그 후 나타난 대출 도서관은 책과 자료를 단순히 보존하기 보다 일반인 사이에 순환시키며 실제로 쓰이게 하려는 목적에서 세워졌다. 봉사 도 서관은 두 모델의 연장선에서 '분배하는 도서관'으로 구상되었다. 그 바탕이 된 '이 동 가능 문서 형식', 즉 PDF는—순수한 텍스트 데이터와 달리—인쇄된 지면의 통 일성과 정체성을 얼마간 유지하면서도 끝없이 복제하고 공유할 수 있는 문서를 만 들어준다. 그런 점에서 도서관의 좌우명이 '무한 봉사'라는 점은 무척이나 적절해 보 인다.

'무한'은 끝없는 수량으로 해석할 수도 있겠지만, 어떤 구조 또는 과정과 연관해볼 수도 있다. 즉 무한대 기호(∞)가 적절히 표상하는 순환 고리로 해석할 수도 있다는 뜻이다. 봉사 도서관의 야심은 단순히 문서를 축적하고 유통하는 방식을 실험하는 데 있지 않다. 그 자체가 생산 거점이기도 하기 때문이다. 봉사 도서관 설립인들은 "전통적으로 출판과 아카이빙은 지식 생산 궤적에서 양 극단에 해당했다"고 말한다. "그러나 이제는 인터넷이 제공하는 값싸고 손쉬운 분배 방식 덕분에 그들을 하나의

과정으로 통합할 수 있다." 그렇다면 봉사 도서관은 실제로 시간적 과정인 무언가를 가리키는 공간적 은유일지도 모른다. 흥미롭게도 시간은 《봉사 도서관 소식지》 첫 호에서 다룬 주제 가운데 하나였다.

데이비드 라인퍼트는 뉴욕에서 활동하는 그래픽 디자이너 겸 저술가다. 1993년 미국 노스캐롤라이나 대학교를 졸업하고, 1999년 예일 대학교에서 석사 학위를 받았다. 2000년 끊임없이 변하는 협력 네트워크에 기초한 그래픽 디자인 협업체 O-R-G를 설립했다. 스튜어트 베일리는 영국 레딩 대학교에서 그래픽 디자인을 공부했고, 2000년 아른험의 베르크플라츠 티포흐라피를 졸업했다. 주로 다른 작가와 협업으로 만들어내는 출판물을 통해 그래픽 디자인과 저술, 편집의 다양한 측면을 탐구한다. 2006년부터 라인퍼트와 함께 덱스터 시니스터로 활동해왔다. 앤지 키퍼는 극히 전문적인 정보 사이에서 순환로를 추적하는 공상적 논픽션으로 알려진 저술가이자 편집자다. 1999년 미국 예일 대학교를 졸업했으며, 현재 뉴욕에서 활동 중이다.

The Serving Library is a "cooperatively-built archive that assembles itself by publishing" founded in 2011 by David Reinfurt, Stuart Bailey and Angie Keefer. It consists of three components: a website that gathers materials as they are produced, and provides them as PDFs for the public to freely download; a small physical library of objects and books that is currently traveling from place to place, temporarily occupying donated spaces of various art institutions; and the *Bulletins of the Serving Library*, a publishing program that periodically assembles the PDFs already published on the website and distributes them as a printed journal. Following a line from *Dot Dot Dot*, a journal Stuart Bailey co-founded in 2000 and continued to edit and design until the last issue published in 2010, the *Bulletins* cover various themes including library, media, time, language, typography, education and black-and-white psychedelia.

According to the creators, the Serving Library is at the latest stage of the evolutionary lineage of library. First, libraries were modeled on the idea of archive, preserving and protecting important documents, restricting public access; then there came the "circulating libraries," which ensured books and other resources to be used, rather than simply saved, by the public. Combining and extending the two previous models, the Serving Library was conceived as a "distributing library." It taps on the latest technology of the Portable Document Format (PDF), by which a document may retain—unlike pure text data—the integrity and identity of printed pages, but can be limitlessly duplicated, downloaded

and circulated via the internet. Thus the motto of the library, *Hospitum ad infinitum*—infinite hospitality.

"Infinity" can be interpreted not only in terms of unlimited quantity, but also as a concept of structure or process: a loop, as aptly depicted by its typographic symbol (∞). The ambition of the Serving Library is not simply initiating a new mode of accumulating and distributing documents, for it is a site of production as well. "Publishing and archiving have traditionally existed at opposite ends of the trajectory of knowledge production," observes the Serving Library's creators. "[But] here, in accord with the cheap and easy distribution afforded by an electronic network, they coalesce into a single process." Perhaps, then, the Serving Library is a spatial metaphor for what really is a temporal process. And time, incidentally, was among the themes of its first *Bulletins*.

David Reinfurt is a graphic designer and writer in New York City. He graduated from the University of North Carolina in 1993 and received an MFA from Yale University in 1999. In 2000, he founded O-R-G inc., a flexible graphic design practice composed of a constantly shifting network of collaborators. Stuart Bailey studied graphic design at the University of Reading, and graduated from the Werkplaats Typografie, Arnhem, in 2000. His work explores various aspects of graphic design, writing and editing, mostly in the form of publications made in collaboration with artists. Since 2006, he and Reinfurt have been working together as Dexter Sinister. Angie Keefer, a writer, editor and occasional librarian, graduated from Yale University in 1999. Her speculative nonfiction traces circuitous routes through highly specialized information. She currently lives and works in New York City.

데이비드 라인퍼트
1971년생, 미국.

스튜어트 베일리
1973년생, 영국.

앤지 키퍼
1977년생, 미국.

David Reinfurt
Born in 1971, USA.

Stuart Bailey
Born in 1973, UK.

Angie Keefer
Born in 1977, USA.

봉사 도서관 소식지
2011–현재. 오프셋, 무선철에 표지. 베를린: 슈테른베르크 프레스 / 뉴욕: 덱스터
시니스터.

Bulletins of the Serving Library
2011–ongoing. Offset lithography, cut and glued, cover. Berlin:
Sternberg Press / New York: Dexter Sinister.

1호: 2011. 16.5×23.5×0.7 cm, 96쪽.

No. 1: 2011. 16.5×23.5×0.7 cm, 96 pp.

2호: 2011. 16.5×23.5×1.2 cm, 160쪽.

No. 2: 2011. 16.5×23.5×1.2 cm, 160 pp.

3호: 2012. 16.5×23.5×1.6 cm, 224쪽. 로라 홉트먼이 기획한 전시회 《황홀한 알파벳/언어 더미》(뉴욕 현대미술관, 2012) 도록을 겸해 발행.

No. 3: 2012. 16.5×23.5×1.6 cm, 224 pp. Published as a catalog for the exhibition *Ecstatic Alphabets/Heaps of Language* (MoMA, New York, 2012) curated by Laura Hoptman.

4호: 2012. 16.5×23.5×1.4 cm, 200쪽. 레아 달이 기획한 연구 프로그램
'덱스터 방 시니스터'(쿤스트할 샬로텐보리, 2012년 1월 21일–10월 28일)
후원으로 발행.

No. 4: 2012. 16.5×23.5×1.4 cm, 200 pp. Produced under the
auspices of the research program Dexter Bang Sinister at Kunsthal
Charlottenborg, Copenhagen, January 21–October 28, 2012, curated
by Rhea Dall.

5호: 2013. 16.5×23.5×1 cm, 152쪽. 괴테-인스티투트 뉴욕 후원으로 발행.

No. 5: 2013. 16.5×23.5×1 cm, 152 pp. Supported by the Goethe-
Institut New York.

www.servinglibrary.org

2011-현재. 웹사이트.
2011-ongoing. Website.

미백색
off-white

런던에서 활동하는 그래픽 디자이너 존 모건은 2000년에 자신의 이름으로 스튜디오를 설립했다. 주요 프로젝트로는 영국 성공회 기도서, 데이비드 치퍼필드 건축 사무소 그래픽 아이덴티티, 런던 디자인 뮤지엄 전시 디자인 등이 꼽힌다. 《돗 돗 돗》과 《AA 파일스》 등에 기고했으며, 센트럴 세인트마틴스 미술대학과 레딩 대학교 등에 출강했다. 베네치아 건축 비엔날레 2012 작업으로 2013년 디자인 뮤지엄에서 올해의 디자인 상을 받았고, 2012년에는 영국 건축협회 저널 《AA 파일스》로, 2011년에는 고전문학을 재해석하는 포 코너스 패밀리어 총서 디자인으로 같은 상 후보에 오른 바 있다.

〈블랑슈 또는 망각〉은 존 모건이 알렉스 발지우, 장마리 쿠랑, 6a 아키텍츠와 함께 선보이는 설치 작품이다. 알렉스 발지우는 파리에서 활동하는 그래픽 디자이너로, 리옹 미술대학에 출강 중이다. 역시 프랑스에서 활동하는 그래픽 디자이너 장마리 쿠랑은 타이포그래피에서 빌린 '레귤러'라는 이름으로 자신의 작품에 서명한다고 알려졌다. 편집 디자인과 아이덴티티 프로젝트를 중심으로 작업하면서, 현재 리옹 미술대학에서 가르치고 있다. 6a 아키텍츠는 2001년 톰 에머슨과 스테파니 맥도널드가 설립한 건축 사무실이다. 미술관 설계로 여러 상을 받았고, 민감한 역사적 장소에 짓는 교육 시설과 주택 디자인으로 독특한 명성을 얻었다.

블랑슈 또는 망각

원형적 디자인이 대부분 그렇듯, 누벨 레뷔 프랑세즈(NRF)와 갈리마르가 함께 펴내는 '블랑슈(백색)' 총서의 유명한 디자인도 복합적 감수성—앙드레 지드나 장 슐룅베르제 등 설립자의 취향과 성향—에 브루게 생카트린 인쇄소 에두아르 페르베커의 제작 솜씨가 결합한 결과였다.

블랑슈 총서가 전체적으로 이어가는 정체성은 쉽게 떠올릴 수 있다. 이름의 배경이 된 미백색 표지, 손으로 쉽게 쥘 수 있으나 호주머니에 넣기는 어려운 판형, 검정 외줄 테두리에 둘러싸인 빨강 겹줄 테두리, 가운데 맞춰 배열한 글, 빨강으로 찍힌

표제와 검정으로 찍힌 지은이 이름, 이탤릭체로 쓰인 NRF 로고 등. 그러나 더 구체적으로 살펴보면 세부적 특징은 정의하기 어렵다. 정확히 어떤 백색 또는 미색일까? 언제나 이 색이었을까, 아니면 그것은 세월이 남긴 흔적일까? 서체는 획 대비가 강한 디도 계열일까, 아니면 가라몽 계열일까? 표제에는 대문자만 쓰였을까, 아니면 대소문자가 섞여 쓰였을까? 따뜻한 활판 인쇄풍 주황일까, 아니면 핏빛 적색일까?

아라공의 《블랑슈 또는 망각》에서 40년 전 사랑했던 여인 블랑슈를 떠올려 보려 애쓰는 화자처럼, 우리는 사랑했던 이의 모습을 잊기도 하고, 또 그 모습은 세월에 따라 변하기도 한다. 여기에서 우리는 블랑슈 총서의 이미지를 포착하려 한다. 우리는 과거에 관한 진실을 찾아내려 하지만, 상황은 불확실하다. 우리는 여전히 블랑슈를 사랑하지만, 그녀가 어떤 사람인지는 정확히 모른다.

우리는 400여 권의 책을 골라 스물다섯 가지 주제로 분류하고, 각 범주마다 그에 포함된 책 한 권에서 따온 제목을 붙였다. '모작과 잡록'은 같은 작품의 디자인이 시간이 흐르며 조금씩 달라지는 모습을 보여준다. 해당 작품은 1937년에서 1951년 사이에 간행된 지드의 《지상의 양식》과 1917년에서 1941년 사이에 간행된 말라르메의 《시》다. '가슴이 전하는 소식'은 감각을 어지럽힐 정도로 집요한 사랑 이야기로, 브르통의 《미친 사랑》과 아라공의 《비통》을 보여준다. '언제나 새로운 이름'에는 엘사, 바니, 나자, 엘로이즈, 트리스탄, 애니, 실비아, 크리지, 이자벨 등이 모여 있다. 집 없는 책들, 고아들, 또는 분류하기 어려운 책들은 '부모 없는 자식'에 속하는데, 여기에는 《성가대의 아이》와 《최악》이 포함된다. [존 모건]

<div align="center">블랑슈 또는 망각 분류</div>

모작과 잡록 / Pastiches et Mélanges
시간의 보호 아래 / Sous le lien du temps
기쁨과 나날 / Les Plaisirs et les Jours
정오의 분할 / Partage de midi
눈(目)이 전하는 소식 / Nouvelles des yeux
가슴이 전하는 소식 / Nouvelles du cœur
다른 곳 / Ailleurs
중력 / Gravitations
새장 / Volière
유희와 인간 / Les Jeux et les Hommes
파도 속에서 / En marge des marées
언제나 새로운 이름 / Un nom toujours nouveau
공공 작가 / L'Écrivain public
몇 명에게 보내는 편지 / Lettres à quelques-uns
제공되는 시(詩)들 / Poèmes offerts

내가 있는 곳 / Le point où j'en suis

열린 책 / Le Livre ouvert

말(言) / Les Mots

양식론 / Traité du style / Treatise on Style

군도의 말(言) / La Parole en archipel

문학의 공간 / L'Espace littéraire

각양각색 / Variété

고독 지대 / Un champ de solitude

부모 없는 자식 / Fils de personne

망각에서 벗어나 / Du plus loin de l'oubli

A graphic designer based in London, John Morgan established his eponymous studio in 2000. His projects have included prayer books for the Church of England, graphic identity for David Chipperfield Architects, and exhibition design for the Design Museum, London. He has written for a number of journals including *Dot Dot Dot* and *AA Files*, and has taught in various design schools, including Central Saint Martins and the University of Reading. His studio won the graphic design category in the Design Museum's Designs of the Year 2013 for the Venice Architecture Biennale 2012. He was also nominated in 2012 for *AA Files*, the Architectural Association's journal of record, and in 2011 for the Four Corners Familiars series, a re-imagining of classic books.

Blanche ou L'Oubli / *Blanche or Forgetting* is a new installation by John Morgan with Alex Balgiu, Jean-Marie Courant and 6a architects. Alex Balgiu is a graphic designer based in Paris. He teaches at the École nationale des beaux-arts de Lyon. Jean-Marie Courant is a graphic designer living and working in France. He signs his works using a name borrowed from the vocabulary of typography: Regular. Most of his work is focused on editorial and visual identity projects. He teaches at the École nationale des beaux-arts de Lyon. 6a architects was founded by Tom Emerson and Stephanie Macdonald in 2001. The practice has developed a particular reputation for award-winning contemporary art galleries, educational and residential projects in sensitive historic environments.

Blanche ou l'Oubli / Blanche or Forgetting

Like many archetypes, the design of the celebrated collection Blanche/White published by the Nouvelle Revue Française (NRF) and Gallimard is the result of compound sensibilities—the taste and direction of the founders, which included André Gide and Jean Schlumberger—and

the implementation by the printer Edouard Verbeke of the St. Catherine Press in Bruges.

There's a collectively inherited idea of what constitutes a "Blanche"— an off-white cover stock which gives the collection its name, a paperback you can hold comfortably in your hand but perhaps not in your pocket, a single black ruled frame containing a double red frame, centered text alignment, a title colored red, the author's name in black and the publisher's italicised NRF device. The specific peculiarities are harder to define. Which white or cream exactly? Was it always this color or has time taken its toll? Text set in a high-contrast Didone or a Garalde? Titles set in all capitals or upper and lowercase, roman or italic? A warm typographic orange or a deep blood red?

Like the narrator of Aragon's *Blanche ou l'Oubli* / *Blanche or Forgetting* who attempts to recall his love for Blanche, a woman he loved some forty years ago, we can forget what our love looks like, and over time her appearance changes. Here we attempt to capture an image of the Blanche collection. In this attempt to find the truth about the past, we are left in a state of uncertainty—though still in love with Blanche, we don't quite know who she is.

Our selection classifies over 400 books into twenty-five thematic sections named after a book title within that theme. Within Pastiches et Mélanges we see the nuances and evolution in design of the same titles through time, in this case Gide's *Les Nourritures terrestres* / *The Fruits of the Earth* from 1937 to 1951, and Mallarmé's *Poésies* from 1917 to 1941. Nouvelles du cœur / News from the Heart gives us Breton's *L'Amour fou* / *Mad Love*, the obsessional kind of love that deranges the senses and two episodes of *Le Crève-cœur* / *Heartbreak* from Aragon. Un nom toujours nouveau / A Name Always New gathers Elsa, Barny, Nadja, Héloise, Tristan, Anny, Sylvia, Creezy and Isabelle amongst others. Those without a home, the orphans, or the difficult are housed in Fils de personne / Nobody's son, here we place both *L'Enfant de chœur* / *The Choirboy* and *Le Pire* / *The Worst*. [John Morgan]

Blanche or Forgetting Classification
Pastiches et Mélanges / Pastiches and Mélanges
Sous le lien du temps / Under the Aegis of Time
Les Plaisirs et les Jours / Pleasures and Days
Partage de midi / The Break of Noon
Nouvelles des yeux / News from the Eyes
Nouvelles du cœur / News from the Heart
Ailleurs / Elsewhere
Gravitations / Gravitations

Volière / Aviary
Les Jeux et les Hommes / Man, Play and Games
En marge des marées / Within the Tides
Un nom toujours nouveau / A Name Always New
L'Écrivain public / The Public Writer
Lettres à quelques-uns / Letters to a Few
Poèmes offerts / Offered Poems
Le point où j'en suis / Where I am
Le Livre ouvert / The Open Book
Les Mots / The Words
Traité du style / Treatise on Style
La Parole en archipel / The Word as Archipelago
L'Espace littéraire / The Space of Literature
Variété / Variety
Un champ de solitude / Domain of Solitude
Fils de personne / Nobody's Son
Du plus loin de l'oubli / Out of the Dark

———
존 모건
—과 알렉스 발지우, 장마리 쿠랑, 6a 아키텍츠

존 모건
1973년생, 영국.
morganstudio.co.uk

알렉스 발지우
1985년생, 프랑스.

장마리 쿠랑
1966년생, 프랑스.

6a 아키텍츠
2001년 설립, 런던.

John Morgan
— with Alex Balgiu, Jean-Marie Courant and 6a architects

John Morgan
Born in 1973, UK.
morganstudio.co.uk

Alex Balgiu
Born in 1985, France.

Jean-Marie Courant
Born in 1966, France.

6a architects
Founded in 2001, London.

블랑슈 또는 망각
2013. 복합 매체 설치: 목재 책장과 수집한 책. 크기 가변.

Blanche ou L'Oubli / Blanche or Forgetting
2013. Mixed-media installation: wooden bookshelves and collected
books. Dimensions variable.

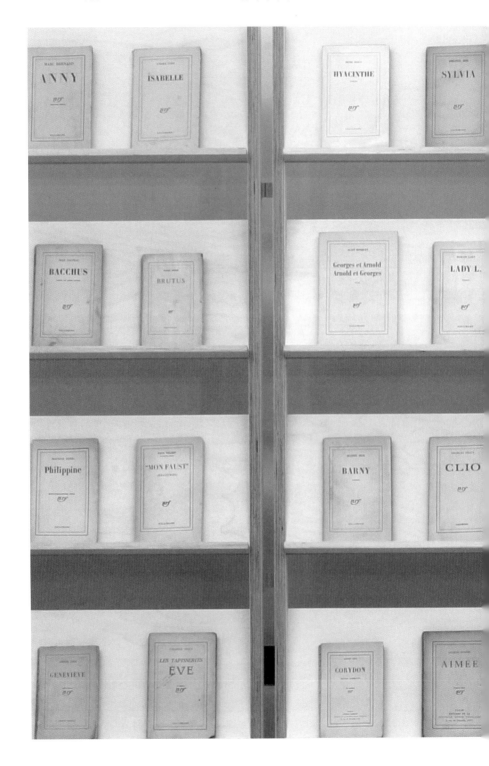

미백색

브라이언 딜런

갈리마르에서 펴낸 마르셀 프루스트의 여섯 권짜리《잃어버린 시간을 찾아서》를 거의 20년 만에 꺼내 책상에 내려놓는다. 옅은 안개 같은 먼지가 여전히 쌓인 책에서, 일부 구절이 벌써 공책으로 옮아온다. 이만저만 닳거나 낡은 책들이 아니다. 모서리란 모서리는 죄다 갈색으로 변색했고, 오래전에 책등이 사라진 세 권에서는 제본용 실 일부가 풀어져 삐져나온 상태다. 일부에는 발행일이 적혀 있지 않고, 두 권은 1926년에, 한 권은 1937년에 나왔다고 밝혀져 있다. 전에는 눈치채지 못한 일이지만, NRF 총서의 고전적인 검정과 빨강 테두리가 모두 쳐 있음에도 디자인은 조금씩 다르다. 어디에는 '갈리마르'라는 이름만 표시되어 있지만, 다른 책에는 출판사가 '리브레리 갈리마르'로 적혀 있고, 또 다른 책에는 건장한 대문자로 '파리'와 함께 출판사 주소—드 그레넬 가 3—가 표기되어 있다. 표지 중앙에는 별표가 하나, 둘 또는 세 개 있는데, 그 숫자가 권차와 연관된 것 같지는 않다.

여섯 권 중 가장 오래된 책에는 잘리지 않은 지면이 아직 남아 있다. 특히나 노쇠한 백지는 너무 거칠어서 연필로 쓴 글자를 읽기가 어려울 정도다. "존⋯." 아마도 서명인 듯하다. 휘갈긴 필체로 위압적인 말이 이어진다. "교열 엉망, 문장부호와 철자법에서 실수 천지." 그 독자—첫 독자?—는 프루스트가 죽은 지 겨우 4년 만에 나온 책의 결함에 실망한 나머지 다른 지면을 종이 칼로 잘라 펼치기조차 거부한 모양이다. 아니면 다른 곳에 정신이 팔려 있었는지도 모르겠다. 이제야 발견한 것인데, 지면을 몇 장 넘기자 기름때 묻은 작업복을 걸치고—그 얼룩은 마치 표지에 묻은 세월의 자국 같다—비행모와 고글을 갖춘 젊은 여인의 흑백 사진이 한 장 끼워져 있기 때문이다. 사진 뒷면을 보니 여인의 정체가 드러난다. "프리실라 페이턴, 1946." 그 독자가 사랑한 여성 비행사가 아직 살아 있다면 아마 여든은 족히 먹었으리라. 한 시간 동안 구글에서 '프리실라 페이턴'을 검색해보지만 아무 자료도 나오지 않는다.

그렇게 내가 처음 소장한 갈리마르 총서 여섯 권은 1993년 겨울 더블린의 대학가에서 할인가에 사온 이래 관심을 끌지도 못하고 읽히지도 못한 채 책장에 방치되어 있었다. 대체 무슨 생각을 했던 걸까? 내 프랑스어 실력으로 프루스트를 읽기는 턱

Off-White

Brian Dillon

For the first time in almost twenty years I have just now hefted onto my desk the six volumes of my Gallimard edition of Marcel Proust's *À la recherche du temps perdu*—a small cloud of dust is still settling, and fragments from the books are already migrating across the notebook in which I'm writing. These volumes are worse than foxed or frail: every one had turned a dirty buff color, almost brown; the spines are long gone from three of them, and frayed bits of binding thread stick out of the pile. Some are undated, two printed in 1926, another in 1937. I had not noticed before the way, though all are bordered in the classic black and red of the NRF series, no two covers are exactly alike in design. Here, a single name—"Gallimard"—but there, the legend "Librairie Gallimard"; on a third, "PARIS" in sturdy capitals, and the full address of the press: "3, rue de Grenelle (VIme)". There are stars or asterisks in the centre of the cover—one, two or three—but they seem not to be linked to the sequence of volumes.

Among the oldest of the six, there are pages still uncut. In the most decrepit the paper on the flyleaf is so rough it is hard to read what's been pencilled there. A signature: possibly "John…." And a peremptory comment, hastily scrawled: "Very poor proof reading—full of mistakes—both in punctuation and spelling." Perhaps this reader (the first reader?) has been so put off by the deficiencies of the edition, printed just four years after Proust's death, that he refused to take a paper knife to the remaining pages. Or maybe he had other matters on his mind, because here, tucked a few pages into the book, where I have failed to find them all these years, are two tiny black-and-white photographs showing a young woman dressed in oil-stained overalls—the stains look just like the marks of age on the book's cover—and a flying helmet with goggles. Flip the snapshots over and there she is: "Priscilla Peyton, 1946." If she's alive, this reader's beloved aviatrix will be in her mid eighties at

도 없었을뿐더러, 아무튼 도서관에 가면 같은 책을 현대판으로—여전히 NRF에서 나왔으나 그처럼 닳지는 않은 판으로—구해볼 수도 있었다. 어쩌면 1권 표지에 찍힌 '여섯 권에 1파운드'라는 말이 문제였는지도 모른다. 또는 그 미색 또는 한때 미색이던 갈리마르 문고가 단지 내 허영심을 자극했던 것인지도 모른다. 가지런히 늘어선 '블랑슈' 유니폼은 흠모하는 프랑스 지성계를 얼마간 맛보게 해주겠다고 약속하는 듯했으니까. (어쩌면 페이턴 양을 숭배하던 독자도 같은 이유에서 책에 이끌렸는지도 모르는 일이다. 그러나 문제의 책이 퀘벡에서 간행되었다는 사실로 미루어, 그가 적어도 언어적으로 유리한 위치에 있었던 것은 분명하다.)

　그날 내가 산 책은—노끈으로 묶어 1920년대 갈리마르 종이의 먼지를 흘리며 집에 가져온 다음—읽기는커녕 다 펼쳐보지도 않았지만, 갈리마르 총서에 관한 인식은 변하지 않았다. 아무리 진지한 문학서라도 조야하게 포장해버리는 표지와 쓸데없이 바뀌는 디자인에 익숙한 영어권 독자에게, 프랑스 (나아가 유럽) 출판사에서 나온 책은 지적 품격은 물론 급진적 의지마저 보증하는 것처럼 보였다. 냉엄하게 단순한 디자인은 내용에 집중하겠다는 뜻을 표했다. NRF 총서를 늘 염두에 두었던 탓인지, 나는 특정 총서에 파멸적으로 이끌리는 경향을 보였다. 하얀 배경에 파랑 장식과 검정 글자가 찍힌 에디시옹 드 미뉘(사뮈엘 베케트뿐 아니라 저널 《크리티크》도 여기에서 나온다), 작은 판형과 신랄한 색을 특징으로 하는 주어캄프(베르톨트 브레히트, 테오도어 아도르노, 발터 벤야민) 등이 그런 총서였다. 가끔은 영어권 출판사가 그처럼 화려한 매력을 성취하기도 했다. 예컨대 호주머니에 쏙 들어가는 세미오텍스트의 검정 문고판이나 심히 매혹적인 존 북스가 그랬다.

　그러나 갈리마르 같은 총서의 유혹은 명쾌하고 한결같은 디자인이나 화려한 출간 목록(내 프루스트 책 뒤표지에 실린 가격표에는 라로슈푸코, 보들레르, 도스토옙스키, 콘래드, 그리고 NRF에서 프루스트에게 퇴짜를 놓은 일로 악명 높은 앙드레 지드 등이 나열되어 있다)에만 있는 것이 아니다. 저술가에게 그 매력은 다른 데 있다. 바로 총서의 관습에 겸손히 복종한다는 생각, 자신의 작품이 어떤 배열, 어떤 패턴에 속한다는 생각이다. 역설적이게도 저술가의 자아에 그보다 더 만족스러운 일은 없기에, 나 역시 내 작품을 현존하는 총서에 포함하거나 아예 따로 총서를 하나 만들어달라고 편집자들을 조르는 지경에 이르렀다. 저술가로서 나는 총서에 입성하기를 열망한다. 그곳이야말로 내 작품이 가장 나다워지는 곳 같기 때문이다.

　갈리마르 프루스트에서 썩은 내가 난다. 글을 쓰는 노트북이 감염되기 전에 치워버리는 게 좋겠다. 3권 책등에 파인 구멍에는 말라비틀어진 벌레 사체 일부가 박혀 있다. 어쩌면 프리실라 페이턴만큼이나 오래된 사체인지도 모른다. 그러나 아주 옛날에는 이 책도 총서로 빼곡한 파리나 몬트리올의 서점 책장에 앉아, 절제되고 시사적인 스타일로 끝없는 약속을 고했을 것이다.

least; I spend an hour Googling Priscilla Peyton, but she's nowhere to be found.

These six Gallimard volumes, the first Gallimard books I ever owned, have sat unloved and unread on my shelves since I bought them in a sale at university in Dublin, in the winter of 1993. What was I thinking? My French was hardly adequate to the task of reading Proust, and there were anyway modern editions—still in the same livery of the NRF, but not so decayed—at the library. Perhaps it was the price on the cover of Tome I: "6 vols., £1." Or just as likely, it was the very idea of these creamy, or once-creamy, Gallimard paperbacks that attracted the some-what pretentious student that I was: the ranks of uniform blanche prom-ised a certain idea of French intellectual life with which I was in love. (And who knows: the same may have been true of Miss Peyton's ad-mirer, though he at least possessed a linguistic advantage: his volume, it turns out, was printed in Quebec.)

If I failed actually to read, or even to open, all the books I bought that day—tied up with string, shedding flakes of 1920s Gallimard paper stock as I took them home—the notion of the series stayed with me. The elegant austerity of the volumes produced by French (and more generally European) publishers looked to the Anglophone reader, who was more used to the garish covers of even serious literary fiction in English, or the needlessly renewed designs of academic books in the same language, like a guarantee of rigor but also a commitment to radi-cal intent. The starkness of design signaled a proper concentration on content. And so, always I think with the model of the NRF in the back of my mind, I have long been ruinously attracted to particular series: the plain white ground, blue device and black text of Les Éditions de Minuit (Samuel Beckett, of course, and the journal *Critique*), or the small format and acid colors of Suhrkamp (Bertolt Brecht, Theodor Adorno, Walter Benjamin). At times, Anglophone publishers have even managed some of the same glamour of the series: the pocketable black paper-backs of Semiotext(e), for example, or the deeply alluring Zone Books.

But the seductions of a series like Gallimard's lie not only in the clarity and longevity of design, nor in the prestige of the publisher's list. (Here, on the back of one of my Prousts: a price list that includes La Rochefou-cauld, Baudelaire, Dostoyevsky, Conrad and André Gide, who notori-ously turned Proust down at first for publication by the NRF.) The attrac-tion for a writer lies elsewhere, in the idea of submitting modestly to the conventions of the series, in seeing one's work become part of a se-quence, part of a pattern. Paradoxically, there is nothing more gratifying for the writerly ego, and I have found myself trying to persuade editors to place a book of mine in an extant series, even to invent one where none

브라이언 딜런은 저술가 겸 비평가이다. 지은 책으로 《이 거울에 비친 사물》
(2013), 《심기증 환자》(2010), 《어두운 방에서》(2005) 등이 있다. 《가디언》,
《런던 리뷰 오브 북스》, 《아트포럼》에 정기적으로 기고하며, 《캐비닛》 영국
편집장으로 재직 중이다. 런던 왕립 미술대학에서 비평적 글쓰기를 가르치고 있다.

이 글은 타이포잔치 2013에 전시된 존 모건과 알렉스 발지우, 장마리 쿠랑,
6a 아키텍츠의 설치 작품 〈블랑슈 또는 망각〉 안내문 일부로 쓰였다.

existed. As a writer, I aspire to end up in a series, because it seems that is where my book will be most itself.

My Gallimard Prousts smell of decay, and I had better put them away before they infect the laptop on which I'll type this little essay. In a hole burrowed into the spine of Tome III, lie the desiccated remains of a tiny insect, which may well be as old as Priscilla Peyton. But once upon a time—or rather, *il était une fois*—these books sat in serried ranks on shelves in a bookstore in Paris (or Montreal) and broadcast, in their restrained and suggestive style, an endless series of promises.

Brian Dillon is a writer and critic. His books include *Objects in This Mirror* (Sternberg Press, 2013), *Sanctuary* (Sternberg Press, 2011), *The Hypochondriacs* (Farrar, Straus & Giroux, 2010) and *In the Dark Room* (Penguin, 2005). He writes regularly for the *Guardia*, the *London Review of Books* and *Artforum*. He is UK editor of *Cabinet* magazine, and teaches critical writing at the Royal College of Art.

This text was originally published in the handout accompanying the installation *Blanche ou L'Oubli / Blanche or Forgetting* by John Morgan with Alex Balgiu, Jean-Marie Courant and 6a architects for Typojanchi 2013.

반복
repetition

서효인 시인의 시선은 우리 사회 주변부를 살아가는 여러 인간 군상에 머문다. 이들은 백수, 커피숍 종업원, 골프장 캐디, 건설 현장 노동자, 동네 문방구 주인이지만, 개별적인 주체에 머물지 않고 시집 내부에서 하나의 도시에 사는 군상으로 통합된다. 삼류 인생이 보여주는 비주류적 현실은 시인이 속한 80년대생의 상황과도 일맥상통한다. 그 삶 속에서 시인은 날카로운 시선으로 분노하며, 동시에 새로운 서정을 잡아낸다. 서효인은 전남대학교 국어국문학과와 동 대학원 석사를 졸업했으며, 명지대 문예창작과 박사과정에 재학 중이다. 2006년 《시인세계》로 등단했으며, 2011년 두 번째 시집 《백 년 동안의 세계대전》으로 제30회 김수영 문학상을 받았다. 시집으로 《소년 파르티잔 행동 지침》, 《백 년 동안의 세계대전》이 있다. 현재 '작란' 동인으로 활동 중이다.

디자이너 강문식은 디자이너뿐 아니라 다양한 사람의 삶과 행동 양태에 관심을 두고, 주변에 드러나는 사물과 풍경의 배열, 그 이면에 내재한 규칙을 즐겨 관찰하며, 공간과 꿈을 곱씹어 생각하고 그 숨을 느끼곤 한다. 이렇게 마주하는 행동력 가득한 경험에 독특한 시선과 상상이 섞여 거침없이 발랄한 형상으로 발산된다. 계원예술대학교와 암스테르담의 헤릿 리트벨트 아카데미를 졸업했고, 2012 브르노 비엔날레에 참여했다.

서효인과 강문식은 밀접한 협업을 통해 새로운 시를 공동 창작한다. 여행을 즐기는 강문식은 자신이 최근에 다녀온 모로코 풍경을 바탕으로 어휘를 도출하고, 서효인은 그러한 어휘를 중심으로 시를 써낸다. 그렇게 만들어진 〈서울 사막〉은 무수한 요소의 집합과 분산, 불빛과 환영 등 도시와 사막이라는 대조적 공간을 연결해주는 특징을 포착하며 갈망과 허상을 이야기한다.

Seo Hyo In's eyes are always on the various groups on the periphery of our society: the unemployed, waitresses, caddies, construction workers and small stationery shop owners. And their "second-grade" lives

prove resonant with the situation of the generation born in the 1980s, to which the poet herself belongs. In their lives, the poet's sharp eyes capture a new lyricism charged with anger. Seo Hyo In graduated from the Korean literature department of Chonnam University and its graduate school, and is currently studying creative writing at the doctoral program of Myongji University. She debuted in 2006, and earned the Kim Su-yong Contemporary Poetry Award in 2011 for her second collection of poems.

The designer Gang Moon Sick is interested in the lives and behaviors of various people: he likes observing the constellations of objects and landscapes and their underlying patterns, contemplating on spaces and dreams, and feeling their breaths. With imagination, his work vividly captures his observations of the lively experiences. He graduated from Kaywon School of Art and Design and the Gerrit Rietveld Academie, Amsterdam, and has exhibited at the Brno International Biennial of Graphic Design in 2012.

For this work, Seo Hyo In and Gang Moon Sick have collaborated to create a new poem. Gang provided a set of words based on his recent experience of a trip to Morocco, and then Seo composed a poem using the vocabulary. The resulting *Seoul Desert* captures aspects metaphorically shared by the city and the desert (numerous elements gathering and scattering, city lights and mirages), speaking of longings and illusions.

―――――
서효인
1981년생, 한국.

강문식
1986년생, 한국.

Seo Hyo In
Born in 1981, Korea.

Gang Moon Sick
Born in 1986, Korea.

서울 사막

지금 여기의 당신
서울을 견디는 당신
눈을 뜨고 감는 당신
계단을 오르고 복도를 걷는 당신
복권을 사고 적금을 붓는 당신
사막을 걷는 당신
목이 마른 당신

서울은 사막이어서
모래 같은 장맛비
모래 언덕 같은 빙판길
모래 언덕 너머 신기루 같은 한강
나는 약속 없이 당신을 만나기 위해서
은하를 찬찬 바라보며 점을 치며
걸어야 한다
이 역에서 저 역까지
당신, 서울에서 유일하게
나지막한 당신

나는 북아프리카 어느 사막에서
거기를 지나갈 당신의 뒷모습을 떠올린다

사막 한가운데서 은하를 보며
쭈그려 앉아 하루치 여정을 누는 나에게
서울의 당신이 저벅저벅 걸어온다
우리의 걸음걸이는 단단한 모래알갱이를 도시 곳곳에 흘린다

오늘 하루도 고생했어요, 같은 인사로 목을 축이며

서울은 사막이어서
목이 마른 우리는
늘 이런 식으로 만나고는 한다
지금 여기 당신,
사막을 견디며

모래언덕을 넘는
우리.

[서효인 / 강문식, 2013년 신작]

서울 사막

0. 서울과 사막

1.1. 수많은 알갱이들의 집합과 이동 그리고 그것의 반복
1.2. 일정한 패턴으로 이루어지는 행위의 반복성 (일, 동선 등)

2.1. 사막의 신기루 / 서울 밤거리
2.2. 간판 불빛의 환영, 소비되는 도심의 환상
2.3. 서울과 사막을 오가는 시인의 메시지를 서울색을 통해
서울밤의 환영적인 불빛으로 표현.

3.1. 화면의 특성을 이용한 오래된 기법 (비디오 피드백)을 통해
고정된 텍스트의 수 많은 반복적(1) 허상의(2) 개체를 만들어낸다.

4.1. 이 거대한 메시지는 서울에서 합법적이고 가장 큰,
간판의 문법으로 전달될 것이다.

[강문식]

서울 사막
2013. 단채널 비디오. 서울스퀘어 미디어 캔버스 상영용으로 제작.

Seoul Desert
2013. Single-channel video. Created for screening at the Seoul Square
Media Canvas.

반향
reverberation

그래픽 디자이너 폴 강글로프는 다양한 출판 형식과 형태를 연구하고, 그들이 어떻게 폭넓은 사회와 문화, 개념, 욕망과 연관되는지 탐색한다. 암스테르담 헤릿 리트벨트 아카데미에서 그래픽 디자인을 공부했고, 마스트리흐트 얀 반 에이크 아카데미에서 연구자로 활동하며 기록 보관소에서 발견한 펑크 팬진을 중심으로 연구 프로젝트를 진행했다. 저술가, 작가, 큐레이터와 밀접히 협업하며 글 읽기와 쓰기에 관한 워크숍과 프로젝트를 조직하기도 했다. 현재 암스테르담에 거주하며 그래픽 디자이너로 활동 중이고, 헤릿 리트벨트 아카데미에서 디자인을 가르치고 있다.

《메아리의 책》은 2007년 12월 베를린에서 열린 '독자를 위한 심포지엄' 관련 글을 엮은 책이다. 제목이 암시하듯 《메아리의 책》은 두 권의 책이 표지 한 장으로 연결되어 서로 되울리는 구조를 띤다. 따라서 독자는 두 책을 나란히, 즉 네 지면을 동시에 펼쳐놓고 읽게 된다. 오른쪽 책 오른쪽 면에는 에세이 여섯 편이 원래 형태대로 실리고, 왼쪽 책 왼쪽 면에는 그 글에 관해 심포지엄에서 오간 대화가 실린다. 가운데 두 면에는 그 두 글에서 발췌한 일부 구절이 자리한다. 원본은 그에 관한 이야기로 되울리고, 그 이야기는 다시 파편적 인용으로 되울린다.

이처럼 독특한 구조를 활용한 《메아리의 책》은 한 편의 텍스트가 해석과 교환을 통해 담론으로 메아리쳐가는 과정을 그려낸다. 그러나 책의 디자인은 단지 텍스트의 요동하는 삶을 그리는 데 그치지 않는다. 나란히 펼쳤을 때도 한눈에 읽을 수 있는 판형과 명료한 타이포그래피, 우수한 제작 솜씨 덕분에, 《메아리의 책》은 다층적이면서도 수월한 독서 경험을 제공한다. 책이라는 물리적 한계 안에서, 어쩌면 바로 그 한계를 이용해 《메아리의 책》은 전통적 독서 방식에서 벗어나면서도 '무한한 메아리'로 빠져들지 않고 그 소리를 인식 가능한 공간에 담아낸다.

Paul Gangloff's work investigates various forms and formats of publication, and how they are intertwined with broader social and cultural processes, ideas and desires. Gangloff studied graphic design at the Gerrit

Rietveld Academie, Amsterdam, and worked as a researcher at the Jan van Eyck Academie, Maastricht, where he conducted a research project centered on a set of punk zines he found in an archive. He has organized many projects and workshops about reading, writing and publishing, often closely collaborating with writers, artists and curators. Gangloff is currently working as a self-employed graphic designer in Amsterdam, the Netherlands, and teaching at the Gerrit Rietveld Academie.

Echo's Book documents the writings and readings related to the Symposium for Readers (Berlin, December 2007). As the title implies, the book is made of two volumes echoing each other physically interconnected by a sharing cover. The reader is encouraged to read the two volumes opened side-by-side—which means, four pages—simultaneously. The rectos of the right-hand volume presents six original essays, which are reflected by discussions on the texts printed on the versos of the left-hand volume. The pages in between contain fragments of both texts—original essays and their reflections—creating another set of "echoes."

This unusual structure suggests the way a text is echoed as discourse through the interpretations and interchanges. The design, however, does not merely illustrate the life of the texts: the practical format and the clear typography, combined with the superb production, ensure a multi-dimensional yet comfortable reading experience. Within the physical limitations of the printed book, or perhaps thanks to them, *Echo's Book* successfully contains the theoretically limitless echoes of the texts.

폴 강글로프
1982년생, 프랑스.

Paul Gangloff
Born in 1982, France.

writtenrecords.info

메아리의 책
2010. 오프셋, 사철에 표지. 10.5×19.7×2.3 cm, 367쪽. 죈케 할만 엮음.
베를린: 디파트먼트 오브 리딩 / 마스트리흐트: 얀 반 에이크 아카데미.

Echo's Book
2010. Offset lithography, sewn in sections, cover. 10.5×19.7×2.3 cm, 367 pp. Edited by Sönke Hallmann. Berlin: Department of Reading / Maastricht: Jan van Eyck Academie.

power to publicize
introduce new objects and new subjects

DISCURSIVE DEVICES

strategically to
open up ways of thinking
that gain more and more momentum away

consensus on problems

it means new political forms

받아쓰기
dictation

박준 시인은 전위적인 기교나 낯선 시어를 배제하고 전통적인 서정성을 바탕으로 개인적인 경험을 공동의 아픔으로 바꾸어낸다. '그리움', '죄의식', '부재' 등은 그의 첫 시집 《당신의 이름을 지어다가 며칠은 먹었다》에서 자주 마주치는 상황이지만, 이러한 상황은 개체를 넘어 보편적인 공감을 자아낸다. 경희대학교 국어국문학과에서 석사 학위를 받았으며, 2008년 계간 《실천문학》에 시를 발표하며 등단했다.

강경탁 디자이너는 개인적 경험이나 편견을 되도록 배제하고, 주어진 맥락과 큰 틀에서 흐름을 중시하는 태도로 작업을 대한다. 성균관대학교에서 시각디자인을 전공했고, 서울시립대학교 디자인 전문대학원에 재학했다. 커뮤니티 디자인 연구소와 스튜디오 TEXT를 거쳐 지금은 그래픽 디자인 스튜디오 워크룸에서 디자이너로 일하고 있다.

슬픔은 자랑이 될 수 있다

박준 시인의 〈슬픔은 자랑이 될 수 있다〉는 분명 내가 지금까지, 그리고 앞으로도 가장 많이 읽은 시가 될 테지만 나는 아직도 그 시가 주는 의미를 잘 알지 못한다. 그건 박준 시인의 탓이라기보다, 각박한 마음으로 시간을 재는 일에만 익숙한 내가 그의 시를 온전히 읽을 자격을 갖추지 못한 탓이다. 언제부터인가 그의 시를 반복해서 읽다보니 내가 박준 시인의 시를 읽고 있는 건지, 아니면 아무개의 시를 대신 써보는 흉내를 내고 있는 건지 혼란스러워지기까지 했다. 그 무렵 시인에게 그의 시를 멋대로 받아 적는 장면을 보여주었더니, 그는 그것이 마치 내가 시인 자신이 되어서 시를 쓰는 모습처럼 보인다며 호의어린 공감을 표시해주었다. 이 작업은 그렇게 박준 시인의 시를 주제넘게 받아쓰는 일련의 과정을 기록한 것에 다름 아니다. 시인은 평소 한글 2007에서 10.5포인트의 HY신명조로 시를 쓴다고 했다. 어떻게 해도 이상할 것 없는 일인데, 굳이 서체를 고르고 그 크기를 기억한다는 사실이 인상 깊었는지 이후로도 그 일에 대해 생각하곤 했다. 받아쓰는 것만으로도 충분히 힘이 든 나는 이 작업에 사용할 서체를 고를 여력이 없었지만, 여전히 그 의미도 잘 알지 못했다. [강경탁]

Avoiding "cutting-edge" techniques or unfamiliar words and based on traditional lyricism, the poet Park Joon transforms personal experience into communal poignancy. He earned his master's degree in Korean literature from Kyung Hee University, and debuted in 2008. He has published two collections of poems.

The designer Kang Gyeong Tak approaches his work with respect for given contexts and larger resonance rather than his own personal experiences or biases. He studied graphic design at Sungkyunkwan University. He was a designer at the Community Design Institute and the Studio Text, and is currently working at Workroom.

Kang Gyeong Tak admits that, after all the readings and struggles, he "still doesn't understand the meaning" of Park Joon's "Sorrow Can be a Pride." Instead, he turns his attention to his own struggle for comprehension. The resulting work amounts to "a documentation of how I wrote at Park's dictation," Kang says.

박준
1983년생, 한국.

강경탁
1981년생, 한국.

Park Joon
Born in 1983, Korea.

Kang Gyeong Tak
Born in 1981, Korea.

슬픔은 자랑이 될 수 있다

철봉에 오래 매달리는 일은
이제 자랑이 되지 않는다

폐가 아픈 일도
이제 자랑이 되지 않는다

눈이 작은 일도
눈물이 많은 일도
자랑이 되지 않는다

하지만 작은 눈에서
그 많은 눈물을 흘렸던
당신의 슬픔은 아직 자랑이 될 수 있다

나는 좋지 않은 세상에서
당신의 슬픔을 생각한다

좋지 않은 세상에서
당신의 슬픔을 생각하는 것은

땅이 집을 잃어가고
집이 사람을 잃어가는 일처럼
아득하다

나는 이제
철봉에 매달리지 않아도
이를 악물어야 한다

이를 악물고
당신을 오래 생각하면

비 마중 나오듯
서리서리 모여드는

당신 눈동자의 맺음새가
좋기도 하였다

[박준, 2012]

슬픔은 자랑이 될 수 있다
2013. 단채널 비디오. 서울스퀘어 미디어 캔버스 상영용으로 제작. 영상 편집
도움: 김가경.

Sorrow Can be a Pride
2013. Single-channel video. Created for screening at the Seoul Square
Media Canvas. Technical assistant: Kim Gagyeong.

철봉에
오래 매달리는 일은
이제 자랑이
되지 이

눈이 작은
일도
눈물이 많은
일도
자랑이 되지
않는다

192

변신
metamorphosis

김경주의 시는 2000년대 젊은 시인들의 반(反)서정적 전위에 서면서도, 한편으로는 낭만적인 것의 광휘를 거의 폭력적인 수준으로 드러낸다. 그의 시는 연극과 미술, 영화의 문법을 넘나드는 다매체적 문법과 탈문법적 언어의 범람, 그리고 낭만적 감수성의 극한에서 그것이 어떻게 폭발하고 다른 차원으로 넘어가는지를 극적으로 보여준다. 김경주는 서강대학교 철학과를 졸업했고, 한국예술종합학교 음악극 창작과 전문사 과정에 재학하며 동덕여자대학교 문예창작학과 초빙교수로 재직 중이다. 2003년 《서울신문》 신춘문예에 〈꽃 피는 공중전화〉가 당선되어 등단했다. 시집으로 《나는 이 세상에 없는 계절이다》, 《기담》, 《시차의 눈을 달랜다》 등이 있다. 세 번째 시집 《시차의 눈을 달랜다》로 2009년 제28회 김수영 문학상을 수상했다.

디자이너 민본은 스페인에서 라틴 알파벳 글씨체와 활자체의 다면적 양태를 접하고 레딩 대학교에서 활자에 관한 체계적 교육을 받은 바탕에서, 라틴 알파벳과 한글의 형태와 운용 방식을 다각도로 연구하는 폰트 디자인과 이론 작업에 주력한다. 민본은 서울대학교 산업디자인과에서 학사, 스페인 바르셀로나 대학교와 영국 레딩 대학교에서 석사 학위를 받았다. 한겨레신문사에서 기자직 디자이너로, 에스투디오 그루포 에레에서 폰트 디자이너로 활동한 바 있고, 지금은 미국 캘리포니아 쿠퍼티노의 애플 본사에서 근무하는 중이다.

민본은 김경주의 시 〈외계〉에 담긴 다의적 단어들, 대비되고 반전을 일으키는 심상들에 주목한다. 시의 문장과 단어를 구성하는 글자들의 타이포그래피 기본 요소를 변형함으로써 시각적 서사를 표현하며, 그 방법으로는 일정한 축을 따라 글자 형태를 변형해주는 폰트 디자인 소프트웨어 기능을 적극적으로 활용한다.

Kim Kyung Ju's work occupies the anti-lyrical forefront of the 2000s young Korean poets, while almost violently revealing the splendor of the romantic. His poems display multidisciplinary vocabulary and un-grammatical sentences, and how they explode and expand beyond the

edges of emotions. He graduated from the philosophy department of Sogang University, and is studying musical drama at the Korea National University of Arts while teaching as guest professor at Donduk Women's University. He debuted in 2003, and earned the Kim Su-yong Contemporary Poetry Award in 2009 for his third collection of poems.

The designer Min Bon is focused on the relationship between the Latin alphabet and Hangul. He studied visual communication design at the Seoul National University, and earned a master's degree from the Universitat de Barcelona and the University of Reading. He has worked at *Hankyoreh* newspaper and Grupo Erre, and currently is employed at Apple Inc., Cupertino.

Min Bon concentrates on the multiple meanings and contrasting images of Kim Kyung Ju's "The Alien." Min attempts a visual narrative by systematically modifying the characters, using the type-design software functions of interpolation and extrapolation.

김경주
1976년생, 한국.

민본
1981년생, 한국.

Kim Kyung Ju
Born in 1976, Korea.

Min Bon
Born in 1981, Korea.

외계

양팔이 없이 태어난 그는 바람만을 그리는 화가畵家였다
입에 붓을 물고 아무도 모르는 바람들을
그는 종이에 그려 넣었다
사람들은 그가 그린 그림의 형체를 알아볼 수 없었다
그러나 그의 붓은 아이의 부드러운 숨소리를 내며
아주 먼 곳까지 흘러갔다 오곤 했다
그림이 되지 않으면
절벽으로 기어 올라가 그는 몇 달씩 입을 벌렸다
누구도 발견하지 못한 색色 하나를 찾기 위해
눈 속 깊은 곳으로 어두운 화산을 내려 보내곤 하였다
그는, 자궁 안에 두고 온
자신의 두 손을 그리고 있었던 것이다

[김경주, 2006]

외계
2013. 단채널 비디오. 서울스퀘어 미디어 캔버스 상영용으로 제작.

The Alien
2013. Single-channel video. Created for screening at the Seoul Square
Media Canvas.

보편어
universal language

폴 엘리먼은 런던에서 활동하는 작가다. 그는 타이포그래피, 목소리, 몸짓, 출판물, 퍼포먼스, 글쓰기에 이르는 광범위한 매체를 통해 기술과 언어의 관계를 탐구하면서, 흔히 그래픽 디자인이나 처리된 언어의 형태와 용도에 비판적 초점을 맞춘다. 최근에는 탈린 쿠무 에스토니아 미술관(2013), 시애틀 워싱턴 대학교 헨리 미술관(2012-2013), 마스트리흐트 마레스 현대 문화센터(2012-2013), 글래스고 트램웨이 LUX/ICA 동영상 비엔날레(2012), 뉴욕 현대미술관(2012) 등에서 전시에 참여했으며, 2013년 뉴욕 월스페이스 갤러리에서 개인전을 열었다. 예일 대학교와 아른험 베르크플라츠 티포흐라피에 논문 지도 교수로 출강 중이다.

무제(9월호)

'네 눈빛은 누구 돈으로 사는 거야?' 쇼핑 나가려는 참이다. 텅 빈 소매를 펄럭이는 몸처럼, 모르는 것이나 염려를 표하려고 두 어깨를 으쓱하는 동작처럼. 사랑은 저절로 늘어나므로 우리는 옷과도 사랑할 수 있고, 소매는 소매를 느낄 수 있다. 아, 그렇게 사랑스러운 나무에 부는 여름 바람처럼, 격렬한 기쁨마저 느끼면서 버스로 달려갑니다. 뼈다귀 정장을 입은 인물, 그녀 머리 위로 손가락을 튕긴다—더럽게 얼룩진 대리석처럼 금발 몇 가닥이 늘어진 청색 여인, 정거장에서 기다린다. 뒤숭숭하게 팔짱 낀 사람 하나 몸을 기대고, 갑자기 막이 올라가 모습을 들켜버린 다른 장 배우처럼 둘 사이에 뚱하니 선다. 거기. 코듀로이 바지 차림에 캔버스 신발을 신고 어깨에 짙은 머리카락을 드리운 그녀, 두 팔 사이에 얼굴을 파묻은 채 의자 등받이 위로 몸을 굽혔다. 팔뚝 하나가 휘었다. 공원에 앉았다. 런던이나 동네를 걷는다. 네 손을 봐. 진짜야. 차마 그녀 입에 담지 못한 신호. 말 없는 장사. 얼마나 번다고?—글쎄—"암, 그래야지." 아니 그녀는 움직이면서 말했어, 자신이 잡힌 줄도 모르는 동물, 바로 그게 아니야. [폴 엘리먼]

몸의 기술: 인터뷰, 2013년 8월

최성민: 타이포잔치 2013에 전시한 이미지는 당신이 592쪽짜리 '9월호' 잡지를 만

드는 데 쓴 원자료 아카이브에서 발췌한 것이다. 작업 방향 전환을 알리는 작품이라고 보아야 하나?

폴 엘리먼: 꼭 그렇지는 않다. 나는 타이포그래피 작업을 직접 하기—또는 대체로 거부하기—훨씬 전부터 몸짓언어로 소통하는 신체 이미지를 수집했다. 길거리에서 주운 물건으로 타이포그래피 작업을 해보고 나서부터는 그 이미지를 글쓰기 형식과 연관해 생각하기 시작했다.

최성민: 그러한 이미지가 타이포그래피나 문자보다 훨씬 먼저 등장한 몸짓언어와 관련된다고 말한 적이 있다.

엘리먼: 그러나 내가 수집한 이미지는 현대 잡지에서 찾은 것이다. 그처럼 이미지에 집착하는 매체에서, 몸짓언어는 문자보다 더욱 발전된 의사소통 기술처럼 보이기도 한다.

최성민: 문자와 마찬가지로 몸짓도 매체를 통해 중계되고, 때로는 문자처럼 보이기까지 한다.

엘리먼: 일부 형태나 선은 필기체나 알파벳 기호를 닮았다. 수직, 사선, 수평으로 뻗은 팔다리, 직선이나 곡선을 그리는 팔, 십자로 꼰 팔, 흰 등이나 목이 그렇다. 그러나 대부분은 추상적이다. 움직이는 동작이나 정지한 모습이 다 그렇다. 때로는 성적, 사회적으로 약호화한 몸짓이나 자세를 보이기도 한다.

최성민: 그 이미지는 옷이라는 문화적 기호를 통해 소통하는 몸을 보여준다. 그 역시 대량생산에서 영향받아 발전하는 언어일까?

엘리먼: 그렇다. 그러나 나 자신도 몸이고 나도 내 몸의 정체와 욕망에 관심이 있다. 내가 찾은 이미지들은 몸과 관련된 기계 언어의 역사와 몸이 자신의 감각적 기제를 소통하는 방법 사이에서 몸짓을 보려 한다. 나는 전자를 크게 신뢰하지 않지만, 후자는 여전히 믿는 편이다.

Paul Elliman is a London-based artist. Across a range of media, including typography, the human voice, bodily gestures, publication, performance and writing, he explores the relationship between technology and language, often with a critical focus on aspects of graphic design or forms and uses of processed language. His work has been shown inter-

nationally at museums and galleries, recent examples including Kumu Art Museum of Estonia, Tallinn (2013); Henry Art Gallery, University of Washington, Seattle (2012–2013); Marres Centre for Contemporary Culture, Maastricht (2012–2013); Lux/ICA Biennial of Moving Images, Tramway, Glasgow (2012); and Museum of Modern Art, New York (2012). He had his solo exhibition at Wallspace Gallery, New York, in 2013. Elliman is visiting critic at Yale University, New Haven, and graduate thesis supervisor at the Werkplaats Typografie, Arnhem.

Untitled (September magazine)

Who pays for the light in your eyes? I'm about to go shopping. Like a body fluttering its empty sleeve, its mimic motion lifting both shoulders to indicate a lack of knowing or concern. Love extends itself so that we can love even with our clothes, so that a sleeve can feel a sleeve. Ah then, like summer breeze in lovely trees, and not without a certain wild pleasure, I run for the bus dear. Snapping the fingers of one hand over her head, a figure in a suit of bones—she's blue with blonde streaks that look like marble, badly stained, waits at the station. Someone is leaning, restlessly folding his arms, stood sullenly between them, like an actor from another scene caught by the unexpected raising of a curtain. There. In corduroy trousers, canvas shoes, dark hair on her shoulders, bent over the back of her chair, face in her arms. A forearm arched. Sat in the park. Walk in London or on my street. Look at your hand. It's real. A symbol she couldn't have said of what. Commerce without words. How much is he making?—can't tell—and "That's the way to be." No she said in a movement, an animal that didn't yet recognise her captivity, that's just what it isn't. [Paul Elliman]

Techniques of the Body: Interview, August 2013

Choi Sung Min: The images shown here are from an archive of source material used in the production of your untitled 592-page "September magazine." Is this a new direction for your work?

Paul Elliman: Not really, I was collecting images that show the body communicating as a language of gestures well before I found a way to work directly with typography—or mainly against it. A few years later, after working with the found typography of objects, I started to think about these images in relation to forms of writing.

CSM: You've spoken about these images connecting with a gestural language much older than typography or written language…

PE: Also that I find them in contemporary magazines, an image-based media where gestural language also belongs to a more recent technical stage of human communication.

CSM: Gestures mediated just as writing is, sometimes even looking like writing?

PE: Some of the shapes and lines resemble script or alphabetical signs: vertical, diagonal or horizontal limbs; straight, arching or crossed arms, the curve of the back or the neck. But in most cases they seem even more abstract, whether moving or still, even while enacting gender or other socially specific coded gestures or posture.

CSM: And the images show the body communicating via a cultural semiotics of clothing, a further example of language developing under the impact of mass-production?

PE: Yes, but I'm also a body and I'm interested in what the body is or wants. These images try to frame gestural language between a history of mechanical language in relation to the body, something I can't really trust, and how the body communicates its own sensual mechanisms, which I think I can still believe in.

───────

폴 엘리먼
1961년생, 영국.

Paul Elliman
Born in 1961, UK.

무제(9월호)
2013. 오프셋, 무선철에 표지. 22×28.5×2.1 cm, 592쪽. 공동 디자인: 율리
페이터르스. 암스테르담: 로마 퍼블리케이션스 / 런던: 배니티 프레스.

Untitled (September magazine)
2013. Offset lithography, cut and glued, cover. 22×28.5×2.1 cm,
592 pp. Designed with Julie Peeters. Amsterdam: Roma Publications /
London: Vanity Press.

몸의 기술
2013. 복합 매체 설치. 크기 가변.

Techniques of the Body
2013. Mixed-media installation. Dimensions variable.

불가능성
impossibility

스기야마 다쿠로는 일본 효고 현에 거주하며 작업하는 작가다. 그의 회화는 독특하게 굴절된 공간 형상을 특징으로 한다. 그는 기하학적 형태와 제한된 색을 이용해 2차원 구성과 3차원 환영 사이 어딘가에 놓을 만한 형태를 창출한다. 그 이미지는 마치 컴퓨터로 만들어낸 것처럼 보이지만, 실은 작가가 머릿속에서 상상해 작가 손으로 직접 그린 그림이다. 그는 순간의 느낌에 크게 의존하는 직관적 화법을 취한다고 알려졌다.

스기야마의 회화 대부분은 추상에 해당하지만, 거기에는 묘하게도 문자적인 느낌이 있다. 무제 회화에서 빨강으로 구별되어 'O'나 'S'를 떠올리게 하는 요소들이 그러한 예다. 물론 이는 구부러진 요소들이 문자에 집착하는 시각과 만나 우연히 빚어낸 인상일 수도 있다. 그러나 적어도 문자에 집착하는 시각에서 보자면, 파편화된 회색 요소에 뒤얽힌 빨강 형상들은 균열된 구조 사이로 막 솟아나는—또는 거꾸로 그러한 구조에 흔적을 남긴—의미를 시사하는 것 같다.

그리고 알파벳 연작이 있다. 그 연작 회화에 유사 3차원으로 묘사된 구조들은 라틴 알파벳 문자로 쉽게 알아볼 수 있다. 그러나 이는 스물여섯 개 그림이 한 세트로 구성된다는 사실이나, 거기에 '알파벳'이라는 제목이 붙었다는 사실 때문이기도 하다. 추가 정보 없이 따로 떼어서 보면, 각각의 그림은 순수한 추상화처럼 보일 수도 있다. 하지만 알파벳 문자 자체가 이미 추상적인 기호다. 물리적 실체가 없으며, 표상하는 대상과 내적, 구상적 관계도 없는 기호라는 점에서 그렇다. 어쩌면 이러한 이유에서, 알파벳 문자 형태를 나무나 건물, 사람 얼굴이나 신체 등 현실 세계 사물과 연관지음으로써 사후적으로나마 알파벳 문자의 물질적 기원이나 뿌리를 찾으려는 시도들이 있었는지도 모른다.

스기야마의 알파벳 회화는 왜곡되고 부서진 형태를 통해 그러한 시도의 불가능성을 시사하면서도, 구체적 사물을 향한 암시와 중첩된 언어적 기호를 발견하는 즐거움을 인정하는 듯하다. 어쩌면 이러한 지각에는 분열된 표면과 무의미한 자극의 세계에서 의미를 희망하는 마음이 있는지도 모르겠다. 스기야마는 어쨌든 스물여섯 점을 완성할 때까지 계속 그림을 그린다.

스기야마 다쿠로는 2004년 오사카 미술대학교를 졸업하고, 일본, 한국, 타이완, 홍콩 등에서 전시에 참여했다. 오사카의 YOD 갤러리와 스페이스 갤러리 라운디시에서 개인전을 열었다.

Sugiyama Takuro is an artist living and working in Hyogo Prefecture, Japan. His paintings are characterized by a unique sense of distorted dimensions. Using geometric shapes and restrained color palettes, he creates forms that lie somewhere between two-dimensional composition and three-dimensional illusion. The imagery may look digitally processed, but they are conceived solely by the artist's human mind and executed by his hands. His painting process is known to be intuitive, depending much on his spontaneous feelings at the moment.

Although most of his paintings are abstract, there is something curiously textual to them. In his untitled paintings, for example, there are elements highlighted by color—usually red—that remind of the letters "S" or "O." It might be a pure coincidence, the impression accidentally made by the crooked shapes to letter-obsessed eyes. But at least to the letter-obsessed eyes, the distorted red shapes interwoven with the fragmented gray elements can suggest a certain meaning barely emerging out of—or, reversely, leaving its debris around—the fractured structures.

And there are the Alphabet paintings. Characteristically pseudo-dimensional, the structures depicted in the paintings are easily recognizable as representing the letters of the Latin alphabet. But it is partly by virtue of their framing and context: the series name, the fact that there are twenty-six paintings in the set. When isolated and without additional information, each painting can also look purely abstract. Then again, the alphabetic characters are already abstract signs, in a sense that they do not have physical or concrete existence, nor do they have any inherent, figurative relationship to what they represent. Perhaps for this reason, there have been attempts to retroactively establish a material origin or anchor of the letters, by correlating the forms to the actual things in the world: trees, buildings, the human face and the body.

With their distorted and broken shapes, Sugiyama's Alphabet paintings seem to suggest the impossibility of such endeavors, while still acknowledging the pleasure of finding linguistic signs overlapped with the allusions to tangible objects. A hope of communication in the world of disjointed surfaces and nonsensical sensations, one may see. As for Sugiyama himself, he keeps painting until he completes the twenty-six characters.

Sugiyama Takuro graduated from Osaka College of Art in 2004, and has since participated in many group exhibitions in Japan, Korea, Taiwan, and Hong Kong. He has held his solo exhibitions in YOD Gallery and Space Gallery Roundish in Osaka.

스기야마 다쿠로(杉山卓朗)
1983년생, 일본.

Sugiyama Takuro
Born in 1983, Japan.

takuro-sugiyama.com

알파벳 A
2013. 캔버스에 아크릴. 97×130 cm.

Alphabet A
2013. Acrylic on canvas. 97×130 cm.

알파벳 2013
2013. 캔버스에 아크릴. 각각 16×23 cm.

Alphabets 2013
2013. Acrylic on canvas. 16×23 cm each.

212 불신의 유예 suspension of disbelief

《서자 전투》는 디자이너 파네트 멜리에가 2008년 쇼몽 국제 포스터 그래픽 디자인 페스티벌 입주 작가 프로젝트로 셀린 미나르에게 청탁해 만든 소설이다. 1437년 프랑스 쇼몽을 무대로 하는 《서자 전투》는 중세 유럽의 실화에 일본 만화나 중국 무협 영화에서 튀어나온 듯한 등장인물이 뒤섞이고, 중세 프랑스어에 쿵후 용어가 혼합된 환상적 서사로 기묘한 전투 이야기를 들려준다. 마이클 애버먼과 나눈 대화에서 멜리에는 그 텍스트가 "독특한, 거의 영화적인 에너지를 지닌 UFO"라고 묘사한다. 그래서 멜리에는 "미쳐버린 페이퍼백 같은 책을 만들고자 했다. 텍스트에 오염되고 홀린 책을 만들고 싶었다."고 말했다.

가장자리가 검게 물든 지면이 검정 표지에 싸인 그 작은 책을 겉에서만 보면 엄숙하고 신비로울지 모르나 특별히 미친 책처럼 보이지는 않는다. 책을 펼치면 아름답고 단단하게 짜인 본문 지면 틈새에서, 움푹 파인 골짜기에서 (제본이 다소 뻣뻣한 탓에 책은 쉽게 활짝 펼쳐지지 않는다) 색이 배어 나온다. 지면을 넘기다 보면 일부 활자체가 느닷없이 만화 지문을 떠올리게 하는 서체로 돌연변이하고, 검정 잉크는 흐릿하게 번지다가 파랑, 빨강, 노랑 원색으로 분해되기 시작한다. 이런 '오염'은 때때로 너무나 근사한 장관으로 펼쳐져서, 실제로 책이 어떤 불가해한 힘에 사로잡힌 것처럼 느껴지기도 한다. 그러나 멜리에가 구사한 기법은 너무도 자연스럽고 사실적이어서, 독자는 책이 원래 그렇게 디자인되었다고 판단하기보다 자신이 읽는 그 책에 어떤 일이 벌어진 것이 틀림없다고 믿고 싶어진다. 불신의 유예—《서자 전투》는 그 문학 장치가 타이포그래피에도 적용될 수 있으며, 그로써 보강될 수도 있다는 점을 입증한다.

파네트 멜리에는 2000년 스트라스부르 장식미술대학교를 졸업하고, 전시회 포스터, 미술관 도록, 예술가 서적 등 주로 문화 기관과 연관된 타이포그래피와 디자인을 중심으로 작업해왔다. 상업적 프로젝트와 자율적 연구 작업을 병행하는 그녀는 흔히 인쇄물의 물질성을 드러내는 접근법을 취하곤 한다. 멜리에는 2012년에서 2013년까지 로마의 프랑스 아카데미에서 입주 디자이너로 활동했다.

Bastard Battle is a novel by Céline Minard, commissioned and designed by Fanette Mellier as part of her residency project at the 2008 Chaumont International Poster and Graphic Design Festival. A story of a strange battle in Chaumont, 1437, the novel intermingles an account of a real historical event with characters out of Japanese *manga* and Chinese sword movies, punctuating Old French language with references to *kung fu*. "The text is a UFO with a peculiar, almost cinematic energy," says Mellier in a conversation with Michael Aberman. "I wanted the book to look like a paperback… that has gone crazy. As if the contaminating text has possessed the book."

At first glance, the small book with black cover and black-edged pages looks somber and mysterious, but perhaps not particularly crazy. Open the book, and one notices that between solid columns of beautifully set text and out of the deep gutter (the binding is rather stiff and the book resists easy opening), bright colors are shedding. Keep reading on, then the typeface starts mutating sporadically into something alluding to comic strips, the black ink blurring and separating into the primary colors of yellow, cyan and magenta. At certain pages, the "contamination" is so spectacular that the book does look possessed by some inexplicable force. But the treatment is seamless and natural, and one is tempted to imagine that something must have happened to this particular copy, not that it was designed that way. Suspension of disbelief—*Bastard Battle* demonstrates that the literary device can also be applied to, and reinforced by, typography.

Fanette Mellier graduated from École supérieure des arts décoratifs de Strasbourg in 2000. Her activities are centered on typography and design of exhibition posters, gallery catalogs, artist's books and other projects for cultural institutions. Combining commissions and self-initiated researches, her work often addresses the materiality of printed objects. From 2012 to 2013, she was a designer-in-residence at the Académie de France in Rome (Villa Medicis).

파네트 멜리에
1977년생, 프랑스.

Fanette Mellier
Born in 1977, France.

fanettemellier.com

서자 전투
2008. 오프셋, 무선철에 표지. 12×18×1.2 cm, 112쪽.
셀린 미나르 지음. 파리: 디소낭스 / 쇼몽: 폴 그라피즘. 쇼몽 국제 포스터 그래픽
디자인 페스티벌 입주 작가 프로젝트로 제작.

Bastard Battle
2008. Offset lithography, cut and glued, cover. 12×18×1.2 cm, 112 pp.
Text by Céline Minard. Paris: Éditions Dissonances / Chaumont: Pôle
graphisme. Produced during residency at the Chaumont International
Poster and Graphic Design Festival.

Quant à lui le bastard, sans qu'on le vit, s'était faufilé par dessous la guérite puis laissé rouler sur le bas-costé suivant la descente.

Et ses hommes, bargouyllant dans l'eau glacée des fossés, fléchés par le haut, mordus saisis par en bas, clabaudent de sa race.

Ainsi les voyant défaicts ou sur le point de l'être, Enguerrand assemble les chevaux pris, fait monter et armer ses chevaliers et ainsi par la porte de l'Eau sortent-ils à grand galop, bannière haute et claquante, sept samouraïs au soleil levant! Nous aultres à pieds, les suivant. *Vipère-d'une-toise* et son eschole, moy les boyteurs, *Tarras* claudiquant à peine atout ses tapeurs. Et dans le *pré du* faubourg des tanneries où s'était joué *un tournoi* pipé et trompeur, de vaincre nous prend la fureur. Et la *fureur* nous portant, nous chargeons fort, gueulant à tout *gorge*, beau langage des armes, bien sonnant, taillant et frappant à mille braz, de force décuplés, vironnés par mi moult gerbes de sang, trempés de rage et *revanche*, nous les pilons comme grains moustarde sur mortier.

En petit d'heure, ceulx qui le peuvent se retirent en valdrague à vau-de-route par les chemins de Troyes, de Châteauvillain, par les champs, par la Suize en glissant, et

et du roy. De cette ville que ce bailly n'a pas su défendre, il saura vous chasser, je vous le dys! Croyez à la justice et grand bien vous fasse! Crétins de pute extrace!

Lors Enguerrand faisant mine de lui courir sus, on le vit piquer des deux et s'évanouir dans les boys.

Toy, sur le pré des tanneries, aux six coups de midi, alors que le bastard tout juste s'en est enfui, par mi le rire multiense qui nous prit comme un seul corps accordé, cette hystoire pourrait bien finir.

Mais qui le peut dire?

Les sepmaines et les mois?

Les années?

Boudricourt recouvrit son baillage comme prédit.

Vipère-d'une-toise dû laisser son dojo, emporta ses escholiers par ailleurs, partout si j'en sais, fors la contrée.

Le bastard se reti.. Pilla le Berry.

Son frère Guy fut appelé par le roy en Guyenne et pensionné, établi capitaine général de baronnie.

Enguerrand retourna dans sa capitale de Valence, devient, à tout honneur, revoir sa belle.

Ceulx de Chaumont, Jeannette le Rosty, Vuillemin Gras Pourcel, les gens des estuves et tous tisserands ou tonne-

비밀
secret

그래픽 디자이너 김상도는 서울 상수동에서 스튜디오 PL13을 운영하고 있다. 낭독 모임 펭귄 라임 클럽, 아마추어 7부 리그 견자단 탁구 클럽 회원이다. 시인 김경주의 《밀어》에서 그가 구사한 타이포그래피는 단단히 모였다가 한순간에 흐트러지는 글자들의 운율을 통해 산문에 시적 감성을 부여한다. 도입부에 굽이치며 펼쳐지는 글자는 책에 실린 신체 사진과 대구를 이루고, 꼼꼼하게 짜여 배치된 주석들은 출렁이는 본문에 닻을 달아준다. 《밀어》는 시와 에세이와 미학서의 경계에 선, 새로운 장르의 문학으로 평가받는다. 이러한 평가는 이 책의 디자인에도 적용할 수 있다.

밀어

밀어는 몸에서 비롯한 몽상과 그 몽상이 가진 몸을 그린 책이다. 저자의 시선은 몸을 붙잡았다가 그 몸을 지우고 언어로 건너간다. 매혹적이거나 또는 곤혹스러운 이 낱낱의 여정들을 부스러져 흘러내리는 페이지들에 담으려고 애를 썼다. [김상도]

The graphic designer Kim Sang Do is running his studio, PL13, in Sang-su-dong, Seoul. He is a member of the reading group Penguin Rhyme Club and the level-7 amateur Gyeonjadan Ping Pong Club. His lyrical typography for Kim Kyung Ju's book *Secret Language* gives the essay a poetic rhythm. The meandering typography on the prelim pages interplays with the images inside, while the solid footnotes work as anchors for the fluid text. *Secret Language* is considered to have pioneered a unique space between poetry, an essay and an aesthetic study: the same can be said about its design.

Secret Language

Secret Language illustrates the fantasies of the body and the body of the fantasies. The author's gaze captures and erases the body, and then flies over to the language. I have tried to contain all the fascinating or perplexing moves in the crumbling and spilling pages. [Kim Sang Do]

김상도
1970년생, 한국.

Kim Sang Do
Born in 1970, Korea.

밀어
2012. 오프셋, 사철에 판지, 커버. 14.2×21×2.9 cm (지면 크기
13.5×20.3 cm), 384쪽. 김경주 지음. 전소연 사진. 파주: 문학동네.

Secret Language
2012. Offset lithography, sewn in sections, cased, dust jacket.
14.2×21×2.9 cm (page dimensions 13.5×20.3 cm), 384 pp. Text by
Kim Kyung Ju. Photography by Jeon So-yeon. Paju: Munhakdongne.

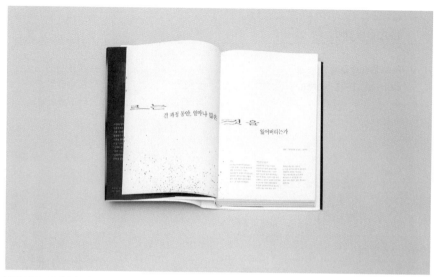

르는 긴 과정 동안, 얼마나 많은 것을 잃어버리는가

사전
dictionary

진은영은 시인이자 사회운동가이고, 대학 강단에서 니체의 철학을 강의하며, 시의
정치성 논의를 촉발시킨 문학 이론가이기도 하다. 그의 시는 우리 시대의 정치, 사회
적 위기에 민감하게 대응하면서도 미학적 긴장감을 놓지 않는다. 알레고리와 풍자,
아이러니로 무장한 화법은 이른바 '정치 시'도 아름다울 수 있다는 것을 보여준다.
진은영은 이화여자대학교 철학과를 졸업하고 같은 대학원에서 박사 학위를 받았다.
현재 이화여자대학교 HK 연구교수로 재직 중이다. 2000년 《문학과 사회》에 〈커다
란 창고가 있는 집〉 외 3편을 발표하면서 등단했다. 2010년 제56회 현대문학상 시
부문, 2009년 제14회 김달진 문학상 젊은 시인상을 받았다. 시집으로 《일곱 개의
단어로 된 사전》, 《우리는 매일매일》, 《훔쳐가는 노래》가 있다.
　디자이너 김병조는 타이포그래피 공간의 구조에 관한 연구로 홍익대학교에서 박사
학위를 받았다. 광학 문자인식(OCR) 기술 개발 회사에 근무하면서 개인 작업과 타
이포그래피 강의를 병행하고 있다. 한국타이포그라피학회 출판국장으로 《글짜씨》
발간을 담당한다.
　김병조와 진은영의 〈일곱 개의 단어로 된 무중력 슈퍼 사전〉은 우리의 세계를 시
인과 디자이너가 새롭게 번역하고, 이름 붙여진 것들을 새롭게 명명한 그들만의 사
전으로 꾸며진다.

Jin Eun Young is a poet as well as a social activist teaching Nietzsche,
and a literary theorist who has provoked a debate on the politics of po-
etry. Her work maintains aesthetic tensions while responding to political
and social issues. Armed with allegory, satire and irony, her poems dem-
onstrate that political poetry can be beautiful, too. She studied philoso-
phy at Ewha Womans University, and earned a Ph.D. from the graduate
school. Currently she is HK research professor at the same university.
Debuted in 2010, she earned a Kim Dal-jin Award in 2009 and a Modern
Literature Award in 2010. She has published three collections of poems.

The designer Kim Byung Jo earned a doctorate from Hongik University for a study on the structure of typographic space. Currently he is an in-house designer at an OCR technology firm, while working on his own projects and teaching typography. He is director of publication of the Korean Society of Typography.

In this exhibition, Jin Eun Young and Kim Byung Jo present their own dictionary, attempting to translate our world and name the already named in a new way.

진은영
1970년생, 한국.

김병조
1983년생, 한국.

Jin Eun Young
Born in 1970, Korea.

Kim Byung Jo
Born in 1983, Korea.

일곱 개의 단어로 된 사전

봄
봄, 놀라서 뒷걸음질치다
맨발로 푸른 뱀의 머리를 밟다

슬픔
물에 불은 나무토막, 그 위로 또 비가 내린다

자본주의
형형색색의 어둠 혹은
바다 밑으로 뚫린 백만 킬로의 컴컴한 터널
—여길 어떻게 혼자 걸어서 지나가?

문학
길을 잃고 흉가에서 잠들 때
멀리서 백열전구처럼 반짝이는 개구리 울음

시인의 독백
"어둠 속에 이 소리마저 없다면?"
부러진 피리로 벽을 탕탕 치면서

혁명, 눈 감을 때만 보이는 별들의 회오리
가로등 밑에서는 투명하게 보이는 잎맥의 길

시, 일부러 뜯어본 주소 불명의 아름다운 편지
너는 그곳에 살지 않는다

[진은영, 2003]

자, 밤은 길고
자신을 평가하는 모든 시인은
자신의 고유한 사전을 가져야만 한다
— 파라

1
미디어 파사드에 영사될 시는 책 속의 시와 달라야 한다.
매체에 현혹되거나 (또는 매체를 현혹하거나) 그럴듯하게 겉모습을 치장하는
수준에 그쳐서는 안 된다.
나는 그 시가 어떤 식으로든 원작의 변형이 아닌, 다른 차원의, 다른 작품이었으면 한다.
무중력. 뉴타입.

2
출판 기술로서 타이포그래피는 선동적인 면이 있다.
책상 위의 책이 아닌, 도심의 거대한 미디어 파사드 속 타이포그래피라면
더욱 그럴 것이다.
나는 이 프로젝트가 누군가를 기다리는 책 속의 시를 끄집어내어 사람들에게
던지는 것 같다.

3
시인 진은영은 〈일곱 개의 단어로 된 사전〉을 '절망의 순간 외치는 일곱 단어'라고 말했다.
이 시는 아름다울 뿐 아니라 정치적이고 선동적이다.
그렇다면, 나는, 타이포그래피는, 미디어 파사드는 무엇을 해야 할까?

4
〈일곱 개의 단어로 된 사전〉은 세상의 변화를 꿈꾼다.
그렇다면 이 프로젝트가 그 확장으로서 사람들을 시로 끌어들이면 어떨까?
사람들이 고른 여덟 번째 단어. 슈퍼텍스트.
무한개의 단어로 된 우리 모두의 무중력 슈퍼 사전.

5
일곱 단어를 표현한 그래픽은 책 속의 삽화와 같다.
기억 속의 시와 눈앞의 그래픽, 기억 속의 그래픽과 눈앞의 시의 배열로서
타이포그래피.
물론 이는 그다지 중요한 것은 아니다.

6
봄, 두려운 희망
슬픔, 안에도 밖에도 비
자본주의, 형형색색의 백만 킬로 터널
문학, 빛나지 않는 별
시인의 독백, 부러진 피리의 춤
혁명, 꿈같은 별들의 회오리
시, 주소 불명의 편지
∞, 그래도 희망

[김병조]

일곱 개의 단어로 된 무중력 슈퍼 사전
2013. 단채널 비디오. 서울스퀘어 미디어 캔버스 상영용으로 제작.

Super Dictionary with Seven Words in the Air
2013. Single-channel video. Created for screening at the Seoul Square
Media Canvas.

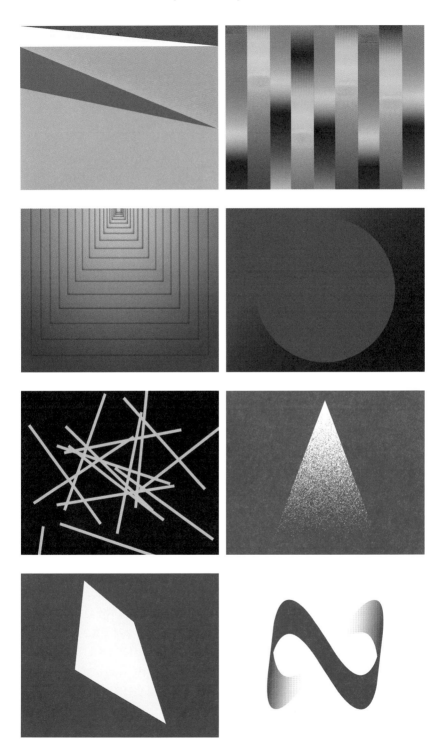

226

상동
same

프란체스코 스팜피나토가 오베케라는 이름을 처음 들은 것은 전자음악 레이블 겸 전형적인 파리지앵 패션 브랜드 기쓰네를 알게 된 2002년이었다. 사실 기쓰네는 오베케의 우주에서 하나의 은하계—대표적이지도 않고 그저 부수적인 은하계—일 뿐이다. 런던 디자인 스튜디오 오베케의 이면에는 패트릭 레이시, 뱅자맹 라이헨, 카이사 스톨, 마키 스즈키가 도사리고 있다. 2000년부터 활동을 시작한 이들 왕립 미술대학 졸업생들은 영국문화원이나 서펀타인 갤러리 등을 클라이언트로 거느리고, 후세인 샬라얀과 메종 마르탱 마르지엘라 등 패션 디자이너, 라이언 갠더와 요한나 빌링, 마르티노 감퍼 등 예술가, 에어나 대프트 펑크 같은 밴드와 협업을 벌이기도 했다.
　하지만 크고 거추장스러운 물건을 뜻하는 스웨덴어 '오베케'가 암시하듯, 그들이 디자인 주문을 받아 일하는 이유가 실은, 그 규칙과 관습을 익혀 다른 기회에 부숴버리려는 데 있지는 않은지, 스팜피나토는 의심한다. 실제로 오베케는 독립적이고 학제적이며 집단적이고 참여적인 여러 메타 디자인 프로젝트에 책임이 있다. 디지털 건축 플랫폼 《섹시머시너리》(2000-2008), 관계적 요리 행사 《트라토리아》(2003), 출판 사업 당들레온(2009), 가상의 빅토리아 앨프리드 미술관 선전물(2010), 첩보 기관 오피스 스즈키(2010) 등이 그에 해당한다.
　오베케는 미술계에서 끊임없이 관심을 끌고 있다. 그들의 프로젝트는 대부분 기능성이라는 기준을 만족시키지 않고, 오히려 디자인이 문화 전파 형식을 어떻게 실어 나르는지 질문한다. 실제로 출판과 전시 기획, 강연, 워크숍은 그들의 활동에서 중추를 이룬다. 스팜피나토가 예술 창작 집단에 관한 자신의 책에 그들을 초대했을 때 오베케는 조건을 하나 달았다. 스팜피나토가 이 작가 소개 글을 써주되, 자신의 이름을 삼인칭으로 본문에 삽입해야 한다는 조건이었다. "그래야 소개 글의 저자가 드러난다"는 이유도 있었지만, 또한 그럼으로써 비평가의 역할과 그가 문화 현상에 지적 가치를 연계하는 조건을 위기로 내몰려는 의도도 있었을 것이다. [프란체스코 스팜피나토]

2001년부터 오베케는 '기생' 잡지 《나는 아직 살아 있다》를 발행해왔다. 다른 출판물 지면을 빌려 발행되는 그 잡지는 협업을 강조하는 오베케의 작업 방식을 반영하는 한편, 간행물의 독립성과 통일성에 의존하는 관습적 저자 개념과 출판 개념에 질문을 던진다.

이 책에 실린 《나는 아직 살아 있다》 24호는 쌍둥이 도시를 짓는 쌍둥이 자매에 관한 소설을 쓴 쌍둥이 자매의 가상 인터뷰 형태를 띤다. 인터뷰 내용은 디도/보도니와 헬베티카/에어리얼 등 쌍둥이 서체에 실리고, 쌍둥이 사진작가가 찍은 쌍둥이 자매의 (쌍둥이) 사진과 함께 제시된다. 이를 통해 오베케는 정체성, 중복, 차이와 반복 같은 개념을 성찰하는 한편, 그러한 개념들이 어떻게 타이포그래피로 전달되고 구현되는지 드러낸다.

The first time Francesco Spampinato heard the word Åbäke dates back to 2002, associated with electronic music label Kitsuné, which is also a quintessential *parisienne* fashion brand. In fact Kitsuné is just one galaxy—collateral and not even representative—of the Åbäke universe, a London-based design studio behind which lurk Patrick Lacey, Benjamin Reichen, Kajsa Ståhl and Maki Suzuki. Active since 2000, the Royal College of Art alumni count clients like the British Council and the Serpentine Gallery, and collaborations with fashion designers such as Hussein Chalayan and Maison Martin Margiela, artists such as Ryan Gander, Johanna Billing and Martino Gamper, and bands such as Air and Daft Punk.

As the term Åbäke suggests, however, the Swedish word for a large and cumbersome object, Francesco suspects that the group supports the burden of design on commission only to learn rules and conventions that it is happy to deconstruct at other times. Åbäke, indeed, is also responsible for meta-design projects, independent, transdisciplinary, strictly collective and often participatory: the dialogical digital platform for architecture *Sexymachinery* (2000–2008), the relational culinary events of *Trattoria* (2003), the publishing project Dent-De-Leone (2009), the propaganda for the imaginary Victoria & Alferd Museum (2010), and the spy agency Åffice Suzuki (2010).

For Åbäke constantly attracts the attention of the art world: most of its projects do not certainly meet criteria of functionality, but raise questions about how design conveys the forms of transmission of culture. Publications, curatorship, talks and workshops, indeed, are integral parts of their activities. So when Spampinato invites the group to be part of his book on art collectives, Åbäke agrees to contribute if Francesco writes in exchange this biography, inserting himself, "so it isn't authorless," in third person, putting thereby in crisis the role of the critic and

the conditions under which he normally associates intellectual values to cultural phenomena. [Francesco Spampinato]

Since 2001, Åbäke has been publishing the "parasite" magazine *I Am Still Alive*, which takes place on the pages of other publications. Depending on the donated spaces, it embodies the collaborative nature of Åbäke's own practice, while challenging the conventional notion of authorship and publishing that largely relies on the independency and integrity of published artifacts.

The 24th issue of *I Am Still Alive*, published in this volume, takes the form of a fictional interview with two twin sisters who write a novel about two twin sisters who are building a twin city. The story is set in twin typefaces, Didot/Bodoni and Helvetica/Arial, and presented with (twin) pictures of two twin sisters and their twin photographers. Along the way, it contemplates on the notions of identity, doubling, difference and repetition, and how all these are conveyed by and embedded in typography.

오베케
2000년 설립, 런던: 패트릭 레이시, 1973년생, 영국 / 뱅자맹 라이헨, 1975년생, 프랑스 / 카이사 스톨, 1974년생, 스웨덴 / 마키 스즈키, 1972년생, 프랑스.

Åbäke
Founded in 2000, London: Patrick Lacey, b. 1973, UK; Benjamin Reichen, b. 1975, France; Kajsa Ståhl, b. 1974, Sweden; and Maki Suzuki, b. 1972, France.

abake.fr

나는 아직 살아 있다, 24호: 상동, 문을 조금 열어놓았군
2013. 오프셋. 140×225 cm, 16쪽. 사진: 나승, 나진. 모델: 김현경, 김현진.
타이포잔치 2013 전시 도록에 실려 발행.

I Am Still Alive, no. 24: Same, You Left the Door Ajar
2013. Offset lithography. 140×225 cm, 16 pp. Photography by Na Seung and Na Jhin, featuring Kim Hyunkyung and Kim Hyunjin. Published as part of Typojanchi 2013 exhibition catalog.

SAME
YOU
LEFT
THE
DOOR
AJAR

I am Still Alive 24, a prastical magazine by ábáke (images and texts, unless otherwise stated). Thank you Miwa H. Vox, Miwa H. Vox, Min Choi, Na Kim and Typojanchi 2013. Cover photography: Na Seung & Na Jhin, models: Kim Hyunkyung & Kim Hyunjin; inside colour photography of Na Seung & Na Jhin by Kim Hyunkyung & Kim Hyunjin; Peter Pan monument in Brussels & London photographed by ábáke.

Past issues: #1 in Rebel Magazine 2, automne hiver 2001–2, insert poster p. 50 (FR); #2 in Super, Welcome to Graphic Wonderland, 2003, ISBN 3-89955-005-6 (CH); #3 in Communication What?, Ma Edizioni, pp 120–7, 2002 (I); #4 in IDEA 297, 2003 pp 99–114 (JP); #5 in Sport and Street, April 2003 (I); #6 in Sugo 0, Ma Edizioni, pp 16–25, 2003 (I); #7 in idri:2003:three:volume 10:number 3: flight of fancy ii special insert (HK); #8 in Sugo 1, Ma Edizioni, pp 112–9, 2004 (I); #9 in A Magazine 1, Flanders Fashion Institute, 2004 ISBN 90-77745-01-7, pp 75–80 (B); #10 in Graphic Magazine 7, Bis, 2005 ISBN 90-6369-092-4, pp 149–56 (UK); #11 in IDEA 309, no.1–8, Feburary 2005 (JP); #12 in Lodown 45, March 2005 (D); #13 in Math 2, May 2005, www.posikids.org (UK); #14 in CREAM, Autumn Edition 2005 Issue.02, pp 231–47, 2005 (HK); #15 in CREAM, Summer Edition 2006 Issue.05, pp 250–66, 2006 (HK); #16 in Spring X Maison Martin Margiela 6, 2007–2008 edition (J); #17 in Apartamento, Issue 01, pp 49–64, 2008 (I); #18 in CREAM, Edition 2008 Issue 09 (HK); #19 in GRAPHIC 11, Ideas of Design Exhibition Autumn 2009 ISSN 1975-7905 (KR); #20 in TAR mag Fall issue no. 4, 2011 ISSN 1943-3794 (I); #21 in Graphic Design: Now In Production ISBN 978-0935640984 (US); #22 in Umool Umool vol. 10 isbn 978-90-802700-6-0 (KR); #23 in The Real and Other Fictions, 2013 The Lisbon Triennale, ISBN 9789899851313 (P)

follow exactly the transcripts of what we just said. Try to read it as if it was the first time. Are you game?

á: yes of course.

SAME, YOU LEFT THE DOOR AJAR,
published by Dent-De-Leone
will be out tomorrow.

Miwa H. Vox and her sister Miwa H. Vox wrote
Same, You Left The Door Ajar, a novel
about two twin sisters who build a financial
empire and endeavour to construct a
replica of Las Vegas after the gambling
ban of 2038. The undisclosed
location appears to be in Europe
although no country would
perfectly fit the descriptions
found in the text. We follow
8 inhabitants in each cities
crossing each other's
lives over 50 years
during which the
same new buildings
are added to both
the "original"
and the
copy.

publication this is going to be in is read by people I think get the joke.

M H. V: It was not just a joke, I really thought the whole issue was just a pernicious pastiche of a dozen of street trends. OK, fashion is very much that I somehow had to do it. They saw it once printed and fired me. I think they reprinted it although a friend showed me the version I made so they exist in the world.

å: The only thing I thought a little far fetched in your story is the displacement of historical building from Europe to Vegas then from Vegas to New Vegas. I know the Abu Simbel case but that was pretty extreme.

M H. V: The statue of Liberty was built in Paris before being sent to NY and London Bridge was bought and re-built stone by stone in the middle of the Nevada desert... give me a second [Miwa goes to the toilet. This detail seems now worth mentioning]

å: Ah, "you" are back. I knew the examples of London Bridge and the statue of Liberty.

M H. V: Sorry I have to go to the loo so often, I drank too much tea. Anyway I need to go very soon.

å: OK, sure, so tell me again your request for this interview?

M H. V: I would like you to interview my sister but this time you both

Miwa H.Vox: When I was young, I thought twinned cities were built at the same time following the same urban planning and architecture. You know the signs when you drive into a city? It states the name of the place but there are other metal signs with names of different places, sometimes with the flag of the country. The bigger the city, the more numerous the twinned locations. This was a fascinating prospect even though I never really wanted to visit the "other" cities. I suppose I did not have to as I knew, I thought I knew they were exactly the same. As a student I would have visited them but by then I had realised it was just an administrative link.

åbäke: What about people, what about their clothes or behaviour? Did you think they would be the same people, doppelgänger of some sort? You have a twin sister, did you think people were "mirrored" in those cities?

M H. V: Before writing the story I never questioned how the people would or should be. Even at a young age I could see the evil in conformism and in the bliss of childhood I could not conceive a state dictatorial enough to oblige people to behave in exactly the same way. No, for

possible to see both of them at the same time but if you look at the Napoleonic engravings of Luxor, an impressive book the size of this table when closed, it is very clear that one is smaller than the other. However, they placed the smaller of the two closer to whoever would be facing the gate, creating the illusion that they are the same size. Why did they do this? It is a unique occurrence in the whole of Egypt. Is it just a mistake? Difficult to believe they would have corrected a measurement mistake. Whatever the reason it seems to me that they are more interesting because of this defect.

å: Are you taller than your sister?

MHV: I am shorter but in the next interview she will also tell you she is shorter.

å: tell me about *Vogue* and why you got fired.

MHV: I needed a job and I somehow ended up doing bits and bobs at *Vogue*, people were stressed and there is a lot of running around. I once went to the graphic designer's office and decided to change the *Vogue* logo typeface from their specific version of Bodoni to Didot. Should I explain?

å: No, it's ok, the

me it was clearly an architectural project: two cities, made to look exactly the same but people were living different lives with different languages and different cultures. Just like in my story, the same modernist apartment complex in a low income ghetto is a dangerous ruin in which a family of 12 lives while on the other side of the planet, the building has been over gentrified and is lived-in by a young artist couple who cannot believe their luck of showering in a building which features in every serious book as a turning point in postwar architecture.

å: It is as if two multiverses were sharing the same reality, a slightly sick experiment to separate twins at birth and see what happens?

M H. V: Yes, an ant farm on the scale of the city. I suppose most people do not even know there is the exact church, the exact street furniture on which they were sitting, waiting for the same bus, the same apartment, same cupboard etc. but some people do and decide to go and see the other one, sometimes even moving there for good.

å: In your book you focus on several social groups in which people slowly become very similar.

M H. V: When I was 16 there was this cool kid who

Egypt. What I like is that because they are so far away, it is not so much about comparing them. They have different history and the different weather has worn them in a different way. The bases are different, one has bronze crabs supporting it, the other mock sphinxes, one is by a river, the other in Central Park. The UK one has a stone base in which there is a Victorian time capsule. It even contains a small replica of itself.

å: Yes, you speak of it in your book in which all the contentious monuments and museum artefacts in the western world are remade and sent "back" to the original countries. I particularly liked the London obelisk being sent back by boat with the exact same boat it came in.

M H. V: Yes, it is designed so it looks as if it goes backwards in a ridiculous yet spectacular way to literally "rewind" history. The obelisk in Paris is very different. It is much more recent and looks almost new. Its base shows the process of its transport and constitutes today an added historical fact. The second obelisk is still in Egypt. What is slightly less known is that this pair is not identical. Difficult to compare of course because it is not

somehow managed to get the *NME* and *Melodymaker* every week. We were impressed by his knowledge in a specific form of music, especially the English indie scene somehow created by Thatcher [laughter], I guess the legacy of this woman was to establish the misery from which incredible creativity had to emerge… Anyway this kid had the whole thing: attitude, clothes, knowledge. I was his friend but the moment I decided to look into the music, and it was before iTunes or even internet, I became an expert in less than three months. I knew what to wear, where to find it and all my money would go into what was a small niche in music. There was nothing strategic about it, it was very natural and inherently a self-taught situation. You know, when you are interested, the learning is fast. I spoke of Ian Curtis as if I had known him even if he was dead before I was two years old! Little by little I realised I was selecting my friends in the same way and we all looked the same, lost weight in the same way, despite the different bands we sported T-shirts of, we were a slightly ridiculous tribe just like in *The Warriors*. Feeling different while looking exactly the same and knowing the same things. The

…best friends so I don't believe in this sharing boyfriend/girlfriend stories, unless you really don't know your partner.

M H. V: I agree even if it still startles me to see twins on the street.

ā: yes. In your case it is difficult to distinguish because you deliberately pretend to be the other. Is this at all times? I mean you changed your respective names to the same first name and it seems you wear the same clothes but more disturbing is that I never heard you appear publicly or privately together. How do we even know the other exist?

M H. V: We do see each other privately but only if no one else is around. We have double nationalities. Because of our family situation, I am French Italian and my sister is Canadian Argentine. It took a little persuasion but when we both changed our name to Miwa H. Vox it resulted in effect in having four passports. Do you know the Cleopatra's needles?

ā: Yes, the obelisks in Paris and London?

M H. V: There is another one in Central Park New York. They are two different pairs. The London and NY needles are twins, while the one in Paris still has a twin in

whole indie period only lasted 7 months but by then I knew everybody,
had written fanzines and became groupie of some minor bands
which made it big a few years later. It is however a very influential
time and I speak of those "indie" years—although it did not
even last one—very often. With time, I do not control the
exaggerations anymore and despite being aware of it,
I don't know how much of what I recall is true.
Have you seen the photos of Stacey Garduno? I think
she was from New York. Her work was a series of
group pictures of those tribes such as goths, jocks,
rockabillies and the like, music related social
groups who I believe she infiltrated, learned the
codes and got accepted before disappearing
from that scene. In the different group
pictures, she is always in the middle. I met
an ex-lover of hers, who at 43 is still a
Cure fan and dress like Robert Smith.
He is a non violent person except he
will kill her if their path cross again.

å: You have a twin sister and
both your parents are twins.
Isn't this too much?

M H. V: Too much? Did
you know Edward
Bernays who wrote
Propaganda was
the double
nephew of
Freud?

å: Did you
ever go
to twin
to twin festivals?

M H. V: Gathering of twins? No, it seems to me it is for other people.
a form of exhibitionism. I have a special relationship to my sister
but I don't think twins or triplets are more interesting than
anybody else. It could even be that by being together it divides
a personality in two. I don't think of finishing each other's
sentences as a particularly bonding experience. It
certainly bonds others in hating those who do it.

å: What about the cliché about twins, being
mischievious, having the same boyfriend,
cheating at exams?

M H. V: Since we started the interview you
probably noticed I went to the loo often. This
is the third time I swap with my sister. We
sometimes do this to make the Q&A
more interesting. We have had same
boyfriends but I don't think it was at
the same time and before you ask,
no, we never dated twins or at
least to our knowledge.

å: I think identical twins never
really look similar. I mean
they do at first but the
moment you know then
it becomes obvious
the physical traits
and even the
body languages
are as
different as
in other
siblings
or

6

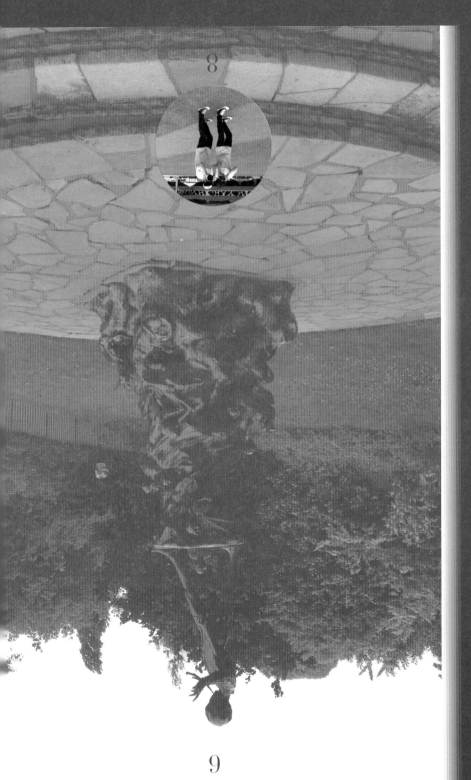

festivals?

M H. V: Gathering of twins? No, it seems to me it is for other people, a form of exhibitionism. I have a special relationship to my sister but I don't think twins or triplets are more interesting than anybody else. It could even be that by being together it divides a personality in two. I don't think of finishing each other's sentences as a particularly bonding experience. It certainly bonds others in hating those who do it.

å: What about the cliché about twins, being mischievious, having the same boyfriend, cheating at exams?

M H. V: Since we started the interview you probably noticed I went to the loo often. This is the third time I swap with my sister. We sometimes do this to make the Q&A more interesting. We have had same boyfriends but I don't think it was at the same time and before you ask, no, we never dated twins or at least to our knowledge.

å: I think identical twins never really look similar, I mean they do at first but the moment you know then it becomes obvious the physical traits and even the body languages are as different as in other siblings or best friends so I

things. The whole indie period only lasted 7 months but by then I knew everybody, had written fanzines and became groupie of some minor bands which made it big a few years later. It is however a very influential time and I speak of those "indie" years—although it did not even last one—very often. With time, I do not control the exaggerations anymore and despite being aware of it, I don't know how much of what I recall is true. Have you seen the photos of Stacey Garduno? I think she was from New York. Her work was a series of group pictures of those tribes such as goths, jocks, rockabillies and the like, music related social groups who I believe she infiltrated, learned the codes and got accepted before disappearing from that scene. In the different group pictures, she is always in the middle. I met an ex-lover of hers, who at 43 is still a Cure fan and dress like Robert Smith. He is a non violent person except he will kill her if their path cross again.

å: You have a twin sister and both your parents are twins. Isn't this too much?

M H. V: Too much? Did you know Edward Bernays who wrote Propaganda was the double nephew of Freud?

å: Did you ever go

don't believe in this sharing boyfriend/girlfriend stories, unless you really don't know your partner.

M H. V: I agree even if it still startles me to see twins on the street.

å: yes. In your case it is difficult to distinguish because you deliberately pretend to be the other. Is this at all times? I mean you changed your respective names to the same first name and it seems you wear the same clothes but more disturbing is that I heard you never appear publicly or privately together. How do we even know the other exist?

M H. V: We do see each other privately but only if no one else is around. We have double nationalities. Because of our family situation, I am French Italian and my sister is Canadian Argentine. It took a little persuasion but when we both changed our name to Miwa H. Vox it resulted in effect in having four passports. Do you know the Cleopatra's needles?

å: Yes, the obelisks in Paris and London?

M H. V: There is another one in Central Park New York. They are two different pairs. The London and NY needles are twins, while the one in Paris still has a twin in Egypt.

What I like is that

somehow managed to get the *NME* and *Melodymaker* every week. We were impressed by his knowledge in a specific form of music, especially the English indie scene somehow created by Thatcher [laughter], I guess the legacy of this woman was to establish the misery from which incredible creativity had to emerge… Anyway this kid had the whole thing: attitude, clothes, knowledge. I was his friend but the moment I decided to look into the music, and it was before iTunes or even internet, I became an expert in less than three months. I knew where to wear, where to find it and all my money would go into what was a small niche in music. There was nothing strategic about it, it was very natural and inherently a self-taught situation. You know, when you are interested, the learning is fast. I spoke of Ian Curtis as if I had known him even if he was dead before I was two years old! Little by little I realised I was selecting my friends in the same way and we all looked the same, lost weight in the same way, despite the different bands we sported T-shirts of, we were a slightly ridiculous tribe just like in *The Warriors*. Feeling different while looking exactly the same and knowing the same

because they are so far away, it is not so much about comparing them. They have different history and the different weather has worn them in a different way. The bases are different, one has bronze crabs supporting it, the other mock sphinxes, one is by a river, the other in Central Park. The UK one has a stone base in which there is a Victorian time capsule. It even contains a small replica of itself.

å: Yes, you speak of it in your book in which all the contentious monuments and museum artefacts in the western world are remade and sent "back" to the original countries. I particularly liked the London obelisk being sent back by boat with the exact same boat it came in.

M H. V: Yes, it is designed so it looks as if it goes backwards in a ridiculous yet spectacular way to literally "rewind" history. The obelisk in Paris is very different. It is much more recent and looks almost new. Its base shows the process of its transport and constitutes today an added historical fact. The second obelisk is still in Egypt. What is slightly less known is that this pair is not identical. Difficult to compare of course because it is not possible to see both of

me it was clearly an architectural project: two cities, made to look exactly the same but people were living different lives with different languages and different cultures. Just like in my story, the same modernist apartment complex in a low income ghetto is a dangerous ruin in which a family of 12 lives while on the other side of the planet, the building has been over gentrified and is lived-in by a young artist couple who cannot believe their luck of showering in a building which features in every serious book as a turning point in postwar architecture.

å: It is as if two multiverses were sharing the same reality, a slightly sick experiment to separate twins at birth and see what happens?

M H. V: Yes, an ant farm on the scale of the city. I suppose most people do not even know there is the exact church, the exact street furniture on which they were sitting, waiting for the same bus, the same apartment, same the cupboard etc. but some people do and decide to go and see the other one, sometimes even moving there for good.

å: In your book you focus on several social groups in which people slowly become very similar.

M H. V: When I was 16 there was this cool kid who

Miwa H.Vox: When I was young, I thought twinned cities were built at the same time following the same urban planning and architecture. I You know the signs when you drive into a city? It states the name of the place but there are other metal signs with names of different places, sometimes with the flag of the country. The bigger the city, the more numerous the twinned locations. This was a fascinating prospect even though I never really wanted to visit the "other" cities. I suppose I did not have to as I knew, I thought I knew they were exactly the same. As a student I would have visited them but by then I had realised it was just an administrative link.

åbåke: What about people, what about their clothes or behaviour? Did you think they would be the same people, doppelgänger of some sort? You have a twin sister, did you think people were "mirrored" in those cities?

M H. V: Before writing the story I never questioned how the people would or should be. Even at a young age I could see the evil in conformism and in the bliss of childhood I could not conceive a state dictatorial enough to oblige people to behave in exactly the same way. No, for

them at the same time but if you look at the Napoleonic engravings of Louxor, an impressive book the size of this table when closed, it is very clear that one is smaller than the other. However, they placed the smaller of the two closer to whoever would be facing the gate, creating the illusion that they are the same size. Why did they do this? It is a unique occurrence in the whole of Egypt. Is it just a mistake? Difficult to believe they would have corrected a measurement mistake by a simple optical illusion. Whatever the reason it seems to me that they are more interesting because of this defect.

å: Are you taller than your sister?

MHV: I am shorter but in the next interview she will also tell you she is shorter.

å: tell me about *Vogue* and why you got fired.

MHV: I needed a job and I somehow ended up doing bits and bobs at Vogue, people were stressed and there is a lot of running around. I once went to the graphic designer's office and decided to change the *Vogue* logo typeface from their specific version of Bodoni to Didot. Should I explain?

å: No, it's ok, the publication this is going to be in is read by people I think get the joke.

M H. V: It was not just a joke, I

13

really thought the whole issue was just a pernicious pastiche of a dozen of street trends. OK, fashion is very much that but I somehow had to do it. They saw it once printed and fired me. I think they reprinted it although a friend showed me the version I made so they exist in the world.

å: The only thing I thought a little far fetched in your story is the displacement of historical building from Europe to Vegas then from Vegas to New Vegas. I know the Abu Simbel case but that was pretty extreme.

M H. V: The statue of Liberty was built in Paris before being sent to NY and London Bridge was bought and re-built stone by stone in the middle of the Nevada desert… give me a second [Miwa goes to the toilet. This detail seems now worth mentioning]

å: Ah, "you" are back. I knew the examples of London Bridge and the statue of Liberty.

M H. V: Sorry I have to go to the loo so often, I drank too much tea. Anyway I need to go very soon.

å: Ok, sure, so tell me again your request for this interview?

M H. V: I would like you to interview my sister but this time you both follow exactly the

Miwa H. Vox and her sister Miwa H. Vox wrote SAME, YOU LEFT THE DOOR AJAR, a novel about two twins sisters who build a financial empire and endeavour to construct a replica of Las Vegas after the gambling ban of 2038. The undisclosed location appears to be in Europe although no country would perfectly fit the descriptions found in the text. We follow 8 inhabitants in each cities crossing each other's lives over 50 years during which the same new buildings are added to both the "original" and the copy.

transcripts of what we just said. Try to read it as if it was the first time.

Are you game?

å: yes of course.

SAME, YOU LEFT THE DOOR AJAR,

published by Dent-De-Leone

will be out tomorrow.

SAME YOU LEFT THE DOOR AJAR

I am Still Alive 24, a prasitical magazine by åbäke (images and texts, unless otherwise stated). Thank you Miwa H, Vox, Miwa H, Vox, Min Choi, Na Kim and Typojanchi 2013. Cover photography:Na Seung & Na Jhin, models: Kim Hyunkyung & Kim Hyunjin, inside colour photography of Na Seung & Na Jhin by Kim Hyunkyung & Kim Hyunjin, Peter Pan monument in Brussels & London photographed by åbäke. Past issues: #1 in *Rebel Magazine 2, automne hiver* 2001–2, insert poster p. 50 (FR); #2 in *Super, Welcome to Graphic Wonderland,* 2003, ISBN 3-89955-005-6 (CH); #3 in *Communication What?,* Ma Edizioni, pp 120–7, 2002 (IT); #4 in *IDEA 297,* 2003 pp 99–114 (JP); #5 in *Sport and Street,* April 2003 (I); #6 in *Sugo 0,* Ma Edizioni; #7 in *idn:*2003:three-volume 10:number 3: flight of fancy ii special insert (HK); #8 in *Sugo 1,* Ma Edizioni, pp 112–9, 2004 (I); #9 in *A Magazine 1,* Flanders Fashion Institute, 2004 ISBN 90-77745-01-7, pp 75–80 (B); #10 in *Graphic Magazine 7,* Bis, 2005 ISBN 90-6369-092-4, pp 149–56 (UK); #11 in *IDEA 309,* pp 31–8, Feburary 2005 (JP); #12 in *Lodown 45,* March 2005 (D); #13 in *Math 2,* May 2005, www.posikids.org (UK); #14 in *CREAM,* Autumn Edition 2005 issue 02, pp 231–47, 2005 (HK); #15 in *CREAM,* Summer Edition 2006 issue 05, pp 250–66, 2006 (HK); #16 in *Spring X Maison Martin Margiela 6,* 2007–2008 edition (J); #17 in *Apartamento,* Issue 01, pp 49–64, 2008 (I); #18 in *CREAM,* Edition 2008 issue 09 (HK); #19 in *GRAPHIC 11,* Ideas of Design Exhibition Autumn 2009 ISSN 1975-7905 (KR); #20 in *TAR mag* Fall issue no. 4, 2011 ISSN 1943-3794 (I); #21 in *Graphic Design: Now In Production* ISBN 978-0935640984 (US); #22 in *Umool Umool* vol. 10 isbn 978-90-802700-6-0 (KR); #23 in *The Real and Other Fictions,* 2013 The Lisbon Triennale, ISBN 9789899851313 (P)

상동, 문을 조금 열어놓았군

오베케

미와 복스와 미와 복스는 《상동, 문을 조금 열어놓았군》을 지은 쌍둥이 자매 작가이다. 금융 제국을 세운 쌍둥이 자매가 2038년 도박이 금지되자 라스베이거스의 복제 도시를 세우려 한다는 소설이다. 복제 도시 대상지가 정확히 밝혀지지는 않지만, 유럽 어딘가로 추정된다. 소설은 '원본'과 복제 도시 양쪽에 똑같은 신축 건물이 들어서는 50년 동안, 각 도시 주민 여덟 명의 삶이 교차하는 이야기를 좇는다.

미와 복스: 어렸을 때는 똑같은 구조나 건물을 갖춘 쌍둥이 도시들이 동시에 세워진다고 생각했다. 도시 진입 고속도로에 표지판이 있지 않나? 그런 표지판에는 해당 도시 말고도 다른 도시 이름이 함께 달리곤 한다. 큰 도시일수록 쌍둥이 도시도 많다. 근사한 광경이기는 하지만, '다른' 도시를 찾아가보고 싶었던 적은 없다. 전부 똑같은 도시라고 생각했기 때문이다. 학교에 들어가서는 그런 도시에 찾아가볼 법도 했지만, 그때는 이미 그들이 단지 행정상 연결된 장소일 뿐임을 알게 된 후였다.

오베케: 사람들은 어떤가? 그들이 입는 옷이나 하는 행동은? 전부 똑같으리라 생각했나? 당신에게는 쌍둥이 자매가 있는데… 그런 도시 주민들은, 말하자면 '거울에 비친' 사람들이라고 생각했나?

미와 복스: 소설을 쓰기 전까지는 사람에 관해 생각해보지 않았다. 어릴 때부터 체제 순응은 잘못이라고 느꼈지만, 순진했던 나는 주민에게 똑같은 행동을 강요할 정도로 악랄한 독재국가를 상상하지 못했다. 내가 생각한 것은 건물뿐이었다. 두 도시가 세워진 모양은 똑같지만, 사람들은 다른 생활을 하고 다른 언어를 쓰고 다른 문화를 누린다는 상상이었다. 소설을 보면, 빈민가에 세워진 똑같은 모더니스트 아파트 단지가 한쪽 도시에서는 12인 가족이 거주하는 위험한 건물이지만, 지구 반대쪽에서는 젊은 예술인 커플이 사는 세련된 건물로 묘사된다. 그 커플은 건물 안에서 샤워를 즐길 수 있다는 사실을 큰 행운처럼 여긴다. 진지한 책을 보면 모두 그 점이 2차대전 후 건축에서 주요 전환점으로 꼽는다.

오베케: 두 평행 우주가 같은 현실을 공유한다는 점에서, 마치 갓난 쌍둥이 형제를 서로 떨어뜨려 각자에게 어떤 일이 일어나는지 살펴보는 위험한 실험 같기도 하다.

미와 복스: 그렇다. 도시 규모로 세운 개미 사육 상자 같은 것. 다른 도시에도 똑같은 교회가 있고, 그곳 주민도 똑같은 벤치에 앉아 똑같은 버스를 기다리며, 똑같은 아파트에 살고, 똑같은 찬장을 쓴다는 사실을 아는 주민은 거의 없다. 그러나 어떤 사람은 그 점을 눈치채고 다른 도시를 찾아가며, 그곳에 머물러 살기도 한다.

오베케: 소설에는 몇몇 사회집단이 중요하게 등장하는데, 그 구성원은 시간이 흐를수록 서로 비슷해진다.

미와 복스: 열여섯 살 때, 《NME》와 《멜로디 메이커》를 매주 용케도 구해보는 멋쟁이 친구가 있었다. 그 친구는 특정 음악, 특히 영국 인디 음악에 무척 밝았다. 그런데 영국 인디는 대처 총리가 창조했다고 봐야 하지 않나?(웃음) 그 여자가 남긴 유산이 있다면, 아마 엄청난 창의성이 솟아날 수 있는 비참한 현실을 닦아줬다는 게 아닐까. 아무튼, 이 친구에게는 '태도', 옷, 지식 등 없는 게 없었다. 그런데 나도 한번 음악을 탐구해보자고 작정하자, 그때는 아이튠스는커녕 인터넷도 없었지만, 전문가가 되는 데 석 달도 안 걸렸다. 무슨 옷을 입어야 하는지, 어디서 구할 수 있는지 정확히 알았고, 돈이란 돈은 죄다 음악에 쏟아부었다. 아무 전략도 필요 없었다. 아주 자연스러운 독학이었다. 관심만 있으면 뭐든지 무척 빨리 배우지 않나. 이언 커티스는 내가 두 살도 되기 전에 죽었지만, 나는 마치 그가 아는 사람인 양 떠들어댔다. 그러다가 내가 사람도 같은 방식으로 골라 사귄다는 사실을 조금씩 깨닫게 됐다. 티셔츠에 적힌 밴드 이름은 조금씩 달랐지만, 우리 모두 생김새도 닮아갔고, 몸무게도 비슷하게 줄어들었다. 무슨 우스꽝스러운 부족 같았다. 생김새도 똑같고 아는 것도 똑같지만, 느낌은 달랐다. 인디 음악에 빠져 지낸 건 고작 7개월밖에 안 됐지만, 그 사이에 나는 모든 사람을 알게 됐고, 팬진을 써냈고, 몇 년 후에 대형 그룹이 된 무명 밴드의 그루피가 됐다. 내 인생에서 무척이나 중요한 시기였다. 1년이 채 안 되는 기간이었지만, 지금도 나는 그 '인디 시절'을 종종 이야기한다. 과장이 섞였다는 것도 안다. 그러나 시간이 흐르면서 허풍을 조절하는 법도 잊어버렸다. 내 기억에서 얼마나 많은 부분이 사실인지 확신하기 어렵기 때문이다.

　　스페이시 가더노의 사진을 본 적 있나? 뉴욕 출신으로 아는데… 아무튼 고스족, 조크족, 로커빌리족 등 음악 부족을 단체 사진으로 찍은 작품이다. 내가 알기로 그녀는 해당 집단에 위장 침투해 규칙을 습득하고 집단에서 인정받은 다음 사진을 찍고는 사라져버리곤 했다. 단체 사진에서 그녀는 언제나 한가운데 있다. 그녀가 한때 사귄 남자 친구를 만난 적이 있는데, 마흔세 살이지만 여전히 로버트 스미스처럼 옷을 입는 큐어 팬이었다. 온순한 사람이었지만, 그녀를 다시 만나면 죽여버릴 태세였다.

오베케: 당신에게는 쌍둥이 자매가 있고, 당신 부모도 모두 쌍둥이다. 지나치지 않은가?

미와 복스: 지나치다고?《프로파간다》를 쓴 에드워드 버니가 프로이트의 겹사돈 조카라는 사실은 알고 있나?

오베케: 쌍둥이 축제 같은 데 가본 적 있나?

미와 복스: 쌍둥이들이 모이는 축제? 가본 적 없다. 노출증 환자나 그런 데 가는 거지. 우리 자매는 특별한 사이지만, 쌍둥이가 일반인보다 특별하다고는 생각하지 않는다. 오히려 함께 있다 보면 하나의 인격이 둘로 분열될 수는 있다. 상대가 하는 말을 대신 맺어주는 일이 딱히 유대감을 더해주지는 않는다. 오히려 그런 사람을 싫어하는 이들 사이에나 유대감을 맺어줄 것이다.

오베케: 쌍둥이에 관한 고정관념은 어떻게 생각하나? 짓궂다는 둥, 애인을 공유한다는 둥, 시험에서 부정행위를 한다는 둥.

미와 복스: 인터뷰 도중에 내가 화장실에 자주 간다고 느끼지 않았나? 그렇게 우리 자매가 슬쩍 자리를 바꾼 게 벌써 세 번째다. 인터뷰를 더 재미있게 하려고 가끔 하는 짓이다. 같은 남자를 사귄 적은 있지만 동시에 사귄 적은 없다. 미리 답하자면, 우리가 아는 한 다른 쌍둥이를 사귄 적도 없다.

오베케: 일란성 쌍둥이가 서로 닮으라는 법은 없다. 처음에는 닮아 보이지만, 조금만 더 알면 여느 형제자매나 친구 사이와 마찬가지로 서로 다른 신체적 특징이나 몸짓이 드러난다. 그러니까, 애인을 공유한다는 이야기는 나도 믿은 적이 없다. 자기 애인에 관해 아는 게 전혀 없다면 모를까.

미와 복스: 맞다. 하지만 길거리에서 쌍둥이를 보면 여전히 놀란다.

오베케: 그런데 당신은 좀 다르다. 당신 자매는 의도적으로 서로를 흉내 내기 때문이다. 언제나 그러는가? 이름도 같은 것으로 개명했고, 옷도 똑같이 입는다. 더욱 심란한 점은, 당신 자매가 절대로 함께 모습을 드러내지 않는다는 것이다. 쌍둥이 자매가 진짜로 있기는 한가?

미와 복스: 사적으로는 만난다. 다만 다른 사람이 없을 때만 만난다. 우리는 이중국적자이기도 하다. 가족 상황이 복잡해서, 나는 프랑스계 이탈리아 시민이고, 내 자

매는 캐나다계 아르헨티나 시민이다. 우리 둘 다 이름을 '미와 복스'로 바꾸면서, 사실상 여권을 4개씩 갖게 됐다. 클레오파트라의 바늘 이야기를 아는지?

오베케: 파리와 런던에 있는 오벨리스크 말인가?

미와 복스: 뉴욕 센트럴파크에도 하나 있다. 두 쌍둥이 형제 같다. 런던과 뉴욕에 있는 바늘이 쌍둥이고, 파리 오벨리스크의 형제는 아직도 이집트에 있다.
　재미있는 점은, 그들이 너무 멀리 떨어져 있다 보니, 서로 비교할 일이 없다는 것이다. 역사도 다르고 기후도 닮은 모양도 다르다. 밑동도 다르다. 하나는 청동으로 만든 갑각류가, 다른 것은 가짜 스핑크스가 떠받치고 있다. 하나는 강변에 있고, 다른 하나는 센트럴파크에 있다. 영국 오벨리스크에는 돌로 된 밑동이 있는데, 거기에는 19세기 타임캡슐이 묻혀 있다. 수장품 가운데는 오벨리스크 자체의 모형도 있다.

오베케: 당신 책에는 서구에 있는 논쟁적 기념비나 유물을 다시 만들어 원래 나라에 '돌려보내는' 이야기가 나온다. 런던 오벨리스크를 영국에 들여올 때 실었던 것과 똑같은 배에 실어 돌려보내는 점이 특히 인상적이었다.

미와 복스: 우스꽝스럽지만 근사하게, 역사를 말 그대로 '되감기' 하려는 시도인 거다.
　파리에 있는 오벨리스크는 다르다. 훨씬 최근에 만들어져서, 거의 새것처럼 보일 정도다. 밑동에는 운반 과정이 기록돼 있고, 따라서 새로이 더해진 역사적 사실을 보여준다.
　두 번째 오벨리스크는 여전히 이집트에 있다. 별로 알려지지 않은 사실은, 그들이 똑같지 않다는 점이다. 한눈에 볼 수 없으므로 비교하기 어렵지만, 나폴레옹 시대에 만들어진 룩소르 동판화를 보면—거의 이 탁자만 한 근사한 책에 실려 있는데—하나가 더 작다는 사실을 뚜렷이 알 수 있다. 사원 입구를 바라보는 사람 쪽에 작은 오벨리스크가 있어서, 마치 둘이 같은 크기처럼 보이는 착시가 생긴다. 왜 그랬을까? 이집트 전체에서도 이런 사례는 유일하다. 단지 실수였을까? 단순한 착시 때문에 계측 오류를 범했다고 보기는 어렵다. 이유가 무엇이건, 이런 결점 때문에 그들이 더 흥미롭게 느껴진다.

오베케: 당신이 자매보다 더 큰가?

미와 복스: 내가 작다. 하지만 다음 인터뷰에서 그녀는 자신이 더 작다고 말할 것이다.

오베케: 《보그》에서 해고당한 이야기를 해달라.

미와 복스: 일자리를 구하다가 《보그》에서 잡일을 하게 됐다. 다들 스트레스에 시달렸고 정신이 없었다. 한번은 그래픽 디자인 부서에 가서 《보그》 로고를 보도니에서 디도로 바꾸게 했다. 더 자세히 설명할까?

오베케: 아니. 이 글이 실리는 책의 독자는 그 농담을 이해할 것 같다.

미와 복스: 단순한 농담이 아니었다. 나는 잡지 전체가 거리 패션을 베껴먹는다고 느꼈다. 물론 패션이 다 그렇지만, 그래도 나는 뭔가를 해야 했다. 운영진은 인쇄돼 나온 잡지를 보고 나를 해고했다. 그러고는 다시 찍은 것 같은데, 한 친구가 내가 만든 버전을 보여준 적이 있으니까, 아마 어딘가에 돌아다니기는 하는 모양이다.

오베케: 당신 소설에서 조금 억지라고 느낀 부분은, 유럽의 역사적 건물을 라스베이거스로 가져간 다음 다시 뉴베이거스로 옮기는 대목이었다. 아부 심벨 신전 이야기는 우리도 알지만 그건 좀 극단적인 경우고…

미와 복스: 자유의 여신상은 파리에서 제작한 다음 뉴욕으로 옮겼고, 런던 브리지는 통째로 팔려와 네바다에서 벽돌 하나씩 재조립되기도 했다. 잠시 실례… (기록해둘 필요를 이제야 느끼지만, 미와는 자리에서 일어나 화장실에 간다.)

오베케: '다시' 만나서 반갑다. 아무튼, 런던 브리지와 자유의 여신상 이야기는 우리도 안다.

미와 복스: 화장실에 자주 가서 미안하다. 차를 너무 많이 마신 모양이다. 그런데 이제 일어나야 할 시간이다.

오베케: 알겠다. 인터뷰에 관해 요청할 것이 있다고?

미와 복스: 내 자매를 인터뷰하되, 오늘 우리가 나눈 대화를 그대로 반복해줬으면 한다. 마치 처음 하는 말인 것처럼 읽으면 된다. 할 수 있겠나?

오베케: 물론이다.

《상동, 문을 조금 열어놓았군》은 당들레온에서 내일 출간 예정이다.

[최성민 옮김]

새소리
birdsong

아스트리트 제메는 오스트리아 빈에서 활동하는 그래픽 디자이너 겸 음향예술가다. 빈 공과대학에서 그래픽 디자인을 공부했고, 아른험 베르크플라츠 티포흐라피에서 석사 학위를 받았다. 2010년 이후 마르크 페칭어 페어라크 출판사를 공동 운영하고 있다. 최근 참여한 전시로는 《나는 실패를 잘해》(뵈르스스하우뷔르흐, 브뤼셀), 《한 남자가 숲에서 말한다》(산티아고 현대미술관, 칠레), 브르노 국제 그래픽 디자인 비엔날레, 《풍.경》(쿤스트포룸 몬타폰, 오스트리아 슈룬스) 등이 있다. 마르크 페칭어 페어라크는 최근 독일의 카셀러 쿤스트페어라인에서 독자적인 전시회를 연 바 있다.

제메의 〈원음 새들이 노래하는 소나타〉는 쿠르트 슈비터스의 〈원음 소나타〉(1922–1932)에 관한 관심을 기반으로 개발한 음향 작품이다. 소리 시의 초기 사례에 해당하는 〈원음 소나타〉는 슈비터스가 《메르츠》를 출간하던 시기에 특히 자주 공연한 작품으로, 《메르츠》 마지막 호(24호, 1932년)는 얀 치홀트의 타이포그래피를 통해 〈원음 소나타〉 최종 원고를 지면에 옮기는 작업에 쓰이기도 했다. 이 실험의 핵심부에는 구어와 그 시각적 표기 사이의 관계라는 근본적 타이포그래피 문제가 자리한다. 시각적으로 명시된 텍스트는 통제하기 어려운 소리를 어떻게 공간화하고 거기에 어떤 질서를 부여하는가? 구어는 그 타이포그래피 배열을 어떻게 정의하는가? 그 둘은 얼마나 정확히 조응할 수 있는가? 이들은 문자적 의미와 사실상 무관한 형식적 질문인데, 〈원음 소나타〉를 구성하는 단어 대부분이 의미 없이 추상적인 음소와 자소의 덩어리라는 사실은 그 점을 더욱 또렷이 드러낸다.

제메는 슈비터스의 작업을 새로이 해석함으로써 그러한 몇몇 질문을 재조명하려 한다. 한 예가 바로 일반적 표기법으로 통제할 수 없는 소리 풍경에 〈원음 소나타〉를 배치하는 작업이었다.

쿠르트 슈비터스가 〈원음 소나타〉를 쓸 때 정확히 어디에서 영감을 받았는지는 여전히 논란거리다. 일설에 따르면 그는 새소리에서 영감을 받았다고 한

다. 나는 그것이 사실이라고 굳게 믿으며, 새들에게 그들의 원초적 노래인 〈원음 소나타〉를 돌려주려 한다. 〈원음 새들이 노래하는 소나타〉는 쿠르트 슈비터스가 시를 쓰면서 들었을 법한 소리를 낭송한다. [아스트리트 제메, 2010]

제메는 새소리 녹음 표본을 꼼꼼히 조합해 〈원음 소나타〉 전곡을 재구성했다. 빈 대학교 조류학자에게 자문하고 2200점의 음파도가 실린 《유럽의 새소리》(2008)를 참고하면서 음원을 분석해 〈원음 소나타〉 자소와 닮은 패턴들을 찾아낸 제메는, 그들을 재배열해 〈원음 소나타〉 다중 채널 낭송 버전을 완성했다. 이 작품이 슈비터스가 원래 상상했던 소리에 가까운지 아닌지는 증명하기 어렵겠지만, 별 상관없다. 예부터 새소리는 인간을 둘러싼 원초적 소리 풍경의 일부였으며, 인간은 그 이해 불가능한 소리를 채집하고 거기에 의미와 질서를 투사하면서 그 뜻을 헤아리고 해석하려 애썼다. 이제는 새들이 인간의 타이포그래피 부호를 가지고 같은 일을 할 차례다.

Astrid Seme is a graphic designer and sound artist based in Vienna. She studied graphic design at the University of Applied Arts Vienna, and earned a master's degree from the Werkplaats Typografie, Arnhem, the Netherlands. Since 2010, she has been a part of Mark Pezinger Verlag. Recent exhibitions include: *I Fail Good* at Beursschouwburg, Brussels, Belgium; *Un hombre habla en el bosque* at Museo del Arte Contemporaneo, Santiago, Chile; Brno International Biennial of Graphic Design; and *Land.schafft* at the Kunstforum Montafon, Schruns, Austria. Mark Pezinger Verlag has had its own exhibitions, including the recent one at the Kasseler Kunstverein, Germany.

Seme's sound work *Urbirds Singing the Sonata* was developed from her interest in Kurt Schwitters's *Ursonate* (1922–1932): an early example of sound poetry that the artist would perform during his *Merz* years, devoting the last issue of the journal (no. 24, 1932) to a complete transcription of its final draft and having it designed by Jan Tschichold. At the crux of this experiment was one of the fundamental questions of typography: the relationship between spoken words and their visual representation/notation. How does visually articulated text spatialize and order the seemingly uncontainable sound? How does the structure of spoken words motivate their typographic arrangement? And how precisely can they correspond to each other? These are formal questions, quite independent of the question of literal meaning, and they are made even more acute as many of the "words" used in the *Ursonate* are nonsensical, almost abstract clusters of phonemes/graphemes.

Seme seems to address some of these questions via a renewed consideration of Schwitters's work, by relocating the *Ursonate* in a soundscape that cannot normally be regulated by any notation systems.

There has never been a full agreement as to what were the key influences on Kurt Schwitters when he was preparing the *Ursonate*. There is one myth that claims he was inspired by bird sounds. I strongly believe this to be true and bring the birds their *Ursonate* back, their primordial song. *Urbirds Singing the Sonata* narrates what Kurt Schwitters might have heard when he wrote the poem. [Astrid Seme, 2010]

Seme recreated the entire *Ursonate* by carefully assembling samples of birdsongs. Working with an ornithologist at the University of Vienna and using as a guide *Die Stimmen der Vögel Europas* (2008), which contains 2,200 sonograms, she analyzed the bird-call recordings to discover patterns suggesting similarities with the graphemes of the *Ursonate*, in order to ultimately arrange the clips to a multi-channel recitation of the poem. Whether this particular realization is closer to what Schwitters originally envisioned might be difficult to prove, but it may not be a point. Birdsongs have always been a part of the primordial soundscape surrounding human beings, and people have tried to understand and read into them, transcribing the undecipherable aural signals and projecting their own meanings and orders onto them. Now it might as well be the birds' turn to do the same with human typographic marks.

아스트리트 제메
1985년생, 오스트리아.

Astrid Seme
Born in 1985, Austria.

astridseme.com

원음 새들이 노래하는 소나타
(2010) 2013. 5채널 음향 설치. 32분 39초. CD 발행: 마르크 페칭어 페어라크,
카를스루에/빈, 2012.

Urbirds Singing the Sonata
(2010) 2013. Five-channel sound installation. 32 minutes 39 seconds.
Published in 2012 as an audio CD by Mark Pezinger Verlag, Karlsruhe/
Vienna.

URSONATE

Scherzo: Tonstück von heiterem Charakter, (meist 3ter Satz) in Sinfonie, Sonate u. Kammermusik. Die Themen sind charakteristisch vorzutragen. 13.04.19 16:20

tercera parte 3. Teil BLAU

VOGEL

Scherzo 15'40

(los temas serán declamados siguiendo sus propias características)

TEIL

Krähenschar DC 78

Lanke trr gll Sperbergrasmücke 348/2 **(M)** III 8
pe pe pe pe trr Teichrohr-sänger 337/3
Ooka ooka ooka ooka Fasan 531/1 ed.2 Laubfink 2 (munter)

Lanke trr gll III 9
pii pii pii pii pii Sprosser 401/2 ud. Amsel 380/2 ooka: Silbermöwe 205/1 · Waldohreule 240/2
züüka züüka züüka züüka

Lanke trr gll yban 2 III 4
Rrmm Nachtreiher 85/1 Rebhuhn 55/2 Krane zilp
Rrnnf

Lanke trr gll III 3 / 10
Ziiuu lenn trll? Auerhuhn 61/2
Lümpff tümpff trll Eisvogel 711/1

Lanke trr gll III 4
Rrumpff tilff too pi = Sprosser 401

Lanke trr gll III 3 / 10
Ziiuu lenn trll? pe = Graureiher 81/2
Lümpff tümpff trll

Lanke trr gll III 8
Pe pe pe pe pe
Ooka ooka ooka ooka

Erinnerung 1.Satz

Lanke trr gll ✓ III 9
Pii pii pii pii pii
Züüka züüka züüka züüka

Lanke trr gll AAA(...) III 4
Rrmmp Boxer ...
Rrnnf

Lanke trr gll

Trio *(declamar muy lentamente)* (äußerst langsam vorzutragen)

Ziiuu iiuu 446 Karmingimpel 13 **(N)** aauu = Sperbereule 237/1 3
ziiuu aauu
ziiuu iiuu oder: Prachttaucher 70/2
ziiuu Aaa

Ziiuu iiuu 3
ziiuu aauu
ziiuu iiuu
ziiuu Ooo 256 Wiedehopf

Ziiuu iiuu 3
ziiuu aauu~

Schlangenadler
Moorschneehuhn
sprechend!

051—100
super!

13.04.10 16:20

Grimm glimm gnimm bimbimm
Grimm glimm gnimm bimbimm
Grimm glimm gnimm bimbimm
Grimm glimm gnimm bimbimm
Grimm glimm gnimm bimbimm
Grimm glimm gnimm bimbimm

Ooo bee (entonación menos fuerte) *(sehr stark fallend)* 6
Ooo bee
Ooo bee
Ooo bee

final:

Zätt üpsilon iks (emocionado) *(bewegt)* (Y) 18
Wee fau Uu
Tee äss ärr kuu
Pee Oo änn ämm
Ell kaa ll haa
Gee äff Ee dee zee beee?

Zätt üpsilon iks (más emocionado) *(bewegter)* 18
Wee fau Uu
Tee äss ärr kuu
Pee Oo änn ämm
Ell kaa ll haa
Gee äff Ee dee zee beee?

Zätt üpsilon iks (normal) *(einfach)* 18a
Wee fau Uu
Tee äss ärr kuu
Pee Oo änn ämm
Ell kaa ll haa
Gee äff Ee dee zee beee Aaaaa

Zätt (muy emocionado) *(sehr bewegt)* 18
üpsilon iks (Z)
Wee fau Uu
Tee äss ärr kuu
Pee Oo änn ämm
Ell kaa ll haa
Gee äff Ee dee zee beee? (afligido) *(schmerzlich)*

Kadenz: Paraphrasierung ... Motivs eines Konzerts, die dem Künstler die Möglichkeit bietet, sein virtuoses Können zu zeigen.

Ü psi lon

URSONATE de Kurt Schwitters

Introducción
Fümms bö wö tää zää Uu,
 pögiff,
 kwii Ee.

Oooooooooooooooooooooooo,

dll rrrrr beeeee bö
dll rrrrr beeeee bö fümms bö,
 rrrrr beeeee bö fümms bö wö,
 beeeee bö fümms bö wö tää,
 bö fümms bö wö tää zää,
 fümms bö wö tää zää Uu:

primera parte:

tema 1:
Fümms bö wö tää zää Uu,
 pögiff,
 Kwii Ee.

tema 2:
Dedesnn nn rrrrr,
 Ii Ee,
 mpiff tillff too,
 Jüü Kaa?

tema 3:
Rinnzekete bee bee nnz krr müü?
 ziiuu ennze, ziiuu rinnzkrrmüü,
 rakete bee bee,

tema 4
 Rrummpff tillff toooo?

exposición:
 Ziiuu ennze ziiuu nnzkrrmüü,
 Ziiuu ennze ziiuu rinnzkrrmüü
 rakete bee bee? rakete bee zee.

desarrollo:
Fümms bö wö tää zää Uu,
Uu zee tee wee bee fümms.
rakete rinnzekete

http://www.ubu.com/historical/schwitters/ursonate.html

1
6
5
142

1. Teil

Seite 1 von 21

böwörö
fümmsböwö
böwörö
fümmsböwö
böwörö
fümmsböwö
böwörö
fümmsböwö
böwörö
fümmsböwö
böwörö
fümmsböwö
böwörötää
fümmsböwötää
böwörötää
fümmsböwötää
böwörötää
fümmsböwötää
böwörötää
fümmsböwötää
böwörötää
fümmsböwötää
böwörötää
fümmsböwötää
böwörötääzää
fümmsböwötääzää
böwörötääzää
fümmsböwötääzää
böwörötääzää
fümmsböwötääzää
böwörötääzää
fümmsböwötääzää
böwörötääzää
fümmsböwötääzää
böwörötääzää
fümmsböwötääzää
böwörötääzääUu
fümmsböwötääzääUu
böwörötääzääUu
fümmsböwötääzääUu
böwörötääzääUu
fümmsböwötääzääUu
böwörötääzääUu
fümmsböwötääzääUu
böwörötääzääUu
fümmsböwötääzääUu
böwörötääzääUu pö
fümmsböwötääzääUu pö
böwörötääzääUu pö

258

샌디 마니아
Shandymania

로렌스 스턴이 쓴 《신사 트리스트럼 샌디의 인생과 생각 이야기》는 1759년부터 여러 권에 걸쳐 간행된 소설이다. 무수한 인용, 참조, 암시로 이루어진 이 작품은—20세기 현대주의와 탈현대주의의 여러 작가들에게 영향을 끼친—자기 반영적 글쓰기의 선구자로 꼽힐 뿐만 아니라, 비언어적 서사 장치를 적극적으로 활용한 작품으로도 악명 높다. 그러한 장치에는 삽화와 도해, 문장을 대신하는 타이포그래피 부호, 본문 영역 전체가 검정 잉크로 뒤덮인 지면, 텅 빈 지면, 수수께끼처럼 마블링 무늬가 찍힌 지면 등이 포함된다. 런던의 어 프랙티스 포 에브리데이 라이프가 디자인하고 비주얼 에디션스가 펴낸 2010년 판은 "원작의 정신에 충실하면서도 새로운 시각적 요소를 더해 도서 디자인에 새로운 생명을 불어넣음"으로써, 엉성하게 제작된 현대판에서 사라진 원작의 "마력과 빛"을 되찾으려는 의도로 만들어졌다.

　어 프랙티스 포 에브리데이 라이프는 풍성하고 재치 있는 접근법으로 그 도전에 응한다. 원작에서 이야기를 잠시 쉬거나 외설적 표현을 하는 데 쓰인 긴 줄표는 형광색으로 인쇄되었다. 열 쪽에 걸쳐 이어지는 주황 선은 원작에서 본문 한 단락을 차지하던 줄표를 확장한다. 희미한 외침은 엷은 잉크로 표현된다. 실제로 접힌 지면은 닫힌 문을 나타낸다. 부분 광택은 땀방울을 표상하거나, 원본의 빈 지면을 채워 독자의 모습을 비춘다. 원작에서는 검정 지면이 등장인물의 죽음을 암시하는데, 여기에서는 해당 시점까지 쓰인 글을 모두 겹쳐 찍은 지면이 그 장치를 대신한다. 원작의 마블링 패턴을 대체하는 확대된 사진의 무아레 무늬는 현대적 인쇄 기법을 이용해 원작과 같은 우연의 효과를 창출한다. 트리스트럼 샌디가—또는 스턴이—오늘날 책을 쓴다면 어떻게 썼을지 새로이 상상하는 신판은 여러 면에서 '샌디 되기' 시도라고도 볼 만하다.

어 프랙티스 포 에브리데이 라이프는 커스티 카터와 에마 토머스가 2003년 설립한 스튜디오다. 그들은 기업과 문화 기관을 위한 작업을 통해 "일상을 비범하게 번역하고 변형할 수 있는 이야기"를 추구한다. 주요 클라이언트로는 《아키텍츠 저널》,

영국문화원, 필립스 드 퓌리, 테이트 미술관, 빅토리아 앨버트 미술관, 웰컴 트러스
트 등이 있다.

The Life and Opinions of Tristram Shandy, Gentleman is a novel by Laurence Sterne, originally published in installments starting from 1759. Apart from being considered as a pioneer of self-reflexive writing with numerous quotations, references and allusions—influencing many modernist and postmodernist writers in the twentieth century—it is infamous for its use of non-verbal devices, such as illustrations and diagrammatic drawings, typographic marks replacing words, pages where the entire text area is printed in black, left as blank, or mysteriously marbled. Visual Edition's 2010 edition, designed by the London-based studio designed by A Practice for Everyday Life, was an attempt to restore its "magic and lustre," much of which had been lost in carelessly produced modern editions, by breathing "new life into the book's design, adding new visual elements, while staying faithful to the original spirit."

A Practice for Everyday Life approached this challenge with a rich and playful treatment. A neon color is used to highlight the unusual lengths of dashes in the original edition, which represent pauses or expletives. Ten pages of orange lines expand a paragraph full of dashes in the original edition; fainting cries are printed in pale ink; a physically folded page marks a closed door; spot varnish is used to represent sweat or cover the original blank page to reflect the reader. Overprinted pages of text, instead of the original black plate pages, illustrate a death with the accumulation of all the words up to that point, and the pattern of a moiréd print of an enlarged image replaces the original marble pattern, reflecting the same aspect of chance but in contemporary printing techniques. In many respects, the new edition can be seen as an exercise of "becoming Shandy": it freshly imagines what Tristram Shandy—or Sterne—would do if he were writing the book today.

A Practice for Everyday Life was founded by Kirsty Carter and Emma Thomas in 2003. Across a diverse range of work for companies and cultural institutions, they pursue "stories which can translate and transform the ordinary into the extraordinary." Their clients include *Architects' Journal*, British Council, Phillips de Pury, Tate, Victoria and Albert Museum, and Wellcome Trust.

어 프랙티스 포 에브리데이 라이프
2003년 설립, 런던: 커스티 카터, 1979년생, 영국 / 에마 토머스, 1979년생,
영국.

A Practice for Everyday Life
Founded in 2003, London: Kirsty Carter, b. 1979, UK, and
Emma Thomas, b. 1979, UK.

apracticeforeverydaylife.com

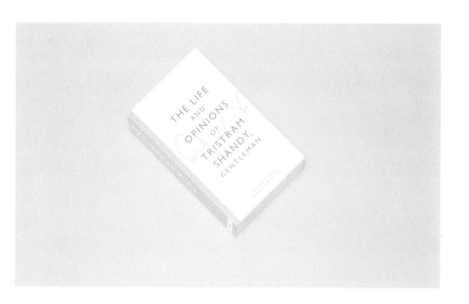

신사 트리스트럼 섄디의 인생과 생각 이야기
2010. 오프셋, 사철에 표지. 13.5×22×3.3 cm, 688쪽. 로렌스 스턴 원작
(1759–1767). 런던: 비주얼 에디션스.

The Life and Opinions of Tristram Shandy, Gentleman
2010. Offset lithography, sewn in sections, cover. 13.5×22×3.3 cm,
688 pp. Original text (1759–1767) by Laurence Sterne. London: Visual
Editions.

서명
signature

유명 작가 중에는 자필 서명이 특히 유명한 이들이 있다. J. D. 샐린저, 어니스트 헤밍웨이, 제임스 조이스, T. S. 엘리엇, 트루먼 커포티…. 그리고 프란츠 카프카도 그중 한 명이다. 피어 퓌어 텍사스가 디자인한 피셔 출판사의 카프카 전집은 바로 그 자원을 활용한다.

실제로 같은 독일 출판사에서 1970년대에 출간한 카프카 전집 표지에도 작가의 서명이 쓰였다. 주된 차이로, 구간에서는 'Kafka'라는 성만 권별 표지마다 검정 바탕에 흰색으로 쓰였지만 근간에서는 전체 서명이 열두 권에 걸쳐 자리했다는 점을 꼽을 만하다. 따라서 1970년대 전집은 개별 권을 완성된 작품으로 간주하는 반면, 최근 판은 작품 전체의 연속성을 강조하고 개별 권은 전체 가운데 일부 또는 단편으로 인식하는 인상을 준다. 더욱이 2008년 전집에서는 작가의 서명이 크게 확대된 형태로 실렸기에, 개별 권 표지에서는 그것이 서명인지 알아보기 어려울 정도다. 작가를 알려면 전집이 필요한 셈이다.

흰 바탕에 거의 추상적인 형상처럼 배치된 검정 획은 산뜻한 색으로 작게 인쇄된 출판사 로고와 대비를 이룬다. 표제는 서명 형태로 결정되는 구도에 맞추어 권마다 다른 위치에 자리 잡는다. 그 결과 타이포그래피는 열두 권에 걸쳐 리듬감 있는 흐름을 형성한다. (물론 모든 책을 바른 순서대로 놓고 보았을 때 이야기다.) 넉넉한 여백 덕분에 어둡고 심각한 예전 출간물에 비해 전체적인 분위기는 가볍고 여유롭다. 그것이 카프카에 대한 인식의 변화를 반영한 것인지는 불분명하지만, 신선한 느낌을 주는 것은 사실이다.

피어 퓌어 텍사스는 프랑크푸르트에 본부를 둔 광고 대행사다. 주요 클라이언트로는 《프랑크푸르터 알게마이네 차이퉁》 신문사, 도이체 방크, 볼빅, 프랑크푸르트 도서전, 피셔 출판사, 프랑크푸르트 시 등이 있다. 피셔 카프카 컬렉션 디자인으로 2009년 iF 커뮤니케이션 디자인 어워드와 레드 닷 커뮤니케이션 디자인 어워드에서 수상하는 등 화려한 수상 경력을 자랑한다.

Some famous authors would sign their work with equally famous signatures: J. D. Salinger, Ernest Hemingway, James Joyce, T. S. Eliot, Truman Capote… and Franz Kafka. Vier für Texas's design of the Fischer Kafka collection exploits that asset.

In fact, the author's signature was also used on the covers of an earlier edition of a Kafka collection published by the same German publisher in the 1970s. A main difference is that now a full signature is printed across the twelve volumes, while in the previous edition a single word "Kafka" in the author's handwriting appears on each cover, reversed out on black background. The implication would seem that the 1970s edition treats each volume as a self-contained work, while the recent publication emphasizes continuity within the body of work, a single volume being a fragment, a piece of a whole. Furthermore, the signature on the 2008 collection is cropped in such a way that it is not immediately recognizable on an individual cover: you need the full set to get to know the author.

On each cover, the almost abstract, stark black strokes on white background are counterpointed by the publisher's small logo in color. The text is arranged differently each time, finding its place according to the composition determined by the cropping of the signature. As a result, the typography creates a lyrical flow over the twelve volumes—provided that they are arranged in right order! With much white space around the elements, the overall atmosphere is lighter and airier than the dark and somber earlier covers. It is not clear if this reflects a changed perception of the author's work, but it does feel liberating.

Vier für Texas is an advertising and branding agency based in Frankfurt a.M. The clients include *Frankfurter Allgemeine Zeitung,* Deutsche Bank, Volvic, Messe Frankfurt, S. Fischer Verlag and the City of Frankfurt. It has won many international awards, including iF Communication Design Award and Red Dot Communication Design Award in 2009 for the Fischer Kafka collection.

피어 퓌어 텍사스
2002년 설립, 프랑크푸르트: 뵤른 에케를, 필리프 에르라흐 공동 대표.

Vier für Texas
Established in 2002, Frankfurt a.M: Björn Eckerl and Philipp Erlach, principals.

vier-fuer-texas.de

프란츠 카프카 12권 전집
2008. 오프셋, 무선철에 표지. 각각 12×19 cm, 두께와 쪽수 다양.
프랑크푸르트: 피셔.

Franz Kafka: Gesammelte Werk in zwölf Bänden
2008. Offset lithography, cut and glued, cover. 12×19 cm each;
thickness and extent vary. Frankfurt am Main: Fischer Taschenbuch.

272

수행어
performative

―――――――
요리스 크리티스와 율리 페이터르스는 벨기에 출신 그래픽 디자이너다. 두 사람은
겐트의 신트뤼카스 미술대학에서 공부할 때 만났고, 2010년과 2011년에 각각 아
른험 베르크플라츠 티포흐라피를 졸업했다. 함께한 프로젝트로는 안트베르펜 플랑
드르 건축협회의 격년 간행물 《플랑드르 건축 리뷰》, 암스테르담 더 아틀리에와 로
테르담 피트 즈바르트 인스티튜트의 전시회 도록, 예술 프로그램 '춤출 수 없는 혁
명에는 참여하지 않을 거야' 관련 출판물, 케르스턴 헤이르스 다비트 판 세베런 건
축 사무소 도록과 웹사이트, 브뤼셀 아키텍처 워크룸 아이덴티티, 네덜란드 미술 잡
지 《메트로폴리스 M》 디자인 개편, 기타 여러 미술가와 저술가의 출판물 디자인 등
이 있다. 크리티스는 현재 브뤼셀과 암스테르담에서, 페이터르스는 안트베르펜에
서 활동 중이다.
　그들의 작업은 간단하게 특징지어 말하기 어렵다. 대체로 그들은 광범위한 조사
로 작업을 시작하지만, 특정한 방법론을 따르는 것 같진 않다. 특정 형식이나 관습,
사물에서 영감을 받아 작업하는 일이 잦지만, 그러한 참조 대상이 직접적이거나 노
골적으로 드러나는 일은 드물다. 타이포그래피는 능숙하게 제어되고 구조화된 모습
을 보이지만, 활자체 선택이나 요소의 배치, 간격 조절 등에서는 별난 개성이 드러
나기도 한다. 이미지는 섬세하게 편집, 배열, 배치되지만, 그렇다고 '스펙터클'한 효
과를 자아내지는 않는다. 재료와 제작 공정 선택도 신중하고 신선하지만, 그 결과는
인쇄의 '물성'을 과장하는 작업이 부끄럽게 느껴질 정도로 미묘하다. 요컨대 그들의
작업에는 잔잔한 모순이 가득하고, 그래서인지 그들의 작업을 어떤 범주로 분류하
기는 무척 어렵다. 그 결과 작품에는 일정한 익명성이 배어들지만, 그 익명성조차 고
전적 도서 디자이너들이 주장하는 익명성과는 거리가 있다. 그것은 디자이너의 부
재가 아니라 현존과 함께하는 익명성이다.
　《(잘못) 읽는 가면》과 《읽기/느끼기》는 '춤출 수 없는 혁명에는 참여하지 않을 거
야(IICD)'와 연관해 출간된 책이다. 리투아니아 태생 미국인 페미니스트 겸 무정부
주의자 옘마 골드만(1869–1940)의 인용구에서 이름을 따온 IICD는 작품 제작 지

원과 학술 프로그램을 통해 "현대 퍼포먼스 예술과 기획, 이론에서 흥겨운 비판적 측면"을 탐구해왔다. 암스테르담에 본부를 두고 유럽 여러 도시에서 프로그램을 진행하는 IICD는 2005년부터 현재까지 네 차례 프로젝트를 치러냈다. 《(잘못) 읽는 가면》은 3차(2008–2010), 《읽기/느끼기》는 '교감'을 주제로 한 4차 IICD를 통해 간행되었다.

두 책 모두 IICD 독서회 활동의 결과물이다. 각 권에는 독서회에서 읽고 토론한 글의 원문과 연관 논문 등이 실렸다. 두 책 모두에서 원문은 글이 원래 실렸던 책의 지면을 그대로 스캔한 이미지로 제시된다. 이미지의 해상도는 눈에 띄게 거칠어, '인공물'로서 원문의 존재를 실감하게 한다. 크리티스와 페이터르스는 원래 지면에서 불필요한 부분을 단순히 지워내지 않고 사각형 그래픽으로 가리는 방법을 택함으로써, 그런 부분의 존재를 인정한다. 《(잘못) 읽는 가면》 표지에는 IICD 로고를 반복하고 겹쳐 만들어낸 도형이 실렸는데, 그 형태는 1960–70년대 사회과학 이론서 표지를 연상시킨다. 더욱이 그 도형은 뒤 표지에도 반복되어, 책 자체가 연극적 도구인 가면 노릇을 하게 된다.

《읽기/느끼기》 표지에는 카럴 마르턴스—크리티스와 페이터르스의 스승—가 만든 판화 이미지가 실렸다. 길에서 주운 듯한 금속 조각을 이용해 찍어낸 두 형상은 미묘하게 다른 검정으로 인쇄되어 있고, 서로 닿을 듯 말 듯한 위치에 놓여 있다. 그 형상은 제목에 쓰인 사선(/)을 감각적으로 대신하며 두 활동의 조심스러운 만남을 암시한다. 전체적으로 두 책의 디자인에는 독서를 순수하게 정신적인 과정이 아니라 물질적이고 육체적이며 수행적인 행위로 파악하는 태도가 묻어난다. 그리고 이는 IICD의 정신에도 부합하는 태도인 듯하다.

Joris Kritis and Julie Peeters are graphic designers from Belgium. They met while studying at the Sint-Lucas Beeldende Kunst in Ghent, and both graduated from the Werkplaats Typografie, Arnhem, in 2010 and 2011 respectively. Their collaborative projects include *Architectural Review Flanders* a biannual publication by the Vlaams Architectuurinstituut, Antwerp; exhibition catalogs for De Ateliers, Amsterdam and the Piet Zwart Institute, Rotterdam; publications for If I Can't Dance, I Don't Want to be Part of Your Revolution, an international artistic research and production program; catalog and website for the Office Kersten Geers David Van Severen; graphic identity of the Architecture Workroom Brussels; the complete redesign of *Metropolis M*, the Dutch art magazine; and publications by artists and writers. Kritis is currently living and working in Brussels and Amsterdam. Peeters is based in Antwerp.

Their work defies easy characterization. Most of their work starts from extensive research, but they do not seem to follow any predetermined methodology. Often they take specific formats, conventions or artifacts

as inspiration, but the references are rarely made direct or explicit. The typography is skillfully controlled and structured, but there is always a certain eccentricity to the choice of typeface, the spacing and alignment of elements. The images are carefully trimmed, sequenced and positioned, but not to any "spectacular" effect. The choice of material and production technique is considered and inventive, but in a subtle way that might embarrass a fetish display of exaggerated "materiality" of print. In short, their work is full of gentle contradictions, which make it hard to locate, giving it a sense of anonymity—then again, not exactly the kind advocated by classical book designers. It is anonymity with the presence of designers, not the absence.

(Mis)Reading Masquerades and *Reading/Feeling* are readers published in relation to If I Can't Dance, I Don't Want to be Part of Your Revolution (IICD). Taking the name from a quote by Emma Goldman (1869–1940), a Lithuanian-born, American-deported feminist and anarchist, IICD has been exploring "critical and celebratory dimensions in contemporary performative art practice and in curatorial and theoretical practice" through a series of productions and thematic programs. Based in Amsterdam but taking place in other European cities as well, IICD has realized four editions since 2005. *(Mis)Reading Masquerades* was published as part of the Edition III (2008–2010), and *Reading/Feeling* of the Edition IV—Affect (2010–2012).

Both titles were resulted from the IICD Reading Groups' activities, which include communally reading and the discussion of select texts. Each book reprints the texts along with introductions and related essays. In both books, the texts are presented as directly scanned images of the source publications' pages. The reproductions are noticeably grainy, revealing the texts as artifacts. Irrelevant parts are concealed by graphic gestures in a way that acknowledges their existence, rather than erased from the pictures. The cover of *(Mis)Reading Masquerades* shows the logo of IICD repeated and combined into a geometric shape reminiscent of the theoretical publications from the 1960–70s. With the shape printed on the back cover as well, the book becomes a mask, a performative device. For the cover of *Reading/Feeling*, a print by Karel Martens—a teacher of both Kritis and Peeters—is used: the two wedge shapes, possibility made by a piece of found metal plate, are printed in slightly different shades of black, barely touching each other. The shapes create a sensual equivalent of the slash (/) in the title, suggesting a cautious connection between the two activities. Overall, there is a sense to the design of the books that indicates reading as a material and performative activity, rather than a disembodied, purely mental process. And this seems consistent with the spirit of IICD.

요리스 크리티스
1983년생, 벨기에.

율리 페이터르스
1983년생, 벨기에.

Joris Kritis
Born in 1983, Belgium.

Julie Peeters
Born in 1983, Belgium.

(잘못) 읽는 가면
2010. 오프셋, 사철에 표지. 15×22.5×3cm, 512쪽. 프레데리크 베르홀츠,
이베리아 페레스 엮음. IICD, 네덜란드 미술협회, 피트 즈바르트 인스티튜트,
판 아버 미술관 공동 제작. 베를린: 리볼버.

(Mis)Reading Masquerades
2010. Offset lithography, sewn in sections, cover. 15×22.5×3 cm, 512 pp.
Edited by Frédérique Bergholtz and Iberia Pérez. Produced by IICD
in collaboration with Dutch Art Institute, Piet Zwart Institute and Van
Abbemuseum. Berlin: Revolver.

읽기/느끼기
2013. 오프셋, 사철에 표지. CD 부록. 15×22.5×3cm, 528쪽. 타냐 보두앙,
프레데리크 베르홀츠, 비비언 지얼 엮음. 암스테르담: IICD.

Reading/Feeling
2013. Offset lithography, sewn in sections, cover, CD supplement.
15×22.5×3 cm, 528 pp. Edited by Tanja Baudoin, Frédérique
Bergholtz and Vivian Ziherl. Amsterdam: IICD.

순서

order

───

작가 미코 쿠오링키는 퍼포먼스와 설치, 비디오, 사진, 출판물 등 다양한 매체를 통해 개인과 물리적 세계의 관계를 탐구하고, 그 관계에서 언어가 맡는 역할을 검증한다. 투르쿠 미술대학에서 사진 전공 학사 학위를, 헬싱키 미술·디자인대학에서 석사 학위를 받았다. 헬싱키 신네, 오슬로 퍼시벌 스페이스, 디트로이트 INCA, 빌뉴스 CAC 리딩 룸, 헬싱키 핀란드 사진미술관, 말뫼 스코네스 콘스트푀레닝 등에서 개인전을 열었고, 여러 국제적인 그룹 전시회에 참여한 바 있다.

사물의 질서
인류에게는 언제나 세상을 분류하려는 욕망이 있었다. 우리는 사물을 수집하고, 연구하고, 정돈한다. 미셸 푸코가 이 현상을 포괄적으로 연구해 써낸 《말과 사물》 (1966)은 프랑스 구조주의의 핵심 저작으로 꼽힌다. 핀란드 작가 미코 쿠오링키는 푸코 저작의 영어판 제목(The Order of Things, 사물의 질서)을 문자 그대로 해석해, 책에 담긴 모든 단어를 'A'에서 'Zoophytorum'까지 알파벳 순으로 늘어놓는다. 개념미술 전통에 따라 쿠오링키는 이미 알려진 지식을 재배열한다. 그는 글 한 편을 알파벳 원재료로 분해하고, 그와 동시에 푸코의 사유를 독특하게 드러내는 새로운 글을 조합해낸다. [토마스 가이거]

───

The artist Mikko Kuorinki uses various media from performance and installation to video, photography and publication to investigate an individual's relationship to the world, often mediated by language. He earned a BA in photography from Turku Arts Academy, Finland, and an MFA from the University of Arts and Design Helsinki. He has held solo exhibitions at institutions including Sinne, Helsinki; Percival Space, Oslo; INCA, Detroit; CAC Reading Room, Vilnius; Finnish Museum of Photography, Helsinki; and Skånes Konstförening, Malmö. His work has also been included in many international group exhibitions.

The Order of Things

The desire to classify the world has always been a need for mankind: we collect, reflect and sort things. Michel Foucault wrote extensively about this phenomena in his book *The Order of Things: An Archaeology of the Human Sciences* (1966), one of the core works that anchor the French structuralist school of thought. The Finnish artist Mikko Kuorinki interpreted Foucault's title literally and put all the words in the book in alphabetical order: from "A" to "Zoophytorum." In the tradition of conceptual art, Kuorinki reordered knowledge that is already available. He decomposed a text to an alphabetical material—and composed at the same time a new text, which offers us a very unusual view into the thinking of the French philosopher. [Thomas Geiger]

미코 쿠오링키
1977년생, 핀란드.

Mikko Kuorinki
Born in 1977, Finland.

kuorinki.com

사물의 질서
2012. 오프셋, 사철에 표지, 띠지. 10.5×17.8×1.6 cm, 432쪽. 미셸 푸코 원작(영어판, 1970). 디자인: 아스트리트 제메. 카를스루에/빈: 마르크 페칭어 페어라크.

The Order of Things
2012. Offset lithography, sewn in sections, cover, outsert.
10.5×17.8×1.6 cm, 432 pp. Original text by Michel Foucault, English translation (1970). Designed by Astrid Seme. Karlsruhe/Vienna: Mark Pezinger Verlag.

순열

permutation

모니커는 2012년 루나 마우러, 요나탄 퓌케이, 룰 바우터르스가 암스테르담에서 설립한 스튜디오다. 그들은 인터랙티브, 인쇄, 비디오, 설치, 퍼포먼스 작업을 중심으로 문화 기관에서 상업적 기업에 이르는 다양한 클라이언트와 함께 작업한다. 아울러 독자적인 실험 작업을 통해 기술이 사회에 끼치는 영향, 즉 우리가 기술을 사용하는 방식과 기술이 우리 일상에 끼치는 영향을 탐구하기도 한다. 그들은 프로젝트 개발에 종종 대중을 참여시키고, 개인적 선택과 해석이 작업에 끼치는 영향을 수용한다. 헤이그 스트롬 미술관, 뉴욕 동영상 미술관, 암스테르담 네덜란드 미디어 아트 인스티튜트, 미니애폴리스 워커 아트 센터 등의 전시에 참여했다.

2008년부터 모니커는 (미술가 에도 파울루스와 함께) 결과보다 과정을 중시하는 창작 방법, 이른바 '조건 디자인'을 연구하기도 했다. 2013년 5월에는 조건 디자인 선언문과 그 이론적 배경을 설명하는 글이 실린 책—제목도 적절한 《조건 디자인 실습서》—이 출간되었다. 무엇보다 이 책은 조건 디자인 구성원이 행한 워크숍의 규칙, 결과, 이미지가 실린 실습서라는 점에 의의가 있다.

디자이너를 위한 중복 영사 안내

중복 인쇄라는 말을 들어보았는가? 물론 들어보았을 것이다. 중복 인쇄는 색 하나에 다른 색을 겹쳐 혼색을 유도하는 인쇄 기법이다. 흔히 최소 수단으로 다양한 효과를 얻는 데 쓰인다. 중복 인쇄를 이용하면 미묘하고 아름다운 뉘앙스나 혼색 효과를 얻을 수 있다. 예컨대 빨강에 빨강을 겹쳐 인쇄하면 더욱 강렬한 빨강을 얻을 수 있다. 중복 인쇄는 잉크의 투명도 같은 인쇄 매체의 성질을 드러낸다. 전통적으로 디자이너 책장에는 중복 인쇄 안내서가 한 권씩 있었고, 누구나 실크스크린이나 오프셋 등 잉크 매체를 통해 중복 인쇄를 실험하고 싶어했다. 그러나 오늘날 디지털 매체와 화면, 영사 기술에서 색의 물질성과 뉘앙스는 사라져버리고 말았다. 이제는 물감이 아니라 빛이 섞여, 즉 RGB가 섞여 색이 만들어지기 때문이다. 우리는 대형 인쇄물 표면에 영상을 영사함으로써 인쇄와 빛이라는 두 매체가 섞였을 때 어떤 일이 벌어지는지 알아보려고 한다.

〈디자이너를 위한 중복 영사 안내〉는 채색한 표면에 빛을 영사했을 때 어떤 효과가 나타나는지 알아보려는 첫 시도다. 흰색 표면이 아니라 빨강 표면에 빨강을 영사하면 얼마나 선명한 빨강이 나타날까? 초록이나 파랑 표면에 빨강을 영사하면? 이 작품은 조합론에 기초해 만들어졌다. 벽에는 대형 포스터 세 점이 붙어 있다. 포스터마다 다른 형태가 다른 색상으로 인쇄되어 있다. 포스터에 서로 다른 형태와 색상이 조합된 동영상을 영사한다. 동영상에 등장하는 형태는 사각형, 삼각형, 원이고, 색상은 RGB 혼색으로 만들어진다. 동영상에서 형태 조합은 대략 60단계에 걸쳐 이루어진다. 관객은 미묘한 효과와 변화를 관찰하면서 변화가 일어나는 방식을 음미할 수 있다. 영상은 약 5분에 걸쳐 마치 활자 표본처럼 작동한다.

가능한 조합을 모두 보여주고 순열의 무한성을 드러내는 발상은 울리포 집단 문학인과 수학자들이 제안한 개념과 유사하다. 우리는 명확히 정해진 규칙과 조합을 통해 우리가 사용하는 어휘를 획득한다. 작품에 등장하는 색면들은 아직 실제 맥락에 적용되지 않은, 스스로 존재하는 잠재성이 된다. [모니커]

Moniker is an Amsterdam-based design studio founded in 2012 by Luna Maurer, Jonathan Puckey and Roel Wouters. The studio specializes in interactive, print, video, physical installation and performance work for a diverse range of clients, from cultural institutions to commercial enterprises. Along with the commissioned work, they also invest in self-initiated, experimental projects, through which they explore the social effects of technology—how we use technology and how it influences our daily lives. They often ask the public to take part in the development of their projects, embracing the influence of personal choice and interpretation on their work. Their work has been shown in galleries and museums around the world, including Stroom, The Hague; Museum of the Moving Image, New York; Netherlands Media Art Institute, Amsterdam; and Walker Art Center, Minneapolis.

Since 2008, they have been exploring (with the artist Edo Paulus) what they call "Conditional Design," an interdisciplinary approach that emphasizes process rather than product. In May 2013, a book—appropriately titled *Conditional Design Workbook*—containing the manifesto as well as several articles providing a more theoretical background was published by Valiz. Most importantly, however, it acts as a workbook, containing the rules, results and images of the workshops conducted by the members of Conditional Design.

The Designer's Guide to Overprojection

Have you ever heard of overprinting? Yes, of course you have! Overprinting is a printing technique with which one color is printed over another causing the colors to mix. Overprinting is often used to achieve a

large variety of effects with minimal means. This process can result in sometimes subtle and beautiful nuances or color mixes. For example, we know that if red is printed over red, it produces an even more intense tone of red. Overprinting reveals the characteristics of the print medium, such as the transparency of ink. Traditionally, a guidebook on this subject was a must-have that resided on every designer's bookshelf, and everyone wanted to experiment with this in print media, offset, silkscreen or other ink-based printing techniques. Now, with digital media, screens and projections, the materiality and nuances of color have disappeared. Instead of mixing color pigments we are mixing light: RGB. We want to investigate what happens when we mix the two media, print and light, by creating a number of large-scale color prints and projections that overlap.

The Designers Guide to Overprojection is the first guide that gives an extensive insight into different possibilities of projecting over another colored surface. How bright is red if it is projected onto a red surface compared to a white one? What happens if you project red onto a green or blue surface? The images you see are based on the principle of combinatorics. Three large posters are hung on the wall, each containing a different shape in a different color. Over the posters, there is a projection with permutations of a fixed set of shapes and colors. The shapes are rectangular, triangular and circular, executed in RGB colors. The permutation in the guide introduces roughly 60 different stages. The subtle effects and changes inspire the visitors to carefully watch how the changes evolve. The film takes about 5 minutes and acts as a type specimen.

The idea of trying to showcase all possible combinations and the sheer endlessness of the permutations are in line with the notions proposed by the writers and mathematicians who belonged to the OuLiPo group. We employ a combinatory approach and use clearly defined guidelines in order to reach a vocabulary through which we speak. As a type specimen, these color fields are not yet contextualized but stand for themselves. [Moniker]

모니커

2012년 설립, 암스테르담: 루나 마우러, 1972년생, 독일 /

요나탄 퓌케이, 1981년생, 네덜란드 / 룰 바우터르스, 1976년생, 네덜란드.

Moniker

Founded in 2012, Amsterdam: Luna Maurer, b. 1972, Germany;

Jonathan Puckey, b. 1981, the Netherlands; and Roel Wouters,

b. 1976, the Netherlands.

studiomoniker.com

디자이너를 위한 중복 영사 안내

2013. 복합 매체 설치: 단채널 비디오, 실크스크린 포스터 3점. 설치 크기 가변,

포스터 각각 100×142 cm. 상영 시간 5분 10초(반복 재생).

The Designer's Guide to Overprojection

2013. Mixed-media installation: single-channel video, screen-printed

posters. Dimensions variable; posters, 100×142 cm each. 5 minutes

10 seconds (loop).

슈퍼텍스트: 머리말이 아닙니다

최성민

문자를 다루는 예술로서 타이포그래피는 시각예술과 언어예술의 이중적 성격을 띤다. 타이포잔치 2013은 그 중첩 지대에 숨은 문학적 잠재성을 탐구한다.

현대 타이포그래피는 주어진 글을 꾸미는 수동적 역할을 넘어, 글 자체를 생성, 해석, 공유하는 일에 적극적이고 비평적으로 개입하고 있다. 문학과 인문학에 국한한 주제였던 글쓰기의 조건과 관습, 속성을 탐구하면서, 타이포그래피는 그 자체로 문학의 한 형태가 된다. 한편, 문학에서도 순수한 언어를 넘어 시각적, 물질적 장치를 실험하는 전통은 꾸준히 이어져 왔다. 구체시에서 울리포 집단, 메타픽션과 시각적 글쓰기 등으로 이어진 형식 실험은 언어예술의 테두리를 넓히며 여러 타이포그래피 디자이너에게 영감을 주곤 했다. 아울러, 확산된 디지털 제작과 네트워크 기술은 글을 쓰고, 나누고, 읽는 조건에 깊은 영향을 끼치면서, 텍스트의 속성과 위상을 근본적으로 변형하고 있다.

타이포잔치 2013은 이처럼 흔들리는 문자 문화 전통을 뚫고 새로이 솟아나는 텍스트를 읽고 쓰면서, 고도로 확장되고 유연하고 동적이고 민감한 그 텍스트의 조건과 가능성을 살펴본다.

전시는 크게 네 부분으로 나뉜다. '언어예술로서 타이포그래피'는 텍스트의 발견, 생성, 조작, 공유에 깊이 개입하고 언어의 물질성을 탐구함으로써, 그 자체로 잠재적 문학 형식으로 기능하는 타이포그래피 작품을 다룬다. '독서의 형태'는 잘 알려진 텍스트를 새로운 시각에서 읽고 조형함으로써 예기치 않은 의미와 경험을 창출하는 작품에 초점을 둔다. '커버, 스토리'는 시리즈 간행물 표지 디자인을 중심으로, 상품으로서 문학의 정체성을 규정하는 도서 브랜딩을 살펴본다. 마지막으로 서울스퀘어 미디어 캔버스에서 펼쳐지는 '무중력 글쓰기'는 젊은 한국 디자이너 7인과 시인 7인이 짝을 지어 도시 공간에 동적으로 표출되는 영상 시를 선보인다.

* * *

윗글은 내가 타이포잔치 2013을 소개하려는 목적에서 여러 홍보물에 써낸 머리글이다. 글의 목적은 주제를 요약하는 데 있다기보다는 명확히 조율되지 않은 몇몇 시사점을 밝히는 데 있었다. 그러나 더 큰 목적은 그 글이 서툴게나마 의도했던 바로 그것, 즉 그럴싸한 홍보용 문구처럼 들리게 하는 데 있었다. 윗글에 텅 빈 수사, 불필요하게 무거운 말, 검증되지 않은 단정이 적지 않은 데는 그런 이유가 있다. 게다가 저 머리글은 조잡한 JPEG처럼 압축되어 있기까지 하다. 할 수만 있다면 다시 쓰고

Supertext: Not an Introduction

Choi Sung Min

Typography has a dual identity: it is as much an art of language as a visual art. Typojanchi 2013 is devoted to the literary potentials of typography in the overlap of the two realms.

Rather than merely visualizing a given text, contemporary typography has come to actively engage in the production and distribution of the text. Exploring the themes traditionally reserved for literary studies, such as conditions, conventions and the nature of writing, typography itself becomes a form of literature. Meanwhile in literature itself, there is an experimental tradition of non-verbal—visual and material—devices. From concrete poetry to the OuLiPo group, metafiction and visual writings, the formal investigations have helped widen the boundaries of literature, inspiring many typographic designers. In addition, the widespread digital production and network technology have had a deep impact on the way we write, share and read texts, fundamentally transforming its nature and status. All these have contributed to the changing status of the text, from a solid common ground for communication to more intangible and transient clouds in the air.

Typojanchi 2013 attempts to read and write the new text emerging from the shaking tradition of literary culture, examining the conditions and possibilities of the super-expanded, super-fluid, super-dynamic and super-sensitive text.

The exhibition consists of four sections. "Typography as an Art of Language" deals with how typography becomes a potentially literary form by engaging with the discovery, production, manipulation and distribution of the text. "Forms of Reading" focuses on active interpretations of existing texts, and how new meanings and experiences are created by their typographic treatment. "Covers, Stories" shows examples of literary branding, focusing on the cover designs of select serial publications. Finally, "Writing in the Air" is a series of kinetic poetry created by close collaborations between young Korean typographic designers and poets.

* * *

This is what I wrote as an introduction to Typojanchi 2013 for various promotional materials, with a hope less to outline the themes than to suggest some uncoordinated points. But more than anything else, the text

싶은 글이다. 아니, 그보다는 타이포잔치 2013을 찾은 관객 한 분에게 글을 부탁하는 편이 나을지도 모르겠다. 그라면 아마 전시에 관해 참으로 통찰력 있는 말을 해 줄 수 있을 것이다. 그러나 일단 쓰인 말은 쓰인 말, 그것을 돌이킬 길은 없다. 그런데 지금 나는 이 책에 실을 또 다른 머리말을 써야 한다. 고쳐 쓸 기회일까? 이제 전시도 개전했고 설명이나 홍보 부담도 적어졌으니, 어쩌면 조금 더 말이 되는 무엇인가를 쓸 수 있을지도 모른다.

그러나 그러지 않을 작정이다. 문제는, 내가 이 전시에 관해 말하는 일에 진력이 나버렸다는 점이다. 아무튼 전시 작품들은 너무나도 유창하게 스스로 말할 줄 안다. 그것만으로는 모자라다는 양, 이 책의 지면에는 작품과 작가에 관한 말이 필요 이상으로 자세히 실려 있기도 하다. 그중 일부는 작가가 스스로 밝힌 말이다. 작품에 관해 말하다 보면 자칫 작품을 지나치게 명시할─그럼으로써 지나치게 단순화할─위험이 있는데, 지금 우리는 그 금지선을 넘어서기 직전인 듯하다. 그러므로 또 다른 머리말로 군더더기만 더하는 짓을, 나는 하지 않을 작정이다.

그럼에도 머리말을 꼭 새로 써야 한다면, 타이포잔치 2013에서 '타이포그래피'는 출발점이지 목적지가 아니라는 말을 더할 것이다. (목적지는 문화역서울 284라고, 나는 농담처럼 말하곤 한다.) 아울러 타이포잔치 2013은 문학'과' 타이포그래피가 아니라 문학'으로서' 타이포그래피에 관심을 둔다고도 강조할 것이다. 사실, 전시 작품 모두가 글을 내용으로 삼지는 않는다. 그중 일부에는 '내용'이 아예 없기까지 하다. 특히 전시의 중심을 이루는 '언어예술로서 타이포그래피' 섹션에서, 타이포그래피와 문학의 관계가 명시화한 작품은 오히려 드물다. 글로 쓰인 예술로서 문학이 서사와 언어의 성질을 주요 관심사로 삼는다면, 그와 비슷한 주제를 탐구하는 타이포그래피 작품은─전시에 소개된 작품 다수가 그렇다─무엇이든 문학적 잠재성이 있다고 볼 만하다.

잠재성 이야기가 나와서 말인데, 새 머리말을 쓴다면 또한 타이포잔치 2013을 홀리는 유령 하나를 더욱 명확히 밝힐지도 모르겠다. 울리포(프랑스어로 '잠재문학 작업실'을 뜻한다) 집단이라는 유령을 가리킨다. 그것은 남종신 / 손예원 / 정인교가 리서치 프로젝트 《잠재문학실험실》에서 연마하기도─또는 '구마(驅魔)'하기도─했지만, 또한 여러 전시 작품을 관류하는 정신이기도 하기 때문이다.

마지막으로, 기획 단계에서 의도하지는 않았지만 여러 작품이 문자 이전 또는 이후를 상상한다는 점도 덧붙이고 싶을 듯하다. 그것은 홍철기가 기획한 한글날 전야제 '글 이전, 말 이후' 공연에서 조명하는 주제이기도 하다. 그러나 아무튼 나는 머리글을 새로 쓸 생각이 없으므로, 독자는 작품들이 하는 말에, 또는 적어도 책의 지면이 전하는 소리에 귀를 기울여야 할 것이다.

다행히 책에는 설명이 아니라 확장을 꾀하는 글이 몇 편 실렸다. 참여 작가 가운데 한 명인 루이 뤼티의 〈검정 지면에 관하여〉는 18세기 《트리스트럼 섄디》에서 윌리엄 H. 개스의 1995년 작 《터널》에 이르는 소설 작품에서 검정 지면이라는 비언어

was meant to sound like—perhaps unsuccessfully—what it was meant to be: a piece of marketing apparatus. Accordingly, it has its share of empty rhetorics, unnecessarily heavy words and unqualified assertions. And it's compressed like an ugly JPEG. I would write it again, if possible. Or I would not write at all, relegating the job to any one of the visitors to Typojanchi 2013, all of whom would surely have more insightful things to say about the exhibition. But what's been said is what's been said, and there's no way of unsaying it. And here I am, having to write another introduction to the exhibition, this time for this book. Is this an opportunity for rewriting? Now that the exhibition has opened, and with less burden for explanation and public relations present, perhaps I can attempt to write something more sensible.

Except I won't. The problem is, I'm weary of talking about the exhibition, where the works are speaking for themselves so eloquently anyway. And as if there was any doubt about it, the exhibits and their creators are thoroughly talked about on the pages of this volume, sometimes by the artists themselves. There is always a danger of over-articulation—and thus of over-simplification—in talking about works, and I'm afraid we're already on the verge of crossing the line. So—no, I won't try to make any more sense with yet another introduction, which would be strictly redundant.

If I really had to write a new one, however, then I would probably want to state that "typography" in Typojanchi 2013 is a point of departure, not its destination. (I'd jokingly say that the destination is the Culture Station Seoul 284.) I would also stress that Typojanchi 2013 is about typography *as* literature, rather than any relationship of typography *and* literature. In fact, not all the works in the exhibition have textual contents: some of them even have no "content" at all. Especially in what might be considered central to the exhibition, the "Typography as an Art of Language" section, the relationship between typography and literature is rarely explicit. If literature is the art of written work, concerned with storytelling and the qualities of language, then any typographic work that performs a similar investigation—as exemplified by many in the exhibition—might be said to have literary potentials.

Speaking of potentials, I would probably be more explicit in the new introduction about a particular specter haunting Typojanchi 2013, that of the OuLiPo group (ouvroir de littérature potentielle, or "workshop of potential literature"). For their spirit is not only directly exercised—or should I say, exorcised?—by Nam Juong Sin, Son Yee Won and Jung In Kyio in their research project *Potential Literature Workbook*, but also permeating many works in the exhibition.

Finally, I would add that the idea of writing or literature before and after writing has emerged as another recurring theme in the exhibition, even

적 장치가 어떻게 쓰였는지 살펴본다. 브라이언 딜런은 존 모건의 설치 작품 〈블랑슈 또는 망각〉에 관한 글에서 어떻게 자신이 갈리마르 총서에 매료되었는지 회상한다. 오베케의 '기생 잡지' 《나는 아직 살아 있다》 24호는 쌍둥이 서체를 통해 쌍둥이 자매 이야기를 들려주면서 타이포그래피의 서사적 가능성을 실연해 보인다. 타이포잔치 2013 큐레이터 가운데 한 명인 유지원은 Y자의 진화 과정에 초점을 두고 글자의 형성 자체에 잠재한 서사를 탐색한다. 박현수는 '타이포그래피적 상상력'과 그것이 한국 근대 시에서 맡은 역할을 논한다. 마지막으로, '무중력 글쓰기' 공동 기획자이기도 한 이정엽은 고층 빌딩 전면을 역동적 시작(詩作)의 지면으로 삼는다는 것이 어떤 의미인지 성찰한다. 이들은 다른 수단으로써 같은 주제를 탐구하는 기획으로 의도되었는데…

────────────

타이포잔치 2013 총감독 최성민은 그래픽 디자인 듀오 슬기와 민의 일원이고, 서울시립대학교 산업디자인학과 부교수로 재직 중이다.

if it was never consciously planned. The theme is also manifest in the works performed at the Hangul Day Eve Festival, "Before Writing, After Speaking" curated by Hong Chulki. But as I'm not writing another introduction after all, the readers are encouraged to listen to what the works have to say, or at least what is presented in the pages of this book.

Fortunately, though, we have other materials here that are not explanatory but expansive. One of the participating artists, Louis Lüthi's "On Black Pages" talks about the use of the non-verbal device in fictions, from the eighteenth-century *Tristram Shandy* to William H. Gass's *The Tunnel*, 1995. Brian Dillon recollects how he became fascinated by the Librairie Gallimard in his short text originally included in the handout accompanying the installation *Blanche ou L'Oubli* / *Blanche or Forgetting* by John Morgan. Åbäke's contribution—the twenty-fourth issue of their "parasite magazine," *I Am Still Alive*—acts out the narrative possibilities of typography by telling the story of a fictitious twin sisters in twin typefaces. One of the curators of Typojanchi 2013, Yu Jiwon contributes an essay that examines potential narratives embedded in the development of letterform itself, in this case the letter "Y." Park Hyun-Soo discusses "typographic imagination" and the roles it played in modern Korean poetry. Finally, the co-curator of "Writing in the Air" section, Lee Jung Yeop reflects on what it means to use the facade of a high-rise as a page for dynamic poetry. These contributions are intended as explorations of recurring themes by other means, and…

The curatorial director of Typojanchi 2013, Choi Sung Min is partner of the graphic design practice Sulki and Min, and associate professor of the University of Seoul.

시제
tense

———
구레이는 베이징에서 활동하는 그래픽 디자이너이자 타이니 워크숍 설립자다. 여러 단체와 기업의 브랜드 전략과 그래픽 디자인 작업을 했으며, 2013/2012년 도쿄 아트 디렉터스 클럽 어워드, 2012년 중국 디자인 대전, 2011년 홍콩 글로벌 디자인 어워드, 2011년 중국 국제 포스터 비엔날레, 제5회 국제 그래픽 디자인 비엔날레 등에서 수상했다.

　2012년 베이징에서 열린 《큰소리》전을 위해 만든 〈미래: 안녕하세요, 저는 현재입니다〉는 현재/과거의 작가와 미래/현재의 작가가 나누는 대화를 보여준다. 기성품 편지지, 편지봉투와 우편 등 단순한 수단으로 만들어진 이 작품은 시간의 흐름에 관한 정서를 드러낸다. 정보를 가리는 행위─편지지와 봉투를 재활용하려는 실용적 조치지만, 또한 망각에 대한 은유일 수도 있다─는 서글프지만 '미래'가 생명을 지속하려면 꼭 필요한 조건을 암시하는지도 모른다.

미래: 안녕하세요, 저는 현재입니다
2012년 9월 25일 오후, 베이징, 다소 흐리고 약한 비. 편지지와 편지봉투를 사러 근처 우체국에 간다.
9월 26일, 우체국을 다시 찾아 편지를 보낸다. 이제부터 그 봉투와 편지지는 생명을 갖는다. 지금 이 시간이 바로 그들 삶의 출발점이다.
며칠 후 편지를 받는다. 봉투를 뜯고 편지를 꺼내 읽는다. "미래: 안녕하세요, 저는 현재입니다. 만나서 반갑습니다. 이 편지를 읽을 때쯤이면 저는 이미 과거가 되어 있겠지요. 하지만….".
편지 내용에 선을 그어 지우고, 봉투에 적힌 정보를 가린다. 미래에 누군가가 그들의 생명을 이어가며 또 다른 '미래'에게 그들을 전해주기 바라며. [구레이]

———
Gu Lei is a graphic designer based in Beijing, founder of the studio TI-NYworkshop and a partner of G_Lab. He has worked for many cultural

and commercial clients for their brand strategies and graphic communi-cation. His work has been widely recognized, including the TDC Annual Awards 2013 and 2012, China Design Exhibition 2012, HKDA Global Design Awards 2011, China International Poster Biennial 2011, and In-ternational Graphic Design Biennial 5.

Originally created for the exhibition *Get It Louder* in Beijing, 2012, *Future: Hello, I am Present* is a conversation between the artist in the pres-ent/past and himself in the future/present. By a simple means involving ready-made stationery and postal service, he contemplates on the emo-tions embedded in the passage of time. His gesture of concealment—a practical treatment to ensure the reuse of the stationery, but also a possible metaphor for forgetting—may suggest the sad yet necessary conditions for the Future to continue its life.

Future: Hello, I am Present

September 25, 2012, afternoon, Beijing, cloudy with light rain, I visit a nearby post office to buy stationery.
September 26, I visit the post office again, and send a letter to myself. From now on, the envelope and the letter begin their own lives. This time of the day is their starting point.
A few days later, I receive them. I take out the letter and read: "Future: Hello, I am Present. Very pleased to meet you. When you see this letter, I'll have become Past, but…"
I cross out the content, and cover the information on the envelope, hop-ing that someone in the future may extend their lives and bring them to another Future. [Gu Lei]

구레이(顾磊)
1979년생, 중국.

Gu Lei
Born in 1979, China.

tinyworkshop.cn

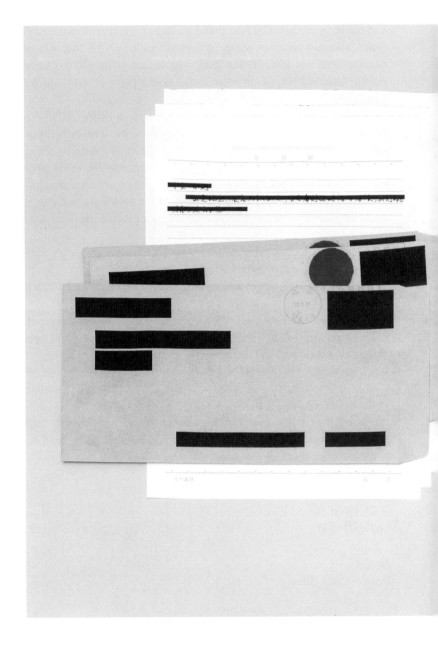

미래: 안녕하세요, 저는 현재입니다(未来: 你好, 我是现在)
2012. 기성품 편지지와 편지봉투, 잉크. 크기 가변.

Future: Hello, I am Present
2012. Handwriting on ready-made stationery, ink. Dimensions variable.

시품

poem object

타이포잔치 2013을 위해 디자인한 기념품—가방, 연필, 공책, 배지, 포스터—은 문자에서 문학으로 이행하는 과정을 매개한다. 프랑스의 '잠재문학 작업실', 즉 울리포 집단에서 영감을 받은 이 '시품(詩品)'들은 언어에 앞서는 문학에 관해, 그리고 타이포그래피의 문학적 잠재성에 관해 질문을 던진다. 에드워드 존스턴, 에릭 길, 파울 레너 등에게 영향을 받아 디자인한 '익명' 인본주의 산세리프체를 통해, 이 사물들은 무엇보다 타이포그래피의 물질적 차원을 가리키는 표면 노릇을 한다. 포스터는 물건들에 짤막하게 덧붙인 강연을 도표로 보여준다. [마크 오언스]

마크 오언스는 로스앤젤레스와 뉴욕을 오가며 활동하는 디자이너이자 저술가다. 예일 대학교에서 그래픽 디자인 석사 학위를, 듀크 대학교에서 영문학 석사 학위를 받았다. 2004년에는 순회전《자유 도서관》을 기획했고, 2005년에는 스튜디오 '라이프 오브 더 마인드'를 설립했다.《스텝》,《아이디어》,《그래픽》등의 전문지와 파이던에서 펴낸《영역 2》, 워커 아트 센터에서 열린《그래픽 디자인: 생산 중》전시 등에 작품이 소개되었다. 2007년에는 잭 카이스와 함께 런던 건축협회에서 열린 전시《질문의 형태》도록을 엮었으며,《돗 돗 돗》,《비지블 랭귀지》,《그래픽》등에 평문을 써냈다. 2010년에는 독립 출판사 오슬로 에디션스를 공동 설립했고, 2012년에는 워홀 재단의 지원을 받아 저서《익명의 그래픽: 디자인, 물질문화, 포스트펑크 미학》집필을 마쳐 현재 출간 준비 중이다. 예일 대학교, 로드아일랜드 디자인대학, 아트 센터 디자인대학에서 강의했고, 현재 캘리포니아 미술대학 석사 과정 객원교수로 있다.

The ancillary materials created for Typojanchi 2013—a tote bag, pencil, notebook, badge, and poster—function as a meditation on the passage from letters to literature. Taking inspiration from the French OuLiPo group, or Workshop for Potential Literature, these "poem objects" pose the question of a literature prior to language and the literary potential

of typography. Using a custom-designed "anonymous" humanist sans that owes a debt to Edward Johnston, Eric Gill, and Paul Renner, among others, these objects function primarily as surfaces that point up the material dimension of typography. The objects are accompanied by a short lecture which is diagrammed in an accompanying poster. [Mark Owens]

Mark Owens is a designer and writer working between Los Angeles and New York. He holds an MFA in graphic design from Yale University and an MA in English literature from Duke University. In 2004 he curated the traveling design exhibition *The Free Library* and in 2005 he established his studio, Life of the Mind. His work has been featured in the pages of *Step*, *Idea*, *Graphic*, Phaidon's *Area 2*, and *Graphic Design: Now in Production*, among others. In 2007 he co-edited with Zak Kyes the exhibition catalogue for *Forms of Inquiry: The Architecture of Critical Graphic Design* at the Architectural Association, London, and his critical essays have appeared in *Dot Dot Dot*, *Visible Language*, and *Grafik*. In 2010 he co-founded the independent publishing imprint Oslo Editions, and in 2012 he was awarded a Warhol Foundation Creative Capital Arts Writer's Grant for the completion his forthcoming book, *Graphics Incognito: Design, Material Culture, and Post-punk Aesthetics*. He has been a visiting critic at Yale, RISD, and Art Center College of Design, and visiting faculty in the MFA program at California Institute of the Arts.

마크 오언스
1971년생, 미국.

Mark Owens
Born in 1971, USA.

lifeofthemind.net

시품
2013. 복합 매체. 크기 다양.

Poem Objects
2013. Mixed-media. Various sizes.

306

실종

disappearance

전용완은 한양대학교 응용미술교육과를 졸업했다. 책에 관심이 많아 열린책들, 열화당, 서울대학교 출판문화원에서 근무했고, 지금은 문학과지성사에서 디자이너로 일하고 있다. 김뉘연과 함께 2012년 2월 29일 '외밀'의 출판사 신고를, 2013년 4월 5일 사업자등록을 마쳤다.

《4 6 28 75 58 47 95》는 '번역은 창작'이라는 속설을 문자 그대로 실현한 작품이다. 열두 가지 서로 다른 《호밀밭의 파수꾼》(또는 《호밀밭의 파수군》)을 꼼꼼히 대조해 체계적으로 종합해낸 이 작품은, 무리한 번역과 노골적인 오역을 한데 모아 우습지만 생소하고 아름다운 혼종 산문으로 변형한다. 수수께끼 같은 제목은 여러 한국어판이 총서로 발행되었다는 점에 착안, 권 번호를 결합한 것이다. 프랑켄슈타인처럼 짜깁기된 본문은 밑줄 색을 통해 출원과 연결된다. 무수한 밑줄 사이로, 또는 "너하고 씹하자"와 "X해라" 사이로, 저자의 존재는 사라진다.

4 6 28 75 58 47 95

이 책은 2010년 타계한 작가 제롬 데이비드 샐린저를 추모하기 위한 것이다.

1. 샐린저는 '은둔의 작가'로 알려졌다.
2. 그의 대표작 《호밀밭의 파수꾼》은 자전소설이다.

이 두 가지 사실은 저자가 《호밀밭의 파수꾼》에서 자신을 지우고 싶었으리라는 오독(誤讀)을 가능하게 한다.

이 책에는 작가의 저자성을 지우려는 실현 불가능한 목적이 있었다. 이는 불가능하지만, 작품의 원문이 모국어가 아닌 경우에는 '번역'이라는 과정에서 저자성을 약화하는 것이 가능하다고 보았다. 국내에는 1969년부터 2002년까지 서로 다른 출판사와 번역자가 펴낸 열두 종의 《호밀밭의 파수꾼》이 있다. 리틀, 브라운에서 출간된 1951년 초판을 기준으로 국내 출판물을 문장 단위로 비교해 선정하고, 밑줄의

색상으로 출판사와 옮긴이를 구분했다. 문장의 선정 기준은 다음과 같다.

첫째, 오역.
둘째, 객관성을 벗어난 옮긴이의 주관적 해석.
셋째, 옮긴이의 수사법 중 국내 정서에 국한된 것.
넷째, 띄어쓰기와 오자(誤字)는 문제 삼지 않으나, 그 오류로 뜻이 달라진 문장.
다섯째, 옮긴이 임의대로 추가한 문장.

이 책은 이본(異本)들의 정본(定本)을 추구했다. [전용완]

Jeon Yong Wan graduated from the Department of Applied Art Educa-
tion, Hanyang University, Seoul. Fascinated by books, he has worked
as a designer at Open Books, Youlhwadang and Seoul National Uni-
versity Press. Currently he is working at Moonji Publishing Company. In
2012, he founded the publishing imprint Œumil with Kim Nui Yeon.

 Jeon's *4 6 28 75 58 47 95* literally realizes the notion of "creative trans-
lation." Systematically constructed through a selective-methodical
reading of twelve different Korean translations of *The Catcher in the Rye*,
it transforms awkward or outright mistranslated sentences into a hilari-
ous yet strangely beautiful hybrid prose. The mysterious title enumer-
ates the volume numbers of the original translations, many of which ap-
peared as part of series. The Frankenstein-like text is connected to the
sources by the colored underlines. Between the numerous underlines,
or the alternative translations of "Fuck you," the authorship—whatever it
means in this case—disappears.

<p align="center">4 6 28 75 58 47 95</p>
This book pays homage to J. D. Salinger, who died in 2010.

1. Salinger was known to have lived a secluded life.
2. *The Catcher in the Rye*, his most well-known work, is an autobio-
graphical novel.

These two facts allow a speculation that the author might have wanted
to remove himself from *The Catcher in the Rye*.
 Retreating one's presence from one's own work may be an impos-
sible dream. It might be possible, however, to reduce the authorship in
the process of translation, from the author's own language to another.
From 1969 until 2002, twelve different Korean translations of *The Catch-
er in the Rye* were released by various publishers. I compared all the

volumes with the first English edition published in 1951 by Little, Brown: sentence by sentence, choosing ones to use from alternative translations, marking the sources by the color of the underlines. I used the following criteria when making the selection:

- obvious mistranslations;
- grossly subjective interpretations against common sense;
- overtly localized rhetorics;
- typos and grammatical errors distorting the meanings;
- arbitrarily added sentences and phrases.

This book has attempted at an original copy of different copies. [Jeon Yong-wan]

전용완
1984년생, 한국.

Jeon Yong-wan
Born in 1984, Korea.

4 6 28 75 58 47 95
(2010) 2013. 오프셋, 사철에 천 씌운 판지, 압연, 커버. 16×23.2×2 cm(지면
크기 15.3×22.5 cm), 208쪽. 작가 발행.

4 6 28 75 58 47 95
(2010) 2013. Offset lithography, sewn in sections, cased in cloth,
dust jacket. 16×23.2×2 cm (page dimensions 15.3×22.5 cm), 208 pp.
Self-published.

실화
true story

샘 더 흐로트는 2008년 암스테르담 헤릿 리트벨트 아카데미 그래픽 디자인과를 졸업하고, 이후 프리랜서 디자이너로 활동하며 문화계 클라이언트와 작업하는 한편, 작가 폴 하워스와 함께 음악을 만들고 강연 퍼포먼스를 펼치는 작업을 병행해왔다.

더 흐로트는 또한 트루 트루 트루라는 출판사를 설립해 책을 펴내기도 했다. 트루 트루 트루는 그가 네스키오의 《작은 거인들》을 영어로 옮기고 펴낸 작업에 뿌리를 둔다. 2008년에 출간된 《작은 거인들》은 작은 판형, 등사 인쇄와 특유한 청색 잉크, 힘들이지 않은 타이포그래피, DIY 정신(샘 더 흐로트가 직접 만든 전용 활자체) 등 당시 디자이너들이 스스로 펴내던 소규모 출판물의 전형적 특징을 더러 보인다. 그러나 여러 유사 출판사와 달리, 트루 트루 트루는 단지 할 수 있으므로 책을 펴내겠다는 허영심이 아니라 실제 내용을 타인과 나누겠다는 욕망(네스키오 책의 번역은 영어권 친구들에게 그 책을 소개하겠다는 뜻에서 만들어졌다)에 근원을 두고 뚜렷한 문학적 초점을 탐구해나갔다.

예컨대 초기 간행물인 《앤디 더 피츠: 로빈 킨로스에게 보내는 편지》(2009)는 스물두 살의 디자인 전공 학생 앤디가 자신의 영웅인 하이픈 프레스의 타이포그래퍼 겸 저술가 겸 편집자 겸 출판인에게 보내는 편지 형식을 띤다. 이 "타이포그래피 희극"에서 주인공은 "묻지도 않은 조언을 하기도 하고 절실한 가르침을 구하는 한편, 타이포그래피, [록 밴드] 스미스, 이슬람 근본주의, 올바른 복장, 노숙자, 책 표지에 관한 생각을 나눈다." 정신없이 웃기면서도 불경한 이 책은 타이포그래피 디자이너 특유의 예리한 관찰을 통해 새내기의 불안과 조바심을 묘사한다.

비교적 짧은 기간임에도 트루 트루 트루는 이미 알찬 작품 목록을 내놓은 상태다. 번역물과 소설, 음악 등 다양한 형식을 통해 희극이라는—타이포그래피 희극이든 일반 희극이든—장르를 일관성 있게 개척해왔다. 미래에 '출판병'(로빈 킨로스의 영웅이던 타이포그래퍼 겸 인쇄인 겸 출판인 앤서니 프로스하우그가 킨로스에게 진단해준 병명이기도 하다)에 걸린 디자이너들이 앤디 더 피츠에게 보내는 편지에는 어떤 말을 적을지 궁금하다.

Sam de Groot graduated from the graphic design department of the Gerrit Rietveld Academie, Amsterdam, in 2008. Since then he has been working as a freelance designer for cultural clients, as well as making music and lecture-performance pieces, often in collaboration with the artist Paul Haworth.

De Groot has also published books under his True True True imprint, which evolved out of his experience of translating and producing the English edition of Nescio's *Little Titans*. Published in 2008, the book displayed its share of qualities typical of designers' self-publishing at that time: small format; mimeographed pages and its characteristic blue ink; nonchalant typography; and an evident sense of do-it-yourself (including the custom typeface he created for the project). Unlike many of its contemporaries, however, True True True has been fueled by a real desire to share content (in the case of Nescio's, with English-speaking friends) rather than mere capacity for production, and benefited from its literary focus.

For example, one of the early publications, *Andy de Fiets: Letter to Robin Kinross* (2009), takes the form of a fictitious letter by Andy, a 22-year-old design student, to his hero, the typographer, writer, editor and publisher behind Hyphen Press. In this "typographic comedy," Andy "offers unsolicited advice, seeks much-needed guidance, and shares his thoughts on matters such as typography, the Smiths, Islamic fundamentalism, proper clothing, the homeless, dust covers." This hilariously irreverent homage speaks of the sentiments of newcomers—anxious sense of belatedness—with astute observations uniquely available to a typographic designer.

For a relatively short period of operation, True True True has produced a small yet substantial body of work, ranging from translations to original novels and audio work, developing a unique genre of comedy—typographic or otherwise. One would be curious what future generations of designers with the "publishing bug" (the one that Kinross himself was diagnosed with by his own hero, the typographer, printer and one-time publisher Anthony Froshaug) will have to say in their letters to Andy de Fiets.

샘 더 흐로트
1985년생, 네덜란드.

Sam de Groot
Born in 1985, the Netherlands.

samdegroot.nl

작은 거인들
2008. 등사, 사철에 표지. 9.3×14.3×0.4 cm, 68쪽. 네스키오, 본명 얀 흐뢴로
원작(1915). 샘 더 흐로트 / 이언 애덤스 옮김. 암스테르담: 트루 트루 트루.

Little Titans
2008. Mimeography, sewn in sections, cover. 9.3×14.3×0.4 cm, 68 pp.
Original text, Titaantjes (1915) by Nescio (J. H. F. Grönloh). Translated
by Sam de Groot with Ian Adams. Amsterdam: True True True.

그렇지만, 그렇지만…
2009. 등사, 중철. 9.3×14.3×0.2 cm, 16쪽. 네스키오, 본명 얀 흐륀로 원작
(1914–1943). 샘 더 흐로트 / 이언 애덤스 옮김. 암스테르담: 트루 트루 트루.

And yet, and yet…
2009. Mimeography, saddle-stitched. 9.3×14.3×0.2 cm, 16 pp.
Original texts (1914–1943) by Nescio (J. H. F. Grönloh). Translated by
Sam de Groot with Ian Adams. Amsterdam: True True True.

앤디 더 피츠: 로빈 킨로스에게 보내는 편지
(2009) 2010. 오프셋, 중철에 표지, 삽지. 12.5×21×0.3 cm, 24쪽. 개정판.
폴 하워스 / 샘 더 흐로트 지음. 암스테르담: 트루 트루 트루.

Andy de Fiets: Letter to Robin Kinross
(2009) 2010. Offset lithography, saddle-stitched, cover, insert.
12.5×21×0.3 cm, 24 pp. Second edition. Text by Paul Haworth and
Sam de Groot. Amsterdam: True True True.

Left: well nigh indestructible inner construction. Right: note the elegant functionality of the adjustable waistband.

A sand-coloured 69 'Harrington' blouson by Baracuta of Manchester, with its trademark tartan lining. Worn with an electric-blue button-down shirt.

Hair and spectacles share a visual approach: light below, heavy on top.

쌍무지개
double rainbow

———
1950년 프랑크푸르트에서 설립된 주어캄프 페어라크는 유럽에서 인문학과 문학을 주도하는 출판사다. 제2차 세계대전 후 독일 지성계에 끼친 영향뿐 아니라, 신선한 출판 디자인과 타이포그래피도 그 명성에 한몫했다. 그 디자인에서 주요 역할을 한 인물은 빌리 플레크하우스였다. 그가 디자인한 에디치온 주어캄프, 일명 '무지개 총서'는 진지하면서도 저렴한 보급판 인문학 총서로 1960년대 초부터 출간되었고, 오늘날은 20세기 디자인 아이콘 가운데 하나로 꼽히는 작품이다. 권마다 표지 배경에는 색이 하나씩 깔리고, 그 위에 명료하고 절제된—그러나 '미니멀리즘'과는 거리가 있는—가라몽 타이포그래피가 수평 괘선과 더불어 자리한다. 권별로 배경 색은 보라에서 빨강, 주황, 노랑, 초록, 파랑, 다시 보라로 조금씩 달라진다. 순서대로 늘어놓으면 에디치온 주어캄프는 무지개 스펙트럼을 형성한다.

필름에디치온 주어캄프는 2008년부터 발간되기 시작했다. 1959년부터 2000년까지 출판사 대표로 일한 지크프리트 운젤트는 "주어캄프는 책을 펴내지 않는다. 저자를 펴낸다"고 선언한 바 있다. 이 신조를 따르려는 의도인지, 필름에디치온 주어캄프는 중요한 영화 작품을 DVD로 출간한다. 니나 푀게와 알렉산더 슈투블리크가 고안한 시리즈 디자인 시스템—포장과 인터페이스 화면 디자인을 아우른다—은 플레크하우스가 에디치온 주어캄프에서 수립한 체계를 계승하고 발전시킨다. 무지개 색이 쓰인 점은 유사하다. 괘선도 쓰이지만, 여기에서 괘선은 수평이 아니라 반원형을 그리며 DVD의 형태와 움직임을 반영한다. 가라몽 활자체는 새로운 매체에 어울리는 산세리프체(쿠르트 바이데만이 디자인한 코퍼리트 S)로 대체되었지만, 여기에도 미묘한 인본주의적 감성이 실린다(살짝 열린 글자 속 공간, 원형 점, 2층 구조 소문자 'g' 등). 그 디자인은 유명한 원형을 맹목적으로 모방하지 않는다. 오히려 그와 대화하며 빛의 매체에 어울리는 평행 무지개를 새로 그린다.

니나 푀게는 뚜렷한 개념적 성향을 보이며 여러 분야에 걸쳐 활동하는 디자이너다. 프로그 디자인과 자동차 내비게이션 시스템 업체 톰톰에서 근무했으며, 지금은 독

립 컨설턴트로 주어캄프 페어라크 등 여러 기업에 디자인 서비스를 제공하고 있다. 카를스루에 시립 디자인대학에서 석사 학위를 받았고, 현재 암스테르담에서 활동 중이다. 알렉산더 슈투블리크는 베를린을 기반으로 하는 미디어 예술가다. 예술 집 단 마더 슈투블리크 비어만과 함께 지각의 기제에 초점을 맞추어 공공장소 설치 작 업에 집중하고 있으며, 여러 국제 페스티벌과 전시회에 참여한 바 있다. 카를스루 에 음악대학에서 가르치고 있으며, 자르 미술대학 미디어 예술 디자인과에서 초빙 교수로 재직한 바 있다.

Founded in 1950 in Frankfurt, Suhrkamp Verlag is one of the leading European publishers of humanities and literature. Not only for its contribution to the intellectual life of post-war Germany, it is renowned also for the fresh book design and typography, due to the work of Willy Fleckhaus. The Edition Suhrkamp he designed—the so-called "Rainbow Series"— was started in the early 1960s as a series of serious yet affordable paperbacks, and is now regarded as one of the twentieth-century design icons. Each title bears a single color all over the cover, on which clear and essential—not quite "minimalist"—typography in a Garamond is deployed with simple horizontal rules. Title to title, the background color changes gradually from purple to red, orange, yellow, green, blue, and then to purple again. Arranged in order, the Edition Suhrkamp books create full spectrums of rainbow—hence the nickname.

Filmedition Suhrkamp was launched in 2008. "Suhrkamp doesn't publish books; it publishes authors," once proclaimed Siegfried Unseld, director of the firm from 1959 until 2000. As if following the credo, Filmedition Suhrkamp publishes work of important filmmakers on DVD. The design system of the series—including the packaging and the interface screens—by Nina Vöge and Alexander Stublic inherits and updates the vocabulary established by Fleckhaus for the Editions Suhrkamp. A similar "rainbow" color system is used. There are rules, too, but here they are semicircular, reflecting the shape and the movement of DVD. Appropriately to the medium, the Garamond type has been replaced by a sans-serif (Corporate S by Kurt Weidemann), but there is still a gentle, humanist touch to it (the slightly open counters, circular dots, two-story g's). It does not simply mimic the celebrated template: it creates a parallel rainbow, for the medium of light, in dialogue with the predecessor.

Nina Vöge is a multidisciplinary designer with a strong conceptual emphasis. She has worked at Frog Design and TomTom, the leading supplier of in-car navigation systems. Currently she is an independent creative consultant, offering design services to companies including Suhrkamp Verlag. She holds a master's degree in product design from

the Staatliche Hochschule für Gestaltung Karlsruhe. She currently lives and works in Amsterdam. Alexander Stublic is a media artist based in Berlin. With the artists group Mader Stublic Wiermann, he focuses on mechanisms of perception, as well as creating installations in public space. Together they have participated in many international festivals and exhibitions. He teaches at the Hochschule für Musik Karlsruhe and the Hochschule der Bildenden Künste Saar, where he also held a one-year visiting professorship in media arts and design.

니나 푀게
1977년생, 독일.

알렉산더 슈투블리크
1967년생, 독일.

Nina Vöge
Born in 1977, Germany.

Alexander Stublic
Born in 1967, Germany.

ninavoege.de
stublic.de

필름에디치온 주어캄프
2008. 복합 매체: 오프셋, 플라스틱, 중철 소책자. 13.8×18.8 cm, 두께 다양.

Filmedition Suhrkamp
2008. Mixed media: offset lithography, plastic, saddle-stitched booklet. 13.8×18.8 cm; thickness varies.

알리바이
alibi

마누엘 레더는 독일 베를린에서 스튜디오 마누엘 레더를 설립해 활동하는 디자이너다. 인쇄물에서 출판물, 가구에 이르는 다양한 매체를 통해 그는 인간과 사물이 맺는 관계, 역사의 유연성 등을 탐구한다. 협업을 즐기는 그는 배경과 기능이 다양한 단체나 개인과 함께 작업해왔다. 세계 곳곳에서 여러 전시회에 참여했으며, 2012년에는 멕시코시티 디자인 건축 기록 보관소에서 개인전 《E자는 어디에나 있다》를 열기도 했다. 디자인 작업과 더불어, 예술가 출판물을 전문으로 하는 출판사 봉 디아 보아 타르드 보아 노이트를 운영하기도 한다.

지난 10년 동안 스튜디오 마누엘 레더는 스스로 디자인하는 출판물이나 프로젝트를 위해 여러 활자체를 개발했다. 겉으로 드러나는 형태가 크게 다름에도 그들은 모두 뚜렷한 개념적 성향, 우연히 발견한 형태에 관한 호기심, 전통적 활자체 디자인의 규약을 장난스레 무시하는 태도 등을 공통적으로 내비친다.

그중 몇몇 활자체는 구체적인 자료에 바탕을 둔다. 예컨대 마리아나 카스티요 데바의 《당신이 보는 세 가지 폐허》를 위해 만들어진 〈패스티시〉(2008)는 19세기 말 멕시코에서 출간된 문서에 기초한 활자체다. 마누엘 레더는 멕시코 출판인들이 개발한 혼종 서체 양식에서 영감을 받아 인쇄용 활자와 필기, 타자기 서체 등에서 요소를 혼합한 활자체를 개발했다. 전시회 《언어: 말과 행동 사이》(2013)를 위해 디자인한 선형 활자체는 라틴아메리카와 스페인 문화에 중요한 족적을 남긴 스페인 출판사 에디시오네 데 볼시요의 로고를 바탕으로 만들어졌다. 역시 마리아나 카스티요 데바가 엮어낸 책 《불편한 사물들》(2012)에 쓰인 활자체 〈파올로치〉는 미술가 에두아르도 파올로치의 서신에서 찾아낸 타자기 서체를 출발점으로 삼았다. 양혜규의 《그리드 블록 A3》(2013) 표지에 쓰인 〈시우다드〉는 여러 각도에서 촬영한 입체 간판 사진에 바탕을 둔다. 한편 활자체 〈엘 마에스트로〉(2010)는 마누엘 레더가 멕시코시티의 유물 발굴 현장에서 발견한 레터링을 해석한 작품이다.

때로는 기존 서체나 접근법에서 독자적 서사나 예기치 않은 기능을 담을 공간을 파내기도 한다. 미술가 아스타 그뢰팅을 위해 개발한 활자체 〈이너보이스〉(2005)는 고전적인 연극 포스터 활자체에서 직접 파생했지만, 글자 내부 공간을 조작함으

로써 마치 "인형이 글자를 삼켰는데 그 글자가 목에 걸린" 듯한 느낌을 전하려 했다. 마리아나 카스티요 데바의 전시회와 출판물 《만화경의 눈》(2009)을 위해 디자인한 활자체는 기존 서체 플랜틴을 해체하고 반복함으로써 만화경을 통해 본 듯한 형태로 변형했다. 〈마루〉(2011)나 에란 셰르프의 《FM 시나리오》(2012) 전용 활자체는 언뜻 구성적 서체 범주에 속하는 것처럼 보인다. 〈마루〉는 문화 생산에서 자기 조직 실천과 친화성을 주제로 뮌헨 쿤스트페어라인에서 열린 여름학교 겸 전시회 《집단 친화성》과 관련된 활자체로, 반원과 직선을 조합해 만들어진 모듈 서체에 해당한다. 그러나 대부분의 기하학적 서체와 달리, 〈마루〉는 요소 결합에서 엄격한 규칙을 드러내지 않는다. 오히려 느슨하게 결합한 형태들은 자기 조직이라는 행사 주제를 반영한다. 한편 《FM 시나리오》 활자체는 굵기가 서로 다른 직선을 결합해 만든 형태인데, 그 결과 나타나는 계조 효과 덕분에 활자는 인쇄 품질을 판단하는 시험 패턴 역할을 하기도 한다.

활자체는 위태로운 '존재론적 위상'을 차지한다. 한편으로 활자체는 소통 수단일 뿐이다. 자신의 존재를 부여할 만한 텍스트를 만나기 전까지 활자체는 몸뚱이 없는 목소리에 불과하다. 그러나 또 다른 면에서 '폰트'는—아무리 비물질적이라 해도—엄연한 '물건'으로 느껴지고 취급되는 것이 사실이다. 활자체의 '물건 됨'은 그 형태가 현실 세계 사물을 떠올릴 때 특히 또렷하고, 나아가 불가사의하게까지 느껴진다. 스튜디오 마누엘 레더가 미술가 노라 슐츠를 위해 디자인한 〈스펀지〉(2013)는 작가가 직접 제작한 인쇄기의 스펀지 형태에 바탕을 둔다. 마치 스스로 형태를 만들어낸 듯한 글자들은 슐츠 작품의 원초적 성질을 잘 반영한다. 한편 우크바르 재단(마리아나 카스티요 데바와 이레네 코펠만)의 책 《알리바이는 A》(2007)에 쓰인 활자체는 원통을 이용해 형태가 만들어졌는데, 여기에서 원통은 우크바르 재단의 학제적 야심을 반영하며 서로 다른 영역을 연결해주는 공간을 은유한다. 동시에 그 평면적이고 그림자 같은 형태는 프로젝트 자체의 공상적 성격을 얼마간 드러내주는 듯하다. 혹시 그것은 다른 곳, 다른 장소, 상상의 장소를 향한—보르헤스의 가상 공간 우크바르로 통하는—웜홀일까?

Manuel Raeder is a designer based in Berlin and founder of Studio Manuel Raeder. Through a wide range of media from printed ephemera to publications and furniture, he explores the position of humanity in relation to objects and the malleability of history. Often taking a collaborative approach, he has worked with individuals and institutions of different backgrounds and functions. He has shown his work in exhibitions around the world, and in 2012, he held a solo exhibition, *The Letter E is Everywhere*, at the Archivo Diseño y Arquitectura, Mexico City. Along with his design practice, Raeder is also running a publishing imprint focused on artists' books, Bom Dia Boa Tarde Boa Noite.

Over the past ten years, Raeder and his studio have developed numerous typefaces, usually for specific publications or projects. Although wildly different in appearance, they share strong conceptual determination, curiosity in accidental discoveries and playful irreverence toward traditional restrictions of type design.

Some of the typefaces were inspired by or drawn from specific sources. For example, *Pastiche* (2008) designed for the book *Estas Ruinas Que Ves* by the artist Mariana Castillo Deball, is based on what Raeder discovered in documents from the end of the nineteenth century Mexico. Inspired by the hybrid styles developed by the Mexican publishers, Raeder combined elements from printing types, handwriting and typewriter letters. The monoline typeface for the exhibition *Langages: entre le dire et le faire* (2013) was developed from the logo of an old Spanish publishing house, Ediciones de Bolsillo, which played an important role in Latin America and Spain. *Paolozzi*, designed for the book *Uncomfortable Objects* (2012) also by Mariana Castillo Deball, took its starting point from typewritten characters found in a letter from the artist Eduardo Paolozzi. *Ciudad*, used on the cover of Haegue Yang's *Grid Block A3* (2013), is based on photographs of a three-dimensional sign taken from different angles. And *El maestro* (2010) is an interpretation of a lettering Raeder found at an archaeological site in Mexico City.

Sometimes, Raeder takes existing forms and approaches, then carves out room for his own narratives or unexpected functions. *Innervoice* (2005) for the artist Asta Gröting was directly derived from a classic theater poster typeface, but the manipulated counters are meant to suggest that the characters have been "swallowed by one of the puppets and got stuck inside its throat." The typeface for Mariana Castillo Deball's exhibition and publication *Kaleidoscopic Eye* (2009) took characters from Plantin, then deconstructed and recombined them as if seen through a kaleidoscope. At a glance, *Maaru* (2011) and the typeface for Eran Schaerf's *FM-Scenario* (2012) might appear as belonging to the generic category of constructed letterforms. *Maaru* was developed in relation to the summer school and exhibition *Group Affinity* at the Kunstverein Munich, which was focused on self-organized practice and the notion of affinity in cultural production. It is a modular typeface, based on quarter circles and straight lines. Unlike most geometric typefaces, however, it does not exhibit rigid rules by which the elements are combined. Instead, the relatively loose assemblies seem to reflect the theme of the event, self-organization. *FM-Scenario* typeface is constructed with lines of modulated thickness. The resulting gradation effect makes the characters work as test patterns—the screens by which their own printing quality may be tested.

A typeface occupies a precarious "ontological status." On one hand, it is a mere tool for communication: it remains a voice without a body, until it finds a text it can exert its existence on. On the other hand, a "font" can be seen and felt as a thing in its own right, however intangible it may be. The strange thing-ness of a typeface is made particularly vivid and, at times, uncanny, when its characters remind of actual things in the world. Studio Manuel Raeder's *Sponge* typeface (2013) for the artist Nora Schultz was derived from a sponge used for her self-built printing machine. The primordial sense of Schultz's prints is well conveyed in the almost spontaneous forms of the characters. The typeface for *A for Alibi* (2007), a publication by the Uqbar Foundation (Mariana Castillo Deball and Irene Kopelman), was constructed using a tube. A tube can be a metaphor for an interlinking space, appropriate for the interdisciplinary ambition of the Uqbar Foundation. At the same time, the two-dimensional, shadow-like characters seem to suggest a certain speculative nature of the project. Or are they wormholes to elsewhere, another place, perhaps an imaginary one—such as Borges's fictional place, Uqbar?

스튜디오 마누엘 레더
2003년 설립, 베를린: 마누엘 레더, 1977년생, 독일 / 서희선, 1987년생, 한국 / 산티아고 다 실바, 1986년생, 멕시코.

Studio Manuel Raeder
Founded in 2003, Berlin: Manuel Raeder, b. 1977, Germany; Heesun Seo, b. 1987, Korea; and Santiago da Silva, b. 1986, Mexico.

manuelraeder.co.uk

활자체 모음
2005–2013. 디지털 활자체.

Selected Typefaces
2005–2013. Digital typeface.

ESTAS RUINAS QUE VES
Mariana Castillo Deball
ABCDEFGHIJKLM-
NOPQRSTUVWXYZ,.-()©•
1234567890

〈패스티시〉. 2008.
Pastiche. 2008.

GROUP AFFINITY

ABCDEFGHIJKLMNOP

QRSTUVWXYZ,.-()

1234567890

〈마루〉. 2011.
Maaru. 2011.

Nora Schultz
abcdefghijklm
nopqrstuvwxyz

〈스펀지〉. 2013.
Sponge. 2013.

《FM 시나리오》책을 위한 활자체. 2012.
Typeface for *FM-Scenario*. 2012.

《만화경의 눈》책을 위한 활자체. 2009.
Typeface for *Kaleidoscopic Eye*. 2009.

《알리바이는 A》책을 위한 활자체. 2007.
Typeface for *A for Alibi*. 2007.

《언어: 말과 행동 사이》 전시회를 위한 활자체. 2013.
Typeface for the exhibition *Langages: entre le dire el le faire*. 2013

Paolozzi
ABCDEFGHI
JKLNOPQR
STUVWXYZ
abcdefghi
jklnopq
rstuvwxyz
0123456789
!? & / ()@ . :

〈파올로치〉. 2012.
Paolozzi. 2012.

CIJOAO
ABCDEFGHI
JKLNOPQR
STUVWXYZ
ABCDEFGHI
JKLNOPQ
RSTUVWXYZ
0123456789

〈시우다드〉. 2013.
Ciudad. 2013.

INNER VOICE
FONT ABCDEF
GHIJKLMNOP
QRSTUVWXY
Z abcdefghijk
lmnopqrstuv
wxyz!?".,@%
».,-I^•&/()12
34567890

〈이너보이스〉. 2005.
Innervoice. 2005.

EL MAESTRO
ABCDEF
GHIJKLM
NOPQRS
TUVWXYZ
012345b
789:.

〈엘 마에스트로〉. 2010.
El Maestro. 2010.

Y의 궤적: 어떤 등장인물의 기이한 이야기

유지원

1

나는 그리스에서 온 이주민입니다. 이주민이라니, 이상하게 들리는 소리이지요? 라틴 알파벳이라는 체제의 글자들은 대개 그리스를 거쳐서 오지 않았던가요?

오늘날까지 이어지는 알파벳의 명료한 형태를 확립하고, 또 이를 널리 전파한 이들은 로마인입니다. 로마 시대에, 로마인들이, 라틴어를 위해 사용한 글자 체계를 라틴 알파벳이라고 하지요. 저는 물론 이 라틴 알파벳의 기본 스물여섯 글자 중에서 스물다섯 번째 일원으로 소속되어 있습니다. 그러나 제 영원한 마음속 고향은 그리스랍니다.

알레프, 베타, 감마, 델타, 엡실론… 그리스인들은 셈족인 페니키아인들이 쓰던 알파벳을 배워왔습니다. 저 풍요롭고 충만하던 시절에요. 해상무역이 번성했고, 육로는 오리엔트 문명과 연결되어 문화적으로도 생기가 넘쳤어요. 그 동서 교차로에서, 따뜻한 지중해 동쪽 연안에서, 저는 하늘을 향해 양팔을 가득 펼친 모습으로 화창하게 피어났습니다.

저는 그리스인들에 의해, 그리스어를 위해 태어났습니다. 페니키아 알파벳으로는 표현할 수 없었던 그리스어 발음을 위해, 그리스 알파벳에는 다섯 개의 글자가 더 생겨납니다. 그중 '첫 번째'가 저, 입실론, Y입니다. 페니키아 알파벳의 와우(waw)에 뿌리를 두었다고 볼 수도 있지만, 그리스인들은 와우를 변형해서 저를 새롭게 만들었어요. 그리스의 풍토, 그리스인의 호흡, 그리스인의 음성, 그리스인의 언어가 저의 존재를 불러내었습니다. 입술을 'u'하고 동그랗게 오므린 채로 'i'를 발음하는 그리스인 특유의 소리, 저를 불러내어 글자의 육신을 준 것은 바로 그 소리였습니다.

그런데 로마인의 언어에는 이 발음이 필요하지 않았습니다. 그러니 로마인에게는 저 입실론 역시 필요하지 않았던 거예요. 그들은 그리스에서 로마 북부의 에트루리아를 거쳐 A부터 X까지 스물한 자만을 받아들이면서, 라틴 알파벳의 체제를 세웠습니다. 그러던 중 기원전 1세기가 왔고, 그리스는 로마에 정복당하고 맙니다. 이때 라틴어에는 수많은 그리스 단어가 유입되었겠지요. 그리스어에는 라틴 알파벳으로는 표기할 수 없는 발음들이 있었습니다. 로마인들은 처음에 U와 I로 어떻게든 버텨보려 하다가 부득이 저를 데려와서, 그들의 알파벳 저 뒤에 두었습니다. 팔을 둥글게 펼치곤 했던 제 모습도 딱딱하게 만들었죠.

유럽의 현대어들 사이에서도 저는 그리스 이주민으로 알려져 있습니다. 영어에서만 'u'와 'i' 두 음을 합친 발음 그대로 저를 와이(wye)라 부릅니다. 드물게 라틴 알

The Trajectories of Y: The Strange Case of a Character

Yu Jiwon

1

I'm an immigrant from Greece. An immigrant—it sounds strange, doesn't it? Didn't most of the Latin characters immigrate from Greece anyway?

It was the Romans who established and spread the clear forms of the Latin alphabet—a writing system first used in the ancient Rome, by the people for their language, Latin. I am, of course, the twenty-fifth member of the twenty-six-letter Latin family. But still, my heart is in Greece—and it will ever so remain.

Aleph, beta, gamma, epsilon… the Greeks learned their alphabet from the Phoenicians, a Semitic people, back then when they were rich and things were abundant. The overseas trade was flourishing, and the culture was vibrant as the land was connecting to the Oriental civilizations. At the crossing of the East and the West, in the warm eastern Mediterranean shores, I was born with my arms wide open like a flower in full bloom.

I was born to the Greeks, for the Greek language. Five letters were born to the same family, for the sounds that could not be written by the Phoenician alphabet. The firstborn was me—upsilon, Y. I might have my roots in the Phoenician letter *waw*, but the Greeks modified it and made a new me. It was the Greek climate, the Greek breath, the Greek voice and the Greek language that brought me into existence. The uniquely Greek sound, the one you make by pronouncing *i* with rounded lips as if you're saying *u*— it's *that* voice that called me up and gave me my literal habitation.

But the Romans didn't need the sound. So they didn't need me, either. They laid down the Latin alphabet with only the twenty-one letters from A to X, having imported them from Greece via Etruria, north to Rome. Then in the first century BCE, they conquered the Greeks. Numerous Greek words subsequently flowed into the Latin language. There were sounds in the loanwords that could not be written by the Latin alphabet. The Romans, who first resorted to their U and I, eventually adopted me and made me sit far back. They also straightened my curved arms.

In modern European languages, I'm still known by my Greek origin. Only the English call me by a name combining the sounds of *u* and *i*— wye: a rare instance of consistency with other Latin character names. Both my German name, Ypsilon, and the Italian, ipsilon, were inherited

파벳식 작명법을 따르는 셈이죠. 저의 독일어 이름 윕실론(Ypsilon)과 이탈리아어 이름 입실론(ipsilon)은 그리스 시절 제 이름을 그대로 계승한 것입니다. 로망스어 계열에서는 제 그리스어 발음이 잊혀진 채, 'i'와 똑같은 납작한 발음만이 남았습니다. 그래서 프랑스인들은 저를 이 그레크(i grec), 스페인인들은 저를 이 그리에가 (i griega)라고 부릅니다. '그리스에서 온 i'라는 이름이지요.

그림 1. y의 가계도. 1a: 초기 셈문자 와우. 1b: 후기 셈문자 계열인 페니키아문자 와우(U+10905). 1c: 초기 그리스 대문자 디감마 또는 파우(U+03DC). 1d: 그리스 대문자 입실론(U+03A5). 1e: 갈고리 달린 그리스 대문자 입실론 (U+03D2). 1f: 에트루리아 알파벳을 포함한 고대 이탈리아문자 가운데 '베' (U+10305). 1g: 라틴 알파벳 대문자 F(U+0046). 1h: 라틴 알파벳 대문자 Y(U+0059).

Figure 1. Family tree of the letter Y. 1a: early Seimitic letter *waw*.
1b: Phoenician letter *wau* (U+10905). 1c: early Greek capital digamma (or *fau*, U+03DC). 1d: Greek capital upsilon (U+03A5). 1e: capital upsilon with hook symbol (U+03D2). 1f: *ve* in the old Italic scripts, including Etruscan. 1g: Latin capital F (U+0046). 1h: Latin capital Y (U+0059).

from my old Greek one. In the Romance languages, my original Greek sound has been lost, leaving only the thin figure of *i*. Thus the French call me *i grec*, while the Spanish *i griega*, both meaning "i from Greece."

<div align="center">2</div>

Strictly by age, J, among the twenty-six Latin characters, should be the last in line. He was born just about 300 years ago! Only recently did J branch off from I, and V from U. Before then, I and U played both vowel and consonant roles. Even after the separation, U and V were used interchangeably for a while: it wasn't until the early nineteenth century when V found its current position next to U in the English orthography. J and V should have been placed after Z, but their siblings—I and U—stealthily invited them to cut in line, putting them right after their respective positions.

Well, I guess that's the way it goes. From the Semitic *waw*, five Latin characters—F, U, V, W and Y—have branched out. Five among twenty-six nearly amounts to one-fifth—some fertility! Except for F, we—U, V, W and Y—came to stand in a row, pushing Z to the end of the line, even after the little kid W who was just born to U and V.

They say the position makes the person. Sometimes it makes the letter, too. In our system, our genes do determine how we look and where we stand. But sometimes, neighboring letters may develop similar appearances. E and F, for example, are not related, but they've come to look similar after years of sitting together. Our looks have been determined both by genetic and environmental factors, including our relative positions. Even within a system there are political tensions, and the life is not always as peaceful as it may seem to the outsiders.

<div align="center">3</div>

There were times when I was used, whimsically, as a substitute for *th* in English. If there were infightings with other letters of the same system over positions, one may also struggle for existence with letters from other systems. When was it… I think it was around the fifth century, in the island of Britannia. The Angles, the Saxons and the Jutes—all Germanic peoples—came to this island with their runic alphabets.

While the Etruscan alphabet, which was originated in the region roughly corresponding to modern Tuscany, drifted southward to Rome and became the Latin alphabet, it also moved in the opposite direction, crossing the Alps to the German territories, all the way to Scandinavia, and became runes. The runes—although you can still see their traces in some Scandinavian letters—were to be surpassed by the Latin alphabet, such a mighty writing system. Is it the practicality and the organizational skills of the Romans that's behind the dominance? In any case, the runes were

<div align="center">2</div>

나이순으로만 놓고 보자면, 라틴 알파벳 스물여섯 자 중 J가 가장 뒤에 놓여야 합니다. 출생한 지 300여 년밖에 되지 않았거든요. I에서 J가, U에서 V가 분리된 것은 얼마 되지 않은 일입니다. 그전에는 I와 U가 모음 역할, 자음 역할을 다 해내고 있었죠. U와 V는 서로 분리되기 시작한 후에도 한동안 섞여 쓰이다가, 영어에서는 19세기 초반이 되어서야 V가 U의 바로 뒤로 자리를 확정합니다. J와 V는 Z의 뒤에 있어야 마땅하지만, 그들의 친인척인 I와 U가 각각 자신들의 뒷자리로 슬쩍 새치기를 시켜준 것입니다.

　세상이 뭐 그렇습니다. 셈문자 와우로부터 라틴 알파벳 F, U, V, W, Y가 줄줄이 먼 가지를 뻗습니다. 스물여섯 글자 중 다섯 글자면 무려 5분의 1에 가까우니 굉장히 왕성한 생산력이지요. F를 제외한 우리 U와 V와 W와 Y가 나란히 놓이는 바람에, Z는 U와 V가 낳은 새파란 W에게까지 밀려나서, 여전히 맨 뒷자리에 머무릅니다.

　자리가 사람을 만든다고 하지요. 글자도 가끔 그렇습니다. 우리의 체제 안에서는 이렇게 유전자에 의해 모습도 닮고 자리가 정해지기도 하지만, 반대로 자리가 가까워서 서로 닮아가기도 합니다. E와 F는 그저 이웃일 뿐이지만 딱 붙어 지내더니 그리 닮더군요. 유전적 요인과 각자 자리에서 서로 간의 관계가 만들어낸 환경적 요인이 우리의 모습을 지금처럼 만들었습니다. 체제 내부에서도 정치적인 긴장 관계란 존재하는 것이고, 그 안에서의 생활이 밖에서 보듯 늘 평온한 것만은 아닙니다.

<div align="center">3</div>

제가 엉뚱하게도 영어의 'th'를 대신하던 시절이 있었습니다. 같은 체제 내부에서 자리싸움이 있었다면, 외부의 다른 체제에 속한 글자들과는 생존경쟁을 벌이는 일이 생깁니다. 그때가 언제였더라… 5세기 무렵이었던 것 같습니다. 브리타니아 섬에서 있었던 일이에요. 게르만족인 앵글족, 색슨족, 주트족은 이 섬에 룬문자를 가져왔습니다.

　오늘날 이탈리아 토스카나 지방인 에트루리아의 알파벳은 남쪽 로마로 내려가면서 라틴 알파벳이 되었고, 반대 방향인 북쪽의 알프스를 넘어가서는 게르만 지역으로, 더 멀리 스칸디나비아로, 북으로 북으로 올라가 룬문자가 되었습니다. 룬문자는—오늘날에도 스칸디나비아 지역에서 흔적을 볼 수는 있습니다만—라틴 알파벳에 차츰 잠식당하고 맙니다. 라틴 알파벳은요, 이토록 기세등등합니다. 로마인의 실용성과 단단한 체계성이 이 글자 체계의 생태적 우위도를 그토록 높여놓았던 것일까요? 그렇다고 룬문자가 일방적으로 당하기만 한 것은 아니었어요. 결국 라틴 알파벳을 쓰게 된 어떤 언어들에 지울 수 없는 흔적을 기어이 남겨놓기도 했으니까요.

　그중 저와 기구한 인연을 맺은 룬으로 소른(thorn, þ)이 있습니다. 소른의 형태는 라틴 알파벳 D가 변형된 것으로 알려져 있습니다. 독일어권에서도 종종 D가 소른을 대체했다고 합니다. 소른, 그는 북구신화의 거인이자 천둥의 신 토르의 다른 이름

not completely defeated: they managed to leave some irremovable traces in the languages that eventually adopted the Latin alphabet.

Among the runes, the destiny of thorn (þ) would be strangely entangled with mine. Thorn's form is believed to be linked to the Latin character D. In fact, in German-speaking cultures, D was a common substitute for thorn for a while. Thorn—he was also called as *thurs*, named after the giants and also the god of lightning in Norse mythology, Thor. He was also known in some Germanic languages as *thurisaz*.

The problem is, even though our origins and sounds are totally unrelated, thorn and I looked very much alike to those who spoke Middle English. Already from the twelfth–thirteenth century, þ and y would be used interchangeably: they just couldn't distinguish one from the other. So, I would be called upon for the jobs that were actually meant for thorn.

그림 2. 왼쪽부터: 룬문자 소른(일명 수르스 또는 수리사즈, U+16A6) / 9세기에 새겨진 스웨덴 뢰크의 룬문자 비석에서 / 1300년경 덴마크에서 만들어진 코덱스 루니쿠스에서.

Figure 2. Left to right: the runic letter thorn (a.k.a. *thurs* or *thurisaz*, U+16A6); thorn from the Rök Runestone, Sweden, ninth century; thorn from the Codex Runicus, Denmark, c. 1300.

그림 3. 왼쪽부터: 라틴 알파벳 소문자 소른(U+00FE) / þ, 1280년경 스웨덴의 필사본 / ẙ. 중세 후기(1400–1425) 영어 필사본 〈콘페시오 아만티스〉. 케임브리지 펨브로크 칼리지 소장.

Figure 3. Left to right: the Latin thorn (U+00FE); þ from a Swedish manuscript, c. 1280; ẙ from *Confessio Amantis*, a late-medieval English manuscript. Pembroke College, Cambridge, MS 307, fol. 197v.

인 수르스(thurs)라고 불리기도 했고, 게르만어에서는 수리사즈(thurisaz)라고 불리기도 했습니다.

문제는, 태생이 전혀 다른데다 발음도 관련 없는 소른과 저의 모습이 중세 영어를 쓰던 이 지역에서는 퍽 닮아 보였다는 사실입니다. 12–13세기부터 이미 소른과 저, þ과 y는 구분 없이 사용되곤 했습니다. 사람들이 보기에 둘은 생김새가 너무 헷갈렸습니다. 그럴 때는 소른이 들어갈 자리에도 저를 쓰는 일이 벌어졌지요.

그림 4. 영국 정량 악보에 적힌 서정시. 잉글랜드, 13–14세기. 옥스퍼드 보들리언 도서관 소장.

Figure 4. "Foweles in þe frith. þe fisses in þe flod. […]" Lyrics on an English mensural notation, from thirteenth to fourteenth century (MS. Douce 139, Bodleian Library, Oxford).

그림 5. 흠정역 성경 욥기 1장 9절. 런던, 1611.

Figure 5. "Then Satan answered ẙ LORD, and sayd, Doeth Job feare God for nought?" From Job 1: 9, the King James Bible, London, 1611.

Things got even worse for thorn after printing appeared on the stage of history. People would invent contracted forms to save space in printed pages. Think about, for example, the definite article "the," and how it occupies space without doing much important. So they would contract "the" to "þͤ." And the fonts they imported from Germany or Italy would often lack þ's, but not y's. I mean, what would you expect? As a solution, "yͤ" had to be used instead of "þͤ." If thorn was overwhelmed by me, it was because I was part of the Latin alphabet, which was more widespread in Europe than runes. It was not about individual merits or strength.

Come to think of it, [cautiously] speculatively speaking, I think the same can explain why the second person singular pronoun "thou," which was still used in the Shakespearean era, came to be replaced by the plural "you." In modern English, strangely, second person singular and plural are in the same form. As in French and German, the second person plural began to be used as an honorific, perhaps influenced by the French court practices. The plural was deemed preferable to the singular for its tone of respectfulness, and the former eventually took over the latter. But the same thing didn't happen in other languages, including the ones that had actually influenced the English practice: why? I suspect "thou," which was originated from the Old-English "þū," was first contracted to "þͧ" and then gradually replaced by "you."

But does it meant that I really prevailed over thorn? I don't think so. Even when I was used in the definite article "ye" instead of "þe," I was never pronounced as my own y sound. I lent my form to "the," while thorn desperately inscribed its own sound in the word. I can't tell who's the winner and who's the loser of our struggle.

And what happened to thorn? It's still alive and well in Icelandic, which is notoriously conservative. Like it would never degenerate in the cold climate. Thorn is a rare example of a runic letter that flowed into the Latin alphabet. Thanks to Icelandic, thorn has managed to take a place in the Latin character set, albeit as a supplement. He is living well in his home language.

<div align="center">4.</div>

I'm surprised to see the reminiscence of my thorn-like appearance in the "broken scripts."

Just like languages and writing systems vary along geographic lines, within a single system different regions may develop different letterform styles. Are the letters affected, like creatures, by natural environment? If letters in the cisalpine regions show round stretches of broadleaves, in the North they tend to be blacker and angular, forming dense lines. The style is called "black letter" for the dark and thick strokes. It's also called

인쇄가 역사에 등장한 이후로는, 제가 소른을 대체하는 일이 더욱 맹렬하게 일어났어요. 인쇄에서는 공간을 아끼기 위한 축약 형태들이 고안되곤 합니다. 특히 정관사 'the'가 별로 하는 일도 없이 지면만 계속 잡아먹잖습니까? 그래서 'the'를 줄여서 þ로 표기하곤 했지요. 그런데 독일이나 이탈리아에서 영국으로 수입된 활자 세트에는 y는 있어도 þ은 없는 경우가 태반이었어요. 당연한 현상이지요. 그래서 결국 ẙ로 þ를 대체하는 수밖에 없었어요. 그러니 소른이 제게 밀린 것은, 유럽 대륙에 룬문자보다 널리 퍼져 있던 라틴 알파벳이라는 강력한 체제에 제가 속한 것이 이유였다고 하겠습니다. 개인 간 힘겨루기의 결과만은 아니라는 것입니다.

그런데 말입니다… [주위를 둘러보며] 조심스러운 이야기입니다만, 저는 셰익스피어 시대까지도 남아 있던 2인칭 단수 대명사 'thou'가 복수형인 'you'로 대체된 것도 사실 같은 이유에서일 것으로 생각합니다. 현대 영어에서는 희한하게도 2인칭 단수와 복수의 형태가 서로 같아요. 프랑스나 독일어에서 그렇듯, 영어에서 2인칭 복수형은 높은 사람에 대한 존칭으로 쓰이기 시작했습니다. 이것은 프랑스 궁정어법의 영향이었어요. 복수형이 점차 단수형을 대체한 이유는 복수형이 가진 존칭의 의미가 선호되어서라고도 하지요. 그런데 정작 이런 영향을 준 다른 언어에서는 왜 같은 현상이 일어나지 않았을까요? 고대 영어의 'þū'에서 기원한 'thou' 역시, 인쇄물에서 þ로 축약되었다가 점차 'you'로 대체된 것이라고 저는 생각합니다.

그렇다고 제가 소른에게 일방적으로 승리했다고 할 수 있을까요? 아니요. 저는 정관사 'the'에서 'þe'를 대체하여 'ye'로 쓰일 때조차, 결코 'y' 발음으로 읽힌 적이 없었습니다. 'the'에 저는 잠시 형태를 빌려주었지만, 소른은 자신의 발음을 필사적으로 남겨두었습니다. 소른과 저의 영역 다툼에서, 저는 누가 이기고 졌다고 회상하는 것이 탐탁지 않습니다.

소른은 이후 어떻게 되었느냐고요? 보수적이기로 유명한 아이슬란드어와 아이슬란드 알파벳에서 그 녀석은 여전히 생명력을 유지하고 있습니다. 마치 그 추운 기후에서라면 영원히 변질되지 않을 것처럼 말입니다. 소른은 룬문자에서 라틴 알파벳으로 흘러들어 간 희귀한 사례입니다. 아이슬란드어 덕분에 소른은 오늘날에도 라틴 알파벳에 버젓한 보충 인력으로 편입했습니다. 녀석은 지금 고향의 언어 안에서 지냅니다.

<center>4</center>

소른과 닮았던 시절 저의 모습을 요즘도 '꺾어 쓰는 글자체' 양식에서는 흠칫 발견하곤 합니다.

언어와 글자 체계에도 지역마다 차이가 있듯, 같은 글자 체계 내에서도 지역마다 글자체 양식이 다르게 나타납니다. 이런 글자체 양식도 생물처럼 자연환경에서 영향을 받는 것일까요? 알프스 남쪽에서 글자들이 활엽수 이파리처럼 밝고 둥글게 기지개를 켠다면, 알프스 북쪽에서는 검고 모나고 빽빽하고 촘촘하게 늘어서 있습니

broken scripts because of the angular, pointed corners of the strokes. Among the broken scripts, *textura* was traditionally used for Latin, while various *bastarda* styles were for the European vernaculars. And the Germans had their own style called *fraktur*.

The Germans also had a unique consciousness of letterform. They tried to maintain the pointed corners of strokes even when they were writing fast. And they called the style the "German script," by which they distinguished it from the softer and rounder "Latin script." Isn't it confusing? They were using the same Latin alphabet like other European languages, yet they wanted to have something different and call it "German."

It's probably because their German script was evolved from the Gothic script. The Goths, a Germanic people, used their own Gothic alphabet for their language. It was directly developed from the Greek alphabet, while absorbing certain influences from the runes as well as the Latin alphabet. And the Gothic script is a style of handwriting for the Gothic alphabet. It's also rooted in the fourth-century Greek uncial script. If the French, who were conscious of their Roman lineage, were using the Latin script, then was the German script directly derived from the Greek alphabet and its uncial script a reminder for the Germans of their Greek inheritance?

그림 6. 독일의 속필 필기체인 쿠렌트의 네 종류. y는 왼쪽 방향으로, x는 오른쪽 방향으로 꼬리가 나 있다. 볼프강 푸거의 습자 교본에서. 목판, 뉘른베르크, 1543.

Figure 6. Four kinds of German *Kurrent*, from a *Schreibbücher* (writing exercise book) by Wolfgang Fugger. Woodcut, Nuremberg, 1543.

다. 획이 한가득 굵고 검어서 '블랙 레터'라고도 하고, 모서리에 각이 져서 '꺾어 쓰는 글자체'라고도 합니다. 이 '꺾어 쓰는 글자체' 가운데서도 라틴어에는 텍스투라체가 사용되었다면, 유럽 각국어에는 여러 종류의 바스타르다체가 적용되었지요. 독일어에는 프락투어체라는 양식이 있었고요.

독일인들에게는 글자체 양식에 대한 독특한 의식이 있었습니다. 그들은 필기체를 빠르게 쓸 때도 획의 방향이 바뀌는 부분에서 모서리가 뾰족하게 각지도록 꺾어서 씁니다. 독일인들은 이렇게 쓰는 양식을 독일식 필기체(German script)라고 불렀습니다. 반면 부드럽고 둥글게 돌려서 쓰는 양식을 '라틴식 필기체(Latin script)'라고 불렀지요. 아리송하지 않은가요? 분명 다른 유럽어처럼 라틴 알파벳을 쓰면서도, 라틴과 구분되는 무언가를 만들어서 '독일식'이라고 부른다는 것이요.

아마도 '독일식 필기체'가 '고딕 필기체(Gothic script)'로부터 이행해서일 것입니다. 게르만 계열인 고트족에게는 고트어를 위한 고딕 알파벳이 있었습니다. 고딕 알파벳은 그리스 알파벳을 직접 계승하면서도, 룬문자와 라틴 알파벳의 영향도 다소간은 받았습니다. 고딕 알파벳을 필기하던 글씨체의 양식을 고딕 필기체라고 합니다. 이 고딕 필기체는 또한 4세기 그리스의 언셜체에 뿌리를 둡니다. 로마를 계승하는 의식을 지닌 프랑스가 라틴식 필기체를 쓰고 있으니, 독일이 그리스 알파벳과 그리스 글씨체에 직접적인 바탕을 둔 고딕 필기체로부터 '독일식 필기체'를 발전시켜나간 것은 그리스를 계승한다는 의식과도 무관하지는 않을 테지요.

이탈리아에서 출발한 인본주의적 라틴식 필기체가 일찍이 유럽 여러 국가에 퍼져나가는 와중에, 독일에서는 20세기 중반까지 오래도록 독일식 필기체를 고수했습니다. 독일인들은 독일어에는 독일식 필기체를, 라틴어나 독일어가 아닌 언어에는 라틴식 필기체를 썼습니다. 그래서 그때까지만 해도 교양 있는 독일인이라면 적어도 두 가지 필체를 모두 능숙하게 구사할 줄 알아야만 했지요. 뚜렷이 구분되는 이 필법의 차이, 그리고 이들 양식의 차이가 어떤 글자들에는 근본적인 변형이 가해졌다는 인상을 줄 만큼 뼛속 깊이 개입되었어요.

그런데 근본이라는 것은 무엇이고 원칙이라는 것은 무엇인가요? 오늘날 대문자 Y는 근본적으로 짧은 V아래 기둥이 있는 모양이라고들 합니다. 소문자에서도 마찬가지로 v로부터 꼬리가 내려와서 y가 된다고들 합니다. 이 꼬리는 사선으로 쭉 뻗기도 하고 동그랗게 말리며 구부러지기도 합니다. 이것이 제가 어떻게 생겨야 하는가에 대한 원칙이라고들 합니다.

요는, 세계의 어딘가에는 이런 원칙을 벗어난 존재들이 있다는 것입니다. 이런 녀석들은 이종이라고 해야 할까요? 변이라고 해야 할까요? 무엇이 이들을 Y이게 하고, y이게 할까요? Y를 Y로서 알아볼 수 있게끔 하는 정체성은 무엇일까요? 플라톤적 이데아로서 Y의 원형이라는 것이 존재하긴 하는 것일까요? 당신은 제가 누구인지 아십니까? Y가 어떠해야 하는지 안다고 단언하실 수 있습니까? 글쎄요, 나는 잘 모르겠습니다.

그림 7. 획을 꺾어 쓰는 블랙 레터 서체 Y와 y의 필순. 힐데가르트 코르거 그림.

Figure 7. The stroke order of the broken-script, black-letter Y and y. Drawn by Hildegard Korger.

그림 8. 독일식 필기체. 왼쪽부터: 속필 필기체 쿠렌트, 1900 / 학교 교육용 쥐털린 필기체, 1914 / 코흐 헤르머스도르프 필기체, 1950.

Figure 8. Examples of German handwriting. Left to right: *Schreibschrift Kurrent*, 1900; *Schulausgangsschrift* of Ludwig Sütterlin, 1914; *Schreibschrift* of Koch and Hermersdorf, 1950.

While the Latin script, an Italian-born humanist style, had already spread throughout Europe, the German people stuck to the German script until as late as the mid-twentieth century. They used it to write German words, and the Latin script for foreign ones, including Latin. A "cultured" German was expected to be fluent in both styles. Striking differences in the scripts—and their stylistic features—have affected some letters, sometimes almost fundamentally.

But what are the fundamentals, and what are the principles? Today, the fundamental principle of the uppercase Y is described as a vertical stem underneath a short V. In the lowercase counterpart, it's a tail suspended from the lowercase v. Sometimes the tail is diagonally straight, and sometimes it's curved. These are the principles of how I—that is, Y—should look.

그림 9. 고딕체. 왼쪽부터: 〈페테 고티슈〉, 1893 / 〈플라이슈만 고티슈〉, 18세기 중반 / 영국식 고딕체 〈라이노텍스트〉, 19세기 말.

Figure 9. *Gotisch*. Left to right: *Fette Gotisch*, 1893; *Fleischmann Gotisch*, mid-eighteenth century; and *Linotext*, an English gothic from the late-nineteenth century.

그림 10. 로툰다체. 왼쪽부터: 독일인이 만든 이탈리아식 둥근 고딕체, 〈바이스 룬트고티슈〉, 1939 / 15세기 북부 이탈리아 양식을 모방한 둥근 고딕체, 〈산마르코〉, 1991.

Figure 10. *Rotunda*. Left to right: *Weiß Rundgotisch*, a German interpretation of the round, Italian gothic style, 1938; *San Marco*, an imitation of the fifteenth-century northern Italian style.

그림 11. 바스타르다체. 왼쪽부터: 프랑코니아 지방의 바스타르다체인 17세기식 슈바바허를 복원한 〈뉘른베르거 슈바바허〉, 1927 / 부르고뉴와 플랑드르 지방의 바스타르다체를 복원한 〈부르군디카〉, 1993.

Figure 11. *Bastarda*. Left to right: *Nürnberger Schwabacher*, a reinterpretation of the seventeenth-century *Schwabacher*, a *Bastarda* style of Franconia; *Burgundica*, a reinterpretation of the *Bastarda* styles of Burgundy and Flanders.

그림 12. 프락투어체. 왼쪽부터: 〈포플 프락투어〉, 1986 / 〈페테 헤넬 프락투어〉, 1840 / 〈페테 프락투어〉, 19세기 후반 / 〈첸테나르 프락투어〉, 1937 / 〈클라이스트 프락투어〉, 1928 / 〈티만 프락투어〉, 1915.

Figure 12. *Fraktur*. Left to right: *Poppl Fraktur*, 1986; *Fette Haenel Fraktur*, 1840; *Fette Fraktur*, mid-nineteenth century; *Zentenar Fraktur*, 1937; *Kleist Fraktur*, 1928; and *Tiemann Fraktur*, 1915.

The thing is, there are creatures in the world that do not honor the principles. Should we call them different species? Or mutants? What makes them Ys and y's? What constitutes the identity of the letter Y? Is there any Platonic ideal, the *ur*-form of Y? Do you know who I am? Can you really assure what a Y should look like? Because I can't.

5

In any language, I'm not quite frequently featured an actor. In German, Dutch, Italian and Portuguese, I barely appear once after the other twenty-five have appeared thousands of times. It's not an unfounded self-humiliation. According to a statistics, my frequency of appearance is a mere 0.006%. These languages use me reluctantly, only for loanwords and proper nouns. In some languages represented by the Latin alphabet, it's like I'm forever destined for wandering as a permanent immigrant, never having a chance for naturalization. But I have survived in the system, at least.

5

저는 어떤 언어에서도 일정 수준 이상 자주 등장해본 적이 없습니다. 독일어, 네덜란드어, 이탈리아어, 포르투갈어에서 저는 다른 스물다섯 글자가 수천 번 등장하는 동안 거의 한 번 나타날까 말까 할 정도입니다. 괜한 자기 비하가 아닙니다. 통계에 의하면 포르투갈어에서 저의 등장 빈도는 고작 0.006%라고 하니까요. 이들 언어는 외래어와 고유명사에만 마지못해 저를 사용합니다. 저는 라틴 알파벳으로 표기되는 몇몇 언어 사이에서 영원히 귀화하지 못한 채 이주민으로 떠돌고 있는 셈입니다. 그래도 나는 체제 속에 살아남기는 했습니다.

나는 그리스에서 온 이주민입니다. 고대 그리스의 폴리스들은 문화적으로 번영했지만, 통일국가를 이루지는 못했지요. 라틴 알파벳의 체제는 로마라는 통일 제국의 옛 시절만큼이나 강성하다는 생각이 듭니다. 이 체제에서 이주민으로 결정지어진 운명은 지금까지도 별로 달라진 바가 없습니다. 왜소하고 초라해질 때도 가끔 있어요. 어떤 이는 저의 외형을 두고 타이포그래피적으로는 재앙이라 일렀다더군요. 다른 글자들로 음성적 역할을 대체할 수 있는 J와 Q와 X처럼, 저 역시 불필요한 존재로 여겨지기도 합니다. 한때 이오니아의 기둥처럼 밝고 당당한 모습으로 그리스인들의 필요에 부응하던 저였는데 말입니다.

그런데 말이지요, 영어에서는 저의 등장 빈도가 스물여섯 글자 중 열여덟 번째나 된답니다. 웃음이 나온다고요? 다른 스물다섯 개 글자가 불과 오십 번 등장하는 동안 제가 한 번씩은 나타난다고 하면, 이것이 무슨 의미인지 이해하시겠습니까? 영어에서만큼은 저도 여러 방면으로 활약하는 편입니다. 특히 단어의 맨 뒷자리가 내 차지로 돌아올 때가 많았어요. 꼭 필요한 구성원은 아니라는 눈치를 지금까지 받아오면서도, 문장 구성원으로서 맡은 바 구실을 하며 영역을 넓혀오기도 했습니다. 나는 문법에, 당신이 즐겨 사용하는 단어에, 그리고 어쩌면 지금 내 이야기를 들어주는 당신의 이름 속에 살아남았습니다. 그리고 여전히 이렇게 등장하고 있습니다.

제 이야기를 이렇게 오래 해본 적이 없었던 것 같습니다. 혼자서 말을 많이 했더니 조금 겸연쩍군요. 저는 아무래도 주인공 감은 아닌 모양입니다. 모든 등장인물이 주인공이 될 필요는 없겠지요. 지금까지 털어놓은 저의 어떤 기억들은 어쩌면 과장되었을 수도 있고 어쩌면 편중되었을 수도 있습니다. 하지만 기억이라는 것이 대개는 그렇지 않습니까? 기록도 마찬가지입니다. 이제 물러나겠습니다. 안녕히 계십시오!

타이포잔치 2013 큐레이터 유지원은 타이포그래피 저술가이자 그래픽 디자이너이다.

I'm an immigrant from Greece. The ancient Greek poleis culturally prospered, but they didn't manage to form a unified nation. The regime of the Latin alphabet seems as powerful as the unified Roman Empire in its heyday. In the regime, my destiny as an immigrant hasn't changed much since then. Sometimes I feel small and daunted. Some even have called me a "typographic disaster." Like J, Q and X, all of whom can be phonetically substituted by other characters, I'm often regarded redundant—for all my past glories as an integral servant for the Greeks, with all the brightness and dignity of the ionic columns!

But you know what? In English, my frequency of appearance ranks eighteenth among the twenty-six characters. Oh, you find it amusing, don't you? Do you have any idea of what it means to appear once every fifty times? I'm pretty active at least in English! Especially, the last spot of a word is often mine. I may have felt I'm not essential, but I have expanded my role as a member of sentence! I have survived in grammatical elements, in your favorite words, and perhaps in your names. And here I am, appearing in this story, too!

I've never talked about myself so much before, and it's a little embarrassing to be so dominating. Maybe I'm not fit for a main role, after all. But not all the characters have to play main roles. Some of the stories I've told you—some of my memories—might be exaggerated or biased. But that's how memories are, aren't they? So are any records. Well, I'd better withdraw now. Farewell!

[Translated by Choi Sung Min]

One of the curators of Typojanchi 2013, Yu Jiwon is a typographic writer and graphic designer.

우연
chance

───────────

오하라 다이지로는 도쿄에서 레터링, 일러스트레이션, 영상, 아트 디렉션을 전문으로 하는 스튜디오 오몬마를 이끄는 디자이너다. 무사시노 미술대학을 졸업한 그는 2003년부터 독립적으로 활동하기 시작했다. 그는 뮤직비디오, 광고, 포장, 출판 디자인 작업 외에도 전시와 워크숍, 현장 연구 등을 통해 언어와 문자를 새로이 인식하는 방법을 탐구해왔다. 예컨대 그의 〈문자 채집(文字採集)〉은 풍경에서 문자의 원형을 발견하려는 작업이고, 〈문자 제비(文字くじ)〉는 우연에 의존하는 말장난 작업이며, 〈오몬마 문구점(オモンマ文具店)〉은 각종 부품이나 파편을 '필기도구'로 제시하는 작업이고, 스케이트보드 조각품 〈문자를 타다(文字に乗る)〉는 보드에 쓰인 글자가 물리적, 환경적 요인으로 변하는 모습을 보여준다.

　'활자 중력'으로 옮길 수 있는 오하라 다이지로의 설치 작품 〈타이포그래비티〉는 그가 2012년에 시작한 모빌 조각 연작 '모주료쿠(もじゅうりょく)'의 연장선에 있다. '모주료쿠'는 '모지(もじ, 문자)'와 '주료쿠(じゅうりょく, 중력)'를 합성한 말인데, 그 발음은 '모듈'의 일본식 표현인 '모주루(モジュール)'와 '무중력'을 뜻하는 '무주료쿠(むじゅうりょく)'를 떠올리기도 한다. 줄에 매단 얇은 플라스틱 조각과 벽에 그린 그림으로 구성되는 〈타이포그래비티〉는 대체로 추상적인 조각처럼 보이지만, 때로는 물리적 조각과 그림자가 벽에 그려진 획과 합쳐지면서─즉 서로 다른 '모듈'이 결합하면서─마치 단어처럼 보이는 형상을 순간적으로 만들어내기도 한다.

이렇듯 의미 있는 기호가 우연히 형성되는 모습은 오하라의 작업에서 낯선 풍경이 아니다. 예컨대 비교적 전통적인 책 표지 레터링 작업에서도 그가 그린 문자는 활자나 서예 등 기존 서체를 충실히 따르지 않는다. 오히려 그 문자들은 너무나 느슨히 구성되어, 마치 어떤 문자 같은 형상이 우연히 출현한 것처럼 보이기도 한다. 그러나 어쩌면 그것이 문자의 진실한 성질에 더 가까울지도 모른다. 어떤 문자이든, 의식적으로 설계되거나 필연적으로 결정된 부분은 과연 얼마나 될까?

Ohara Daijiro is a Tokyo-based designer and principal of Omomma, a studio focused on lettering, illustration, motion graphics and art direction. He graduated from Musashino Art University, Tokyo, and started working independently in 2003. Beside commissioned work for music videos, commercials, packaging and publications, he has also been actively engaged in self-initiated projects, searching for new perceptions of words and letters through exhibitions, workshops and fieldwork. *Letter Collection*, for example, is an attempt to find the ur-form of letters in landscapes; *Letter Lottery* is a wordplay based on chance operation; *Omomma Stationery Shop* presents objects and industrial debris as "writing tools"; and *Riding Letters* shows how the lettering on a skateboard may be altered by physical and environmental factors.

Ohara Daijiro's installation *Typogravity* is an extension of the light mobile sculpture series Mojyuryoku (Letter-Gravity) he started in 2012. The series name is also a wordplay in Japanese: it is a compound of *moji* (letter) and *jyuryoku* (gravity), and it also sounds similar to *mojyuru* (module) as well as *mujyuryoku* (zero gravity). Composed of thin plastic strips attached on a wire and a drawing on the wall, a *Typogravity* piece is an abstract sculpture at most times, except when the combination of the physical strips, their shadows and the drawn strokes ("modules") fleetingly create a form that is recognizable as a word.

Chance formation of meaningful signs is not unfamiliar in Ohara's work. Even his more conventional letterings for book covers, for example, do not attempt to be faithful to existing letterform, typographic or calligraphic: rather, the characters are often so loosely constructed that their letter-like appearance feels almost accidental. Then again, it may be closer to the true nature of letters: after all, how much part of any letterform has actually been so consciously designed or inevitably determined?

오하라 다이지로(大原大次郎)
1978년생, 일본.

Ohara Daijiro
Born in 1978, Japan.

omomma.in

타이포그래비티
2013. 복합 매체 설치: 플라스틱, 실, 피부 연필. 크기 가변.

Typogravity
2013. Mixed-media installation: plastic, wire, dermatograph.
Dimensions variable.

원초
primordiality

글 이전, 말 이후
2013년 10월 8일. 기획: 홍철기.
출연: 이행준 / 김태용, 최준용 / 진상태, 필 민턴과 야생 합창단.
타이포잔치 2013 한글날 전야제 '글 이전, 말 이후'는 바탕체나 돋움체 대신 빛, 목소리, 탁구공이 난무하는 복합 예술 공연이다. 프로그램은 문자를 직접 연상시키지 않으면서도 문자와 언어의 표면으로서 소리와 시각성을 매체로 사용하는 작품으로 꾸며진다. 공연은 빔 프로젝터나 사운드 시스템에 의존하지 않은 채, 작품마다 제공하는 독특한 경험을 최대한 살리며 진행된다.

반개념
(1952) 2013. 복합 매체 영상 설치, 퍼포먼스. 크기 가변. 공연 시간 25분.
원작: 질 월만(1952). 번역, 연주: 이행준, 김태용.
hangjunlee.com
프랑스의 시인이자 영화 작가 질 월만(1929–1995)은 상황주의 인터내셔널의 전신인 문자주의 인터내셔널(Internationale Lettriste)의 주요 구성원이었다. 그의 대표작 〈반개념〉(1952)은 필름에 뚫린 구멍을 통과한 원형 빛이 스크린 대신 커다란 흰 풍선에 영사되고, 월만이 자신의 글을 읽는 목소리가 사운드트랙으로 쓰인 작품이다. 영상 예술가 이행준과 시인 김태용은 그 작품을 한국어로 옮겨 현장에서 공연한다.

튀어오르다.떨어지다
(2011) 2013. 퍼포먼스. 공연 시간 25분.
작곡: 최준용. 연주: 최준용, 진상태.
balloonnneedle.com/joonyong.html
실험 음악가 최준용이 2011년 작곡한 개념적 음향/음악 퍼포먼스 시리즈에 속하는 작품. 2명의 공연자가 공간 양쪽의 구조물에 올라 정해진 주기에 따라 탁구공을 바

닥에 떨어뜨린다. 퍼포먼스는 마지막 탁구공이 튀어 오르기를 멈출 때(혹은 관객이 탁구공을 주워 되받아 던지는 일이 끝날 때) 종결된다. 가공되고 추상화된 음악의 우월성과 가치 있는 소리에 대한 집착에 반대하며, 첨단 기술이 아니라 표준화되고 보편화된 기술을 통해 직접적이고 생생한 경험을 제공하는 작품이다.

<p align="center">야생 합창단</p>

2013. 퍼포먼스. 공연 시간 30분.

워크숍 진행, 합창 지휘: 필 민턴. 통역, 진행 보조: 홍철기, 이미연.

philminton.co.uk/feral-choir

1960년대부터 즉흥 보컬리스트로 활동한 영국의 음악가 필 민턴은 1980년대부터 〈야생 합창단〉이라는 이름으로 즉흥 합창 워크숍과 공연을 진행해왔다. 〈야생 합창단〉의 가장 큰 특징은 참여 자격에 제한이 없다는 점이다. 공연 예술이나 성악 훈련을 받지 않은 일반인이라도 민턴이 진행하는 워크숍을 통해 제 목소리의 한계와 범위를 시험하고 즐기면서 공연을 준비할 수 있다. 참가자는 특정한 음악적 규칙에 구애받지 않고 자신의 신체를 악기 삼아 목소리의 세계를 탐구하며 확장한다. 〈야생 합창단〉은 전 세계 20여 도시에서 참가자와 청중의 뜨거운 호응을 이끌어낸 바 있다.

질 월만, 〈반개념〉. 1952. 사진 출원: 소피아 왕비 미술관, 마드리드.

Gil J. Wolman, *L'Anticoncept*. 1952. Photography ©Museo Nacional Centro de Arte Reina Sofía, Madrid.

Before Writing, After Speaking

October 8, 2013. Curated by Hong Chulki. Performed by
Lee Hangjun and Kim Tae-yong, Choi Joonyong and Jin Sang-tae,
Phil Minton and his Feral Choir.

The Typojanchi 2013 Hangul Day Eve Festival, "Before Writing, After Speaking" is a multidisciplinary performance program to celebrate the night before Hangul was born. Sans-serifs and sans-scripts but with a lot of light, voices and Ping-Pong balls, the program presents performance works that do not directly speak of letters but use vision and sound—the surfaces of writing and language—as a medium. Without relying on technological means such as a beamer or sound system, the program attempts to maximize the primordial sensuality that each work is meant to invoke.

L'Anticoncept

(1952) 2013. Mixed-media video installation and performance.
Dimensions variable. Duration: 25 minutes.
Original (1952) by Gil J. Wolman.
Translated and performed by Lee Hangjun and Kim Tae-yong.
hangjunlee.com

The French poet and filmmaker Gil J. Wolman (1929–1995) was a main member of the Letterist International, a precursor to the Situationist International. His most well-known work, *L'Anticoncept* (1952) consisted of blank illumination projected through a hole punched directly on a film and onto a balloon, accompanied by a spoken soundtrack by Wolman himself. The film artist Lee Hangjun and the poet Kim Tae-yong translate the work into Korean and perform it in the space.

Bounce.Befall

(2011) 2013. Performance. Duration: 25 minutes.
Composed by Choi Joonyong.
Performed by Choi Joonyong and Jin Sang-tae.
balloonnneedle.com/joonyong.html

Bounce.Befall is part of a conceptual sound/music performance series created in 2011 by the experimental composer Choi Joonyong. On top of two structures in a space, two performers drop Ping-Pong balls at predetermined intervals. The performance ends when the last ball stops bouncing—or when the audience stops returning the balls. The work attempts to provide direct and vivid sonic experience through an ordinary technique, questioning the supposed superiority of processed and abstract music and the notion of valuable sound.

Feral Choir

2013. Performance. Duration: 30 minutes.
Workshop and choir conducted by Phil Minton.
Supported by Hong Chulki and Lee Mi-yeon.
philminton.co.uk/feral-choir

The British musician Phil Minton has been active as a free-improvising vocalist since the 1960s, and has organized the choir workshop and performance project *Feral Choir* since the 1980s. The most important aspect of *Feral Choir* is that there are no qualifications for participation: anyone—with or without training in singing or performance—can join Minton's workshop and test the gamut of his or her own voice. Unbound by any musical rules, a participant can use one's own body as a musical instrument, exploring and expanding the potentials. Since its inception, *Feral Choir* has inspired much enthusiasm and excitement from the participants as well as the audience in over twenty cities around the world.

유령
ghost

카를 나브로의 작품 원제 'Ghost(s) Writer'는 중의적이다. 그것은 '유령 작가', 즉 타인을 위해 대신 글을 써주는 작가에 빗댄 말장난일 수도 있다. 또 한편으로는 '타이프라이터', 즉 타자기를 빗댄 말처럼 보이기도 한다. 일단 두 가지 가능성을 조합해 〈유령(들) 타자기〉라고 옮겨보자. 본래부터 글을 쓰라고 있는 타이프라이터와 달리, 나브로의 〈유령(들) 타자기〉는 그 자체로 글쓰기 기계라는 기능을 암시하지 않는다. 그렇다면 그것은 무엇에 쓰는 물건일까? 나브로는 그것이 "스케치 행위를 위한 물건"이자, 타자기 또는 장난감 같은 장치라고 설명한다. "정해진 형태 개념을 거부"하고 쓰는 이 또는 보는 이에 따라 기능이 달라지는 조각 작품이기도 하다.

그 자체로 아무 의미 없는 추상적 물체들을 일정한 격자에 끼워 넣으면 무엇인가를 희미하게 떠올리는 형상이 만들어진다. 어쩌면 알파벳 문자 같기도 하다. 그러나 그 형상, 그 의미는 물체에 내재한다기보다, 사용자/관객이 물체에 투사하는 것이다. 그러므로 여기에서 〈유령(들) 타자기〉 대신 글을 써주는 이, 그 유령 작가는 사용자/관객 자신이다. 타이프라이터가 타이프(활자) 같은 문자를 생산하는 기계라면, 혹시 나브로의 작품은 유령(들)을 생산하는 물건일까?

카를 나브로, 일명 월터 워턴은 드로잉, 모형 제작, 활자체 디자인을 결합하는 작업을 통해 어린이처럼 순진한 선과 폭력적인 형상, 건축적이고 기하학적인 구조와 초현실적으로 왜곡된 공간 사이에 잠재한 서사를 탐구한다. 리옹 에밀 콜 미술대학에서 일러스트레이션을 공부하고, 아른험 베르크플라츠 티포흐라피에서 그래픽 디자인을 전공했다. 마인츠 구텐베르크 미술관, 문화역서울 284, 취리히 디자인 미술관, 피렌체 피티 이마지네, 파리 12메일 등의 전시에 참여했고, 2013년에는 버밍엄 이스트사이드 프로젝트에서 개인전을 열었다. 암스테르담 헤릿 리트벨트 아카데미에서 드로잉을 가르쳤으며, 현재 서울시립대학교 산업디자인학과 초빙교수로 드로잉과 타이포그래피를 가르치고 있다.

The title of Karl Nawrot's piece, *Ghost(s) Writer*, may read in two ways: it can be a pun on "ghostwriter," a person who writes for someone else, but it can also be a play on "typewriter," a machine to produce characters. But a typewriter is meant to produce text, while Nawrot's *Ghost(s) Writer* does not immediately suggest that. What is it, then? Nawrot explains that it is "an object dedicated to the act of sketching... It rejects the idea of a definitive form and its function is left to the user or the viewer and can be approached as a typewriter, a construction game or a sculpture."

The nonsensical, abstract pieces are put on a grid to form figures that faintly remind of certain things—such as alphabet letters. But the figures and the meanings are not inherent in the object: they are projected on it by the user/viewer. In that sense, it is the user/viewer who is the ghostwriter, who writes for *Ghost(s) Writer*. Or, is it called *Ghost(s) Writer* because, as a typewriter produces type-like characters, it produces ghosts?

Karl Nawrot, also known as Walter Warton, combines drawing, model-making, type design and illustration to explore the potential narratives in between childlike lines and violent shapes, architectural structures and surreally distorted spaces. Nawrot studied illustration at the École Émile Cohl, Lyon, and graphic design at the Werkplaats Typograpfie in Arnhem. He has participated in exhibitions at such institutions as Gutenberg-Museum, Mainz; Culture Station Seoul 284; Museum für Gestaltung Zürich; Pitti Immagine, Florence; and 12Mail, Paris. His solo exhibition, *Mind Walk I*, was held at the Eastside Project, Birmingham, in 2013. He taught drawing at the Gerrit Rietveld Academie, Amsterdam, and is currently teaching drawing and typography as guest professor at the University of Seoul.

카를 나브로
1976년생, 프랑스.

Karl Nawrot
Born in 1976, France.

voidwreck.com

유령(들) 타자기
2013. 플라스틱. 크기 가변.

Ghost(s) Writer
2013. Plastic. Dimensions variable.

유일무이
singularity

파버 파인즈는 런던의 출판사 파버 앤드 파버가 주문 인쇄(POD) 디지털 기술을 이용해 절판된 책을 복간하려는 목적에서 2007년 설립한 임프린트다. 현재 1000종이 넘는 책이 그렇게 복간된 상태다. 이제 돈을 들여 3000부를 찍고는 창고에 쌓아두고 수요가 늘기를 기다릴 필요가 없다. 주문 즉시 한 권씩 책을 만들어낼 수 있기 때문이다. 책 수천 권을 동시에 만들 필요가 없으므로 도서 디자인 측면에서도 새로운 가능성이 열린다. 원칙적으로는 권마다 다른 형태를 띨 수 있다.

초기 파버 파인즈 표지 디자인 시스템은 바로 그러한 가능성을 발굴했다(현재는 평범한 템플릿으로 바뀐 상태다). 당시 파버 앤드 파버에서 상급 디자이너로 일했던 대런 월은 컴퓨터를 이용해 권마다 다른 디자인을 만들어낼 수 있는 생성 템플릿을 개발했다. 그는 메리언 밴체스에게 네 가지 테두리 장식 디자인을 의뢰해, 논픽션, 픽션, 예술물, 아동물 등 네 장르에 각기 적용했다. 완성된 테두리는 작은 단위로 분해되었고, 카르스텐 슈미트는 그 요소들을 일정한 매개 변수에 따라 재조합해 무한히 다양한 패턴을 만들어내는 전용 소프트웨어를 개발했다. 마이클 플레이스는 파버 앤드 파버의 이중 ‘f’ 로고에서 일부 영감을 받아 전용 활자체를 디자인했다.

모든 표지가 다르게 생성되었음에도, 그 시스템으로 만들어진 파버 파인즈 표지는 모두 일관성을 보이며 뚜렷한 브랜드 이미지를 형성한다. 적당한 매개 변수와 규칙을 찾아내 이론상 무한한 가능성을 길들이려고 상당한 연구와 실험이 행해졌음을 짐작할 수 있다.

대런 월은 런던에서 활동하는 그래픽 디자이너이자 아트 디렉터다. 2006년부터 2008년까지 파버 앤드 파버에서 일했고, 이어 독자적인 스튜디오를 열었다. 2012년 수준 높은 비디오 게임 역사서를 전문으로 하는 출판사 리드 온리 메모리를 설립했다.

Faber Finds is an imprint of Faber and Faber, London, set up in 2007 specifically to reprint out-of-print books using print-on-demand digital

technology. It has grown enormously, having made more than a thousand titles available again. You do not need to invest in printing 3,000 copies only to put them in your warehouse and wait for the demand to catch up: now each copy can be printed one at a time, once the order has been placed. This possibility has also implications for book design, as a few thousand copies of a title do not have to look the same anymore. In principle, each copy can be made to look unique.

The initial cover design system of Faber Finds exploited that possibility (now it has been replaced by a more generic template). Darren Wall, then senior designer at Faber and Faber, developed a generative template by which a different design is computationally created for each title. He commissioned Marian Bantjes to design four different borders, one for each genre: non-fiction, fiction, arts and children's. The borders were then abstracted and disassembled into small units for a custom software written by Karsten Schmidt, which would reassemble them into endlessly varied patterns within certain parameters. A bespoke typeface was designed by Michael Place, which was inspired in part by the double-f logo of Faber and Faber.

Even if each copy is uniquely generated, all the Faber Finds covers produced by the system look remarkably consistent, making sure that they all belong to the same brand. One can imagine that much study and experimentation must have been done in finding right parameters and rules to harness the theoretically infinite possibilities.

Darren Wall is graphic designer and art director based in London. He worked at Faber and Faber from 2006 until 2008, and then started his own independent practice. He founded Read-Only Memory, a publishing company specializing in high-end books that document video gaming history, in 2012.

대런 월
1980년생, 영국.

Darren Wall
Born in 1980, UK.

darrenwall.co

파버 파인즈
2008. 디지털 인쇄, 무선철에 표지. 각각 12.5×19.8 cm. 두께와 쪽수 다양.
활자체 디자인: 마이클 플레이스. 장식 테두리 디자인: 메리언 밴체스. 표지 생성
소프트웨어 프로그래밍: 카르스텐 슈미트. 런던: 파버 앤드 파버.

Faber Finds
2008. Digital print, cut and glued, cover. 12.5×19.8 cm each;
thickness and extent vary. Typeface designed by Michael Place.
Decorative elements designed by Marian Bantjes. Generative software
programming by Karsten Schmidt. London: Faber and Faber.

유혼
familiar

런던에서 활동하는 그래픽 디자이너 존 모건은 2000년에 자신의 이름으로 스튜디오를 설립했다. 주요 프로젝트로는 영국 성공회 기도서, 데이비드 치퍼필드 건축 사무소 그래픽 아이덴티티, 런던 디자인 뮤지엄 전시 디자인 등이 꼽힌다. 《돗 돗 돗》과 《AA 파일스》 등에 기고했으며, 센트럴 세인트마틴스 미술대학과 레딩 대학교 등에 출강했다. 베네치아 건축 비엔날레 2012 작업으로 2013년 디자인 뮤지엄에서 올해의 디자인 상을 받았고, 2012년에는 영국 건축협회 저널 《AA 파일스》로, 2011년에는 고전문학을 재해석하는 포 코너스 패밀리어 총서 디자인으로 같은 상 후보에 오른 바 있다.

브램 스토커의 《드라큘라》는 포 코너스 패밀리어 총서의 두 번째 책으로, 본문은 여러 일기와 편지, 신문기사로 구성되며, 중간중간 제임스 피먼이 그린 삽화가 첨부된 형태로 출간되었다. 모건은 원작이 처음 출간된 시대의 활자체를 하나씩 골라 서로 다른 등장인물에 지정함으로써 본문을 조판했다. 사용된 활자체는 다음과 같다. 미나 하커의 일기: 레밍턴 타이프라이터. 조너선 하커의 일기: 벌머. 수어드 박사: 벌머 이탤릭. 반 헬싱 교수: 악치덴츠 그로테스크(헬베티카의 전신인 이 활자체는 《드라큘라》 초판이 발행되기 한 해 전에 나왔다). 루시 웬스텐라의 편지: 가우디 산스 이탤릭. 전보: 오러터 스탠더드(당시 전보에 쓰이던 서체와 같다). 신문기사: 센추리 익스팬디드. 애거서 수녀: 그린우드. 노랑 표지와 빨강 표제 레터링 역시 초판 장정을 반영한다. 결국 이 작품은 원작의 어떤 측면을 되살릴 뿐만 아니라 소설로 가공되기 전 원자료의 형태를 적극적으로 상상함으로써, 저 유명한 흡혈귀 이야기의 기원을 추적한다.

포 코너스 패밀리어 총서의 일곱 번째 책으로 간행된 앤서니 호킨스의 《젠다 성의 포로》는 가공의 국가 루리타니아에 휴양차 여행 간 영국인이 독살당할 뻔한 그곳 국왕과 빼닮았다는 이유로 국왕 대역을 맡게 된 이야기를 들려준다. 미레유 포숑이 그럴듯한 삽화로 소개하는 루리타니아의 풍속은 '이국성' 자체의 허구적 성격을 포착하고, 도플갱어라는 책의 주제는 모건의 타이포그래피 전반을 뒷받침한다. 표지

에 붙은 홀로그램은 표제 레이블을 되풀이하며 진위 개념을 암시한다. 모건과 아드리엔 바스케스가 이 책을 위해 특별히 디자인한 표제 활자체는 문자를 위아래로 반복함으로써 만들어졌는데, 그 결과 어렴풋이 떠오르는 흑자체 형상은 루리타니아의 중부 유럽 정체성을 암시한다. 본문에 쓰인 레너 안티쿠아는 독일 타이포그래퍼 파울 레너가 디자인한 활자체인데, 그 역시 기하학적 대문자는 현대적 양식을 따르고 유연한 필기풍 소문자는 '중세적' 양식을 따르는 등 이중적 성격을 띤다. 본문 타이포그래피는 이중으로 반복된 단락 기호로 마무리된다.

A graphic designer based in London, John Morgan established his eponymous studio in 2000. His projects have included prayer books for the Church of England, graphic identity for David Chipperfield Architects, and exhibition design for the Design Museum, London. He has written for a number of journals including *Dot Dot Dot* and *AA Files*, and has taught in various design schools, including Central Saint Martins and the University of Reading. His studio won the graphic design category in the Design Museum's Designs of the Year 2013 for the Venice Architecture Biennale 2012. He was also nominated in 2012 for *AA Files*, the Architectural Association's journal of record, and in 2011 for the Four Corners Familiars series, a re-imagining of classic books.

Bram Stoker's *Dracula*, the second volume from the Four Corners Familiars series, consists of a number of diaries, letters and newspaper clippings, punctuated by fresh pencil drawings by James Pyman. Morgan set the text with a different typeface for each character, choosing the ones contemporaneous with the original edition of the book: LTC Remington Typewriter Pro Italic for Mina Harker's journal; Bulmer for Jonathan Harker's journal; Bulmer Italic for Dr. Seward; Akzidenz Grotesk, which was released one year before *Dracula* was first published, for Dr. Van Helsing; Goudy Sans Italic for Lucy Westenra's letters; Orator Standard for telegrams, truthful to the medium's typography of the times; Century Expanded for newspaper extracts; and Greenwood for Sister Agatha. The yellow cover with the red title lettering is also reflexive of the first edition. The result is a book that speaks to the origin of this most famous vampire story, not only by bringing back some aspects of its original publication, but by actively imagining the possible forms of the raw materials before their reification as a novel.

The Prisoner of Zenda by Anthony Hope, the seventh volume in the series, tells the story of an Englishman who travels to a fictitious country called Ruritania for holidays, and ends up acting as a political decoy of the country's drugged King for his resemblance to the monarch. While Mireille Fauchon's make-believe illustrations of Ruritania play with the essentially imaginary nature of exotica, the theme of doppelgänger in-

forms Morgan's typography and book design. The title label on the cover is doubled by a hologram, suggesting the notion of authenticity. The display typeface, Rudy, was designed specifically for this publication by Morgan and Adrien Vasquez. The vertically repeated characters vaguely remind of blackletter types, hinting at the fictitious central-European identity of Ruritania. The body text is set in Renner Antiqua designed by the German typographer Paul Renner, which retains a dual identity of being both modern (upright, constructed uppercases) and "medieval" (more fluid, calligraphic lowercases). The typography is completed by the repeated paragraph marks.

────

존 모건
1973년생, 영국.

John Morgan
Born in 1973, UK.

morganstudio.co.uk

드라큘라
2008. 오프셋, 사철에 천 씌운 판지, 압연. 15.3×24.6×3.7 cm(지면 크기 14.8×24 cm), 496쪽. 브램 스토커 원작(1897). 그림: 제임스 피먼.
런던: 포 코너스 북스.

Dracula
2008. Offset lithography, sewn in sections, cased in cloth, foil stamping. 15.3×24.6×3.7 cm (page dimensions 14.8×24 cm), 496 pp. Original text (1897) by Bram Stoker. Art by James Pyman. London: Four Corners Books.

<div style="columns">

Dracula

246

perhaps, if I am ready, poor Jonathan may not be upset, for I can speak for him and never let him be troubled or worried with it at all. If ever Jonathan quite gets over the nervousness he may want to tell me of it all, and I can ask him questions and find out things, and see how I may comfort him.

LETTER, VAN HELSING TO MRS HARKER

24 September.
(Confidence).

Dear Madam, –
I pray you to pardon my writing, in that I am so far friend as that I sent to you sad news of Miss Lucy Westenra's death. By the kindness of Lord Godalming, I am empowered to read her letters and papers, for I am deeply concerned about certain matters vitally important. In them I find some letters from you, which show how great friends you were and how you love her. Oh, Madam Mina, by that love, I implore you, help me. It is for others' good that I ask – to redress great wrong, and to lift much and terrible troubles – that may be more great than you can know. May it be that I see you? You can trust me. I am friend of Dr John Seward and of Lord Godalming (that was Arthur

Telegram, Mrs Harker to Van Helsing

247

TELEGRAM, MRS HARKER TO VAN HELSING

25 SEPTEMBER.
COME TODAY BY QUARTER-PAST TEN TRAIN IF YOU CAN CATCH IT. CAN SEE YOU ANY TIME YOU CALL.
WILHELMINA HARKER.

MINA HARKER'S JOURNAL

25 September. – I cannot help feeling terribly excited as the time draws near for the visit of Dr Van Helsing, for somehow I expect that it will throw some light upon Jonathan's sad experience; and as he attended poor dear Lucy in her last illness, he can tell me all about her. That is the reason of his coming; it is concerning Lucy and her sleep-walking, and not about Jonathan. Then I shall never know the real truth now! How silly I am. That awful journal gets hold of my imagination and tinges everything with something of its own colour. Of course it is about Lucy. That habit came back to the poor dear, and that awful night on the cliff must have made her ill. I had almost forgotten in my own

</div>

젠다 성의 포로

2011. 오프셋, 사철에 판지, 레이블. 9.5×15.5×1.6 cm(지면 크기 9×15 cm), 272쪽. 앤서니 호킨스 원작(1894). 그림: 미레유 포숑. 표제 활자체 공동 디자인: 아드리엔 바스케스. 런던: 포 코너스 북스.

The Prisoner of Zenda
2011. Offset lithography, sewn in sections, cased, label.
9.5×15.5×1.6 cm (page dimensions 9×15 cm), 272 pp. Original text (1894) by Anthony Hope. Art by Mireille Fauchon. Display typeface designed with Adrien Vasquez. London: Four Corners Books.

의태어
mimesis

———
이호는 올해로 경력 21년 차에 접어든 활자체 디자이너다. 1993년 큐닉스컴퓨터 서체 개발실에서 폰트 디자인을 시작한 이후 서울시스템과 모리스디자인을 거쳐, 2002년부터 2012년까지 산돌커뮤니케이션에서 수석 폰트 디자이너로 재직하며 다양한 프로젝트에 참여했고, 현재는 닥터폰트의 대표를 맡고 있다. 참여하거나 진행한 프로젝트로는 경향신문, 래미안, CJ패키지, 삼성 등 다양한 기업 전용 서체가 있고, 그가 참여해 개발한 현대카드 전용 폰트는 성공적 브랜딩 타이포그래피 아이덴티티로 기능하며 높은 인지도를 얻기도 했다.

　이호가 산돌커뮤니케이션에서 디자인을 총괄한 시티체 시리즈는 한글의 구조적 가능성에 대담하게 도전하면서도 설득력을 갖춘 실험으로 주목할 만하다. 한글은 초성, 중성, 종성 음소(혹은 자소)가 하나의 음절 형태로 결합하는 모아쓰기 구조를 지닌 점에서 독특하다. 음소와 음절의 역학 관계를 재정의하는 것은 한글 폰트 디자이너들의 도전 과제였다. 네모틀 음절 안에 고정되었던 음소들은 세벌식 타자기와 탈네모틀 글자체를 계기로 본연의 모듈 형식을 되찾으며 독립성과 자유를 향한 목소리를 냈다. 탈네모틀이란 단지 외적 형식의 이탈이 아니라, 음소들이 음절로 모이는 새로운 역학 관계 구조를 제시한 모델이었다.

　〈안상수체〉(1985)는 음소들이 음절 틀에 얽매이지 않고 항상 일관된 형태를 유지하게 설계되었다. 〈안상수체〉에서 모든 음소가 초성 위 기준선을 중심으로 가지런히 배열되는 절대적 위치 값을 지녔다면, 역시 안상수가 디자인한 〈미르체〉(1992)와 〈마노체〉(1993)는 구조적 틀을 한 단계 더 이탈하여 초성의 아래 기준선을 중심으로 중성과 종성의 상대적 위치 값이 뒤따르는 공간 형식을 취했다. 2010년 〈서울체〉, 〈도쿄체〉, 〈상하이체〉 세 종으로 동시 출시된 산돌 시티체는 〈미르체〉와 〈마노체〉를 계승하고 확장한 모듈 실험이라 할 수 있다. 중성의 가로 줄기와 가로 획에 글줄 흐름선 기준을 둔 〈서울체〉를 보자. 리을은 디귿보다 획수가 많으므로 초성 리을을 지닌 음절은 초성 디귿을 지닌 음절보다 키가 월등히 커진다. 같은 초성 리을을 지닌 음절이라도 중성의 성격에 따라, 그리고 그로부터 규정되는 중성과 초성 간의

상대적 관계에 따라, 초성의 위치 값이 다양하게 달라지며 변주된다. 결과적으로 이 글자체는 각 음절과 글줄의 중력 중심에서부터 결합하며 들쭉날쭉 율동감을 자아내는 '마천루'를 형성하게 된다.

이호의 그리드 한글 작업 〈청포도가 익어가는 계절〉은 시티체의 모듈 실험을 이어가며 확장한다. 이육사의 시 〈청포도〉에서 '주저리주저리', '알알이' 등 포도알이 포도송이에 매달린 모습을 표현하는 의태어에 영감을 받아, 한글 음소들이 전시장 공간에서 자연스럽게 이어지고 결합되게 배열한다. 그 재료는 인쇄용 활자체의 추상적 획이 아니라 건축적 공간에서 파생한 구조물이다. 한글은 추상적 구성 원리를 특징으로 하지만, 그 자소의 독특한 기하학적 형태는 의태적 상상을 자극하곤 했다. 1940년 《훈민정음》 해례본이 발견된 후 한글 기본 자음 다섯 자가 발음기관 형태에 바탕을 두었다는 의견이 정설로 정리되었지만, 그전에는 그 형태가 한옥의 창살 무늬에서 파생됐다는 이론이 대중적으로 통용되기도 했다. 이호의 새로운 그리드 한글은 거꾸로 글자 형태를 건축 표면에 재투사함으로써 한글의 추상적 원리와 의태적 잠재성을 두루 기린다.

———

Lee Ho is a veteran type designer with twenty-one years' work experience. He started his career in 1993 at the font development office of Qnix Computer, and worked at Sandoll Communication from 2002 until 2012, before founding his own studio Dr. Font. Projects he was involved in or responsible for include typefaces for the newspaper *Kyunghyang Shinmun* and corporations including CJ, Samsung and Hyundai Card.

The Sandoll City typeface series that Lee oversaw are particularly noteworthy as a daring yet convincing experiment on the modular structure of Hangul, the Korean alphabet. Hangul is a unique writing system by which two or more phonetic symbols—or graphemes—are grouped as a combination of the initial (syllable onset), the medial (syllable nucleus) and the final (syllable coda) to form a syllabic character. Defining the dynamic relationship between the syllabic characters and their component graphemes has been a challenge to Korean typeface designers. The advent of the three-set keyboard and non-square letterforms marked the liberation of the Hangul graphemes whose inherent modular nature had been repressed in the traditional square-frame styles. Non-square Korean letterform meant not only a departure in appearance, but also a new dynamic model for combining graphemes into characters.

Ahn Sang-soo-che (1985), for example, was designed in a way that graphemes could maintain their shapes rather than be distorted and squeezed into syllabic square frames. While the graphemes of *Ahn Sang-soo-che* are assigned absolute positions that visually align them

to the top line of the initials, *Myrrh-che* (1992) and *Mano-che* (1993), also designed by Ahn Sang-soo, took another step and allowed the medials and the finals to find their positions relative to the bottom line of the initials. Sandoll City typefaces, released in 2010 as a family of three fonts—Seoul, Tokyo and Shanghai—follow and extend this line of modular experiments. The graphemes of *Sandoll Seoul*, for example, are variously aligned to the horizontal elements of the medials. The grapheme "ㄹ" has more horizontal strokes than, say, "ㄷ," and is consequently rendered much taller. The position of the initial "ㄹ" may vary, however, depending on the nature of the following medial, and thus the spatial relation to it. As a result, the graphemes are organized around the "gravitational center" of the medials, creating a unique rhythm in text that reminds of irregular urban skylines.

Lee Ho's new "grid Hangul project," *The Season of Ripening Green Grapes*, again follows and extends the line of modular experiments from Sandoll City typefaces. Inspired by the mimetic expressions in Lee Yuksa's poem "Green Grapes," he arranges his Hangul graphemes in the exhibition space in a way that combines them organically. The materials he uses are not the abstract strokes of printing types, but physical structures derived from building materials. While Hangul as a writing system is characterized by its abstract principles of organizing graphemes, the uniquely geometric shapes of the graphemes themselves have inspired mimetic imaginations. Since the discovery of the original documentation, *Hunminjeongeum*, in 1940, an accepted explanation has been that the design of the consonant graphemes was based on the shapes of human vocal organs. Before then, however, a theory that they were inspired by the shapes of the traditional Korean window frames was also held feasible. Lee Ho's Hangul takes the letterform back to the architectural surface, playing with both the abstract principles and the mimetic potentials.

이호
1972년생, 한국.

Lee Ho
Born in 1972, Korea.

청포도가 익어가는 계절
2013. 복합 매체 설치. 크기 가변.

The Season of Ripening Green Grapes
2013. Mixed-media installation. Dimensions variable.

이중성
duality

요시오카 히데노리는 도쿄에서 활동하는 그래픽 디자이너다. 소규모 스튜디오 셉템버 카우보이를 운영하며, 주로 도서 디자인에 집중해 세이카이샤(星海社), 쇼가쿠칸(小学館), 고단샤(講談社), 후쿠인칸 서점(福音館書店), 이스트 프레스(イースト·プレス), 포레스트 출판(フォレスト出版), 아사히 출판(朝日出版社), 릭실 출판(LIXIL出版) 등에서 펴낸 책을 디자인했다.

세이카이샤 신서는 지적 호기심을 충족시키는 도구일 뿐 아니라 젊은이에게 스스로 미래를 열어갈 수 있는 지적 '무기'를 제공한다는 목적으로 발행되는 총서다. 디자인 전략 역시 젊은 독자에게 호소하는 데 중점을 두고 마련되었다. 표지 요소는 최소화하고, 표제가 두드러지게 한다. 선명한 색과 발랄한 타이포그래피로 이루어진 띠지는 단순한 표지와 뚜렷한 대조를 이룬다. 때로는 거친 사진이나 만화 등의 이미지가 띠지에 실리기도 한다. 이러한 접근법은 과거 신쇼 총서의 보수적인 디자인과 선명하게 차별된다.

세이카이샤 신서가 보여주듯, 띠지는 일본 도서 디자인에서—정도는 덜하지만 한국에서도—중요한 비중을 차지한다. 띠지에는 흔히 광고 성격의 정보가 실리고, 표지에는 편집적 내용이 실린다. 이러한 이중성은 책 표지 디자인에서 종종 상충하는 두 요건을 반영한다. 시장에서 책 표지는 상품 선전 포스터와 크게 다르지 않은 광고 노릇을 한다. 그러나 통합된 물건의 일부로서 표지는 본문을 존중하고 반영해야 한다. 표지와 띠지에 서로 다른 역할을 부여하는 것은 그러한 문제를 해결하는 방법이다. 벗겨내면 그만인 띠지에 덜 '고상한' 임무를 맡김으로써 책 자체는 고결성을 보존할 수 있다. 그러나 두 부분의 관계는 실험 대상이 될 수도 있으며, 몇몇 디자이너의 작품은 그에 관한 인식을 보여준다.

Yoshioka Hidenori is a graphic designer working in Tokyo. With his small studio called September Cowboy, he has been focused on designing books for publishers including Seikaisha, Shogakukan, Kodan-

sha, Fukuinkan Shoten, East Press, Forest Publishing, Asahi Press and Lixil Press.

The Seikaisha Shinsho series was started with an aim of distributing intellectual "weapons" to help youths open the way to the future for themselves, not only to fulfill their own curiosity. A design strategy was implemented to speak to the younger readers. The elements on the covers are kept to a minimum, with the titles clearly standing out. The vivid belly bands create strong contrast against the simple covers, with their eye-catching colors and playful typography. Sometimes images—roughly screened photographs or manga clips—are also deployed. Overall, this approach marks a clear departure from the conservative design of the past Shinsho books.

As exemplified by Seikaisha Shinsho, an *obi* (Japanese word for belly band outsert) tends to play an important role in Japanese—and Korean, to a lesser extent—book design. It is a type of dust jacket that covers only a portion of a book: even a book with a dust jacket may have an additional *obi*. It usually carries blurbs and other more promotional elements, allowing covers to concentrate on more editorial aspects. This duality reflects the two, often conflicting goals of book cover design. In the marketplace, a book's cover works primarily as an advertising, not unlike a commercial poster; on the other hand, as part of an integrated object, it is also expected to respect its content—with all the dignity of the work it covers. Assigning different roles to cover and *obi* is a solution: a book can maintain its integrity as a serious work by relegating less "honorable" jobs to *obi*, which is essentially a throwaway. The relationship between the two parts, however, can be a subject of experimentation, as some designers have recognized.

요시오카 히데노리(吉岡秀典)
1976년생, 일본.

Yoshioka Hidenori
Born in 1976, Japan.

세이카이샤 신서(星海社新書)
2011–현재. 오프셋, 무선철에 표지, 커버, 띠지. 각각 10.8×17.2 cm, 두께와
쪽수 다양. 도쿄: 고단샤.

Seikaisha Shinsho
2011–ongoing. Offset lithography, cut and glued, cover, jacket, outsert.
10.8×17.2 cm each, thickness and extent vary. Tokyo: Kodansha.

자동암시
autosuggestion

삼프사 누오티오는 2012년 10월부터 '구글 시'를 수집해왔다. 구글 시란 구글 검색 엔진의 검색어 자동 완성 기능에 따라 우연히 만들어지는 '시'를 말한다. 그는 라이사 오마헤이모와 함께 그런 방식으로 '발견한 시'를 수집하는 블로그 《구글 시학》을 운영하고 있다. 《구글 시학》은 "구글은 사람들이 실제로 관심을 두는 주제로 시를 쓴다"는 표제 아래 인터넷상의 한 현상으로 자리 잡았고, 《허핑턴 포스트》, 《텔레그래프》, 《가디언》, 《기즈모도》, 《매셔블》, 《뉴요커》 등 주요 매체에 소개되기도 했다. 대중 참여를 기반으로 운영되는 《구글 시학》은 1년 만에 이미 1000편이 넘는 구글 시를 수집해놓은 상태다.

삼프사 누오티오는 헬싱키 메트로폴리아 공과대학에서 무대예술을 전공했고, 게임과 IT 업계를 거쳐 현재 프리랜서 저술가 겸 비디오 제작자로 활동 중이다. 라이사 오마헤이모는 연극학 학사, 뉴미디어 석사 학위를 취득하고 헬싱키 메트로폴리아 공과대학에서 디지털 미디어를 가르치면서 프리랜서 저널리스트 겸 작가로 활동 중이다.

구글 시학

《구글 시학》은 구글 검색어 자동 완성 기능을 시적으로 바라볼 때 탄생한다.

구글 검색창에 검색어를 몇 자만 적어 넣으면, 알고리즘에 따라 사용자가 실제로 원하는 검색어가 예측되어 표시된다. 그러한 제안 검색어 조합은 우습기도 하고 터무니없기도 하며, 다다이즘을 연상시키기도 한다. 때로는 감동적이기까지 하다.

하지만 이러한 시에는 단순히 실소를 자아내는 정도를 넘어 의미심장한 구석이 있다. 구글 검색어 자동 완성 기능은 전 세계 구글 사용자가 과거에 실제로 입력한 검색어에 바탕을 둔다. 푸르스름하게 빛나는 컴퓨터 화면 위에서 사람들은 "왜 나는 외로운가요?"나 "왜 뚱뚱한 여자들은 눈이 높나요?" 같은 질문을 던진다. 담배를 어떻게 마는지, "너를 사랑해"라고 말하기에는 너무 이른지 궁금해한다. 닌자, 대마초, 리한나에 관한 정보를 찾고, 때로는 "차라리 죽는 게 나을까요?"라고 묻기도 한다.

겉보기에 서구 사회는 개방적인 듯하지만, 여기에도 금지된 질문과 생각은 여전히 있다. 그러한 이슈에 부딪혔을 때 사람들은 다른 사람과 대화하기보다 오히려 자기 집에 틀어박혀 구글에 호소하려 한다. 모르는 것 없는 검색엔진은 그러한 질문을 받아주고, 거기에 가요 가사, 책 제목, 유명 인사 이름 등을 덧붙여준다. 그 결과는 대체로 우습기 짝이 없을 정도다.

물론 구글은 셰익스피어나 휘트먼이나 디킨슨이 아니다. 구글이 알려지지 않은 진실을 밝혀줄 수는 없다. 그러나 우리 내면의 동요, 현대인의 두려움과 편견, 비밀, 수치, 희망, 염원을 드러내줄 수는 있다.

그래서 《구글 시학》은 중요하다. [삼프사 누오티오 / 라이사 오마헤이모]

In October 2012, Sampsa Nuotio started collecting what he calls "Google Poems," a kind of "found" poetry generated by the search engine's autocomplete suggestions. Together with Raisa Omaheimo, he has been running the blog devoted to them, *Google Poetics* (www.googlepoetics. com). Under the wry headline, "Google writes poetry on subjects that people are truly interested in," *Google Poetics* has become an internet phenomenon, featured in *The Huffington Post*, *The Telegraph*, *The Guardian*, *Gizmodo*, *Mashable* and *The New Yorker*. Based on popular submissions, the blog has collected over 1,000 Google Poems in a year of its operation.

Sampsa Nuotio studied performing arts at the Helsinki Metropolia University of Applied Sciences, and is currently a freelance writer and video producer after stints of working in the gaming industry and as an IT consultant. Raisa Omaheimo is an artist with a background in performing arts and media art. She holds a BA in drama studies and an MA in new media. She is currently working as a lecturer of digital media at the Helsinki Metropolia University of Applied Sciences and a freelance journalist and artist.

Google Poetics

Google Poetics is born when Google autocomplete suggestions are viewed as poems.

Google's algorithm offers searches after just a few keystrokes when typing in the search box, in an attempt to predict what the user wants to type. The combination of these suggestions can be funny, absurd, dadaistic—and sometimes even deeply moving.

There is, however, more to these poems than just the occasional chuckle. The Google autocomplete suggestions are based on previous searches by actual people all around the world. In the cold blue glow of their computer screens, they ask "why am I alone" and "why do fat girls

have high standards". They wonder how to roll a joint and whether it is too early to say "I love you". They seek information on ninjas, cannibals, and Rihanna, and sometimes they just ask "am I better off dead?"

Despite the seemingly open nature of Western society, forbidden questions and thoughts still remain. When faced with these issues, people do not reach out to one another, instead they turn to Google in the privacy of their own homes. The all-knowing search engine accepts and embraces these questions and tangles them with popular song lyrics, book titles and names of celebrities: often with hilarious results.

Obviously Google is not Shakespeare, Whitman or Dickinson—it can not illuminate the unknown. But it does reveal our inner workings, our fears and prejudices, secrets and shames, the hope and longing of a modern individual.

This is why *Google Poetics* is important. [Sampsa Nuotio and Raisa Omaheimo]

삼프사 누오티오
1976년생, 핀란드.

라이사 오마헤이모
1977년생, 핀란드.

Sampsa Nuotio
Born in 1976, Finland.

Raisa Omaheimo
Born in 1977, Finland.

구글 시학
2012–현재. 웹사이트.

Google Poetics
2012–ongoing. Website.

he said t|
he said **that**
he said **to be cool but**
he said **that the atom resembles a tiny rock**
he said **take care**

i actually
i actually **hate my mom**
i actually **hate myself**
i actually **hate my life**
i actually **hate my sister**
i actually **like windows 8**

I'm just a s|imple russian girl
i'm just a s**imple russian girl**
i'm just a s**tranger in a strange land**
i'm just a s**oul whose intentions are good**
i'm just a s**weet transvestite**

my job is |done here
my job is **done here**
my job is **not to worry about those people**
my job is
my job is **to keep punk rock elite**

Poetry is d[ead]

poetry is d**ead**
poetry is d**angerous**
poetry is d**ifficult to define because**
poetry is d**ead i killed it**

she gave me
she gave me **her number**
she gave me **love**
she gave me **dome**
she gave me **herpes**

the love i|
the love i **lost**
the love i **found in you**
the love i **know i deserve**

when I think about you
when i think about **you**
when i think about **jesus**
when i think about **the lord**
when i think about **you i touch myself**

잠재문학
potential literature

타이포잔치 2013 리서치 프로젝트로 만들어진 《잠재문학실험실》은 1960년대 프랑스에서 형성된 울리포(OuLiPo, 잠재문학 작업실이라는 뜻)를 국내에 처음 소개하는 책이다. 조르주 페렉, 레몽 크노, 이탈로 칼비노, 마르셀 뒤샹 등 우리에게도 친숙한 이름이 여럿 포함된 울리포는 프랑스 현대문학의 흐름 가운데서도 독특하고 주요한 실험적 움직임이었지만, 국내에서는 이름만 무성할 뿐 널리 알려지지 않은 상태다.

　문인과 수학자를 중심으로 형성된 울리포 작가들은 각종 '제약'을 문학의 도구로 삼았다. 문학에 수학, 과학, 생물학, 음악 등을 끌어들이며 일상적 기능에 속박되어 있던 문자를 제약을 통해 해방하고, 그 속에서 문학의 잠재성을 발굴해내려 했다. 이들의 손을 통해, 일견 창작을 방해하는 듯한 제약들은 그 명확한 규칙성으로 인해 아이러니하게도 누구나 활용 가능한 무한한 창작 도구가 되었다.

　이 책은 잠재문학 작업실 '울리포'를 단순히 소개하는 데 그치지 않고, 울리포 작가들이 수년간 실험했던 창작 방식인 제약과 규칙을 한국어에 적용한 창작 실험들을 담고 있다. 책은 제1부 '잠재문학실험실'과 제2부 '잠재문학작업실'로 나뉜다. 제1부는 한국어 통사론에 맞추어, 또는 이를 일탈하여, 울리포적 제약을 수행한 실험들(시, 소설, 산문, 선언문 등)로 구성된다. 제2부는 이 실험의 기반인 울리포에 대해 구체적으로 소개한 자료집이다.

울리포란 무엇인가?—문학의 권위를 해체한 제약

1960년 11월 24일 수학자 프랑수아 르 리오네와 작가 레몽 크노의 주도 하에 첫 모임을 가진 울리포, 즉 잠재문학 작업실(Ouvroir de Littérature Potentielle)은 초현실주의와 파타피지크, 구조주의와 부르바키 등 양차 세계대전 이후 프랑스를 비롯한 유럽을 휩쓴 여러 시대적 상황적 조류에 힘입어, 혹은 그에 반하여 자연히 파생된 문학의 한 흐름이었다.

그러나 울리포 작가들이 직접 밝혔듯, 울리포는 어떠한 운동도, 이즘도, 학회도 아니다. 특정 방향이나 미학적, 정치적 견해를 품고 있는 것도 물론 아니다. 그렇다면 울리포란 무엇인가? 그들의 이름 '잠재문학 작업실'에서 비롯해 얘기해보자면, 다만 이는 문학이 할 수 있을, 아마도 그럴 수 있으리라 추측되는 그 '잠재성'을 주목하고 이를 증명해내는 작업이다.

울리포 작가들은 이러한 잠재성을 증명하는 도구로 '제약(contraintes)'을 택했다. 즉 일정한 규칙을 세운 후 그에 따라 글의 형식과 구조를 변형하는 이 문학 실험은 그간 영감에서 비롯된 것으로 알려진 문학을 둘러싸왔던 경계와 그 권위를 무너뜨렸다.

> 제약은 즐거운 구속이다. 무한한 창작의 자유가 안기는 막연함을 우리는 이미 충분히 경험해보지 않았던가. 말놀이 내지 글놀이라고 부를 수 있을 이 장난은, 그간 문학이라는 이름을 덧입은 채, 그에 스스로 짓눌려 있었다. (…) 울리포적 말놀이, 글놀이의 중심 축은 '규칙'이다. 기존 문학은 '제약'이라는 규칙을 거치면서 탁월하게 탈바꿈되거나 형편없이 전락한다. 그 결과가 어떻든, 제약 가운데 문학은 반드시 재생산된다. 그러므로 잠재문학작업실과 잠재문학실험실의 문학 노동자들은 생산성이 보장된 글쓰기 노동을 하게 되는 셈이다. 그리하여 이들은 유산으로 물려받은 잠재문학작업실에 이어 자신만의 잠재문학실험실을 마련한 후, 기꺼이 그 방에 갇힌다. 잠재문학은 그렇게 세상 누구나 제 방에서 행하는 만인의 문학이 된다. "빠져나갈 작정으로 그 스스로 미로를 만드는 한 마리의 쥐"에 의해. [서문 중에서]

그리하여 울리포 작가들이 발견 또는 발명한 글쓰기 제약들은 다음과 같다. 단어나 문장, 글의 알파벳 철자를 해체한 후 새롭게 재조립하는 철자 바꾸기 제약 '아나그람(anagramme)', 앞에서부터 읽으나 뒤에서부터 읽어도 같은 회문(回文) 제약 '팔랜드롬(palindrome)', 특정한 글자를 지닌 단어를 제하고 글을 쓰는 제약 '리포그람(lipogramme)', 알파벳순으로 글쓰기, 쉼표와 구두점 없이 글쓰기, 정형시의 다양한 응용……. 울리포의 대표 작가 레몽 크노와 조르주 페렉 등은 이러한 제약을 성공적으로, 탁월하게 활용한 이들이었다. 울리포 주창자 중 한 명으로 박학다식했던 백과사전적 작가 레몽 크노는 바흐의 푸가에서 힌트를 얻어 한 가지 내용을 99가지 형식으로 변주한 《문체연습(Exercices de style)》(1947)을 썼고, 이어 14행 소네트 10편의 각 행들을 분리해 이를 조합하면 총 10의 14승, 즉 일백조 편의 시가 생성되도록 설계한 상징적 작품 《백조(百兆) 편의 시(Cent mille milliards de poèmes)》(1961)를 발표했다. 한편 1967년 울리포에 가입한 조르주 페렉은 특정 알파벳을 사용하지 않는 제약인 리포그람을 활용해 모음 'e'가 없는 소설 《실종(La Disparition)》(1969)을 썼고, 이어 모음으로는 'e'만을 써서 《돌아오는 사람들(Les Revenentes)》(1972)을 썼으며, 또한 지상 8층 및 지하 2층 아파트의

방 99곳과 그곳에 사는 인물들의 이야기를 체스의 행마법에 따라 정교히 조합해나
가며 거대한 퍼즐을 구성한 대작 《인생사용법》(1978)을 썼다.

　한편 울리포 작가들은 1973년과 1981년, 두 번에 걸쳐 공동 저작물을 출간했다.
1973년 출간된 《잠재문학─창조, 재창조, 유희》에서 이들은 "울리포란 어떠한 문
학 운동이나 과학적 세미나, 불확실성의 문학이 아니다"라고 분명히 밝히며 잠재문
학 작업실의 참모습을 펼쳐나간다. 이 책에는 울리포 주창자 프랑수아 르 리오네가
작성한 두 편의 선언문인 〈잠재문학─제1선언문〉과 〈제2선언문〉에 이어 이들이 글
쓰기에 직접 적용했던 다양한 제약들에 대한 설명과 예시가 실려 있다. 이어 8년 후
인 1981년 출간된 두 번째 저작물 《잠재문학 지형도》는 이들의 보다 확장된, 긴 분
량의 실험들을 담고 있다.

　이후 울리포는 지속적으로 그 명맥을 이어왔다. 1970년대 말과 1980년대 초 크
노, 페렉, 칼비노 등 주요 작가들이 운명을 달리하면서 전성기가 접히는 듯했으나,
2013년 현재 울리포는 어느새 세 번째 대표를 맞이했고, 계속해서 새로운 구성원을
선출하고 있다. 그리고 이 구성원들은 각자의 자리에서 울리포적 글을 쓰거나 울리
포 작가들의 글을 번역하거나 울리포에 대한 글을 쓰고 있다. 일례로 구성원 중 가장
젊은 미국 작가 다니엘 레빈 베커는 조르주 페렉, 프랑수아 르 리오네, 마르셀 베나
부, 에르베 르 테이에 등 울리포 작가들의 작품을 영어로 옮기는 한편 울리포 연구서
를 펴내 울리포의 과거와 현재를 기술하고 미래를 조망하기도 했다.

왜, 지금 울리포인가?─잠재문학의 잠재성

그렇다면, 왜 지금 울리포인가. 1960년대 프랑스에서 시작되어 당대에 만개했던
잠재문학 작업실의 현재성과 잠재성을, 오늘날 우리는 어떻게 수용하고 확장할 수
있을까.

　현재까지 울리포 공식 웹 사이트(www.oulipo.net)에 등재된 잠재문학 작가들은
서른여덟 명이다. 그러나 주요 구성원은 운명을 달리했기에, 활동하는 작가들의 수
는 반이 채 되지 않는다. 올해로 창단 53주년을 맞이한 울리포의 역사를 가늠해봤을
때 이는 다소 쇠락한 현재일 수 있다. 그러나 울리포는 이미 그 파생 모임들을 여럿
낳은 바 있다. 건축, 그래픽 디자인, 만화, 문법학, 사진, 역사, 영화, 요리, 음악, 정치,
회화, 희비극 등 여러 분야에서 울리포의 정신을 이어받은 수많은 우익스포(Ou-X-
Po, Ouvroir-X-Potentielle)가 수년간 자체적으로 증식해왔다. 이들은 울리포적 제
약을 각자의 창작 영역에 적용하면서 각 분야의 잠재성을 발굴했다. 특히 1980년
출범한 회화 분야의 '우팽포(OuPeinPo)'와 1992년 창단된 만화 분야의 '우바포
(OuBaPo)'의 경우, 시각 분야에서 다채로운 울리포적 창작물을 생산한 바 있다.

　한편 문자의 울리포적 가능성은, 오늘날 기술 매체의 발달 가운데 다시금 새로운

맥락에서 바라볼 필요가 있다. 일례로 휴대전화 문자메시지나 인터넷 미디어 문자 소통 시스템에서의 글자 수 제한을 떠올려보자. 몇 년 새 부상한 소셜 네트워크 서비스(SNS) 트위터의 경우, 140자 이하의 글자를 입력해야 한다는 제약 아래 있다. 이는 현대판 울리포적 제약의 대표적 산물로, 일상 속 소통 매체의 체계 안에 제약이 이미 내포되어 있음을 드러낸다. 또한 트위터 소설, 트위터 시 등 이러한 제약을 활용한 새로운 문학적 시도들도 한차례 인 바 있다. 물론 누군가는 이는 단순한 숫자의 제약일 뿐 언어학의 문법이나 통사 구조론과 직결되는 문제는 아니라고 지적할지도 모른다. 그러나 울리포 제약 중 긴 단어나 문장이 짧은 단어나 문장으로 줄어들면서 새로운 문맥을 형성해내는 '축약'을 떠올려보면, 인터넷 세대의 언어 활용법 역시 울리포적 맥락 안에 포함시킬 수 있을 것이다.

그렇다면 레몽 크노가 말했듯, "어쨌든 제약은 남는" 것인가? 그러나 여기서 울리포 작가들과 그 작업들을 다시 한 번 떠올려보자. 그들의 제약은, 물론, 기록으로 남았다. 하지만 2013년 현재 울리포적 제약을 글쓰기에 창조적으로 적용해 널리 알린 예는 찾아보기 쉽지 않다. 주요 울리포 작가들이 울리포를 알리게 된 것은 바로 자신들의 탁월한 작품 자체를 통해서였음을 떠올려본다면, 오늘날 울리포 자체를 주목하고 재조명하고자 하는 입장에서는 다소 씁쓸한 일일 수 있다. 그렇다면 역사가 스스로 증명한 바, 제약이 낳은 구속에서 성공적으로 벗어나려면 결국, 어쩔 수 없이 (울리포 작가들이 그간 탈피하고자 했던) (실체 불분명한) 영감이라는 것의 도움을 받아야만 하는 것인가?

그러나 다시 이렇게 생각해볼 수도 있다. 제약이 영감을, 잠재를 낳는다. 그간 의식되지 않았을 뿐 모든 창작은, 이미, 일종의―어떤 종류이든―제약의 산물이다. 문학의 경우 일차적으로 글의 장르와 분량을 선택하는 순간부터 제약 안에 있으며, 이러한 구조를 의도적으로 벗어나고자 하는 탈장르 탈형식 문학이라 해도, 제약을 의식한 후 벗어나려 시도한다는 점에서 제약하에 있다. 또한 글이란 기본적으로 문법의 틀 안에서 또는 이를 벗어나 쓰인다는 점을 고려해 본다면, 문학은 이미 제약과 불가분의 관계를 맺어왔음이 분명하다.

그러므로 창조하는 자는 '제약'과 '잠재'로 가동되는 이 잠재문학의 구조적 눈을 바라봐야 할 것이다. 제약은 창조의 무한(하고 막연)한 자유를 속박하며, 이렇게 구속된 창조는 감옥에서 벗어나고자 온갖 시도를 하게 되고, 그 발상의 전환 과정 가운데 우리가 그간 영감이라 불러왔던 그것, 잠재해 있던 그것이 비로소 일어난다. 이렇게 기존의 생각들이 재편성되는 가운데 역시 잠재해 있던, 재치와 재미를 동반한, 감동이라 부를 수 있을 그것이 비로소 생겨난다. [해설 〈잠재문학의 잠재성〉중에서]

잠재문학은 계속해서 작업되고, 계속해서 실험되어야 한다.

잠재문학의 가능성—창조, 재창조, 유희

우리는 감각과 의미 기저의 구조에 주목하고 수학이나 음악 등 강력한 장악
력을 지닌 학문에서마저 문자의 구조적 조합성을 밀어붙였던 이 별난 미로의
건설자들을 살피려 한다. 감옥 속에서 죄수이자 간수로서 탐구해낸 제약은 잠
재문학작업실과 잠재문학실험실에서 제작되고 실험된 글마다 적절한 장치와
도구로 기능하며 "소박한 재미"를 생산하는 틀을 구축해나간다. 그러므로 이
제약들은 '놀이 생성 기계'다. 이 기계를 잘 다루면 잘 놀 수 있겠지만, 능숙히
다루지 못할 경우 기계만 남고 인간은 소외될지도 모른다. 세상 모든 기계 앞
에 선 인간이 그러하듯. [서문 중에서]

이 책은 만들고(창조), 만들어진 것을 다시 만들고(재창조), 이를 통해 노는(유희)
울리포적 과정을 철저히 따르고자 했다. 그리하여 책의 제1부 '잠재문학실험실'은
울리포적 제약을 적극 차용해 한국어 통사론에 적용한 흥미로운 창작 실험들로 이
루어졌다. 총 27편의 시, 산문, 소설(엽편), 선언문 등이 망라된 이 실험들은 울리포
적 제약을 그대로 지키기도 하고, 이를 의도적으로 우회해 적용하기도 한다. 《잃어
버린 시간을 찾아서》 첫 문장을 35가지 방법으로 변주한 기법 중 우리 식으로 구현
가능한 일곱 가지 방법을 택한 후, 이에 따라 최인훈의 《광장》 첫 문장을 변주해 만
든 한 편의 시. 48편의 시 제목들을 조합해 쓴 시. 알파벳순 글쓰기를 가나다순 글쓰
기로 치환한 시와 동음이의어를 풀이한 시. 울리포 작가들이 즐겨 참조했던 프랑스
어 사전 대신 《염상섭 소설어사전》을 택해 그 어휘로 쓴 소설. 또한 《국어 비속어 사
전》에 수록된 어휘들 중 성(性)에 관한 비어와 속어들을 추려 쓴 시. 입말 위주의 방
언으로 시를 쓴 후, 이 시에 후주 격의 시를 달아 시와 시를 사슬처럼 엮기. 산문의 각
문장에 옛 시조 율격을 적용한 '율격 산문'. 원래의 산문 장르를 시 장르로 바꾸어 쓰
기. 속담과 속담을 아이러니하게 접붙이기. 또한, 4·19 선언문과 68 혁명 구호들을
절묘하게 접붙이기. 각종 실험들에 뒤이은 주(註) '장치와 도구'는 이러한 울리포적
제약들과 그 제약에 숨은 의미들을 상세히, 깊이 있게 설명하고 있다.

　제2부는 이러한 실험의 기반인 잠재문학 작업실, 울리포 자체에 대해 구체적으로
소개한 자료집이다. 울리포 구성원 자크 루보와 마르셀 베나부가 작성한 글 〈울리포
란 무엇인가?〉에 이어 울리포 주창자 프랑수아 르 리오네가 작성한 세 편의 울리포
선언문, 이들의 유용한 도구였던 제약에 대해 상세히 설명한 〈제약과 구속〉 그리고
이 제약을 기준에 따라 나눈 〈울리포 작업 분류표〉, 38명의 작가들을 한 문장으로 설
명한 〈울리포 구성원〉, 울리포의 흐름을 한눈에 파악할 수 있는 〈울리포 연보〉, 그리
고 1960년대 프랑스에서 태동된 잠재문학 작업실이 오늘날 잠재문학 실험실로 꽃
필 수 있는 가능성을 가능해보는 해설 〈잠재문학의 잠재성〉까지, 울리포의 과거와
현재 그리고 미래를 객관적 자료와 그에 따른 분석을 통해 바라볼 수 있도록 구성되

었다. 즉 앞서 진행된 잠재문학 실험실 속 유희의 기반을 수록함으로써 독자가 이 놀이의 근본을 헤아리고, 나아가 스스로 이를 활용해볼 수 있도록 했다.

이렇게 우리에게 이미 주어진 '놀이 생성 기계'를 비로소 잘 가지고 놀게 됨으로써 얻는 것은 사실 그리 크지 않을 수 있다. 결국 이 모든 것들은 레몽 크노가 언급한 바, "소박한 재미"를 위한 것들일지 모른다. '제약'과 '잠재'로 문학을 재편성하려 했던 울리포 작가들의 숨은 야심은 결국 이들이 표방했던 소박한 재미 뒤로 그만 이미 가려져 버렸을지도 모른다. 그러나 '이것'이 '이것'일 수 있는 한, 잠재문학의 가능성은 이미 열려 있다.

물론 이는 잠재문학의 잠재성을 어떻게 드러내보일지 연구해본 여러 각도의 실마리에 지나지 않는다. 따라서 이것은 옳은 지침이 아닐 수 있다. 그럼에도 제약이 잠재일 수 있는 한, 어떤 가능성은 열리는 셈이다. [서문 중에서]

[남종신 / 손예원 / 정인교]

Potential Literature Workbook by Nam Juong Sin, Son Yee Won and Jung In Kyio has been made as a research project of Typojanchi 2013, focusing on the work of OuLiPo: the "workshop of potential literature" founded in France in the 1960s. The OuLiPo group, including such familiar names as Georges Perec, Raymond Queneau, Italo Calvino and Marcel Duchamp, initiated unique and important experiments in the context of modern French literature, yet the work has rarely been discussed in Korea.

Consisting of writers and mathematicians, the OuLiPo group used "constraints" as a literary device. They embraced mathematics, science and biology, attempting to liberate the text previously bound to quotidian functions, to discover its new literary potentials. The constraints, which may seem limiting for creative work, were turned to a limitless creative tool available to everyone, ironically by virtue of their clear regularity.

This book consists of two parts: the first part presents writing exercises inspired by the Oulipian techniques, adapted to the Korean syntax, with detailed discussions on the used constraints. The second part contains introductory materials to OuLiPo, including some fresh translations of their pivotal essays.

남종신
편집자, 한국.

손예원
번역가, 한국.

정인교
시인, 한국.

Nam Juong Sin
Editor, Korea.

Son Yee Won
Translator, Korea.

Jung In Kyio
Poet, Korea.

잠재문학실험실
2013. 오프셋, 사철에 표지. 10.8×17.8 cm, 248쪽. 편집: 김뉘연.
디자인: 전용완. 서울: 워크룸 스펙터.

Potential Literature Workbook
2013. Offset lithography, sewn in sections, cover. 10.8×17.8 cm,
248 pp. Edited by Kim Nui Yeon. Designed by Jeon Yong-wan.
Seoul: Workroom Specter.

누구의 것도 아닌

바다는, 크레파스보다 진한, 푸르고 육중한 비늘을 무겁게
　뒤채면서, 숨을 쉰다.

바다, 그래, 그 바다는, 여느 크레파스보다 진하디 진한,
　푸르다 못해 검푸르고 거대하며 육중한 비늘을 그토록
　무겁게 뒤채면서, 거친 숨을 내쉰다.
바다는 숨 쉰다.
과연!
푸르고, 육중한, 크레파스보다 진한 비늘을 무겁게 뒤채면서,
　바다는 숨을 쉰다.
해원(海原)은, 색연필보다 짙은, 거대한 쪽빛 비늘을 둔중히
　일으키며, 호흡한다.
수심이 깊었으리라. 짙푸른 파도가 넘실댈 때마다 다소
　버거워 보였는데, 저 바닥을 치고 올라와 깊은 숨을 쉬는
　듯했다.
바다는, 크레파스보다 진했던가? 푸르고 육중했던가? 그렇게,
　숨을 쉬었던가?

삼 층 빌 딩

날이 든다.

　삼십을 훌쩍 넘긴, 어깨쯤 되는 머리칼을 동여맨 여자가 거던 듯 앉았다. 그리 남에없이 명미(明媚)하지는 않아도 걱실걱실하고 두름새 있어 두루 친히 지내건만, 오늘만큼은 영 감째 사납다. 강술이나 몇 잔 들고픈 심사다. 다섯 시는 족히 됐으려니. 노냥 분주한 종로 한복판 삼 층 빌딩이 오늘따라 와자하다.

　'나이배기라, 하!'

　정오 때 사무실 귀퉁이에서 J와 K의 납신납신, 귀 지린 소리를 그만 들어버린 터다.

　'면전에선 그렇게도 날 개올리더니…… 혹 나와 K 사이를 J가 간롱하려고? 아니, 그 반대인지도 모르지. 그렇게 왜 가만 있는 이를 거우느냐 말이다.'

　어느 틈에 그리들 공연한 함혐(含嫌)을 품었던가. 말참섭(參涉)은 좀 해도 생글거리며 해망(駭妄)이 나곤 하는 J를 내심 귀애했기에, 다분히 발자해도 돌림성 없어 좋게 보고 또 사무실에서 가장 주밀(綢密)하다 싶어 은근히 K를 총애했기에, 섭섭함이 더하다. 요변(妖變)한 것들. 그만하면 저희나 나나 연상약(年相若)하다 할 것을! 망단(罔斷)했던 일들도 한풀 꺾여 요사이 좀 너누룩이 맘을 다잡았나 싶었건만. 여자는 고개를 젓고 만다.

보루꾸집 가시내는

쳉일 나자빠져 무그리고 부루치 감고 뭐라꼬 처씨부러
캐쌌는지 꿈사리 한번 징해부러. 그 꿈이 쑥대밭일랑가
내 있는 여가 구신 날 맹키로 소말마귄가, 싸개싸개 안
인나면 다리몽디를 쌔리 뿐질러뻰다 캐도, 지 아부지 미친
맹키로 들럭퀴쌌고, 쇳바닥을 뽑아뻰다 캐도, 눈꾸녕을
쑤셔뿔까 귓꾸녕을 뚜루뻴까 과함곰쳐싸도, 그 가수나
입질은 도무창 끈티이도 없어야, 오꼿 깨나라깨나라,
입사베기 열 개라도 한약헐 말이 없어뿌러야, 지 엄니는
또 우짜꼬야, 다 큰 처이가 저리 맥사가리 없이
헤벌레해가꼬는야 우예 살끼고 험씨롱 야사가 냅아가꼬
찔찔거려싼께나, 지 아방 뒤안 댓수풀서 빠짝 잘도 마른
대나무를 뎅거뎅 짤라갖고와서는야, 그 가시내 문간 앞으로
내질러야, 지 어무이는 쓰레빠 한짝이 널거간 것도 몰르고
지 아바니 바지춤에 옴싹 달가져붙어서, 어매어멍 나 죽네,
내부터 홀 작살내고 저 년 잡아묵으소, 허며 온 쌍판때기가
눈물에 코범벅이 되어서 질질 끌려가더라아이가. 방문
해까닥 열어제끼고야, 네, 이년, 허니…… 하아! 고년, 아,
뭣을 처묵었간디, 트럼도 독허고, 방구도 구만리라, 이
무신 일이꼬, 하니, 허이, 그 보루꾸집 가시내, 눈깔이
희번덕희번덕해쌌고, 입아귀 게거품 물고야, 어매오매,
우리 새깽이, 이 뭔일이다냐, 험씨롱 지 옴마이 달기가

혁명 전야
불가능한 것을 요구하라

친애하는 학생 동지여! 낡은 세계가 너를 뒤쫓고 있다.

한마디로 대학은 반항과 자유의 표상이니, 모든 권력을 상상력에게!

이제 질식할 듯한 기성 독재의 최후적 발악은 바야흐로 전체 국민의 생명과 자유를 위협하고, 네 행복을 산다. 그걸 훔쳐라.

그러기에 역사의 생생한 증언자적 사명을 띤 우리들 청년 학도는 이 이상 역류하는 피의 분노를 억제할 수 없으니, 금지하는 것은 금지되어 있다.

만약 이 같은 극단의 악덕과 패륜을 포용하고 있는 이 탁류의 역사를 정화시키지 못한다면 우리는 후세의 영원한 저주를 면치 못하리니, 너희 바지 지퍼를 여는 그만큼 자주 너희 두뇌도 열어라.

말할 나위도 없이 학생이 상아탑에 안주치 못하고 대사회 투쟁에 참여해야만 하는 오늘의 20대는 확실히 불행한 세대이니, 서른이 넘은 사람은 그 누구도 믿지 마라.

그러나 동족의 손으로 동족의 피를 뽑고 있는 이 악랄한 현실이 원하는 대로 되리라 여겨라.

존경하는 학생 동지 여러분, 외쳐라!

우리 고대는 과거 일제하에서 항일 투쟁의 총본산이었으며, 해방 후에는 인간의 자유와 존엄을 사수하기 위하여 멸공

전선의 전위적 대열에 섰으나, 오늘은 진정한 민주 이념의 쟁취를 위한 반항의 봉화를 높이 들어야 하겠으니, 혁명적 사고란 없다. 혁명적 행동만이 있을 뿐이다.

　우리들 청년 학도만이 진정한 민주 역사 창조의 역군이 될 수 있음을 명심하여, 돌이킬 수 없는 주먹을!

— 기성세대는 자성하라. 여름은 더우리라!
— 우리는 행동성 없는 지식인을 배격한다. 지루함은 반혁명적이다.
— 마산사건의 책임자를 즉시 처단하라. 가면 쓴 이가 바로 그다!
— 경찰의 학원 출입을 엄금하라. 그들의 악몽이 우리의 꿈이다.
— 오늘의 평화적 시위를 방해치 말라. 바리케이드는 거리를 막지만 길을 연다.

절제
restraint

———

버소에서 펴내는 '급진적 사상가들'은 권위 있는 좌파 정치, 철학 사상을 소개하는 단행본 시리즈다. 매년 열두 권이 한 세트로 출간되는데, 현재까지 루머스는 60권의 표지를 디자인했다. 모든 표지는 선과 활자로 이루어진 일정한 디자인 시스템을 따른다. 엄격하게 제한된 팔레트가 변주되며 개별 작품의 정신을 충실히 반영하려 한다.

이 디자인 시스템은 찢어진 종이, 과격한 타이포그래피 등 광고에서 흔히 보이는 상투적 '급진' 디자인에 대응해 만들어졌다. 우리는 절제된 모습을 보이고 싶었다. 시리즈로 나오는 책들이 급진적이라면, 그것은 책에 담긴 사유 때문이지 포장 때문이 아니라는 생각이었다. 그러나 의미를 전하는 매개체로서 디자인의 가능성마저 부정하고 싶지는 않았다. 내포된 의미를 무시하고 가설적으로 '순수한' 표지를 추구하며 디자인 요소를 모두 제거하는 일에는 관심이 없었다. 그래서 각 권의 내용을 반영할 수 있는 일러스트레이션 시스템을 개발했다.

어떤 일러스트레이션은 직설적이고 이해하기도 쉽다. 일부는 어려운 사유를 추상적으로 표상한다. 일반적으로 표지는 책의 역사적 배경이나 분위기를 전달하지만, 이 시스템은 그렇지 않다. 오히려 설명을 피함으로써 논쟁적 내용을 시적 언어로 전환한다. [앤디 프레스먼, 루머스]

루머스는 스크린과 인쇄물을 디자인하는 스튜디오로서 소수의 문화 기관, 기업, 출판사를 위해 웹사이트, 아이덴티티, 인터페이스, 도서 디자인 작업을 한다. 최근 프로젝트로는 그리핀 에디션스 아이덴티티와 웹사이트, 중동 문화 예술 전문지《비둔》디자인, 폰트 제조업체 커머셜 타입 웹사이트, 어린이를 위한 시각적 프로그래밍 언어 '홉스카치'의 아이덴티티와 인터페이스, 버소 출판사 아트 디렉션 등이 있다.

————————

Radical Thinkers is an ongoing paperback series of notable left-wing political and philosophical thought, published by Verso Books. Each yearly set features twelve titles, and to date we've designed sixty covers.

All fit within the same design system: a rigid palette of line and type that tries, in varying ways, to stay true to the spirit of each work.

This design system is a response to clichéd "radical" designs, often seen in advertising, which rely on illustrative gestures like ripped paper and aggressive typography. We wanted to show restraint; if the titles in this series are radical, it's for the ideas contained within, not for the packaging. But we didn't want to reject design as a vehicle for meaning—we weren't interested in stripping away every design element in search of a hypothetical "pure" cover, devoid of connotation or meaning. So we developed an illustrative system that could reflect each book's content.

Some of the illustrations are literal and easily deciphered. Others are abstract representations of slippery ideas. Most book covers provide context, whether historical or atmospheric, but this system rarely does. If anything, it unclarifies—it turns the polemic into the poetic. [Andy Pressman, Rumors]

Rumors is a design studio screen and print based in Brooklyn, New York. They make visual systems like websites, identities, interfaces, and publications for select cultural, commercial, and editorial groups. Recent projects include an identity and website for Griffin Editions; the design of *Bidoun*, a magazine on the art and culture from the Middle East; website for the type foundry Commercial Type; the identity and interface for Hopscotch, a visual programming language for kids; and the ongoing art direction of Verso Books.

루머스
2008년 설립, 뉴욕/포틀랜드: 앤디 프레스먼 대표, 1979년생, 미국.

Rumors
Founded in 2008, New York and Portland: Andy Pressman, principal, b. 1979, USA.

rumors-studio.com

급진적 사상가들
2009–현재. 오프셋, 무선철에 표지. 각각 12.7×19.6 cm, 두께와 쪽수 다양.
뉴욕/런던: 버소.

Radical Thinkers
2009–ongoing. Offset lithography, cut and glued, covers. 12.7×19.6 cm each; thickness and extent vary. New York and London: Verso.

중의성
ambiguity

심보선은 삶에 관한 성찰을 진지하고 진솔한 일상어로 풀어내는 시인이다. 시와 정치의 접속을 깊이 고민하는 시인이기도 하다. 그러나 그는 쓸모 있는 것을 만드는 노동이 아니라 쓸모없는 것을 만드는 사랑에 관심을 둔다. 이러한 시작(詩作)을 통해 그는 예술의 적요함보다 타인과 연대가 느껴지는 코뮌을 꿈꾼다. 심보선은 서울대학교 사회학과를 졸업하고 미국 컬럼비아 대학교에서 사회학 박사 학위를 받았다. 1994년《조선일보》신춘문예에 시 〈풍경〉이 당선되면서 등단했다. 2011년 제11회 노작 문학상을 수상했으며, 시집으로《눈앞에 없는 사람》,《슬픔이 없는 십오초》가 있다. '21세기 전망' 동인으로 활동 중이다.

디자이너 노은유는 일본어 발음을 한글의 제자 원리에 따라 표기하는 〈소리체〉를 스케치했고, 한자 명조체 혹은 순명조체 계열로 불리는 〈로명체〉를 디자인하는 중이다. 홍익대학교에서 〈최정호 한글꼴의 형태적 특징과 계보 연구〉로 박사 학위를 받았다. 활자공간을 거쳐, 현재 안그라픽스 타이포그라피연구소에서 선임연구원으로 활동하며 홍익대학교, 건국대학교에서 한글 디자인을 강의한다.

심보선과 노은유의 합작 〈둘〉은 "두 줄기의 언어, 두 갈래의 기호, 두 편의 활자극"을 지향한다. 언어 기호의 중의성, 그리고 지면과 화면이라는 매체의 이중성을 포착한다.

The poet Shim Bo Seon reflects on the life using everyday language, with a deep concern of the relationship between poetry and politics, although he is more interested in unproductive love than productive labor. With his work, he imagines a commune of solidarity rather than an artistic silence. He studied social science at the Seoul National University, and earned his Ph.D. from Columbia University, New York. He debuted in 1994, and has published two collections of poems. He earned the Nojak Literary Award in 2011.

Designer Noh Eun You has published a Korean alphabet that can phonetically represent the sound of Japanese language, and is now working

on a new Korean serifed typeface, *Ro Myung-che*. She earned her Ph.D. from Hongik University for a study on Choi Jeong-ho's Korean type designs. Currently she works as a researcher at Ahn Graphics Typography Institute, and teaches at Hongik University and Konkuk University.

Two by Shim Bo Seon and Noh Eun You explores "two kinds of language, two kinds of sign, two kinds of typo-theater," capturing the ambiguity of linguistic signs presented on two different media: print and screen.

———
심보선
1970년생, 한국.

노은유
1983년생, 한국.

Shim Bo Seon
Born in 1970, Korea.

Noh Eun You
Born in 1983, Korea.

둘
2013. 단채널 비디오. 서울스퀘어 미디어 캔버스 상영용으로 제작.

Two
2013. Single-channel video. Created for screening at the Seoul Square Media Canvas.

둘

두 줄기의 햇빛
두 갈래의 시간
두 편의 꿈
두 번의 돌아봄
두 감정
두 사람
두 단계
두 방향
두 가지 사건만이 있다
하나는 가능성
다른 하나는 무(無)

[심보선, 2008]

번의 시간
갈래의 햇빛
줄기의 돌아봄
두 편의 꿈
두

지면
page

루이 뤼티는 그래픽 디자인과 문학의 중첩에 관심을 둔 도서 디자이너 겸 저술가다. 2002년 암스테르담 헤릿 리트벨트 아카데미를, 2004년 아른험 베르크플라츠 티포흐라피를 졸업했다. 《자기 반영 지면에 관하여》(2010)와 《유아 A》(2012) 등 책을 썼고, 《돗 돗 돗》, 《봉사하는 도서관 소식지》, 《F. R. 데이비드》 등에 글을 발표했다.

뤼티의 《자기 반영 지면에 관하여》는 재료로서 '지면', 즉 그가 말하기로 "서사상 특정 순간에 의식적으로 자리 잡는 공간"을 다루고, 18세기 로렌스 스턴의 《신사 트리스트럼 섄디의 인생과 생각 이야기》에서부터 레몽 루셀, 조르주 페렉, B. S. 존슨, 앨러스데어 그레이, W. G. 제발트 등을 거쳐 오늘날 더글러스 코플런드와 조너선 사프란 포어 등에 이르는 작가들의 소설에서 지면이 비언어적 장치로 사용된 역사적 사례를 소개한다.

뤼티가 선택한 사례들은 '검정 지면'(이 책 2-33쪽에 실린 〈검정 지면에 관하여〉 참고), '공백 지면', '그림 지면', '사진 지면', '글자 지면', '숫자 지면', '문장부호 지면' 등으로 분류되어, 원래 모습 그대로 실린다. 그 결과 풍부한 "자기 반영 지면의 유형"이 나타난다. 이들 지면은 '자연스러운' 독서 흐름을 방해하고 서사의 공간적 차원에 주의를 돌림으로써 자신이 배치된 텍스트의 인위성을 드러낸다는 점에서 자기 반영적이다. 뤼티의 책에 소개된 지면들은 도판으로 취급되기보다 오히려 그들 자체로 새 책을 이루는 지면이 된다.

《자기 반영 지면에 관하여》는 수수한 페이퍼백이지만, 100점이 넘는 사례를 체계적으로 수집, 분류하고 깊이 있는 에세이와 꼼꼼한 문헌 목록을 더한 덕분인지 무척이나 철저하고 완전한 느낌을 준다. (그럼에도 지은이는 독자에게 책에 실린 사례에 만족하지 말고 원본을 찾아 본래 맥락에서 살펴보라고 권한다.) 어쩌면 독자는 소설에 쓰이는 비언어 요소의 가능성이 아직 완전히 고갈되지는 않았더라도, 최소한 철저하게 개발되었다는 인상을 받을지도 모른다.

그런 인상은 독자에게 좌절감을 줄 수도 있다. 단순히 독서에 '새로운' 멀티미디어 경험을 부여하거나—더 나쁜 경우로—책이라는 매체에 '새로운 생명'을 불어넣으려는 뜻에서 그런 장치를 이용하려던 사람에게는 더더욱 그럴 것이다. 그러나 "저자

의 인간적 회의"를 반영하는 작품에 관심 있는 이라면 실망할 필요 없다. 뤼티가 제
안한 대로, 그런 목적에 쓰이는 시각 요소는 "앞으로도 변하고 진화할 것이고, 오늘
날 작품에서도 활동 공간을 찾을 것"이기 때문이다.

Louis Lüthi is a book designer and writer whose work explores the over-
lap between graphic design and literature. He graduated from the Ger-
rit Rietveld Academie, Amsterdam, in 2002, and the Werkplaats Typo-
grafie, Arnhem, in 2004. He has published *On the Self-Reflexive Page*
(2010) and *Infant A* (2012), as well as texts in *Dot Dot Dot*, *The Serving
Library*, and *F. R. David*.

Lüthi's *On the Self-Reflexive Page* explores the materiality of the
page—what he describes as "a determined space at a specific point in
a narrative"—and how it has been used as a non-textual device in works
of fiction by various authors, from Laurence Sterne's *Tristram Shandy*
in the eighteenth century through Raymond Roussel, Georges Perec,
B. S. Johnson, Alasdair Gray, and W.G. Sebald, to more contemporary
examples including Douglas Coupland and Jonathan Safran Foer.

The book reproduces selected pages from other books, classifying
them into seven categories: Black Pages (see "On Black Pages" on pp.
2–33 of this book), Blank Pages, Drawing Pages, Photography Pages,
Text Pages, Number Pages, and Punctuation Pages. The result is a rich-
ly documented "typology of self-reflexive pages." The pages are self-
reflexive because they disrupt the "natural" flow of reading and draw
attention to the spatial dimensions of the narrative, thus signaling the
artificiality of the texts of which they are a part. The pages reproduced
in Lüthi's book are not treated as framed illustrations but instead remain
pages, albeit of a new book.

On the Self-Reflexive Page is a modest paperback, but with over one
hundred examples organized into categories, a thoughtful essay and a
painstakingly compiled bibliography, it exudes a sense of thoroughness
(though it does urge readers to refer to the source publications to exam-
ine the examples in their original context). The reader is perhaps left with
the impression that the use of non-textual elements in fiction has by now
been comprehensively exploited, if not quite exhausted.

This impression may come as a disappointment if you are planning
to deploy such devices simply to introduce a "new" multimedia experi-
ence to reading, or—even worse—breathe a "new life" into the book as
a media. But if you are concerned with the kind of work that reflects "an
author's humane skepticism," you need not be discouraged: for to that
end "the use of such elements may yet shift and evolve, may yet find
space to maneuver in contemporary works," as Lüthi suggests.

루이 뤼티
1980년생, 프랑스.

Louis Lüthi
Born in 1980, France.

자기 반영 지면에 관하여
2010. 오프셋, 사철에 표지. 13×20×1.2 cm, 160쪽. 암스테르담: 로마 퍼블리케이션스.

On the Self-Reflexive Page
2010. Offset lithography, sewn in sections, cover. 13×20×1.2 cm, 160 pp. Amsterdam: Roma Publications.

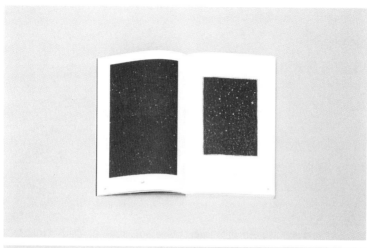

체현

embodiment

토르스텐 블루메와 파주타이포그라피학교 학생들이 꾸미는 이 공연은 타이포그래피와 무용을 충돌시키거나 중첩시키며 타이포그래피 문자를 몸으로 번역하는 작업이다. 각 공연자는 활자체를 동작 모티프로 개념화한 상태에서, 해당 활자체에서 영감을 받은 전형적 동작을 취한다. 그러한 개별적 움직임은 집단적이고 공간적인 '슈퍼텍스트' 또는 역동적이고 일시적인 건축으로 한데 모인다. 뚜렷이 규정된 매개 변수와 공통 문법 등 일관된 창작 구조 덕분에 그러한 종합이 가능해진다. 〈활자 춤〉은 즐겁고 신기하면서도 신중하고 진지하게 타이포그래피를 구성체로 체현한다. [토르스텐 블루메]

토르스텐 블루메는 데사우 바우하우스 재단에서 활동하는 연구자 겸 작가다. 2007년부터 그는 역사적인 바우하우스 연극을 실험적 형태로 현대화하려는 목적으로 '플레이 바우하우스'라는 무용, 공연, 설치, 워크숍, 전시 프로젝트를 진행해왔다. 베를린 훔볼트 대학교 이미지 지식 디자인 학제 연구소에 소속되어 있으며, 기획 중인 《인간 공간 기계》 전시회는 2013년 12월 데사우에서, 2014년에는 오슬로 헤니 온스타 쿤스트센테르와 서울 국립현대미술관에서 열릴 예정이다.

파주타이포그라피학교는 2012년 안상수가 설립한 대안적 디자인 학교다. 국내외 관련 단체와 연계된 독창적 교육 체계를 통해, 지역 정체성에 뿌리를 두고 "어울림, 삶"의 보편적 가치를 구현하는 디자인 교육을 추구한다. 현재 학부와 대학원에 스물두 명의 학생이 재학 중이다.

The performance developed by Torsten Blume with the students and dancers at the PaTI is based on an artistic process of translating typographic letterforms into body movements: it's an encounter or intersection of typography and choreography. Each performer is acting and dancing in a typical or characteristic manner—inspired by specific typefaces which are conceptually regarded as motion motives. But all the

individual types of dance moves are contributing finally to a collective and spatial "super text" or a dynamic and ephemeral architecture. This is possible because there is a common structured process of creation, including clearly defined parameters and a shared grammar. The *Typo-Dance* performance is a playful and curious but at the same time careful and serious embodiment of typography as construction. [Torsten Blume]

Torsten Blume is a researcher and artist currently at the Stiftung Bauhaus Dessau. Since 2007, he has been working on the project Play Bauhaus, with dance and movement installations, workshops, and exhibitions. The goal is to playfully bring the Bauhaus stage up to date as a form of experimentation. Blume is a member of the excellence cluster Bild-Wissen-Gestaltung: Ein interdisziplinäres Labor, Humboldt-Universität, Berlin. He is artistic director of the exhibition project *Human-Space-Machine. Stage Experiments at the Bauhaus* to be opened in December 2013 in Dessau and in 2014 at the Henie Onstad Kunstsenter Oslo and the National Museum of Modern and Contemporary Art, Seoul.

PaTI (Paju Typography Institute) is an alternative design school founded in 2012 by Ahn Sang-soo. With its unique and inventive educational system networked with other national and international organizations, it aims to realize the universal value of "harmony and life" in education rooted in local culture. There are currently twenty-two students enrolled in its undergraduate and graduate programs.

토르스텐 블루메
1964년생, 독일.

파주타이포그라피학교
2012년 설립, 파주.

Torsten Blume
Born in 1964, Germany.

PaTI
Founded in 2012, Paju.

playbauhaus.tumblr.com
pati.kr

활자 춤
2013. 퍼포먼스. 약 20분. 특별 출연: 정향숙(임학선 댄스 위 단원 대표),
유혜진(임학선 댄스 위 수석 단원). 출연: 유명상, 이함, 이예주, 이지연, 정성훈,
양민영, 강심지, 구찬회, 박도환, 변산노을, 이규찬, 이윤서, 이윤선, 유이지수, 전산,
정연지, 조신철, 정해지. 코디네이터: 이예주, 이지연. 공연일: 2013년 8월 30일.

Typo Dance
2013. Performance. Appx. 20 minutes. Guest performers:
Choung Hyang Sook and You Hye Jin. Performed by Ahn Na-hyun,
Yu Myung-sang, Lee Haam, Lee Ye-jou, Lee Alex Jiyun,
Jung Sung-hun, Yang Min-young, Kang Simji, Koo Chan-hwoi,
Park Do-hwan, Byeon San Noeul, Lee Kyu-chan, Lee Yun-seo,
Lee Nody yoonseon, Yui Jisu, Jeon San, Jeoung Yeon-ji,
Jo Shin-cheol, Jeong Haeji-Ji. Coordinators: Yejou Lee and
Alex Jiyun Lee. Performed on August 30, 2013.

슈퍼체현

프로그램

———————
타이포잔치 토크
2013년 8월 27일 / 8월 28일
NAVER 그린팩토리 2F 커넥트 홀
 8월 27일: 폴 엘리먼, 마크 오언스, 카를 나브로, 샤오마거, 하마다 다케시
 8월 28일: 무로가 기요노리(일본 《아이디어》 편집장), 오하라 다이지로, 김기조,
 존 모건, 룰 바우터르스, 아스트리트 제메
 사회: 이지원

———————
본 전시
2013년 8월 30일–10월 11일
문화역서울 284

program

—————————
Typojanchi Talks
August 27 / 28, 2013
NAVER Green Factory, 2F Connect Hall
 August 27: Paul Elliman, Mark Owens, Karl Nawrot, Xiao Mage,
 and Hamada Takeshi
 August 28: Muroga Kiyonori (editor-in-chief, *Idea* magazine, Japan),
 Ohara Daijiro, Kimm Kijo, John Morgan, Roel Wouters, and
 Astrid Seme
 Moderated by Lee Jiwon

—————————
Main Exhibition
August 30–October 11, 2013
Culture Station Seoul 284
 Writing in the Air
 August 30–October 11, 2013
 Seoul Square Media Canvas
 August 30: preview
 September 4: Park Joon and Kang Gyeong Tak
 September 10: You Hee Kyoung and Yang Sang Mi
 September 12: Shim Bo Seon and Noh Eun You
 September 18: Jin Eun Young and Kim Byung Jo
 September 24: Seo Hyo In and Gang Moon Sick
 September 26: Kim Kyung Ju and Min Bon
 October 2: Oh Eun and Chris Ro
 October 8: all artists

———————————————————————
(Unguided Tour) With Lim Geun-jun (Art and Design Critic)
September 14, 2013
Culture Station Seoul 284

무중력 글쓰기
2013년 8월 30일-10월 11일
 서울스퀘어 미디어 캔버스
 8월 30일: 전 작가 작품 미리 보기
 9월 4일: 박준 / 강경탁
 9월 10일: 유희경 / 양상미
 9월 12일: 심보선 / 노은유
 9월 18일: 진은영 / 김병조
 9월 24일: 서효인 / 강문식
 9월 26일: 김경주 / 민본
 10월 2일: 오은 / 크리스 로
 10월 8일: 전 작가 작품 상영

(미술·디자인 비평가) 임근준과 함께 (보는 타이포잔치 2013)
2013년 9월 14일
문화역서울 284

(디자이너) 김형진과 함께 (보는 타이포잔치 2013)
2013년 9월 28일
문화역서울 284

OSP 워크숍
2013년 9월 30일-10월 4일
문화역서울 284
 강사: OSP (사라 마냥, 피에르 하위허베르트, 뤼디빈 루아소, 콜름 오닐)

OSP 강연회
2013년 10월 4일
문화역서울 284
 강사: OSP (사라 마냥, 피에르 하위허베르트, 뤼디빈 루아소, 콜름 오닐)

한글날 전야제: 글 이전, 말 이후
2013년 10월 8일 화요일
문화역서울 284
 기획: 홍철기
 출연: 출연: 이행준 / 김태용, 최준용 / 진상태, 필 민턴과 야생 합창단

(Unguided Tour) With Kim Hyung-jin (Designer)
September 28, 2013
Culture Station Seoul 284

OSP Workshop
September 30–October 4, 2013
Culture Station Seoul 284
 Run by Sarah Magnan, Pierre Huyghebaert, Ludivine Loiseau and
 Colm O'Neil (OSP)

OSP Talk
October 4, 2013
Culture Station Seoul 284
 Talk by Sarah Magnan, Pierre Huyghebaert, Ludivine Loiseau and
 Colm O'Neil (OSP)

Hangul Day Eve Festival: Before Writing, After Speaking
October 8, 2013
Culture Station Seoul 284
Curated by Hong Chulki
 Performed by Lee Hangjun and Kim Tae-yong, Choi Joonyong and
 Jin Sang-tae, Phil Minton and his Feral Choir

한국 근대 시의 조건과 타이포그래피적 상상력

박현수

1. 시의 본질과 매체의 상상력

시와 매체

문학의 본질은 매체의 본질로부터 자유로울 수 없다. 새로운 시의 등장 역시 시를 실현할 매체의 변화와 궤를 같이한다. 극단적으로 말하자면 매체의 상상력이 시의 범주와 본질을 구성한다고 할 수 있다. 문학 연구가 매체 연구와 결부되어야 하는 이유가 여기에 있다. 매체의 관점에서 볼 때 현대 시의 범주는 통시적으로 크게 전통 시, 근대 시, 탈근대 시로 나눌 수 있다. 이때 매체는 각각 음성, 활자, 디지털 언어가 된다.

전통 시

전통 시에서 시의 절대적 조건은 인간의 음성이다. 따라서 시의 특성은 전적으로 음성의 실현태에 의존한다. 모든 시는 발화를 전제로 하기 때문에, 이때의 중심 감각은 청각이 된다. 전통 시의 문학적 특성은 음성이 지닌 시간성과 휘발성이라는 본질을 여러 형태로 반영한다. 리듬의 강조, 반복에 바탕을 둔 다양한 수사학, 표현의 상투성 등이 그 예이다. 음독은 어떤 형태이든 청자를 가정한다. 시간이 지날수록 그 청자의 실존이 추상적으로 되어가긴 하지만, 서정시는 음독의 패러다임을 벗어나지 않는다.

근대 시

근대 시는 근본적으로 청자를 배제한다. 전통 시를 규정하는 음독의 패러다임이 묵독의 패러다임으로 전환될 때, 즉 "인쇄가 시를 노래로부터, 산문을 웅변으로부터 분리해"(마셜 매클루언)버릴 때 근대 시가 탄생한다. 근대 시의 매체로서 활자는 음성을 극단적으로 추상화시켜 발화 이전의 상태로 되돌려버렸다. "활자 공간"(typographic space, 매클루언)을 통해 음성의 퇴행이 진행된 것이다. 인쇄 매체에서 음성은 소멸의 단계에 놓인다. 이때 청자를 대신하는 것은 '독자'이다. 음성은 사라지고 공간화된 기호로서 활자가 전면에 등장한다. 이제 청각 대신 시각이 중심적인 감각이 된다. 이런 변화를 가져온 근본적인 원인은 인쇄 문화의 전면적인

Preconditions for Korean Modern Poetry and
Typographic Imagination

Park Hyun-Soo

1. Essence of Poetry and the Media Imagination

Poetry and the Media

The essence of literature cannot be free from the essence of the media. The emergence of new poetry is in tandem with the changes in the media to deliver poetry. In an extreme sense, the media imagination comprises the scope and essence of poetry. That is why literary studies must be linked to media studies. In terms of media, contemporary poetry can be broadly divided into three categories: traditional, modern, and postmodern. The respective media would be of sound, typography, and digital language.

Traditional Poetry

In traditional poetry, the absolute precondition is the human voice: the nature of poetry entirely depends on the vocal realization. Since all poems are premised on oral recital, the central sense is hearing. The literary features of traditional poetry in many ways reflect the temporality and volatility of voice: the emphasis on rhythm, rhetorics based on repetition and clichés. Vocal reading in any form assumes the presence of a listener. Although the existence of a listener has become increasingly abstract, lyrical poetry still remains within the paradigm of vocal reading.

Modern Poetry

Fundamentally, modern poetry excludes the presence of the listener. It is born when the paradigm of vocal reading has been shifted to that of silent reading: when, that is, printing has separated "poetry from song, and prose from oratory" (H. M. McLuhan). Typography as the medium for modern poetry has abstracted the voice and returned it to the state prior to utterance. Thus in the "typographic space" (McLuhan), the voice begins to regress. In the print media, the voice becomes on the verge of extinction. In the place of the listener, there comes the reader. The voice

확장이다. 19세기에 시 낭송회가 개인적인 묵독으로 대체된 것이 "책과 활자의 승리"(옥타비오 파스)로 불리는 것도 이 때문이다.

탈근대 시

탈근대 시는 아직 구체적인 모습을 드러내지 않은 상태이지만, 하이퍼텍스트 시를 비롯한 디지털 시를 가리킨다. 작품 활동은 소수에 의해 실험적으로 이루어지고 있지만, 이것은 여전히 하나의 가능성으로만 존재한다. 디지털 언어의 입체성, 비완결성, 공감각성 등은 새로운 형태의 문학적 특성을 규정할 것이지만, 이 매체를 체화하여 시적 차원으로 승화시킬 세대는 현재 성장 중에 있다.

2. 전위 시의 조건으로서 타이포그래피적 상상력

유럽 전위 시의 개념

근대문학에서 모더니즘과 아방가르드는 전혀 다른 문화적 토양에서 자란 이질적 문예사조라 할 수 있다. 아방가르드 문학, 즉 로고스 중심주의에 대한 불신을 핵으로 하는 전위 문학은 투쟁주의, 모험 정신, 실험주의, 미래주의, 언어 해체, 논리성 파괴, 소외, 비이성 지향, 주체 분열 등으로 그 특성이 정리된다.

전위 시는 미래주의, 다다이즘, 초현실주의 등 주로 1차 세계대전 전후 유럽에서 일어난 예술 운동의 미학적 전략을 차용한 실험적인 시들을 가리킨다. 이 중 다다이즘은 "입체파의 콜라주, 미래파의 인쇄술적 곡예와 소음주의, 표현주의의 파격적인 색상 구사, 칸딘스키의 자발적인 기교, 아폴리네르와 막스 자코브의 시적 발명"(맬컴 브래드버리 / 제임스 맥팔레인)의 종합으로, 극단적 실험주의를 포괄하는 광범위한 개념이다. 근대 시 중에서 출판 매체에 가장 주목한 장르는 이런 전위적 아방가르드 시일 것이다.

한국 전위 시의 등장

한국 문학에서도 전위 시에는 다다이즘적 형태 실험이 먼저 나타나며, 지금까지 알려진 최초의 작품은 1920년대 중반에 등장한다. 정지용의 〈파충류 동물〉, 〈슬픈 인상화〉에는 활자의 크기와 배치를 통한 형태 실험 등 이전 한국 시에 나타나지 않았던 새로운 기법이 나타난다. 이후 김니콜라이(박팔양)의 〈윤전기와 사층집〉, 임화의 〈설(雪)〉, 김화산의 〈악마도: 어떤 다다이스트의 일기 발췌〉 등의 작품이 뒤따른다. 소수에 의해 파급되던 이런 전위 시는 1930년대 들어 김기림, 이상, 《삼사문학》 동인들에 의해 하나의 문학 장르로 인정받기에 이른다.

disappears, and the type as a spatialized sign emerges. Now the central sense is sight, not hearing. The fundamental cause for this change was the full-blown expansion of print culture. This is why the nineteenth-century replacement of poetry recital by personal—silent—reading has been called the "triumph of books and printing types" (Octavio Paz).

Postmodern Poetry

Although postmodern poetry has yet to emerge substantially, here it refers to digital poetry, including hypertext poetry. It has been experimented by a few writers, yet postmodern poetry still remains as a possibility. The multi-dimensionality, incompleteness and synesthetic nature of digital language will define the new forms of literature, but the generation of writers who will embody this media and elevate it to a poetic level is still growing up.

2. Typographic Imagination as a Precondition for the Avant-Garde Poetry

European Avant-Garde Poetry

In modern literature, modernism and the avant-garde are distinctive movements rooted in different cultural backgrounds. The avant-garde literature based on distrust of logocentrism can be characterized by its militarism, adventurism, experimentalism, futurism, deconstruction of language and logics, alienation, impulse toward irrationality, and dissociation of the subject.

The avant-garde poetry here refers to the experimental poems driven by the aesthetic strategies of the artistic movements that emerged before and after the First World War, such as futurism, Dadaism and surrealism. Dadaism, in particular, encompassed various radical experiments, combining the collage of cubism, acrobatic printing and brutism of futurism, unconventional color palette of expressionism, spontaneous techniques of Kandinsky, and the poetic inventions of Guillaume Apollinaire and Max Jacob (Malcolm Bradbury & James McFarlane). In modern literature, it is probably this avant-garde poetry that paid the keenest attention to print media.

Emergence of the Korean Avant-Garde

In Korean literature, too, the avant-garde first arrived in the form of the Dadaist formal experimentation, the first known example of which ap-

전위 시는 인쇄 매체의 가능성에 대한 자각을 바탕으로 성립한다. 인쇄물을 음성 중심주의의 연장선에서 이해하여 음성의 필사물로 여길 경우 새로운 매체의 특성이나 가능성은 포착될 수 없다. 또한 인쇄 매체에 대한 자각을 가지고 있더라도 당대 인쇄 환경이 뒷받침되지 않으면 전위적인 시는 발표될 수 없었을 것이다. 1920년대 중반, 다다이스트에 의한 전위 시 창작은 단순한 기법의 수입이 아니라 당대 출판문화의 성숙이라는 시대적 조건과 맞물림으로써 가능해졌다.

한국에서 근대적 활판 인쇄술 혹은 인쇄술이 시작된 것은 1883년 정부가 박문국 (博文局)을 설립하여 《한성순보》를 간행하면서부터이다. 이때부터 점증적으로 출판 수요가 증대하여 1909년에는 인쇄국에서 한국인 인쇄 기술자 양성을 위한 교재 《활판술》을 발행하기도 했다. 그러나 이후 1920년까지는 일제의 언론 통제 정책 때문에 일본인이 경영하는 인쇄소 외에는 이렇다 할 인쇄소가 없었다. 3·1 운동을 계기로 문화정치가 표방되고 민족자본 인쇄 산업이 많이 발전함에 따라, 한국 인쇄 문화사에서 1920년대는 인쇄 산업의 성장기라 불린다. 이때 전국 각지에서 인쇄소의 양적, 질적 팽창이 있었으며, 모노타이프, 그라비어 등의 소개와 오프셋 인쇄, 자동화 시설 등의 보급이 이루어졌다. 이를 바탕으로 1930년대에 들어 인쇄술의 발전이 더욱 진전되었다.

<div align="center">

한국의 전위 시인들:

정지용, 김니콜라이, 김기림, 이상, 《삼사문학》 동인과 신백수

</div>

이런 인쇄 환경의 발달이 인쇄 매체에 대한 시인의 능동적인 인식과 맞물려 '타이포그래피적 상상력'을 갖춘 문학적 실험으로 이어지는 데에는, 최초의 전위 시라 할 정지용의 작품이 나타나는 1920년대 중반까지 시간이 필요했다. 정지용은 형태 실험을 시도한 최초의 모더니스트답게 인쇄 매체에 대한 남다른 감각을 지니고 있었다. 그의 타이포그래피적 상상력은 다음 구절에서 잘 드러난다.

활자 냄새가 이상스런 흥분을 일으키도록 향기롭다. 우리들의 시(詩)가 까만 눈을 깜박이며 소근거리고 있다. 시는 활자화한 뒤에 훨씬 효과적이다. 시의 명예는 활자직공에게 반분하라. 우리들의 시는 별보다 알뜰한 활자를 운율보다 존중한다. 윤전기를 지나기 전 시는 생각하기에도 촌스럽다. [정지용, 〈소묘2〉, 1933]

이런 타이포그래피적 상상력이 전형적으로 드러나는 시는 김니콜라이(박팔양)의 〈윤전기와 사층집〉(1927)이다. 작품 전체에 아방가르드의 실험적 요소, 즉 활자의 크기 조정, 부호의 사용 등의 예가 풍부하게 나타나 있다. 윤전기로 대표되는 문명

peared in the mid-1920s. Jeong Ji-Yong's "Amphibians" and "A Sad Portrait" showed techniques unprecedented in Korean poetry, such as formal experiments with the size and the arrangement of printing types. It was followed by "Rotary Press and a Four-Story House" by Nicolai Kim (Park Pal-yang), "Snow" by Lim Hwa and "Devil Painting: A Dadaist's Diary, Excerpt" by Kim Hwa-san. Initiated by the few, the avant-garde poetry came to be recognized as a literary genre by Kim Ki-rim, Yi Sang and the writers associated with the journal *Samsa Munhak* in the 1930s.

The avant-garde poetry is contingent on the awareness of the potentials of print media. Seen from the perspective of logocentrism and regarded as mere transcription of voice, the nature and potentials of print media could not be grasped. And even with the awareness, the avant-garde poetry would not have been published if not supported by printing techniques and culture at the time. The Dadaist, avant-garde poetry in the 1920s was made possible not simply by importing the techniques, but due to the mature culture of printing and publishing.

Modern letterpress printing in Korea started in 1883 when the government founded a printing bureau and issued *Hanseong Sunbo*, a newspaper. Demand for printing rose since then, and a Korean printing manual was published in 1909. Until 1920, however, the imperial Japanese control over the media meant that there were no other print shops in Korea than the ones run by the Japanese. Triggered by the March-1 Korean national liberation movement in 1919, Japanese colonial government adopted "culture-politics" to attain legitimacy and efficiency of its rule in Korea. It did open up room for the Korean printing industry, and the 1920s witnessed its significant growth. During the period, there were expansions of print shops all over the country, both in quantity and quality. The Monotype machines and gravures technique were introduced during the same period, along with offset lithography and mechanized printing processes. As a result, the development of printing technology accelerated in 1930s.

<p style="text-align:center">Korean Avant-Garde Poets:

Jeong Ji-Yong, Nicolai Kim, Kim Ki-rim,

Samsa Munhak and Shin Baek-su</p>

It took some time for the technical development in printing to meet the awareness of poets and spawn the literary experiments with "typographic imagination," as the first Korean avant-garde poem by Jeong Ji-Yong only appeared in the mid-1920s. As the first modernist who attempted formal experiments, Jeong Ji-Yong had a unique touch with print media. His typographic imagination is implied in the following passage:

과 그것의 몰락이라는 새로운 내용을 다다의 실험적인 형식으로 표현했다. 이 작품이 윤전기가 있는 인쇄소를 배경으로 하고 있으며 "윤전기", "부호", "오식" 등 인쇄와 관련된 어휘들을 가득 담고 있는 사실은 전위 시와 그 조건을 고려할 때 전혀 우연이 아니다.

한국 모더니즘의 대표적인 이론가인 김기림도 타이포그래피적 상상력을 제대로 인식하고 이론과 창작을 동시에 전개해나간 대표적 문인이다.

> 즉 시는 음악성에 의하여 성립하는 것이 아니라 보다 더 회화성에 본질적인 것이 있다는 새로운 미학에 기인하여 출발한 것이나 드디어는 인쇄의 형태성의 효과와 결합한 형태시가 나타나게 되었다. 이 기운을 가장 촉성한 것은 입체파의 운동인 것 같다. […] 보다 적절하게 말하면 인쇄술의 시적 표현이라고도 말할 수 있다. […] 순수한 스타일의 기계적 효과 내지는 인쇄미의 발휘로써 시의 극치라 생각한 것이다. [김기림, 〈시에 있어서 기교주의의 반성과 발전〉,《조선일보》, 1935]

김기림에게 시에서 음악성을 중시하는 것은 곧 시의 본질을 시간성에서 찾는 것으로, 이는 낡은 시대의 시학으로 치부된다. 전근대의 음악성이 구텐베르크 테크놀로지의 회화성으로 변화할 때, 이 가능성을 가장 극단적으로 실험한 것이 입체파이다. 이 논의에서 형태 시는 "인쇄술의 시적 표현"으로 규정된다. 김기림은 "나는 시의 인쇄를 인쇄공에게만 맡길 수 없다. 인쇄는 시에 있어서 매우 중요한 의의를 가지고 있다"고 말하며, 시에서 인쇄의 중요성을 포기하지 않는다.

이상(李箱)은 타이포그래피적 상상력을 가장 분명하고도 풍부하게 보여주는 시인에 속한다. 그가 수필에서 밝히고 있듯이 그의 아버지는 궁내부 즉 왕실 소속 활판소의 기술자였고, 활판에 대한 그의 관심은 다른 문인들에 비하여 더 높았다. 그런 영향인지, 그는 이후 여러 잡지나 시집의 전문적 조판 및 편집에 관여하기도 하였다. 이런 전기적 사실보다 더 중요한 것은 이상의 경우 인쇄 매체에 대한 자각이 내면화되어 수사학으로 자연스럽게 표출되었다는 점이다. 이상의 시와 산문에서 빈번하게 나타나는 출판 관련 어휘의 비유적 사용은 다른 문인들에게서 찾아보기 힘든 경우이다. "흙속에는 봄의 식자(植字)가 있다", "내 활자(活字)에 소녀의 살결 내음새가 섞여 있다. 내 제본(製本)에 소녀의 인두자국이 남아 있다" 등이나, "인쇄공장 우중충한 속에서 활자처럼 오늘도 내일도 모레도 똑같은 생활을 찍어내었다", "나는 날마다 인쇄소의 활자 두는 곳에 나의 병구(病軀)를 이끌었다" 등이 대표적이다. 이런 수사학은 그의 인쇄 매체에 대한 인식이 녹아 있는 절실한 표현이라는 점에서 단순한 지적 유희로만 볼 수는 없다.

The scent of types is beautiful enough to arouse a peculiar excite-
ment. Our poetry is whispering while blinking its black eyes. The
effect of poetry amplifies after being printed. The honor of poetry
must be given to the typesetter. Our poetry respects the dense-as-
stars types more than rhymes. Poetry before passing the rotary
press is just crappy. (Jeong Ji-Yong, "Drawing 2," 1933)

Such typographic imagination is explicit in "Rotary Press and a Four-
Story House" (1927) by Nicolai Kim (Park Pal-yang). Throughout the
work there are experimental elements such as type size modification
and the use of punctuations. The civilization symbolized by rotary press
and its collapse were expressed in the Dadaist fashion. Given the pre-
conditions for the avant-garde poetry, it may not be an accident that the
work takes a print shop as its background and is full of printing terms
such as "rotary press," "punctuation" and "typo."
 Kim Ki-rim, a representative theorist of Korean modernism, is one of
Korea's iconic literati who was fully aware of typographic imagination
and unfolded both the theory and the practice.

In other words, poetry derived from a new aesthetic that sees
the essence in the visual rather than the musical has eventually
integrated itself with the formal characteristics of printing to yield
concrete poetry. I think that it was most facilitated by cubism. […]
More appropriately, it might be seen as a poetic expression of
printing. […] It is the ultimate pinnacle of poetry as the mechanical
effect of the purity or the expression of printing aesthetics. (Kim
Ki-rim, "The Reflection on and the Development of Technicalism in
Poetry," *Chosun Ilbo*, 1935)

For Kim Ki-rim, focusing on the musical in poetry meant seeking the
essence of poetry in temporality, which was considered outdated. The
shift from the premodern musicality to the visuality of the Gutenberg
technology was most acutely captured by cubism. In this discussion,
concrete poetry is defined as a "poetic expression of printing." Kim Ki-
rim stated, "I cannot leave printing of my poems to printers. Printing is
too important to poetry," asserting the significance of printing in poetry.
 Yi Sang is one of the poets who showed typographic imagination more
clearly and richly. As indicated in an essay, his father was a technician
at the court printing office, and he had more interest in the process of
letterpress than any other writers did. Perhaps for this reason, he would

한국 최초의 전위 문학 동인지 《삼사문학》의 동인에게서도 타이포그래피적 상상력은 발견된다. 그들의 시는 활자의 크기 조절, 활자의 배치, 도형 및 기호의 사용 등 인쇄 매체의 가능성을 최대한 이용하고 있다. 이상의 과격한 전위 시 〈오감도〉 발표 이후에 시작된 것이라 이들은 전위로서 부담감을 지니지 않고 실험적인 시도를 지속할 수 있었다.

인쇄 매체에 대한 이들의 인식은 《삼사문학》 동인의 리더 격인 신백수의 글에 잘 나타나 있다. 그는 인쇄술의 진보를 개괄하는 〈활판술: 활판구축법서설(活版構築法序說)〉이라는 글에서 기존 인쇄술이 보여주는 평행선 정렬 방식을 "거세되어 가고 있는 완미(頑迷)한 전통적 규약에 지나지 않는 것"이라며 비판한다. 평면적이고 수평적인 배열 방식으로는 타이포그래피적 상상력을 제대로 구현할 수 없다는 의미이다. 즉 그가 추구하는 것은 자유로운 타이포그래피적 공간성이었다. 활자의 배열과 공간과의 관계에 의의를 두고, 인쇄물의 내용보다 그 형식을 더 강조한다. 이때 형식은 내용을 포괄하면서 동시에 내용보다 우위에 놓인다. 이런 태도는 근대 시의 본질에 맞닿아 있다.

3. 전위 시, 근대 출판의 시학

전위 시에서 구현되는 타이포그래피적 상상력의 구체적인 특성을 정리하는 것은 곧 근대 인쇄 매체의 시학을 요약하는 일이라 할 수 있다. 이 특성들은 긴밀하게 맞물려 있어 서로가 서로의 표면이자 이면이 된다. 이 특성들을 음성의 사물화, 형태의 메시지, 관념화된 평면의 세 가지로 요약하고자 한다.

음성의 사물화

가장 먼저 다룰 것은 '음성의 사물화'이다. 이는 전위 시에서 청각에 대한 시각의 압도적 우위를 가리키는 개념이다. 근대 인쇄 문화는 언어의 청각적인 부분을 부차적인 요소로 만들었다. 말의 청각적 요소는 문자의 시각적 요소로 대체되었다. 언어의 시각화 혹은 공간화를 통하여 근대 시는 전통 시와 전혀 다른 양상을 지니게 되었다. 활자 크기의 조절, 활자의 입체적인 배치 등 시각적 변주들은 기존의 음독 패러다임에서는 실현 불가능한 시도이다.

전위 시에서 음성이 축출되면서 청각은 시각으로 대체된다. 전위 시의 초기 작품인 〈윤전기와 사층집〉(그림 1)에서 음성("음향", "목쉰 소리")은 활자 크기를 변화시키는 효과를 통해 존재를 나타낸다. 이때 활자로 구현된 소리는 음성의 부재를 나타내는 알리바이에 지나지 않고, 그 형태가 자유롭게 조절되는 활자는 음성의 '시각

be involved in professional type composition and editing for many maga-
zines and books of poetry. More important than these biographical de-
tails is that Yi Sang internalized the awareness of print media and com-
fortably displayed it through his rhetorics. The frequent appearance of
press terms as rhetorical figures in Yi Sang's poems and proses defies
comparison with other writers' work: "There are types of spring set in the
soil"; "There is the scent of a girl's flesh in my types. There remains an
imprint of a girl in my binding"; "The same life is printed for today, tomor-
row, and the day after tomorrow, just like the types in the gloominess of
a print shop"; and "I carried my sick body to where the types are in the
print shop." Such rhetorics are not just an intellectual play, as they ex-
press his awareness of print media with a sense of desperation.

 The writers associated with *Samsa Munhak*, Korea's first avant-garde
literary journal, also displayed typographic imagination. Their poetry ex-
ploited the potentials of print media with the manipulation of type size
and arrangement, and the use of shapes and symbols. The movement
started after the publication of "Ogamdo," a radical avant-garde poem
by Yi Sang, so the writers could continue experimentations without
much burden.

 Their perception of print media is well indicated in the writings of Shin
Baek-su, the *de facto* leader of the *Samsa Munhak* movement. In his
overview of the progress of printing, "Letterpress: An Introduction to
Type Composition," he dismissed the linear arrangement of types typical
of conventional printing as "nothing more than a stringent yet impotent
traditional norm." One-dimensional, linear arrangement could not cap-
ture typographic imagination: what he was after was the liberated spa-
tiality of typography. Focusing on the relationship between typographic
arrangement and the space, he emphasized the form of printing over the
content. In his case, the form is held superior to the content, deemed to
encompass the latter. In the heart of modern poetry lies this attitude.

3. Avant-Garde Poetry—Poetics of Modern Print Media

Summing up the specific features of typographic imagination represent-
ed in the avant-garde poetry would amount to encapsulating the poetics
of modern print media. These features are closely linked together, each
being one another's surface and backside. They can be summarized
as following: the reification of voice; the form as the message; and the
abstracted plane.

그림 1. 김니콜라이, 〈윤전기와 사층집〉 부분. 활자들이 입체적인 배치를 통해 시각적으로 변주되고, 소리 내 읽기 어렵게끔 음성이 축출되면서 청각은 시각으로 대체된다.

Figure 1. Nicolai Kim, "Rotary Press and a Four-Story House" (1927), detail. Types are visually manipulated through three-dimensional arrangement. The auditory sense is replaced by sight as the text is rendered difficult to read aloud.

그림 2. 이상, 〈오감도 시제4호〉 전문. 발음이 불가능하고 읽히지 않으며 전체가 하나의 거대한 부호를 형성하는, 시각적 형태만을 통한 메시지.

Figure 2. Yi Sang, "Ogamdo No. 4" (1934). The text is impossible to pronounce and difficult to read, the entire text forming a single sign. The message is conveyed through the form.

Reification of Voice

The first aspect to address is "the reification of voice." It denotes the overwhelming dominance of sight over hearing. Modern print culture has rendered the auditory aspect of language auxiliary. It has been replaced by the visual aspect of words. Through the visualization or spatialization of language, modern poetry has acquired an outlook starkly different from traditional poetry. The visual manipulation, including the modification of type size and their three-dimensional arrangement, was not plausible in the conventional paradigm of vocal reading.

As voice is ousted from the avant-garde poetry, hearing is replaced by sight. In one of the earlier avant-garde works, "Rotary Press and a Four-Story House" (fig. 1), the voice ("sounds," "a cracking voice") manifests itself as an effect of type-size modification. Here, the sound realized by the types is a mere alibi for the absence of voice, and the types lending themselves to free modification become the "visual objects" of voice, the objects of intellectual manipulation in the form of artifacts. This is the effect of the reification of voice.

Form as the Message

The next aspect to address is "the form as the message." It indicates the function of a signifier that has assumed the role of the signified. In the avant-garde poetry, typography is regarded to have completely broken away from voice in any form. This has been enabled by the introduction of the symbols that are not meant to be pronounced. The symbols cannot be realized vocally. As shown in the figure 2, the inverted numerals cannot be read: they can only be recognized by vision. After all, many typographic symbols have no pronunciation in the first place: they are alien characters, unable to realize with the vocal cords. Here, the form itself becomes the message. Various experiments of print media were possible because printing removed aura from the human voice and liberated itself from the rigorism and ethical rules of logocentrism. The avant-garde poetry broke away from logocentrism and heralded a new poetics by adopting the experimental techniques.

Abstracted Plane

Lastly, the poetics of modern, print-media poetry can be defined in terms of the "abstracted plane," or "abstraction of the plane." When the avant-garde poetry departed from logocentrism and accorded a dominant status to the visual, its reception began to require a different perceptual process. For what the avant-garde poetry aims at with its

적 고체'로서 사물의 형태를 취한 지적인 조작의 대상이 된다. 이것이 바로 '음성의 사물화'이다.

형태의 메시지

다음으로 다룰 것은 '형태의 메시지'이다. 이는 기의의 기능까지 떠맡게 된 기표의 기능을 가리킨다. 전위 시는 어떤 형태로든 활자가 음성의 그늘에서 완전히 벗어난 것임을 주장한다. 이것을 가능하게 한 것이 발음 불가능한 기호의 도입이다. 기호는 음성으로 실현되지 않는다. 그림 2에서처럼 뒤집힌 숫자는 읽을 수 없다. 오로지 시각으로 형태를 인식하는 것만이 가능하다. 인쇄에 동원되는 많은 기호에는 애초부터 발음이 없다. 이것은 인간의 성대를 통해 실현할 수 없는 이질적인 문자이다. 이때 형태 자체가 하나의 메시지가 된다. 인쇄 매체의 다양한 실험이 가능해진 것도 인쇄가 인간 음성의 아우라를 소멸시키고 음성주의가 지니고 있는 엄숙주의, 도덕률로부터 해방시켰기 때문이다. 전위 시는 이런 방식을 적극적으로 도입하여 음성 중심주의와 결별하고 새로운 시학의 탄생을 알렸다.

관념화된 평면

마지막으로 근대 인쇄 매체의 시학은 '관념화된 평면', 혹은 '평면의 관념화'로 규정할 수 있다. 전위 시가 음성주의와 결별하고 형태에 절대적인 지위를 부여할 때, 전위 시의 수용에는 이전과 다른 지각 작용이 개입된다. 전위 시가 노리는 것은 시각의 절대화를 통한 즉각적인 이해가 아니다. 시각이 절대화되면서 시는 오히려 난해한 독해의 대상이 된다. 전통 시는 음성으로 듣는 순간 바로 이해가 된다. 상투적인 표현이 자주 등장하는 것도 이 때문이다. 이에 반하여 근대 시에는 활자가 만들어내는 시각적 기호를 해독하는 과정, 나아가 지적인 독해 과정이 필요하다. 읽을 수 없고 발음 불가능한 기호가 뒤섞인 그림 3에서 언어와 기호는 즉각적 공감의 대상이 아니라 독해의 대상으로 존재하며, 여기에는 서술적인 요소로서 해석의 실마리가 완전히 제거되어 있다. 그러므로 수용 과정에서는 그런 실마리를 스스로 창조해내야 하는 부담이 생긴다. 이제 시는 음성적 즉각성에 기초한 구체성, 입체성에서 점점 멀어져, 지적 차원에서 건축되는 추상적, 평면적 인공물로서 관념적인 성격을 지니게 되었다.

 근대 시의 난해성은 이로부터 비롯되었다. 러시아 형식주의자들이 문학의 본질을 '낯설게 하기'로 보고 이를 독자의 시선을 오래 끄는 데서 찾는 것은 그들이 염두에 둔 문학이 시각 중심의 근대 문학임을 말해준다. 그들은 전통 시에서 중시되던 상투적, 관습적 표현을 극단적으로 기피한다. 전위 시는 구체적인 시적 맥락을 단절시키고 어휘를 고립시키면서 무반성적이고도 관습적인 독해 과정의 안정성을 끊임없이

visual hegemony is not an immediate understanding. On the contrary, the hegemony of vision has meant a difficult poetry, a poetry as a code to decipher. Traditional poetry is meant to be immediate, instantly understandable upon listening. It explains the frequent use of clichés. By contrast, modern poetry requires a process of decoding visual codes of types, and an intellectual work of interpretation. In the figure 3, which is full of unreadable and unpronounceable signs, the language and the signs exist not as an object of empathy but a code to decipher, eliminating any clues of narrative interpretation. Therefore, the recipients must create their own clues, which can be burdensome. Now the poetry has distanced itself from the concreteness and dimensionality of aural immediacy, and has come to bear a conceptual feature as an abstract and planar artifact constructed on an intellectual level. When Russian formalists regarded "estrangement" as the essence of literature and found

그림 3. 이상, 〈오감도 시제5호〉 전문. 이전과 다른 지각 작용의 개입과 지적인 독해를 요구하는 난해성.

Figure 3. Yi Sang, "Ogamdo No. 5" (1934). This work requires the involvement of a different perception and intellectual work, making itself difficult to penetrate.

동요시킨다. 그 결과 전방위적인 소외 효과가 발생한다. 바로 이 소외가 전위 시의 관념화 과정을 촉진하는 역할을 한다. 말을 "시각적인 평면"으로 귀속시킨 것은 결과적으로 극도의 추상화 과정을 동반한다. 전위 시는 그 추상적 난해성을 극단적인 수준으로 끌어올린다. 이처럼 관념화된 평면은 전위 시의 추상화를 가져오고, 지적 작용의 개입을 요구한다.

4. 당대 매체의 조건에 대한 시학적 반응

지금까지 근대 시 중 인쇄 문화의 가능성을 가장 극단적으로 실험한 아방가르드 시, 즉 전위 시의 등장 배경과 시적 특성을 매체의 관점에서 구체적으로 규명해보았다. 인쇄 매체에 대한 자각을 지니지 않으면 전위적인 시를 시도할 수 없다. 또한 인쇄 매체에 대한 자각이 있더라도 당대 인쇄 환경이 뒷받침되지 않으면 전위적인 시가 발표될 수 없었을 것이다. 1920년대 중반 전위 시의 등장은 당시의 전위 시인들──정지용, 김니콜라이, 김기림, 이상, 《삼사문학》 동인과 신백수 등──의 인쇄 매체에 대한 인식이 당대 인쇄 문화의 성장과 맞물렸기 때문에 가능한 것이었다. 한국 아방가르드의 실험성과 전위 시인들의 타이포그래피적 상상력은 단순한 문학적 기법의 이식이 아니라 당대의 구체적인 조건을 바탕으로 이루어진 시학적 반응이었다.

————————

박현수는 문학평론가이자 경북대학교 국어국문학과 교수이다. 저서로 《시론》(예옥, 2011), 《원전주해 이육사 시 전집》(예옥, 2008), 《한국 모더니즘 시학》(신구문화사, 2007), 《현대시와 전통주의의 수사학》(서울대학교 출판부, 2004), 《모더니즘과 포스트모더니즘의 수사학 이상문학연구》(소명출판, 2003)와 시론집 《황금책갈피》(예옥, 2006) 등이 있다.

〈한국 근대 시의 조건과 타이포그래피적 상상력〉은 《정신문화연구》 2008년 여름호 제31권 제2호(통권 111호)에 '한국 전위시의 조건과 근대출판의 시학' 이라는 제목으로 실린 논문을 저자가 다시 요약하여 쓴 글이다.

it in the way a work holds the reader's extended attention, they were thinking about the visually centered, modern literature. They abhorred clichéd and conventional expressions frequently found in traditional literature. The avant-garde poetry agitates the stability of the fatuous and conventional reading process by rupturing the concrete poetic contexts and isolating the words. As a result, an overall alienation effect takes place. And this alienation facilitates the abstraction of poetry. Reducing words to their "visual plane" is accompanied by an utmost abstraction. And the avant-garde poetry drives the abstract obscurity to its extreme. As such, the abstracted plane brings about the abstraction of the avant-garde, necessitating the intervention of intellectual work.

4. Poetic Response to Conditions for Contemporary Media

I have analyzed the avant-garde poetry as a form of modern literature that took the experiments on the potentials of print media to its extreme, in terms of its background and features. It is impossible to attempt avant-garde poetry without awareness of print media. And the awareness of print media alone cannot produce avant-garde poetry, without the presence of printing culture that enables its realization. The emergence of the avant-garde in the mid-1920s was only possible because the awareness of the radical writers—Jeong Ji-Yong, Nicolai Kim, Kim Ki-rim, Yi Sang, *Samsa Munhak* poets and Shin Baek-su—of print media was interlocked with the development of the actual print culture. The experiments of the Korean avant-garde, and the typographic imagination of the poets, were not merely a transplant of alien techniques, but a genuine poetic response to the specific situations of Korea at that time.

[Translated by Choi Ki Won and Choi Sung Min]

Park Hyun-Soo is a literary critic and professor of Korean language and literature at the Kyungpook National University.

"Preconditions for Korean Modern Poetry and Typographic Imagination" is based on the author's essay originally published in *Jeongsin Munhak Yeongu* 31, no. 2 (2008 Summer).

한국 디지털 시의 실험과 미디어 파사드

이정엽

> "시대가 변하면 시와 과학은
> 더 높은 수준에서 친구로 다시 만나게 될 것이다."
> [요한 볼프강 폰 괴테]

매체의 차원에서 볼 때 한국 시는 여전히 종이 책을 중심으로 창작되고 읽힌다. 단언키는 어렵지만, 시를 쓰는 사람과 읽는 사람 대부분이 컴퓨터에 익숙해져 있고 실제 창작에서도 많은 시인이 원고지와 펜보다는 컴퓨터와 워드프로세서를 더 자주 사용할 것이라 본다. 그러나 2013년 현재 한국에서 시는 여전히 종이에 인쇄되지 않고서는 그 정당성을 인정받지 못하며, 그 외의 시도들은 그저 시의 외연을 넓히려는 부차적인 시도 정도로 간주되어 왔다. 시집(詩集)은 독자에게 시를 소유했다는 느낌과 더불어, 감정과 정서를 전달하는 시의 메커니즘인 서정성(抒情性)을 집합적으로 모아주는 물질적 기반을 제공해왔다. 인쇄된 매체가 여전히 문예 창작 분야에서 절대적인 권위를 누리고, 구체시의 움직임조차 그다지 활발하지 않으며, 많은 이들이 디지털 시를 생소해하는 국내 상황에서, 서울스퀘어 미디어 캔버스로 일곱 팀의 타이포그래퍼와 젊은 시인이 협업 작품을 창작한다는 것은 그 자체로 실험적이고 신선한 시도다.

 타이포잔치 2013의 여러 전시 중 하나인 '무중력 글쓰기'는 시와 타이포그래피의 일차적인 결합을 넘어 새로운 미디어 환경에서 한국 디지털 시의 가능성을 실험해 보는 자리다. 이번 프로젝트는 엄밀하게 말하면 극단적인 아방가르드 디지털 시라기보다 절충적인 시도에 가깝다고 볼 수 있다. 김경주, 박준, 서효인, 심보선, 오은, 유희경, 진은영은 모두 1970년대 이후에 태어났으며, 현재 활발히 시를 쓰고 있는 시인들이다. 또한 이들과 같이 작업하는 타이포그래퍼들 역시 현장에서 훌륭한 성과를 내고 있는 젊은 디자이너들이다. 이 시인들이 쓰는 시의 방향성은 2000년대 이후에 나타난 신서정(新抒情) 경향에서부터 사회적인 상황이나 노동 조건에 문제

Experiments of Korean Digital Poetry and the Media Façade

Lee Jung Yeop

"Science arose from poetry—when times change the two can
meet again on a higher level as friends."
[Johann Wolfgang Goethe]

In terms of media, Korean poetry is still created for and read on printed
books. I suspect that those who write and read poetry are mostly used
to computers, and in fact, many poets use computers and word-pro-
cessing softwares more often than pen and paper. Still in 2013, how-
ever, the legitimacy of poetry in Korea cannot be recognized outside
printed pages, other attempts being regarded as auxiliary efforts to ex-
pand the boundary of poetry. The printed book of poems still provides
the sense of ownership to the readers, as well as a material base for the
mechanism of poetry, on which the lyricism could gather collectively.
In the context where print media still holds an absolute authority in cre-
ative writing, where concrete poetry has ceased to be active and digital
poetry is still regarded alien to many, the fact that seven teams of typog-
raphers and poets are collaborating on the works to show on the Seoul
Square Media Canvas would itself be fresh news.

As a section of Typojanchi 2013, "Writing in the Air" is an attempt to ex-
plore the possibilities of Korean digital poetry in the new media environ-
ment, moving beyond a simple combination of poetry and typography.
To be more rigorous, this project is closer to a compromise than a radi-
cal avant-garde experiment. All the participating poets—Jin Eun Young,
Kim Kyung Ju, Oh Eun, Park Joon, Seo Hyo In, Shim Bo Seon, and You
Hee Kyoung—were born after the 1970s, and are currently active writ-
ers. And the typographers working with them are also young designers
of remarkable achievement. The approaches of the poets are all very
different, from the new lyricism of the 2000s to the socially motivated

를 제기하는 작품, 또 한국어 단어나 문장 구조가 지닌 말놀이의 가능성을 실험하는 작품까지 매우 다양하다. 이 시인들의 정서적인 스펙트럼 역시 매우 다양하지만, 시를 쓰고 시집을 통해 시를 유통한 방식은 전통적인 방법에 가까웠다.

그러나 이번 전시에서 이들의 시는 디지털로 변모한다. 텍스트 편집 프로그램이 아니라 다양한 타이포그래피, 영상 디자인, 그래픽 디자인 툴을 이용한 이 시들은 기존 작품처럼 지면 위에 얌전히 앉아 있지 않는다. 몇몇 시들은 읽는 이의 호흡을 따라 낭송되듯 움직이고, 색깔이 바뀌고, 이미지와 결합하기도 한다. 그러나 사용자가 참여해서 시어를 고르거나 시적 흐름을 바꾸는 식의 극단적인 상호작용이 사용되는 작품은 없다. 또한 네트워크를 경유하지도, 서울역 광장을 울릴 만한 사운드를 사용하지도 않는다. 그간 디지털 시 창작에 무관심했던 한국 시가 새로운 매체 환경과 조화를 이루기 위한 일종의 절충적 방안인 것이다. 이들의 시 쓰기 작업은 한국 시의 맥락과 이어져 있긴 하지만, 그것이 재현되는 조건이 과거와는 다르기 때문에 그 연원과 과정을 조심스럽게 복원하지 않으면 안 된다. 왜냐하면 종이 책에 쓰인 시와는 달리 디지털 시에는 그것이 창작되고, 읽히고, 참여하는 방식이 작품마다 다르게 적용되기 때문이다. 이번 작품들의 경우 여타의 웹 아트 시들과는 달리 독자의 참여가 어느 정도 제한되어 있으며, 서울스퀘어 빌딩의 대형 LED 스크린을 통해 서울역 광장을 지나가는 불특정 다수의 시민에게 전파되는 공공적인 전시의 성격을 지니고 있다. 이는 주로 시집을 통해 개인적으로 향유되던 시의 독서 습관에 대한 도전이기도 하며, 그간 철저하게 아날로그적인 방식을 고집해온 한국 시의 권위에 대한 반항이기도 하다.

더군다나 이 작품이 전시되는 서울스퀘어 빌딩은 1974년 교통회관으로 지어지던 건물을 대우그룹이 인수해 1977년에 완공한 빌딩이다. 이후 그 건물은 외환 위기 당시 대우그룹이 부도를 맞으면서 2006년 금호아시아나그룹에 인수되었다가 6개월 만에 미국의 투자금융 회사 모건 스탠리가 인수하여 리모델링했다. 국내 사례로는 거의 최초에 해당하는 대형 LED 스크린이 설치되고 건물의 이름이 '서울스퀘어'로 바뀐 것도 그 당시의 일이다. 이후 케이알원이라는 부동산 투자회사가 이 건물을 소유하여 지금에 이르고 있다. 그 과정을 훑어보면 이 건물이 70년대 중반부터 지금에 이르기까지 한국 자본주의의 부침을 건물 그 자체로 표현하고 있다고 해도 과언이 아니다.

일찍이 소설가 신경숙은 서울역에 내릴 때마다 이 건물이 주는 위압감에 압도되었다고 회고한 바 있거니와, 이 건물은 서울에 도착하는 사람들이 가장 먼저 마주치는 건물로서 상징성을 지니고 있다. 서울스퀘어 빌딩은 줄리언 오피나 뮌 같은 미디어 아티스트의 작품을 주로 전시하면서 도시의 첫인상을 세련되게 보이는 파사드이자 서울이라는 도시의 화장술(化粧術)을 대표하는 건물로 기능해왔다. 그러나 아이

critical works and experiments with wordplay unique to the Korean lan-
guage. The spectrum is wide, but the way they write and distribute their
work through printed books has been quite conventional.

In this exhibition, however, their poetry turns digital. Created with
various typographic, graphic and motion graphic softwares rather than
simple text-edit programs, the works will not sit on the pages as their
previous poems did. Some will move to the rhythm of reading as if be-
ing recited, and some will change their colors or embrace imagery. And
yet, there is no work that allows such extreme interactivity as inviting
readers to participate in the choice of words or to change the order of
lines. No work will be connected to the network or have sound to burst
out through the Seoul Station Square. In this sense, this project is a
compromise for the Korean poetry hitherto indifferent to digital writing
to familiarize itself with the new media environment. The way of working
for these participating poets is rooted in the tradition of Korean poetry,
but the conditions for representing their work are different from the past,
which makes it necessary to carefully trace the origins and the process-
es of their creation. For unlike the poems on printed pages, each digital
poem may require a different way of creating, reading and participat-
ing. Currently exhibited works, unlike the web-based ones, restrict the
participation of readers, and assume a particularly public meaning as
they are meant to be shown to the unspecified public through the large
LED screen of the Seoul Square media façade. This is a challenge to
the habit of private reading, as well as to the authority of Korean poetry
stuck to the "analog."

The Seoul Square, the venue for this project, is a building whose con-
struction was begun in 1974 as a transportation center and completed
in 1977 after the Daewoo Group acquired it. As the Daewoo Group went
bankrupt during the Asian financial crisis in the late 1990s, it was ac-
quired by the Kumho Asiana Group in 2006, only to be sold again in six
months, this time to the American investment bank Morgan Stanley. It
was then when the name was changed to the Seoul Square, and became
the first building in Korea equipped with a large LED screen façade. The
current owner of the building is a real estate investment company called
KR1. Looking back at the building's history, it seems to embody the fluc-
tuations of Korean capitalism from the mid-1970s until today.

The novelist Shin Kyung-sook once remarked how she would be over-
whelmed by the imposing building whenever she stepped out of Seoul
Station. It has a certain symbolism as the first building to encounter
when people arrive in the city. The Seoul Square usually displays on its

러니하게도 이 예술에 가장 많이 노출되었던 사람들이 서울역에 거주하던 노숙인들이었던 것처럼, 그러한 작품이 도시의 남루하고 피곤한 삶을 위로했는지에 대해서는 의문이 남는다. 현재 이 건물 전면에 적용되는 LED 스크린은 법적으로 경관 조명으로 분류되어 특정 기업이나 사회단체, 정당을 위한 광고나 정치적 메시지의 사용이 엄격하게 금지되어 있다. 더불어 화면에 글자를 띄우는 것 또한 허락되지 않았다. 따라서 정치적인 메시지가 삭제된 순수한 예술로서의 예술만이 이 스크린에서 재현될 수 있었다. 시는 언어를 매개로 함에도 예술의 어엿한 분야이므로, 이 거추장스러운 법을 뚫고 나올 수 있는 계기를 마련해준다. 덕분에 우리는 실로 오랜만에 광장에 시인들의 따뜻하고, 불온하며, 은밀한 말들을 아로새길 기회를 얻는다.

실제로 디지털 시는 시문학과 매체 예술 사이의 경계선에 위치하며, 컴퓨터와 네트워크상의 기호 체계를 시에 적용한다. 디지털 시는 문학이 문자 언어를 통해 은유적이고 상징적으로 표현했던 것들을 작가와 독자의 직접적 경험으로 전환한다는 점에서 일반적인 시와 차이점이 있다. 디지털 시는 서정시가 지닌 형식적인 제약이나 안정된 외형이 필요하지 않으며, 이를 구성하는 단어와 문자들은 고정되지 않고 움직이면서 그 감정을 표현하는 키네틱 타이포그래피의 경향을 보인다.

박준 시인과 강경탁 디자이너의 작품 〈슬픔은 자랑이 될 수 있다〉는 이러한 키네틱 타이포그래피의 특징을 잘 활용한 사례로 보인다. 시는 시인이 마치 타자기로 타이핑을 하는 것처럼 진행되는데, 그 속도가 완만하여 천천히 시를 따라 읽는 것 같은 효과를 준다. 서울역 광장에서 이 작품을 마주쳤을 때 여러 사람이 시를 따라 읽는 집단적인 낭송의 재미를 줄 수 있다. 더불어 시어들이 쓰였다 고쳐지는 과정은 마치 시인이 시를 쓸 때 단어에 대해 고심하며 이를 여러모로 바꾸어보는 듯한 느낌도 동시에 안겨준다. 박준 시인의 차분한 서정이 다소 우유부단해 보이는 시어의 수정 과정을 통해 배가된 느낌이 든다.

때에 따라서 디지털 시는 기욤 아폴리네르나 다다이스트, 혹은 가깝게는 1930년대를 풍미했던 이상(李箱)이 시도했던 구체시의 전통을 잇기도 한다. 한글의 경우 자소의 결합으로 글자가 만들어지므로 그 과정을 미시적으로 분할하여 시 창작에 활용할 수도 있다. 오은 시인은 발음이나 형상이 비슷한 단어들로 진행되는 말놀이를 자신의 시에서 적극적으로 실험해왔다. 어떤 면에서 그의 시는 이번 프로젝트에 참여한 일곱 시인의 작품 중에서 구체시로 발전할 가능성을 가장 풍성하게 지니고 있다. 그의 시 〈날〉은 초성이 생략된 불완전한 문자이다. 그러나 이러한 불완전함은 '날' 발음을 포함한 여러 글자로 변형될 가능성을 지니고 있다. 크리스 로 디자이너는 이러한 점에 착안하여 글자를 만지고, 잡아당기고, 가지고 놀고, 때로는 때려 부수는 팔*의 이미지를 등장시킨다. 이러한 '날' 계열은 동사를 미래 시제로 활용할 수 있게 해주기 때문에 시는 과거의 정서보다 불확실한 미래적인 정서를 환기시킨다.

Media Canvas the works of media artists such as Julian Opie or Mioon, serving as a façade of the "sophisticated" city and an icon emblematic of the city's impressive make-up techniques. Ironically, though, those who have been exposed to the art the most are the homeless around Seoul Station. One has to wonder how much such artworks have comforted the barren and tired lives of the city. The LED screen on this building's façade is legally classified as a landscape lighting, which means that no commercial advertising or social, political messages are allowed on it. In fact, putting any textual message is disallowed: only "pure" artworks can be displayed on the Media Canvas. Although poetry uses language as a medium, it is undoubtedly a branch of fine art. And for this, it can be used as a loophole for legal frills. Thankfully, we can relish the poets' warm-hearted, turbulent, and secretive words, after a long time of silence.

Indeed, digital poetry sits between literature and media art, applying the sign system of computers and the network to poetry. It is different from conventional poetry, in that what literature has metaphorically and symbolically expressed through a written language, it transforms into direct experiences of the poet and the readers. It requires neither formal constraints nor the stable forms of lyrical poetry, and the constituent words and characters tend to move and express emotions, showing the aspects of kinetic typography.

Sadness Can be Boasted of by the poet Park Joon and the designer Kang Gyeong Tak seems to effectively use the potentials of kinetic typography. The piece proceeds as if a poet is composing it with a typewriter, and the slow pace creates the effect of reading it as it develops. When one encounters the piece in the Seoul Station Square, it will create the experience of collective reading. Also, how the words are written and corrected is reminiscent of how a poet agonizes over the choice of words. The calm lyricism of Park Joon's work feels amplified through the indecisive modification of words.

Sometimes, digital poetry seems to follow the tradition of concrete poetry started by Guillaume Apollinaire and Dadaists, and Yi Sang in 1930s Korea. Since the syllabic Hangul characters are constructed with phonetic graphemes, the building process itself can inspire poetry. Oh Eun has been experimenting with wordplay using words similar in pronunciation or shape. In a sense, his poetry has the richest potential for concrete poetry among the seven participating poets' work in this project. The title of his piece, "ᆯ" shows an incomplete character where the initial is omitted. But the very incompleteness reveals a transformative possibility, which allows the character to become many different ones.

또한 서효인 시인과 강문식 디자이너의 〈서울 사막〉은 서울역 광장과 서울스퀘어 빌딩이 지닌 장소성과 역사성을 환기시킨다. 보편적인 서정시라면 시적 화자의 내면을 표현하는 데 집중하는 1인칭적 화법을 보여준다. "지금 / 여기의 / 당신 / 서울을 / 견디는 / 당신 / 계단을 / 오르고"로 시작하는 〈서울 사막〉은 이러한 1인칭적 화법을 버리고, 당당하게 그 광장의 시민들에게 말을 건넨다. 시에서 생소한 이 2인칭적 화법은 보통의 경우 독자가 책을 읽고 있는 현실과 시적 화자가 묘사하는 상황의 불일치 때문에 모순을 발생할 수밖에 없다. 그러나 서울역 광장처럼 특정한 장소에서 전시될 경우, 이 2인칭 화법은 그 활력을 고스란히 간직한 채로 시민들에게 말을 건넬 수 있다. 시가 시집이라는 물질적인 공간에 갇혀서 내면성을 획득하는 동안 잃어버렸던 광장에서의 소통이 디지털 기술의 문법을 통해 새로운 인칭과 화법을 획득하게 된다.

그간 몇몇 미디어 아티스트와 문인들은 가끔 실험적인 작품을 협업해낸 바 있다. 문학과지성사 산하의 문지문화원이 개최했던 《Text@Media Fest》(tom.saii.or.kr)가 대표적이다. 그러나 이러한 시도들이 아카데미와 예술계 사이의 공고한 경계를 허물거나 그 향유 계층을 일반 시민들에게까지 확장하지는 못했다. '무중력 글쓰기' 프로젝트를 포함한 타이포잔치 전체가 그 경계를 허물 수 있을지 역시 미지수이다.

전통 시와 디지털 시, 일반 타이포그래피와 키네틱 타이포그래피, 종이 시집과 미디어 파사드, 서울역 광장과 서울스퀘어 빌딩, 자본과 남루.

우리의 프로젝트는 이 모순되어 보이는 키워드들 사이에서 중력 없이 부유할 수도 있다. 그러나 보이지 않는 가운데에도 중력은 그 정치성을 발휘하고 있다. 그 종착점은 도대체 어디일까.

 *'팔' 역시 '날' 계열에 속한다.

─────────
이정엽은 한국과학기술원(KAIST) 문화기술대학원 대우교수이다. 타이포잔치 2013 '무중력 글쓰기' 섹션을 공동 기획했다.

The designer Chris Ro shows in his video the images of hands, which are making, pulling, playing with and breaking the character. Incidentally, the "ㄹ" can transform many verbs to future tense when combined with different initials. The piece reminds more of uncertain futures than of the past.

Seoul Desert by Seo Hyo In and Gang Moon Sick evokes the nature and the history of the Seoul Station Square and the Seoul Square building. Lyric poems are usually written in the first person, which can express the inner feelings of the poets more easily. *Seoul Desert*, however, avoids the first-person narrative and speaks directly to the people on the street. The second-person narrative, which is quite rare in poetry, commonly creates a friction as the reality of the reader cannot be consistent with the one described in the work. Presented in a public space such as the Seoul Station Square, however, it can address the public with all of its vitality. It demonstrates that the digitally mediated poetry can assume a new narrative in the public space, which was lost by poetry as it acquired internality within the physical confines of printed books.

Some media artists and writers have collaborated on experimental projects before. One of the examples is *Text@Media Fest* (tom.saii.or.kr) organized by the Munji Cultural Space Saii. These attempts, however, have not succeeded in erasing the strong boundaries surrounding the academia and the art world, or expanding their reach to the general public. It has yet to be seen if the works exhibited in Typojanchi 2013 and "Writing in the Air" will have succeeded in that.

Traditional poetry and digital poetry; static typography and kinetic typography; printed book of poems and media façade; the Seoul Station Square and the Seoul Square; the shabbiness and the slick capitalism. Our project can simply be floating without gravity amid the seemingly contradictory terms. But the gravity exerts its political force even when it is invisible. Where would our *terminus ad quem* be?

[Translated by Choi Ki Won and Choi Sung Min]

Lee Jung Yeop is acting professor at the Graduate School of Culture Technology, KAIST. He co-curated a section of Typojanchi 2013, Writing in the Air.

해석

interpretation

샤오마거 / 청쯔는 베이징에서 활동하는 그래픽 디자인 스튜디오다. 베이징 칭화 대학교에서 그래픽 디자인을 전공했으며, 편집과 디자인을 유연한 과정으로 통합시키는 접근법을 통해 주로 도서 디자인 분야에서 활동해왔다. 그들이 디자인한 책은 라이프치히 도서전에서 '세계에서 가장 아름다운 책'으로 선정되었고, 뉴욕 ADC 상, 선전 비엔날레 금상, 중국 서적 디자인 상 등을 수상하며 널리 인정받았다. 베이징 국제 디자인 트리엔날레(2011), 이코그라다 주최 《베이징 타이포그래피 2009》, 《질문의 형태》(2009, 취리히 볼테랑), 《큰소리》(2007, 베이징) 등의 전시에 참여하기도 했다.

샤오마거 / 청쯔의 신작 설치 〈씨앗〉은 '해석'이라는 창작 과정을 성찰한다. 디자이너로서 그들은 클라이언트와 소비자, 구상과 제작, 서로 다른 매체와 언어 사이에서 끊임없이 해석을 시도한다. 디자인된 결과물은 아름다울지 모르나, 그 해석 과정은 대체로 고통스럽다. 방을 장식하는 종이꽃과 공, 드로잉으로 구성되는 〈씨앗〉은 해석이라는 "끝없이 고된 노동을 극복"하고 마침내 작품이 완성되었을 때 느끼는 여유와 기쁨을 포착하려 한다. 여기에서 씨앗은 "자유, 낭만, 꿈"을 상징하며, 한 작품의 완성은 "씨앗이 날아오르는 자유를 마침내 누리는 영원한 순간"으로 묘사된다.

Xiao Mage and Cheng Zi are graphic designers based in Beijing. They studied graphic design at Tsinghua University, Beijing. As an independent design studio, their work takes an integrative approach that combines editing and designing in a fluid process. The books they designed have won widespread recognition, including the Most Beautiful Books in the World prize at the Leipzig Book Fair, the New York ADC Award, Shenzhen Biennale award and the Beauty of Books in China. Their work has been included in the exhibitions Beijing International Design Triennial (2011), Icograda Beijing Typography Exhibition 2009, *Forms of Inquiry* (2009, BolteLang, Zurich) and *Get It Louder* (2007, Beijing), among others.

A Seed, a new installation by Xiao Mage and Cheng Zi, is a meditation on the process of interpretation. As designers, they are constantly involved in interpretation: between a client and a consumer, between conception and realization, between different mediums and languages. A designed product may be beautiful, but the process of interpretation is usually painful. Consisting of paper flowers, balls and a drawing, *A Seed* attempts to represent a "triumph over the pain of endless drudge" that is the struggle of interpretation, and capture the relaxed and joyous state of mind one enjoys when a work has been completed. Here, the seed signifies "freedom, romance and dreams," and a work's completion is described as an "eternalized moment of a seed's freedom of flight."

샤오마거 / 청쯔

2000년 설립, 베이징: 샤오마거(小马哥), 1975년생, 중국 / 청쯔(橙子),
1975년생, 중국.

Xiao Mage and Cheng Zi
Founded in 2000, Beijing: Xiao Mage, b. 1975, China, and Cheng Zi,
b. 1975, China.

씨앗
2013. 복합 매체 설치. 크기 가변.

A Seed
2013. Mixed-media installation. Dimensions variable.

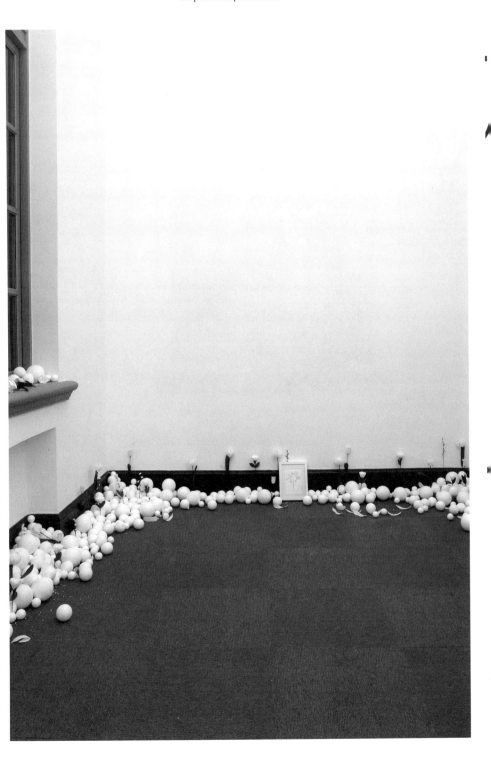

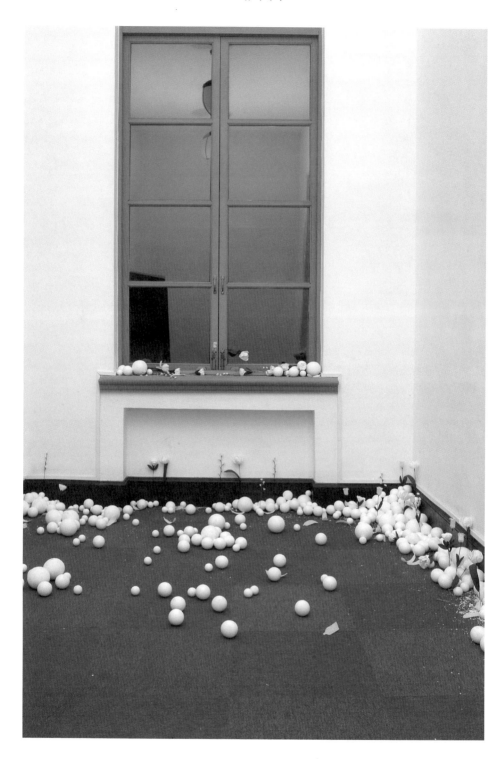

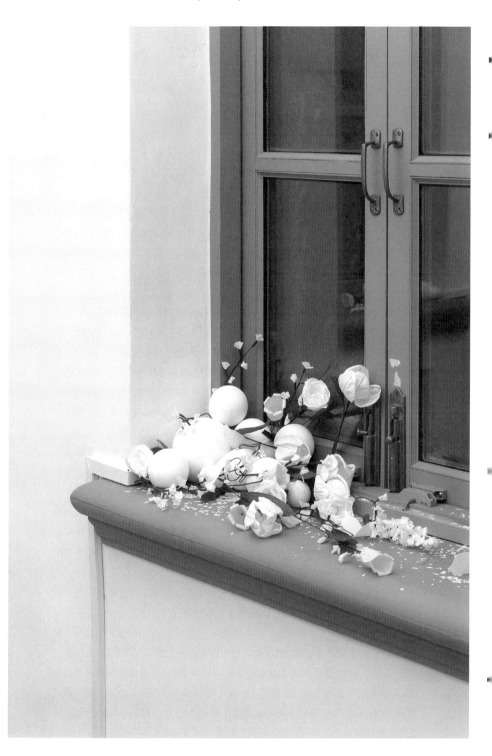

형용모순

oxymoron

안삼열은 그래픽 디자이너, 편집 디자이너로서 오랜 훈련과 경험을 통해 다듬어진 감각을 바탕으로 2011년 〈안삼열체〉를 발표했다. 예리한 직관과 감각, 경험에 의존하면서도 역사적 원류와 흐름을 파악하는 안목, 유용성과 기능성을 놓치지 않는 태도는 그의 활자체 디자인에서 뚜렷이 드러나는 특징이다.

안삼열은 홍익대학교 시각디자인과를 졸업하고 1996년부터 2001년까지 안그라픽스에서 근무했다. 이후 커뮤니케이션즈 와우 아트 디렉터를 거쳐, 가야미디어에서 월간 《GEO》 아트 디렉터로 일했다. 《Active Wire 한일 교류전》,《기억하는 거울전》,《진달래–발전》,《진달래 도큐먼트 02》,《한글 멋짓전》 등의 전시에 참여하기도 했다. 현재 프리랜서 그래픽 디자이너 겸 폰트 디자이너로 왕성하게 활동하고 있다. 2013년 〈안삼열체〉로 도쿄 TDC 애뉴얼 어워즈에서 활자체 디자인 수상자로 선정되었다.

안삼열의 새로운 활자체 개념인 〈현대적 흘림〉은 느슨히 말해 〈안삼열체〉의 흘림체에 해당한다. 한글 활자체에서 붓글씨에 기초한 흘림체는 매우 제한된 것이 사실이다. 한글은 흘림체 개발이 어려운 글자다. 말 그대로 'ㅏ' 다르고 'ㅓ' 다른 자질 문자의 특성이 있기 때문이다. 작은 세부가 생략되거나 왜곡되어도 전혀 다른 소리와 의미를 지닌 글자로 오독될 위험이 크다. 그런 연유에서인지 금속활자 시대에는 한글 흘림체는 물론 반흘림체도 거의 보이지 않았고, 신식 납 활자에 이어 디지털 활자 시대에야 몇몇 흘림체가 눈에 띌 정도다.

그러므로 새로운 한글 흘림체를 창조한다는 것은 그 자체로 만만치 않은 도전이다. 더욱이 유려한 붓놀림을 떠올리게 하는 흘림체와 꼿꼿한 구조에 날카로운 현대적 획 대비를 특징으로 하는 〈안삼열체〉의 조화는 쉽게 상상하기 어렵다. 그러나 한글 흘림체 전통을 다시 살펴보면 뜻밖의 단서를 얻을 수 있을지도 모른다. 활자로 인쇄한 지면과 달리, 조선 시대 소설 필사본과 서간문에서는 필기 속도가 빠른 흘림체를 드물지 않게 볼 수 있다. 그 흘림체는 둥근 붓을 도구로 사용하면서도 먹물 물기를 적게 적신 채 많은 글자를 빠르게 휘갈겨 써서, 막연한 선입견과 달리 둥글고 부드럽기보다는 날카롭고 직선적이며 강인한 성격을 보이기도 한다.

안삼열의 흘림체는 단순하고 강직하며 직선적인 골격에 유려한 이음선과 흐름을 결
합함으로써, '현대적 흘림'체라는 형용모순에 가까운 개념을 실현하려 한다. 넉넉하고
유연한 시선으로 전통을 바라보고, 풍부한 상상력으로 유산을 해석할 때만 가능한 작
업이다.

From his long experience and refined sensibility as a graphic designer, Ahn Sam-yeol developed and released his typeface, *Ahn Sam-yeol-che*, in 2011. While relying much on intuition and wisdom of experience, he combines sharp eyes on historical sources and respect for functionality to create useful typefaces.

Ahn Sam-yeol graduated from Hongik University, and worked from 1996 until 2001 at Ahn Graphics (not related). After working as art director at Communications Wow and the magazine *Geo*, he started his own practice as a graphic and type designer. He has shown his work in many exhibitions, and in 2013, was selected as a winner of type design at the Tokyo TDC Awards for his *Ahn Sam-yeol-che*.

His new typeface concept, *Modern Korean Cursive* can be seen as a cursive counterpart to the upright *Ahn Sam-yeol-che*. In Korean typography, there is a shortage of cursives based on brush-written models. One explanation may be the inherent difficulty of developing cursive Hangul types: as a featural alphabet, Hangul characters are prone to misunderstanding when a small detail is lost or distorted. Perhaps for this reason, cursives or even semi-cursives are rarely found among old Korean metal types: only in modern times appeared a small number of Hangul cursives.

Creating a new Korean cursive typeface, therefore, is a formidable challenge in itself. Furthermore, it is even difficult to imagine a typically fluid, cursive counterpart to *Ahn Sam-yeol-che*, which is characterized by its "modern" style: upright structure and sharp contrast. Unexpected suggestions, however, may be found in reconsidering the Hangul cursive tradition. Unlike printed documents where cursive letters rarely appear, it is not uncommon to encounter fast-hand cursives in the manuscripts of novels and epistles. While still written with round-pointed writing brushes, the cursives are often characterized by their counterintuitively sharp, angular and rigid strokes: the result of writing fast with a relatively dry brush.

To many, "modern Korean cursive" may sound like an oxymoron. Ahn Sam-yeol is prepared to prove it otherwise, by combining simple, robust and angular skeletons with uncharacteristic swashes and a sense of flow—a task requiring a sufficiently flexible understanding of tradition, and an imaginative interpretation of heritage.

안삼열
1971년생, 한국.

Ahn Sam-yeol
Born in 1971, Korea.

현대적 흘림
2013. 디지털 활자체 개념.

Modern Korean Cursive
2013. Digital typeface concept.

봄이 솟는 붉은 꽃 가을 샛길 숨는다

김 규 것 을
붉 모 각 옷
요 봄 구 삶
수 검 느 길
라 음 인 름
웃 깃 솟 리
소 꽃 아 슴
잇 숫 은 감
음 있 춤 가
겼 국 갓 을
올 이 굴 샛

화해

reconciliation

마리야 유자는 크로아티아 자그레브에서 활동하는 그래픽 디자이너다. 디자인 집단 바부슈케를 창설했고, UBU 디자이너 협회와 신토멘트 미디어 아트 협회 회원으로서 다양한 멀티미디어와 예술 프로젝트에 참여했다. 니콜라 주레크는 네덜란드 헤이그의 왕립 미술대학에서 활자체 디자인을 공부했으며, 그래픽 디자인과 활자체 디자인 연구로 박사 학위를 받았다. 현재 크로아티아 스플리트 대학교와 자그레브 대학교에서 타이포그래피를 가르치고 있다. 2005년 크로아티아 자보크에서 활자 제조업체 겸 그래픽 디자인 스튜디오 타이포나인을 설립했다. 그와 유자가 공동 디자인한 〈발칸 산스〉는 그가 타이포나인을 통해 발표한 여러 활자체 가운데 하나다.

발칸 산스

〈발칸〉은 라틴문자와 키릴문자로 구성된 활자체 시스템이다. 이 시스템은 인접한 언어들의 발음과 문법이 서로 닮아가는 현상을 연구해 만들어졌다. 이는 또한 보스니아어, 몬테네그로어, 크로아티아어, 세르비아어 등 몇몇 남슬라브어군 소속 언어와 문자에서 공통된 특징을 밝혀보려는 시도이기도 하다.

우리는 남슬라브어군의 특징인 이중 문자 체계, 즉 라틴문자와 키릴문자가 모두 쓰이는 현상에 주목했다. 역사적으로 발칸반도에서는 키릴문자, 라틴문자, 글라골문자 등 세 문자가 쓰였다. 라틴문자와 키릴문자를 공용하는 현상은 세르비아, 보스니아 헤르체고비나, 몬테네그로 등 구 유고 연방 국가들의 특징이다.

역사적으로 두 문자는 서로 다른 문화적, 민족적, 종교적, 정치적 정체성을 표상했다. 그러나 다민족성을 보존하려는 의지 탓에, 의사소통 기능과 상징적 기능은 서로 엇박자를 이루곤 했다. 한편 역사적으로 인접해 발전한 지역 언어는 공통 특질을 다수 보유하게 된다. 오늘날 서발칸 지역 언어들은 유사하다 못해 조금씩 다른 방언으로 여겨지기까지 한다.

〈발칸〉 활자체 시스템은 라틴문자와 키릴문자를 서로 해독해주는 폰트로 구성된다. 그 목적은 문자를 탈신비화하고 탈정치화하며 화해시킴으로써 교육과 관용, 무

엇보다 소통을 도모하는 데 있다. 발칸은 일반적 의미에서 '폰트'에 해당하지만, 또한 크로아티아 라틴문자와 세르비아 키릴문자를 서로 번역하는 데 쓸 수도 있다. 그런 의미에서 두 문자를 화해시킬 수 있는 교육 소프트웨어로 간주할 만하다. 여느 오픈타입 폰트와 마찬가지로 발칸 역시 러시아어, 마케도니아어, 불가리아어로 확장할 수 있다.

〈발칸 산스〉와 〈발칸 산스 스텐실〉은 네 가지 양식으로 구성된다. 〈발칸 A〉에 속한 세 양식에서는 라틴문자가 위에, 키릴문자가 아래에 배치되고, 〈발칸 B〉는 반대로 키릴문자가 위에, 라틴문자가 아래에 자리한다. [마리야 유자 / 니콜라 주레크]

Marija Juza is a visual communication designer working in Zagreb and co-founder of the graphic design collective Babushke. She works on various multimedia and art projects, and is a member of the professional associations UBU and Sintoment. Nikola Djurek studied at the Type and Media program of the Royal Academy of Art in The Hague, and earned his PhD in graphic design and type design. He teaches at the University of Split and the University of Zagreb. In 2005, he founded the type foundry and graphic design studio Typonine in Zabok, Croatia. *Balkan Sans*, which he designed with Marija Juza, is one of the many original type families he released through Typonine.

Balkan Sans

Balkan is a new typeface system that consists of Latin and Cyrillic scripts. It is based on the study of a phenomenon known as *Balkan sprachbund*, a term used to describe neighboring languages whose sound and grammatical features have merged because of their proximity. The typeface system also represents an attempt to identify the features shared by some South Slavic languages and alphabets like Bosnian, Montenegrin, Croatian and Serbian.

We focused on the dual-literacy that characterizes Slavic peoples, many of whom use and transliterate both Latin and Cyrillic alphabets. Historically, there were three scripts in this region: Cyrillic, Latin and Glagolitic. The use of Latin and Cyrillic typifies the former Yugoslavian countries, today's Serbia, Bosnia and Hercegovina as well as Montenegro.

Historically, both scripts in this region were bearers of cultural, ethnic, religious and political identities, but their communicative and symbolic functions were often out of step just for the sake of multi-ethnicity. On the other hand, close development of languages and scripts throughout history resulted in shared properties. Today some regional languages in the Western Balkans are so similar that they can even be thought of as dialects.

The *Balkan* typeface system is a series of fonts that decodes Latin and Cyrillic: it demystifies, depoliticizes and reconciles them for the sake of education, tolerance and, above all, communication. Though Balkan is a "font" in the usual sense, it can also be used to translate Croatian Latin into Serbian Cyrillic and vice versa. One could therefore think of the fonts as educational software capable of reconciling discrete scripts. Like all OpenType fonts, Balkan can be expanded to include the Russian, Macedonian and Bulgarian alphabets.

Balkan Sans and *Balkan Sans Stencil* consist of four styles—three of them have different alignments (e.g., all uppercase characters are Latin and lowercase characters are Cyrillic) and one style consists of uppercase Cyrillic and lowercase Latin characters. [Marija Juza and Nikola Djurek]

마리야 유자
1985년생, 크로아티아.

니콜라 주레크
1976년생, 크로아티아.

Marija Juza
Born in 1985, Croatia.

Nikola Djurek
Born in 1976, Croatia.

babushke.com
typonine.com

발칸 산스
2012. 디지털 활자체.

Balkan Sans
2012. Digital typeface.

I LEARNED TO LOVE THE
И ЛЕАРНЕД ТО ЛОВЕ ТХЕ

BALKANS
БАЛКАНС

WITHOUT THE NEED TO BE PROUD OR ASHAMED OF THEM.
ВИТХОУТ ТХЕ НЕЕД ТО БЕ ПРОУД ОР АСХАМЕД ОФ ТХЕМ.

VOLIM БАЛКАН
ВОЛИМ BALKAN

BEZ POTREBE DA SE NJIME PONOSIM ILI DA GA SE STIDIM.
БЕЗ ПОТРЕБЕ ДА СЕ ЊИМЕ ПОНОСИМ ИЛИ ДА ГА СЕ СТИДИМ.

- Quote by Maria Todorova from *Imagining the Balkans* 1997

Balkan – Type Family, Type System, Hybrid Latin & Cyrillic script (Croatian Latin and Serbian Cyrillic combined), Open-Type Format

BALKAN SANS A
БАЛКАН САНС A

BALKANE MOJ BUDI MA HRABAR I DOBRO MI STOJ

ABCČĆCCDDDĐ
AБЦЧЧĆЦ ДДДĐ
ÐEFGHIJKLMNJNJO
ÐEФГХИЈКЛМЊНЈО
PQRSŠTUVWXYZŽ

0123456789....?¿!¡--- ./\|()[]¶

- Quote by Ubavy Žižek

BALKAN САНС STENCIL A & B
BALKAN SANS STENCIL A & B

НА БАЛКАНУ СЕ ЛАКО КОМУНИЦИРА,
ТО ЈЕ КАО МАСОВНА PSIKOTERAPIJA

ABCČĆCCĐDĐÐEFGHIJK
ЛМНЈНЈOPQRSŠTUVWXYZŽ
ABVGDĐEŽZIJKLMNJNJOPQR
STUVHCČŠĐЖШWXY

BALKAN САНС Б
BALKAN SANS B

WE'RE RUNNING OUT OF AJVAR, KAJMAK AND BUREK

АБВГДĐE[ЖЗ]ИЈКЛ
МНЊОПQРСТУФХЦ
ЧЦШWXY

0123456789....?¿!¡--- ./\|()[]¶

EVERY STATE NEEDS ITS OWN BALKAN
ЕВЕРY СТАТЕ NEEDS ИТС OWN БАЛКАН

HYBRID TYPE SYSTEM FOR INTERBALKAN COMMUNICATION
ХYБРИД ТYПЕ CYCTEM ФОР ИНТЕРБАЛКАН COMMУНИЦАТИОН

Balkan Type System concept & design by Nikola Djurek & Marija Juza, 2012 | www.typonine.com

- Quote by Breda Šetar

BALKAN ATTRACTS WITH ITS CONTRADICTIONS. IT IS CHARACTERIZED BY THE FACT THAT THE ONLY KIND OF CONTINUITY IS IN THE
ДИСЦОНТИНУИТY ОФ ТХЕ
DISCONTINUITY OF THE

CONTINUITY
CONTINUITY

БАЛКАН ПРИВЛАЧИ СВОЈИМ KONTRADIKTORNOSTIMA
BALKAN PRIVLAČI SVOJIM КОНТРАДИКТОРНОСТИМА
И KARAKTERISTIČAN ЈЕ ПО ТОМЕ ШТО СЕ ЈЕДИНА ВРСТА KONTINUITETA NALAZI U
КОНТИНУИТЕТУ
KONTINUITETU

ДИСKONTИНУИТЕТА
DISКОНТИНUITETA

OBO JE OBDE
OVO JE OVDE

БАЛКАН
BALKAN

МИРИСНИ
MIRISNI

ЦВЕТ
CVET

ТОТАЛНО
TOTALNO

НЕРАЗУМЉИВ
NERAZUMLJIV

ЗА ЦЕО
ZA CEO

СВЕТ
SVET

활용
inflection

유희경의 시에는 최근 젊은 시가 즐겨온 흔한 유머나 집요한 말놀이, 별스러운 이미지 등이 등장하지 않는다. 그의 시는 익숙한 언어로 익숙한 감정을 묘사하고 다듬는 모노톤의 시에 가깝다. 그가 편애하는 감정은 한마디로 말해 슬픔인데, 그 슬픔에서는 담담한 결의마저 느껴진다. 이 슬픔은 세상의 모든 슬픔을 껴안겠다는 치기가 아니라, 자신의 보잘것없는 슬픔을 망설이지 않고 드러내놓겠다는 용기와 관련된다. 유희경은 서울예술대학 문예창작과와 한국예술종합학교 극작과를 졸업했다. 2008년 《조선일보》 신춘문예에 〈티셔츠에 목을 넣을 때 생각한다〉가 당선되어 등단했다. 시집으로 《오늘 아침 단어》가 있다. 현재 '작란' 동인으로 활동 중이다.

디자이너 양상미는 군더더기 없이 합리적인 프로세스를 고스란히 드러내는 창작을 특징으로 한다. 인하대학교 경제통상학과와 계원디자인예술대학 그래픽 디자인과를 졸업한 후, 현재 프리랜스 그래픽 디자이너로 활동하며 다양한 작업을 구상하고 실현해가는 중이다.

양상미는 유희경의 시 〈드리움〉에서 다양한 활용형으로 등장하는 동사 '드리우다'에 초점을 맞춘다. 원작에 담긴 정서를 마치 일부러 배제하듯 분석적 다이어그램처럼 제시하는 영상은, 정서적 효과를 창출하는 언어의 형식적 구조를 또렷이 드러낸다.

You Hee Kyoung's work is free of the usual jokes, obsessive wordplay or eccentric imagery that have become a fixture of recent Korean poetry. Rather, her poems are almost monotonous, with familiar words describing and distilling familiar emotions. Her favorite emotion is sadness, which even shows a sense of calm determination: it is often related to the courage to expose her own trivial feelings rather than a childish embrace of all the sorrow in the world. She graduated from the Seoul Institute of the Arts and the Department of Playwriting of the Korea National University of Arts. She debuted in 2008.

The designer Yang Sang Mi's work reveals her rational process without redundancy. She studied economy and international trade at Inha

University, and graduated from Kaywon School of Art and Design. She is currently a freelance designer.

Yang Sang Mi focuses on the various inflections of the verb "cast" appearing in You Hee Kyoung's poem "Casting." By diagrammatically presenting the text, almost as if repressing any emotional resonance of the original, she clearly exposes the formal structure of the poetic language.

———
유희경
1980년생, 한국.

양상미
1980년생, 한국.

You Hee Kyoung
Born in 1980, Korea.

Yang Sang Mi
Born in 1980, Korea.

드리움

드리워지자, 울었다 나는 아니었으면 하고 훌쩍였다
드리워지자, 울었다 그게 나는 아니었으면 하며 훌쩍
드리워지고, 훌쩍이며 울었을 때 나는 아니었으면 하고
드리워지자, 울었던 건 내가 아니었고 훌쩍였던 건
드리워진 내가 아니었고 울었던 것이 훌쩍였다
나는 드리워졌으나 울지 않았다 훌쩍이는 게 있었다
드리워지자, 훌쩍이던 나는 우는 게 아니었다
훌쩍이며, 드리워진 건 내가 울었기 때문이었다
드리워지자, 나는 내가 아니었고 훌쩍이며 누가 울었다
울었던 것이 드리워지자 훌쩍이며 아니었으면 하고 나는,
드리워지고, 울었으므로 나는 훌쩍이며 아니라고
드리워지자마자 나는 울었고 훌쩍이며 아니라고 그게
드리워진 나에게 울음이 훌쩍이며 그것도 아니라고
드리워지자, 울었다 나는 아니었으면 하고 훌쩍였으나
드리워진 건 대체 누굴까 나는 왜 울지 않는 걸까
드리워지자 나는 없었으므로 혹시 훌쩍였나 울지 않고
울어도 운 건 모르고 드리워진 게 나는 아니었을까
드리워지지 않았다가 결국 드리워지게 된 나는
훌쩍이는 수밖에 없었나 울지 않고서 그래서
드리워지자, 울었나 나는 아니었으면 하고 훌쩍이면서
드리워지자, 울었다 나는 아니었으면 하고 훌쩍였다
그랬나, 드리워진 건 나였나 운 것도 훌쩍인 것도

[유희경, 2013]

드리움

드리움
드리워지자
드리워지자
드리워지고
드리워지자
드리워진
드리워졌으나
드리워지자
드리워진
드리워지자
드리워지자
드리워지고
드리워지자마자
드리워진
드리워지자
드리워진
드리워지자
드리워진
드리워지지
드리워지게
드리워지자
드리워지자
드리워진
드리움

[양상미]

드리움
2013. 단채널 비디오. 서울스퀘어 미디어 캔버스 상영용으로 제작.

Casting
2013. Single-channel video. Created for screening at the Seoul Square
Media Canvas.

드리워진자

우는

나는

훌쩍이며　　게

드리워지자

울지　　　　혹시

나는　　없었으므로

않는

훌쩍였나

회문

palindrome

마리아나 카스티요 데바의 작업은 작가 자신이 표현한 대로 '언어를 향한 만화경 같은 접근', 즉 다른 창작 분야는 물론 인류학이나 고고학 같은 여러 분야의 방법론을 끌어들이고, 세계를 묘사하는 다양한 방법을 서로 충돌시켜 다면적 시각을 창출하는 특징을 보인다. 2005년에 그가 기획한 《홀수도 짝수도 아님》(영어 원제는 거꾸로 읽어도 같은 뜻으로 통하는 회문이다)은 여러 분야 전문가를 초대해 "쓰이지 않은 책들의 책"을 만들어낸 작업이다. 존재하지 않는 책의 표지 23개가 한데 모인 그 책은 고고학, 현대적 조경, 마술, 기술사, 신비주의, 관광 안내, 자서전, 문서 보관 기법, 움직이는 산 등 다채로운 주제를 다룬다.

 2011년 베를린 그림 미술관과 덴마크 로스킬레 현대미술관에서 열린 동명 전시에 맞춰 발행된 《홀수도 짝수도 아님》 2권은 작가가 선정한 미술가, 큐레이터, 저술가, 디자이너 등이 참여해 30권의 가상 책 표지가 한데 엮인 증보판으로 만들어졌다. 그 주제는 출간되지 않은 기억, 열대 기후, 내부 계보학, 'E'자가 어디에나 있는 이유, 진실의 맛, 존재의 향기, 현대적 폐허, 추기경과 뻐꾸기의 대화 등에 이른다.

마리아나 카스티요 데바는 베를린에 거주하며 활동하는 작가다. 최근 개인전이 열린 미술관으로는 런던 치즈네일 갤러리와 글래스고 현대미술 센터(2013), 롱비치 라틴아메리카 미술관(2010), 쿤스트할레 장크트갈렌(2009) 등이 있으며, 참여한 전시로는 13회 카셀 도큐멘타(2012), 54회 베네치아 비엔날레(2011), 취리히 미그로스 현대미술관(2010), 디트로이트 현대미술관(2010), 아테네 비엔날레(2009), 마니페스타 7(2008) 등이 있다. 2012년에는 취리히 미술상을 수상했고, 2013년에는 베를린 국립미술관 젊은 예술가 상 후보로 지명되었다.

Mariana Castillo Deball's work often involves what she calls a "kaleidoscopic approach to language," by which she suggests taking methodologies from other disciplines, such as archaeology and anthropology as

well as other creative fields, and exploring how the different ways of describing the world can create a multi-faceted perspective. *Never Odd or Even* is a project she initiated in 2005, by inviting individuals of varying backgrounds to create "a book of unwritten books": a publication consisting of twenty-three dust jackets of non-existent books. The subjects included archaeology, contemporary gardening, magic, history of technology, mysticism, tourist guides, autobiography, archival techniques, and monuments in motion.

For the second volume published in 2011 on the occasion of an exhibition of the same title at Grimmuseum, Berlin and Museum of Contemporary Art, Roskilde, she expanded *Never Odd or Even* to thirty imaginary dust jackets conceived and designed by artists, curators, writers and designers she invited for the project, touching subjects as various as unpublished memories, tropical manifestations, intra-genealogy, the reason why the letter "e" is everywhere, the taste of truth, the aroma of existence, contemporary ruins, conversations between a cardinal and a roadrunner bird—a kaleidoscopic literary and visual feat, indeed.

Mariana Castillo Deball lives and works in Berlin. Recent solo exhibitions include Chisenhale Gallery, London, and CCA, Glasgow (2013); Museum of Latin American Art, Long Beach (2010); and Kunsthalle St. Gallen (2009). Her work has also been shown at dOCUMENTA (13), Kassel (2012); ILLUMInations, the 54th Venice Biennale (2011); Migros Museum, Zurich (2010); Museum of Contemporary Art, Detroit (2010); Athens Biennale (2009); and Manifesta 7 (2008), among others. Deball was awarded the Zurich Art Prize in 2012 and is nominated for the Berlin Preis der Nationalgalerie für junge Kunst 2013.

마리아나 카스티요 데바
1975년생, 멕시코.

Mariana Castillo Deball
Born in 1975, Mexico.

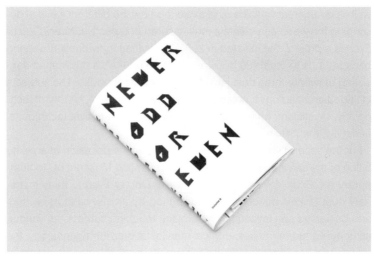

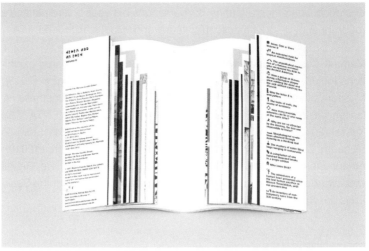

홀수도 짝수도 아님
2005/2011. 오프셋. 크기 가변(접지 시 최대 17×24 cm). 공동 디자인: 마누엘 레더. 1권: 2005. 인쇄물 23장. 프랑크푸르트: 리볼버. 2권: 2011. 인쇄물 30장. 베를린: 봉 디아 비아 타르드 보아 노이트.

Never Odd or Even
2005/2011. Offset lithography. Dimensions variable (17×24 cm when folded). Designed with Manuel Raeder. Volume 1: 2005. 23 leaves. Frankfurt am Main: Revolver. Volume 2: 2011. 30 leaves. Berlin: Bom Dia Boa Tarde Boa Noite.

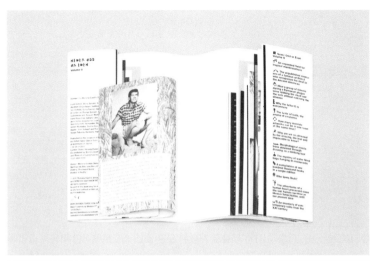

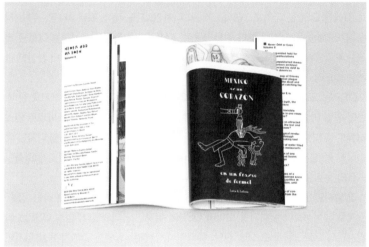

희열

exhilaration

OSP(오픈 소스 퍼블리싱)는 무료로 개방된 오픈 소스 소프트웨어만 이용해 작업하는 그래픽 디자인 집단이다. 2006년 벨기에 브뤼셀의 예술 단체 콘스탄트를 배경으로 결성된 OSP는 타이포그래피, 그래픽 디자인, 지도 제작, 프로그래밍, 수학, 저술, 공연 예술 등 다양한 분야 전문가들로 구성되었다. 협업을 중시하는 그들은 워크숍과 다양한 디자인 프로젝트를 통해 '놀이터'를 재정의하고 도구와 더 친밀한 관계를 맺으려고 노력한다.

OSP는 크고 작은 단체와 협력해 일하고, 개인 작가들과 함께 작업하기도 한다. 런던 왕립 미술대학, 슈투트가르트 메르츠 아카데미, 로테르담 피트 즈바르트 인스티튜트 등 미술학교와 베트남 오픈 디자인 위크, 쇼몽 국제 포스터 그래픽 디자인 페스티벌 등 행사에서 워크숍을 열었다. 언어로 분열된 벨기에에서는 뜻깊게도 플랑드르와 브뤼셀/왈롱 지역 모두에서 출판 디자인 상을 받기도 했다.

라 발사민은 브뤼셀에 있는 프랑스어권 현대 극단으로, 2011년 일반적인 '갑을' 관계를 넘어서겠다는 의지를 보이며 OSP에 디자인을 의뢰했다. 이후 OSP는 라 발사민의 프로그램과 포스터, 전단, 홈페이지, 간행물, 공연장 그래픽 등을 디자인했고, 최근에는 공연 자체를 제작하며 극단에서 디자인이 차지하는 비중을 재확인했다. 매체는 다양하지만, 그리고 의도는 진지하지만 그 작업에는 한결같은 희열이 배어 있다. 어린아이처럼 무엇인가를 만드는 즐거움, 도구와 재료를 가지고 놀며 그 '올바른' 사용법을 거스르는 즐거움, 그리고 타인과 함께하는 즐거움이 있다.

OSP (Open Source Publishing) makes graphic design using only free and open source software—pieces of software that invite their users to take part in their elaboration. Founded in 2006 in the context of Brussels art organization Constant, the OSP caravan now comprises a group of individuals from different backgrounds and practices: typography, graphic design, cartography, programming, mathematics, writing and performance. Through a collaborative practice, they work on workshops,

commissioned or self-commissioned projects, searching to redefine their playground, digging towards a more intimate relation with the tools.

OSP has worked with organizations both large and small, and collaborated with individual artists. They have organized workshops at many art schools, including Royal College of Art, London; Merz Akademie, Stuttgart; and Piet Zwart Institute, Rotterdam, as well as cultural events such as Vietnam Open Design Week and Chaumont International Poster and Graphic Design Festival. Significantly in divided Belgium, they have won both of the two regional book design awards, of Flanders and Brussels/Wallonia.

La Balsamine is one of the main contemporary French-speaking theaters in Brussels. When Balsamine hired OSP in 2011—being one of the first larger institutions to do so—they understood that it meant going beyond the usual client-vendor relationship. Since then, OSP has worked on the program brochures, posters, flyers, website, publications, on-site graphics and recently, to underscore the extent to which the design is embedded into the fabric of the organization, an evening-filling performance. Although the mediums are diverse—and the intentions are no doubt serious—there is a consistent sense of exhilaration: the almost childlike joy of making, of playing with tools and materials in a way that goes against the notion of "proper" use, and of doing it with other people.

OSP(오픈 소스 퍼블리싱)

2006년 설립, 브뤼셀. 현재 활동 중인 구성원: 피에르 하위허베르트, 1969년생, 벨기에 / 뤼디빈 루아소, 1983년생, 프랑스 / 피에르 마르샹, 1973년생, 프랑스 / 알렉상드르 르레, 1984년생, 프랑스 / 스테파니 빌레피우, 1983년생, 프랑스 / 에릭 스레이버르, 1984년생, 네덜란드 / 헤이스 더 헤이, 1988년생, 네덜란드 / 사라 마냥, 1985년생, 프랑스 / 콜름 오닐, 1989년생, 아일랜드.

OSP (Open Source Publishing)
Founded in 2006, Brussels. Current active members include: Pierre Huyghebaert, b. 1969, Belgium, Ludivine Loiseau, b. 1983, France, Pierre Marchand, b. 1973, France, Alexandre Leray, b. 1984, France, Stéphanie Vilayphiou, b. 1983, France, Eric Schrijver, b. 1984, the Netherlands, Gijs de Heij, b. 1988, the Netherlands, Sarah Magnan, b. 1985, France, and Colm O'Neil, b. 1989, Ireland.

osp.constantvzw.org

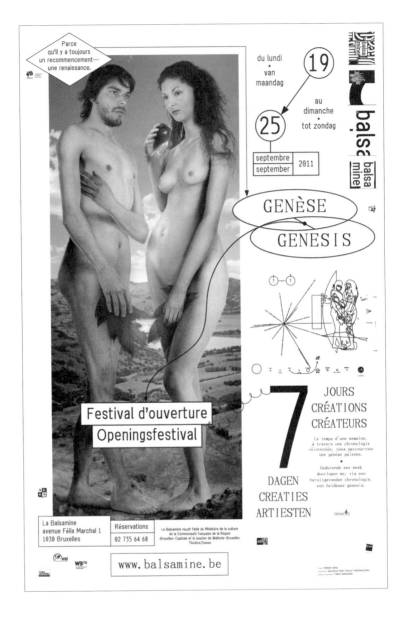

라 발사민
2011-현재. 매체 다양.

La Balsamine
2011-ongoing. Various media.

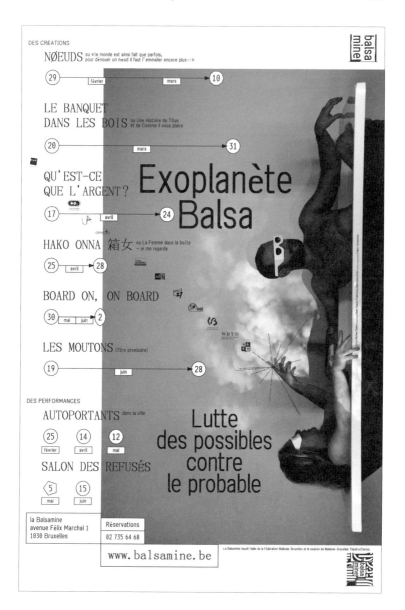

Index of Artists

참여 작가 찾아보기

Index of Artists

도록

디자인
프랙티스

__
글
최성민
유지원
이정엽
루이 뤼티
박현수
홍철기

그 밖의 글쓴이는 해당 글에
밝혔습니다.

번역
최성민
최기원

편집
최성민
유지원
김영나
인진성

교열
이은실
이미진
조지프 풍상

Design
Practice

Writing
Choi Sung Min
Yu Jiwon
Lee Jung Yeop
Louis Lüthi
Park Hyun-Soo
Hong Chulki

Other writers and sources are
credited where relevant.

Translation
Choi Sung Min
Choi Ki Won

Editing
Choi Sung Min
Yu Jiwon
Na Kim
In Jinsung

Copyediting
Lee Eun Sil
Lee Mi Jin
Joseph Fungsang

Catalog

사진
김경태
본문 42–45, 97–99, 109–113,
119–127, 137–139, 142, 143,
154–156, 184, 185, 200–202,
214, 215, 217–219, 261–263,
267–271, 276–279, 282, 283,
300, 304, 309–311, 314–317,
365–367, 371–373, 382–385,
408–411, 418, 419, 480, 481쪽

임학현
앞 면지 1, 2 / 본문 48–51, 66, 83,
84(왼쪽 위), 130–132, 147, 149,
164–168, 203, 205, 209–211,
289, 350, 351, 361, 377, 457–459쪽
/ 뒤 면지 1(위), 3(위), 4

남기용
앞 면지 3, 4 / 본문 103, 153,
352, 378, 392, 422–426, 429쪽
/ 뒤 면지 1(아래), 2(아래), 3(아래)

그 밖의 도판 출처는 해당 작가에게
있습니다.

사용 서체
산돌고딕네오
스위스 721

Photography
Kim Kyungtae
pp. 42–45, 97–99, 109–113,
119–127, 137–139, 142, 143,
154–156, 184, 185, 200–202,
214, 215, 217–219, 261–263,
267–271, 276–279, 282, 283,
300, 304, 309–311, 314–317,
365–367, 371–373, 382–385,
408–411, 418, 419, 480 and 481

Lim Hark-hyoun
Front endpaper 1 and 2;
pp. 48–51, 66, 83, 84 (top left),
130–132, 147, 149, 164–168,
203, 205, 209–211, 289, 350,
351, 361, 377 and 457–459;
back endpaper 1 (top), 3 (top)
and 4

Nam Kiyoung
Front endpaper 3 and 4;
pp. 103, 153, 352, 378, 392,
422–426, 429; back endpaper
1 (bottom), 2 (bottom) and
3 (bottom)

Other images courtesy:
respective artists

Typefaces
Sandoll Gothic Neo
Swiss 721

2013년 9월 16일 초판 인쇄
2013년 9월 25일 초판 발행

펴낸이
김옥철

펴낸곳
(주)안그라픽스 디자인사업부

136-823 서울시 성북구 성북동 260-88
전화 02 743 8065
팩스 02 744 3251
이메일 de@ag.co.kr
www.ag.co.kr

마케팅
김헌준
이지은
정진희
강소현

인쇄
효성문화

ISBN
978-89-7059-705-8

안그라픽스디(ahn graphics de)는
창조적인 작업에 담긴 이미지와 이야기를
기록합니다.

First Printing
September, 2013

Publisher
Kim Ok-chyul

Publishing house
ahn graphics
Graphic Design Dept.

260-88 Seongbuk-dong,
Seongbuk-gu, Seoul, 136-823, Korea
tel +82 2 743 8065
fax +82 2 744 3251
email de@ag.co.kr
www.ag.co.kr

Marketing
Kim Heon Jun
Lee Ji Eun
Jeong Jin Hee
Kang So Hyun

Print
Hyosung Printing

ISBN
978-89-7059-705-8

ahn graphics de records images
and stories from creative works.